Hill

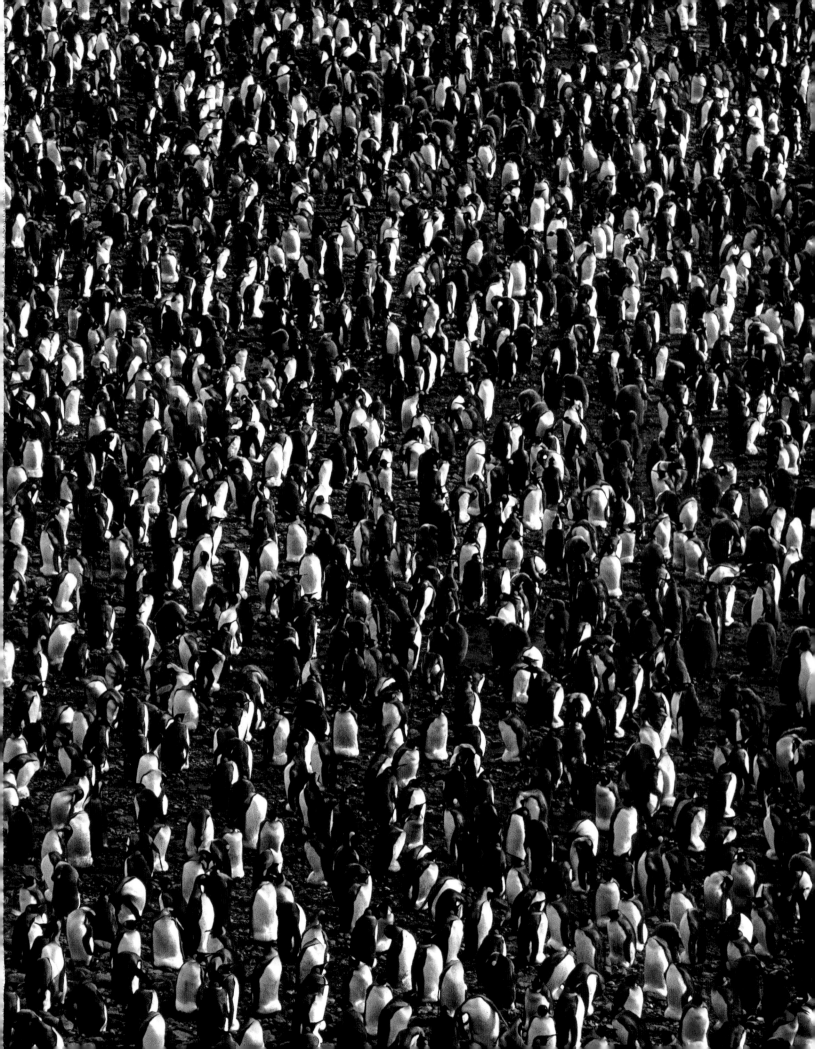

Glimpses of Paradise

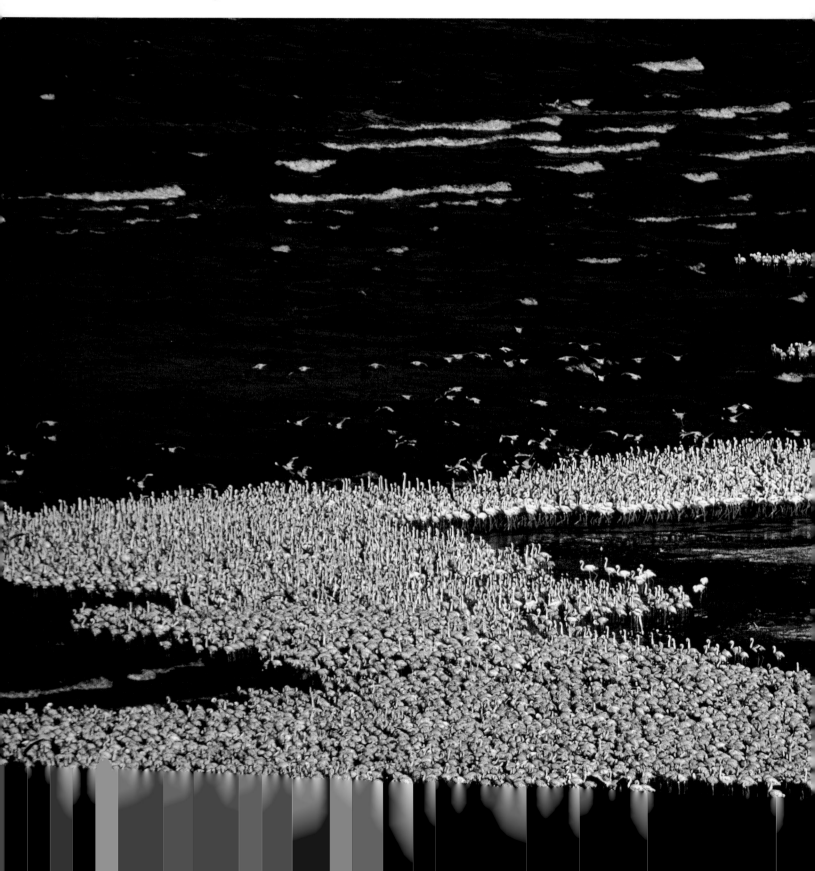

The Marvel of Massed Animals Fred Bruemmer FIREFLY BOOKS

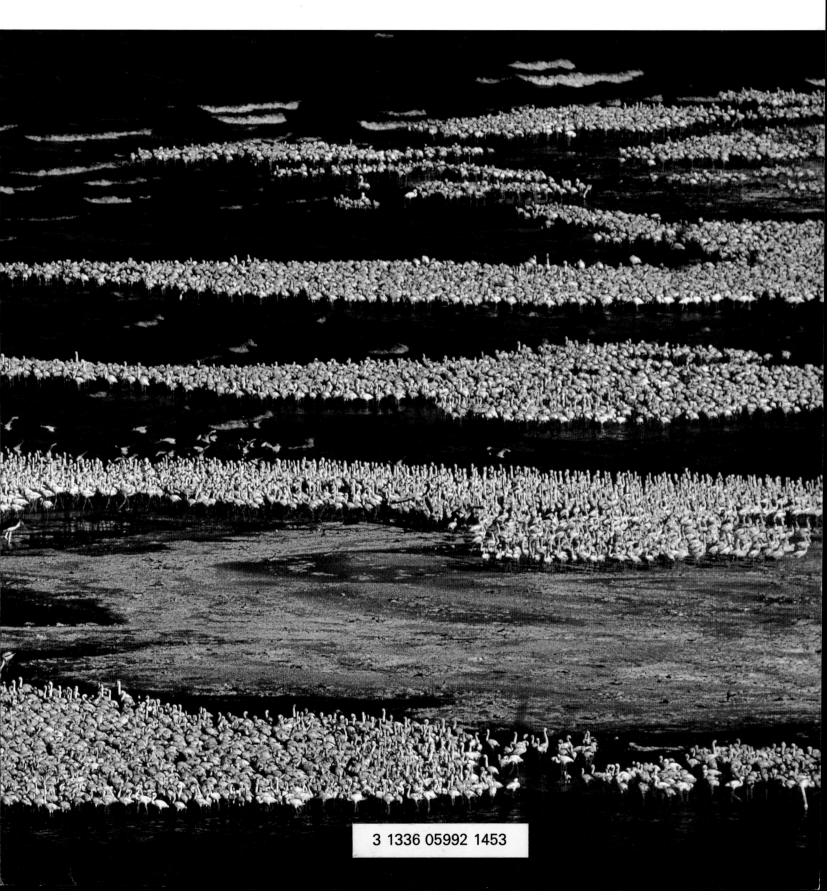

A Firefly Book

Published by Firefly Books (U.S.) Inc. 2002

First Printing

U.S. Publisher Cataloging-in-Publication Data

Bruemmer, Fred.
 Glimpses of paradise : the marvel of massed animals / Fred
Bruemer.—1st ed.
[256] p. : col. photos. ; cm.
Summary: Photographs of massings of wild animals around the world,
with commentary.
ISBN 1-55297-666-1
1. Wildlife. 2. Animals. 3. Nature. I. Title.
333.95/ 4 21 CIP QL705.B78 2001

First Published in the United States in 2002 by
Firefly Books (U.S.) Inc.
P.O. Box 1338, Ellicott Station
Buffalo, New York, USA
14205

Published in Canada in 2002 by Key Porter Books Limited.

Design: Peter Maher

Electronic formatting: Jean Lightfoot Peters

Printed and bound in Hong Kong, China

Contents

Red Knot Delaware Bay, New Jersey, U.S.A. Red Knots, robin-sized shorebirds, commute between the antipodes. They winter near the tip of South America and breed in the Arctic of North America. They stop each May at Delaware Bay to feast and fatten on horseshoe crab eggs, doubling their weight in two weeks. 89

Ruddy Turnstone Delaware Bay, New Jersey, U.S.A. The horseshoe crabs provide vital food for migrating shorebirds on their flight from South America to their arctic breeding grounds. The birds eat 25 billion horseshoe crab eggs, weighing more than 100 tons. Their spring gathering has been called "the greatest shorebird spectacle in North America." 95

Red-Sided Garter Snake Manitoba, Canada. Hundreds of thousands of Manitoba's garter snakes hibernate in deep caverns beneath the frostline. In spring, they emerge from their subterranean caverns to mate. They first emerge into limestone pits, where they cover the rocks and appear to form an elegant carpet. This is the largest concentration of snakes in the world. 101

Harp Seal Gulf of St. Lawrence Ice, Canada. Every spring, hundreds of thousands of female harp seals haul out onto the ice to bear their beautiful white-furred pups. The females lie dispersed over miles of ice, but the males occasionally mass in large numbers. 107

Adélie Penguin/Chinstrap Penguin Antarctica. Both these species of penguins breed in immense colonies on the Antarctic continent and on subantarctic islands. These areas are surrounded by food-rich seas, which have enabled the penguins to thrive in colonies that number hundreds of thousands of birds. The fact that the birds are protected by conservation policies has also allowed their numbers to grow. 113, 119

Monarch Butterfly Mexico. In the fall, millions of monarch butterflies from North America migrate to remote mountain ranges in Mexico. There they hibernate in tight clusters that fill treetops and cover tree trunks. 123

Caribou Canadian Arctic. These caribou are the last of North America's great wildlife herds. In spring and summer they migrate from the northern forests to the vastness of the tundra; they return to the forest in late fall. 129

Dovekie Greenland. These high arctic alcids breed on steep scree slopes. Some dovekie colonies consist of more than a million birds. Some of the birds are eaten by Greenland's Polar Inuit, the northernmost people on earth. 135

Steller Sea Lion Alaska, U.S.A. This is the largest of the world's five sea lion species. Adult males weigh up to a ton. Highly gregarious, these sea lions breed in dense colonies on beaches in the Far North. 141

Heermann's Gull Baja California, Mexico. About 90 percent of the world's population of Heermann's gulls nests on one heat-baked chunk of rock, known as Rasa Island; it lies in Mexico's Sea of Cortez. 147

Rockhopper Penguin Falkland Islands. Small but tough, rockhopper penguins routinely land on wave-lashed rocky coasts to reach their breeding colonies. They often nest with the strikingly-colored king cormorants. 153

King Cormorant Falkland Islands. Hardiest of the world's 30 cormorant species, king cormorants nest on many subantarctic islands and even on the rim of Antarctica. Some of its largest colonies are on the Falkland Islands. 159

Semipalmated Sandpiper New Brunswick, Canada. The Bay of Fundy has the highest tides in the world. One and a half million shorebirds use the bay as a vital feeding area during their migration. Most numerous are the lovely semipalmated sandpipers. 165

Mexican Free-Tailed Bat Texas, U.S.A. About four million of these bats live in one huge cave. It is a maternity cave, inhabited only by mother bats and their pups, as the young are called. At dusk the adult bats leave the cave in several mass flights, each with about half a million bats. They emerge from the cave in a great cloud and rush up into the evening sky. 171

Greater Snow Goose Quebec, Canada. Every fall, some 200,000 greater snow geese migrate from their arctic breeding grounds to the eastern seaboard of the U.S. En route, they stop off at Cap Tourmente in Quebec to feed on the extensive tidal flats and on nearby fields and meadows. Their mass flights against a background of autumn foliage are a marvelous symphony of color and sound. 177

Ladybird Beetle or Ladybug Arizona, U.S.A. In summer, when the temperature soars beyond 104°F (40°C), the ladybird beetles fly to a remote mountain region. They estivate there at an altitude of 7,500 feet (2,500 m), where it is relatively cool. Millions of densely packed beetles cover tree trunks, rocks, and leaves there, appearing to form a lacquered red forest. 183

Cape Fur Seal Namibia, Africa. Once hunted by lions and Bushmen on land, South Africa's fur seal lived only on offshore islands. Now that lions and Bushmen have nearly vanished from the coasts, fur seals flourish in colonies on the mainland. The largest colonies are on diamond-holding beaches, which are off-limits to everyone except fur seals. 189

Kittiwake Rochers aux Oiseaux, Quebec. Gregarious and noisy, these elegant little gulls breed in immense colonies on steep-cliffed islands; there they are relatively safe from predators. One of the most beautiful kittiwake colonies is on this red sandstone island in the Gulf of St. Lawrence. 193

White Whale or **Beluga** Canadian Arctic. Every summer about 1,000 white whales gather in a bay in the High Arctic to reproduce, to molt, and to talk. Belugas are the most vocal of all whales. At high tide, they mass near the delta channels of a river and then frequently ascend the river. 199

Pierid and Swordtail Butterflies Upper Amazon region, Peru. In a blur of color, pierid butterflies settle, along with some swordtails, near an Indian village at the spot where men urinate. They also land on sweating humans to suck up perspiration. 205

Geoffrey's Roussette Bali, Indonesia. Millions of these fruit-eating bats cover the walls and the domed ceiling of the immense Goa Lawah cave on Bali. The sacred cave is part of a 1,000-year-old temple complex and every day pilgrims come to pray in front of the cave entrance. 211

Red-Winged Blackbird Nebraska, U.S.A. Redwings are among the most numerous birds of the United States. Although they disperse in summer, the red-winged blackbirds begin to mass in fall. Immense flocks feed together, and winter roosts often number in the millions. 217

Mealy Parrot Upper Amazon region, Peru. The mealy parrot and some other rainforest species eat unripe fruits that are often poisonous. To counteract the toxins, they eat a certain type of clay. They gather in large flocks at clay licks in the early morning. 219

Galah Australia. These elegant, excitable cockatoos often travel in large raucous flocks. In Kalbarrie, they feed on grasses and weeds on the town's extensive lawns and gather in disputatious groups to drink from a local spring. 225

Sandhill Crane Nebraska, U.S.A. During their migration from the southern states to their arctic breeding grounds, about half a million sandhill cranes stop off to feed on the maize fields of Nebraska and to rest on the Platte River's broad but shallow sandbanks. 231

Red Crab Christmas Island, Indian Ocean. About 120 million red crabs live on this remote tropical island. At the beginning of the rainy season, the crabs march from their burrows in the rainforest to the sea. At high tide, the females drop their fertilized eggs into the ocean. And then the survivors of this epic migration return to their burrows in the forest. 237

Blue-Headed Parrot Upper Amazon region, Peru. At dawn, the parrots gather above their favorite clay licks on steep riverbanks. They are eager to eat the clay because it neutralizes the toxins in the unripe fruits they like to eat. 243

Red-and-Green Macaw Upper Amazon region, Peru. Certain parrots that inhabit South American rainforest, most notably these gorgeously colored macaws, like to eat unripe fruit. Plants try to discourage this by making their unripe fruit poisonous. But the parrots have discovered that by eating certain types of clay they can protect themselves from the poison in their favorite fruits. 249

Afterword 255

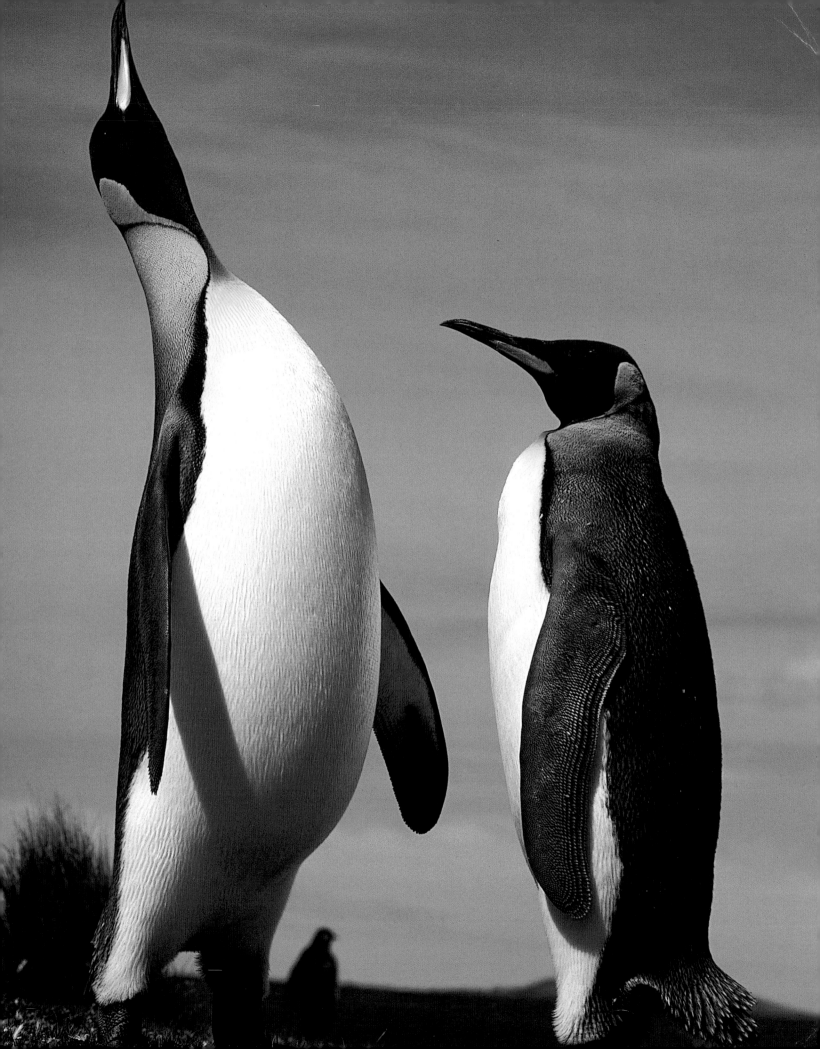

Introduction

In 1919, toward the end of his life, the great American naturalist John Burroughs looked back in sorrow at the vanished world of his youth. Then spring had brought "vast armies of passenger pigeons...the naked beechwoods would suddenly become blue with them, and vocal with their soft, childlike calls. It was such a spectacle of beauty, of joyous, copious animal life, of fertility in the air and in the wilderness, as to make the heart glad. I have seen the fields and woods fairly inundated for a day or two with these fluttering, piping, blue-and-white hosts. The very air at times seemed suddenly to turn to pigeons."

The passenger pigeon was once the most numerous bird in the world. Alexander Wilson, the so-called father of American ornithology, estimated in 1808 that one Kentucky flock numbered more than two billion birds. John James Audubon saw such a flock cross the Ohio River in 1813: "The air was literally filled with Pigeons; the light of noon-day was obscured as by an eclipse."

Death waited for the massed pigeons. "The people were all in arms," wrote Audubon. "The banks of the Ohio were crowded with men and boys incessantly shooting...Multitudes were thus destroyed."

Market hunters killed the birds in millions. In 1805, Audubon saw "schooners loaded in bulk with pigeons...coming in to the wharf at New York," and on New York markets passenger pigeons were sold for one cent a piece.

Farmers shot adult pigeons, knocked down nests and chicks, and fattened their hogs with the dying birds. Sport hunters captured passenger pigeons, sewed their eyes shut, and set them out as decoys on small perches to attract other pigeons into shooting range (hence the term "stool pigeon").

By the 1880s the marvelous flights of massed pigeons ended, never to be seen again. Ruthlessly hunted, the birds became rare. The last wild passenger pigeon was shot on March 24, 1900. The very last passenger pigeon on earth, a female named Martha, died at the age of 29 at 4 p.m. on September l, 1914 in the Cincinnati Zoo. All that remains of these lovely birds that once filled the sky in rushing masses of life are 1,532 skins and mounts in the museums of the world, where their luster has faded.

The mighty bison, the largest land animal in North America, nearly shared the passenger pigeon's fate. In herds that numbered 100,000 or more, these animals roamed the infinite prairies. When they migrated south in fall to better grazing grounds, early European explorers saw streams of the mighty animals fill the land from horizon to horizon, and it filled them with awe. The total number of bison was estimated to be about 60 million. They were probably the most numerous large animals on earth.

"The Bison has several enemies," wrote Audubon, "The worst is, of course, man." Bison formed the basis of existence for the Plains Indians, but since there were few of them and their weapons were simple, they never threatened the vast herds. That changed when white hunters came to the plains. They were dubbed "buffalo butchers," or "hide and tongue hunters," because they took only the skins that could be sold and the bison's tongues, which were prized as a delicacy. They left the carcasses to rot. In 1882 alone, the Northern Pacific Railway carried 200,000 bison hides out of Montana and the Dakotas. The vast herds dwindled, and the Indians starved. "A cold wind blew across the prairies when the last buffalo fell... a death-wind for my people," mourned the great Indian chief Sitting Bull.

A few animals did survive the slaughter. In 1889, William T. Hornaday of the Smithsonian Institution estimated that 835 bison remained, 200 of them in Yellowstone National Park. Legislation was introduced to protect the last few bison. Their numbers began to increase, but the animals were

limited to parks and reserves, for nearly all their vast prairie realm was turned into farms and ranches.

Humans have multiplied prodigiously and most of the ancient animal wealth of our world has been destroyed. We shall never see passenger pigeons again, and the great herds of bison are a wonder of times past. But here and there, for a variety of reasons, some animal species still exist in huge numbers and convey in their multitude a vision of Eden, of a world that once existed.

I have searched for paradise for more than 30 years. I've sought out those magic places where animals congregate in large numbers, places that teem with the fullness of life.

Not surprisingly, some of the greatest concentrations of animals are in regions where humans do not live or where populations are small—the Far North and the Far South, the Arctic and the Antarctic.

In the dialect of northwestern Greenland's Polar Inuit May is called *agpaliarssuit tikarfiat*, which means "the dovekies are coming." I was in that part of the world in May of 1971. I stood at the floe edge with Jes Qujaukitsok, an Inuit hunter. We were waiting for seals, and I was also hoping to see narwhal. It was an enchanted night, clear and cold and beautiful; the sea glossy black, the ice deep blue, the light honey yellow on the far mountains. Belugas swam in the distance, their milky white backs arching out of the dark water. We could hear them trill and grunt in the quiet of the night. Eider ducks flew past in great flocks. And then the dovekies came—great dark clouds in the blue-green sky, hundreds of thousands, all winging north, toward the great breeding slopes of the Siorapaluk–Etah area to keep their date with destiny.

Thirty years later I was on South Georgia, a subantarctic island with lush green valleys hemmed by glittering glaciers. On great Salisbury Plain stood nearly half a million king penguins, the most beautiful of all penguins. Each adult bird was nearly three feet (1 m) tall, its belly glossy white, its back a shining slate blue, with glowing golden orange patches on nape and bill and bib. In addition to the elegant adults there were groups of thick-downed, solemn hungry chicks. They stood like tubby men in fuzzy cloaks, waiting for their parents to arrive with food. I looked down from a slope and beneath me the neatly spaced birds spread toward the far hills in a marvelous tapestry of life.

Many years ago, when the migration routes of caribou were still relatively unknown, a biologist and I followed one large herd by plane, flying high above the animals every day. It was late fall and the caribou were marching southward. During the day, they scattered as they fed but then came together in the afternoon, the haphazard drift becoming a purposeful march. Far beneath us, the many mile-long mass seemed to glide across the tundra, skirting lakes and bunching into tight brown clusters at rivers and narrows. The sun was setting. The land beneath lay somber, its myriad glittering lakes reflecting the copper sky. Over the dark earth snaked the vast throng of migrating caribou, a golden ribbon of life in the sun's slanting rays.

Later, in Tanzania, I flew high above the Serengeti, that immense grassy plain that is home to Africa's largest wildlife herds. Most wildebeest had given birth within a two-week period, and now brownish long-legged calves were trotting near their mothers. The herds, consisting of more than a million wildebeest, were marching northward in search of greener pastures, following their age-old migration trails.

Some concentrations of animals, such as fur seal colonies, were discovered centuries ago. Others have only recently been discovered. In 1963, *National Geographic* published an article entitled the "Mystery of the Monarch Butterfly." The

mystery concerned the whereabouts of the monarch's winter roosting grounds. Twelve years later the mystery had been solved and *National Geographic* published: "Discovered: The Monarch's Mexican Haven." A few years later I visited this butterfly haven high in the Sierra Madre Mountains, where millions of monarchs covered the branches and trunks of tall oyamel trees. Toward noon when the sun was warm, the butterflies soared, appearing golden against the blue sky; the delicate rustling of a million wings sounded like the soft murmuring of distant surf upon a beach.

Over the years my quest for massed animals has taken me to all five continents and to many remote and marvelous islands. On the journeys I made to the Arctic and the upper Amazon, I was accompanied by the photographer Tom Mangelsen, whose work I admire and whose friendship I cherish. However, on most trips my companion was Maud, my wife of 40 years, who shared with me the beauty of our world, these glimpses of paradise. And for that and the wonders we have seen together I am truly grateful.

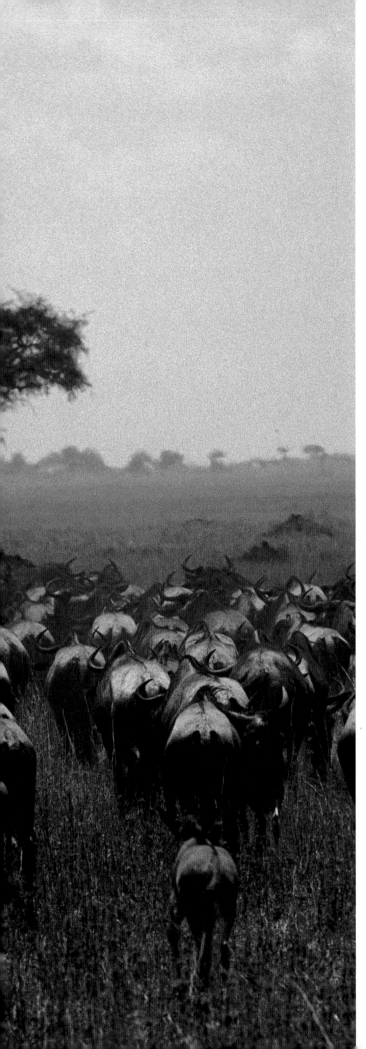

Wildebeest,
Tanzania, Africa

The annual wildebeest migration of eastern Africa has been called "the greatest natural wildlife spectacle on earth," by the American author Shana Alexander. In an endless cycle, determined by the seasons and by rainfall, 1.5 million wildebeest pour across the immense plains of the Serengeti-Mara ecosystem of Tanzania and Kenya, their migration as immutable as the tides.

We were waiting for them in late March, near the end of the rainy season, on the shortgrass plains of the southeastern Serengeti. We had parked near a small wooded ravine. It had rained during the night and now the morning was clear and luminous.

Around us was the splendor of Africa: herds of elegant impalas, tan and gold in the morning sun; flocks of doves that gently cooed; a well-fed pride of lions, sprawled lazily beneath an acacia tree; giraffes that browsed on thorny bushes, plucking small rosettes of bright green leaves with long, bluish violet tongues.

And then the wildebeest came—an immense dark throng of large animals, wandering toward new pastures. Some walked in single file, others in dense clusters. But they all marched intently onward to new green grass, their heads nodding. They poured through the ravine, skirted our car, and spread out over the plains beyond until the latter were covered from horizon to horizon with grazing animals.

Most of the 9,846-square-mile (25,500-sq-km) Serengeti-Mara ecosystem lies within Tanzania's Serengeti National Park (which measures 5,699 square miles [14,760 sq km], more than five times the size of the Grand Duchy of Luxembourg) and

Mass migration of wildebeest across the vast Serengeti Plain in Tanzania. In order to use the best pasture of each season and not to overgraze a particular region, the immense herds of wildebeest (altogether about 1.5 million animals) move in cycle with the seasons.

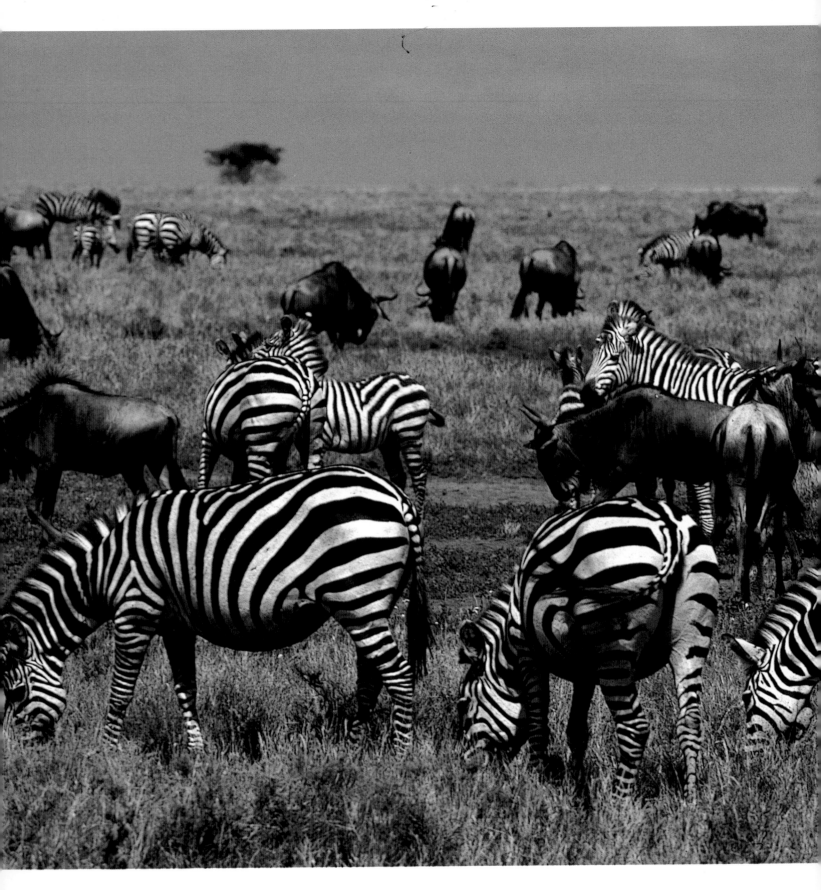

Wildebeest and zebra often migrate together. They do not compete with each other when feeding. Zebras, which have teeth in both jaws, bite off the taller, coarser parts of grasses. But the wildebeest prefer the lower, lusher parts of plants, as their upper palates lack teeth.

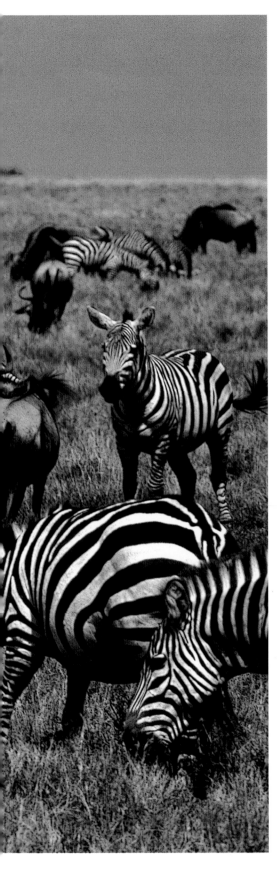

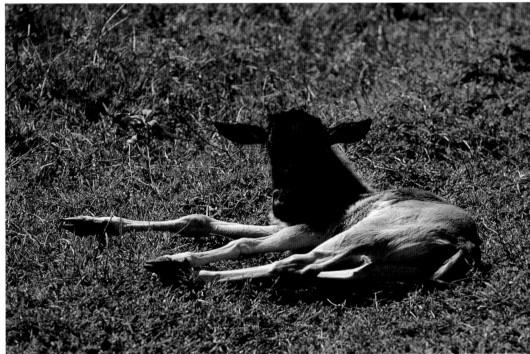

the contiguous Masai Mara National Reserve in Kenya. This ecosystem is aptly named: Serengeti means "the endless plain" in the language of the Masai. Fritz Jaeger, a German geographer who surveyed the Serengeti on foot in 1907 described it as "grass, grass, grass, grass, and grass," adding plaintively, "One looks around and sees only grass and sky." True, but large parts of the savanna contain trees and shrubs, making them almost parklike.

The wildebeest's name comes from its startling appearance. It looked so odd to European settlers that they called it *wildebeest*, "wild beast" in Afrikaans. Its fore-quarters are massive, its rump low. Cowlike horns jut out from its large and heavy head, and its tail ends in a long, coarse-haired fly whisk. The animal's fur is a dark brindled brown. Large males can weigh up to 600 pounds (272 kg).

In addition to the wildebeest's odd appearance, the antics of the male surprised settlers. "Clown of the veld," they called the prancing wildebeest. Later, travellers also found the animal's antics

A tired wildebeest calf rests on the Serengeti. Minutes after birth, calves totter on long and unsteady legs and soon begin to nurse. After a few days, the new-born calves are able to keep up with the adults. Within a week, if threatened, a calf can sprint alongside its mother, at speeds of up to 50 miles per hour (80 km/h), and outrun nearly all predators.

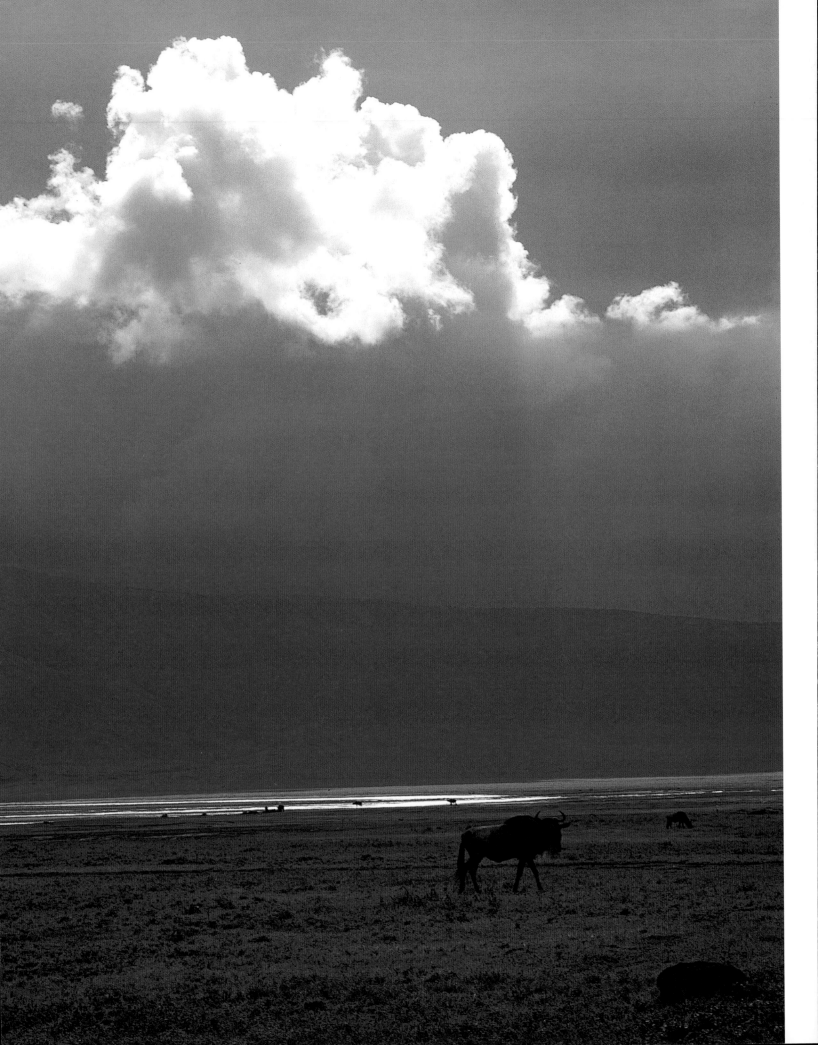

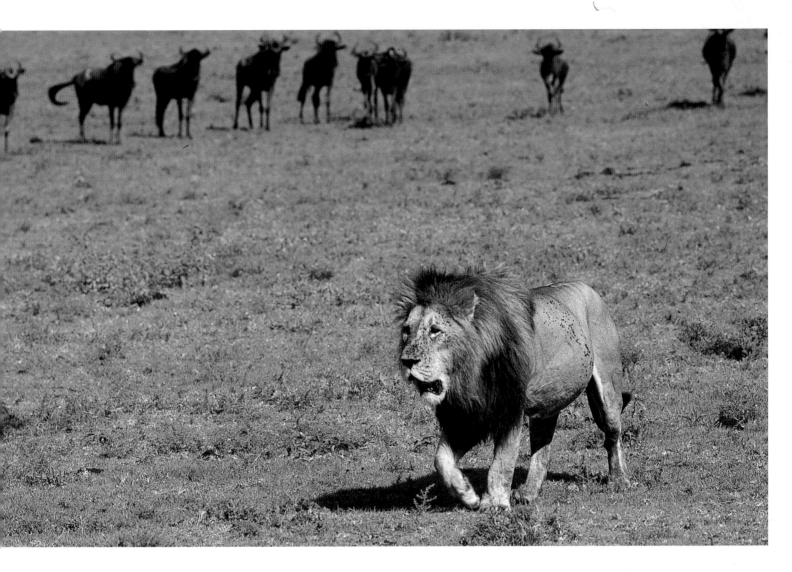

remarkable. Theodore Roosevelt wrote: "As one approaches a herd of wildebeest, they stand and gaze, sometimes snorting or grunting, their heads held high and their manes give them a leonine look. The bulls may pace up and down, pawing the ground and lashing their tails...[As humans come nearer] down go their heads and off they start, rollicking, plunging, and bucking...or a bull will almost stand on its head to toss up the dust with its horns."

What Roosevelt mistook for the highjinks of manic males was really the behavior of annoyed bulls who had been forced to vacate hard-won

About 15,000 wildebeest live on the lush plain of Tanzania's Ngorongoro Crater, the 10-mile-wide (16-km-wide) bottom of a collapsed volcano. Rain storms hit the crater's rim and water seeps down the densely forested crater walls to the verdant bottom. Its herds of wildebeest and a profusion of other animals make the Ngorongoro Crater one of the most magnificent reserves in the world.

Wildebeest watch with interest but no fear as a fly-pestered lion walks past them. Both adults and even week-old calves can outrun an approaching lion. However, lions that hunt from ambush, or lionesses hunting as a team, often kill wildebeest—one of their most important and abundant prey animals.

territories. Mature male wildebeest establish territories even during migrations, and females will only mate with established property owners.

The animal's mating season is short and ardent. Nearly all wildebeest mate during two weeks in June, and, as a result of this synchronous breeding, all calves are born within about two weeks of one another just before the rainy season. At this time the massed herds stop briefly. But soon the long-legged calves are strong enough to walk, and the herds resume their vast migration to the best pastures of the season.

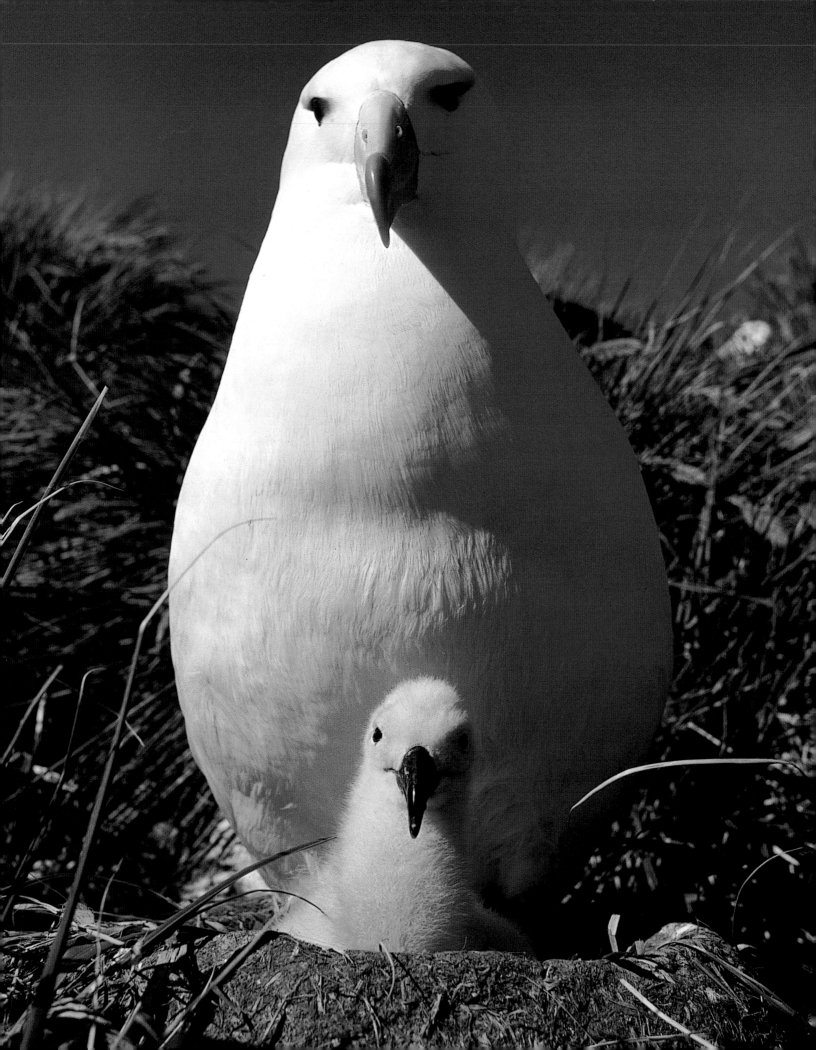

Black-Browed Albatross, Falkland Islands

Albatrosses are the master gliders of the avian world. One banded albatross flew around the world in slightly less than 80 days. Riding the prevailing westerly winds of the far-southern hemisphere, in that belt of gales known to sailors as the "Roaring Forties" and the "Furious Fifties," they glide incessantly, scanning the sea for food. Their flights can continue for months, sometimes years.

I lived once with scientists on Enderby, one of the Auckland Islands, between New Zealand and Antarctica. We were right in the path of the worst gales in the world. A few times we crawled from the shelter of the island's rata forest to its windward edge to watch the primal fury of the wind and waves.

The gale roared and waves, as high as a house, smashed the island cliffs and exploded into 300-feet-high (100-m-high) walls of spray. Above this terrifying chaos, albatrosses soared serenely, swooping down to pick up bits of food and rushing up again, their long slender wings riding the winds. For the master aerialists of the world, this was fine flying weather. With a wingspan nearly 12 feet long (3.7 m long), the wandering albatross is the largest seabird in the world.

The most numerous of the world's 13 albatross species is the black-browed albatross. It has 12 colonies on the Falkland Islands, where I once lived for several months. Breeding had just begun on Saunders Island when I arrived in October. Some birds were already on their nests, foot-high pedestals of mud and grass; others were busy repairing and shaping last year's nests.

That little sculptured pillar of earth is the central point of the albatross's married life. Once fledged, immature birds fly out to sea and will not return to land for several years. Albatrosses mature late, but they also live long. Their lifespan is an average of about 30 years, with a few reaching an age of 70 to 80 years, during which time they will have flown millions of miles.

Courting ceremonies are long, elaborate, loud, and ecstatic. At the ceremony's climax, both birds face each other, wings spread, long-billed heads pointed toward the sky, and moo and bray in adoration. It's not very musical but it is ardent, and in due course they mate and remain mated for life.

They build their nest pedestal. The female soon lays a single egg, and then both parents alternately incubate the egg for two months. Once the chick is grown, both parents leave the island and go their separate ways. But at the beginning of the next breeding season, they will meet again at the mud mound that is their perennial nest, where they will greet each other with exuberant joy.

This site fidelity is particularly impressive on the remote and nearly inaccessible Steeple Jason Island, near the northeastern Falklands. The island is home to the largest albatross colony in the world. Here, neatly spaced at 5 feet (1.5 m) from one another, more than a million black-browed albatrosses nest. The glossy-white birds perch solemnly upon their pedestals, hemmed by lush green slopes.

The spacing of the nests is important. Albatrosses appear infinitely graceful in the air, but their landings put an end to this illusion. As they approach the nest site, they begin to wobble like a plane that is stalling. Next they brake frantically with their wings and huge flat feet, and then just crash close to home, if they're lucky. Because they land in such a clumsy fashion, sailors called albatrosses "gooney birds," an old word for simpleton.

Back at the nest one parent guards the chick, while the other forages for food, which consists mainly of squid and lobster krill snatched from the ocean surface. Albatrosses glide with the winds, flexing their long narrow wings. This way they avoid

While one parent roams the sea in search of food, the other guards the single chick for at least three weeks. Following this period, the chick becomes sharp-billed and feisty. Now that it is strong enough to fend off enemies, both parents can fly out to sea to collect food.

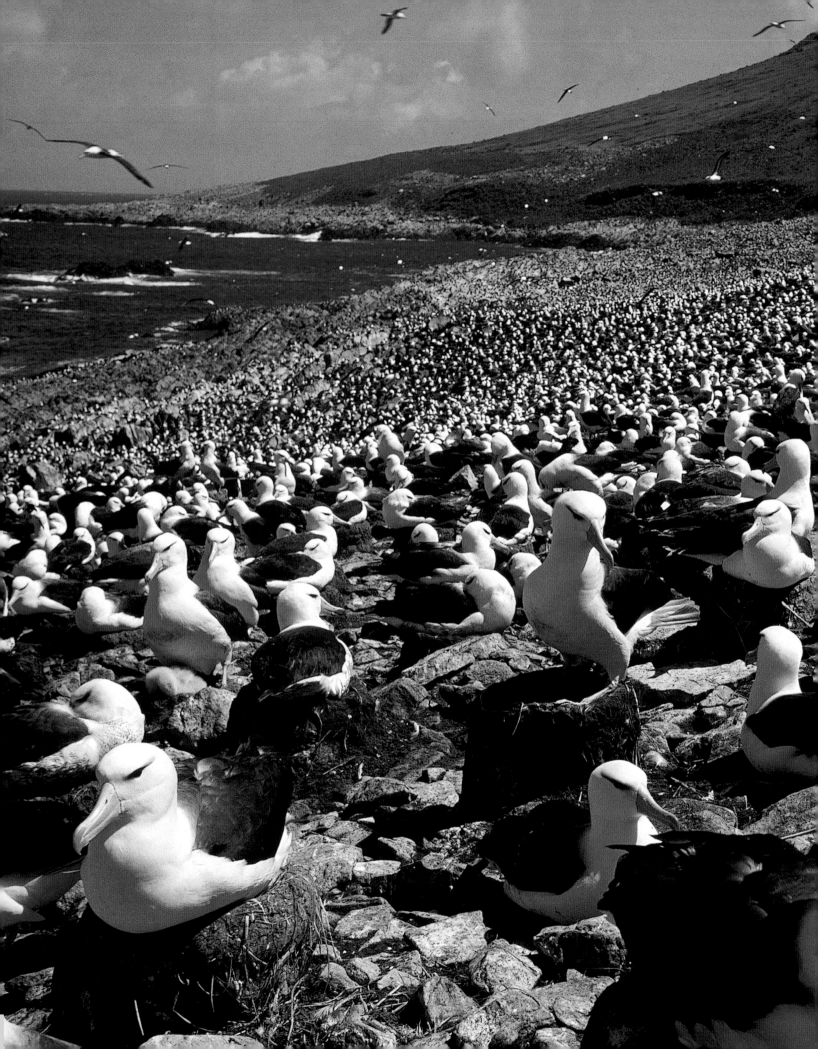

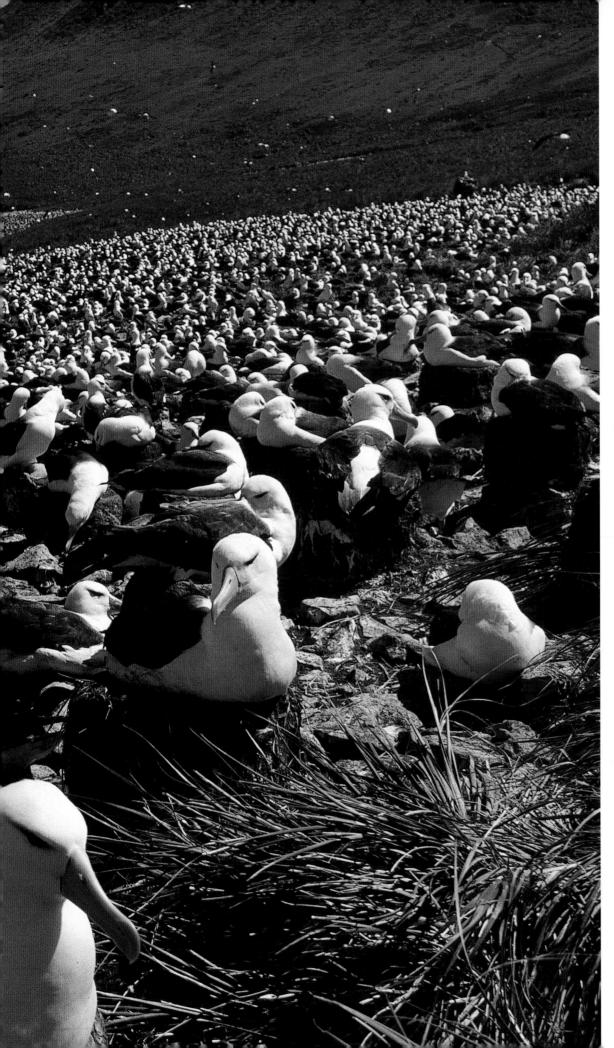

*An immense colony of black-
browed albatrosses on
Steeple Jason, an
uninhabited, hard-to-reach
island in the Falklands. This
is the largest albatross
colony in the world, with
more than one million birds.
Albatrosses mate for life and
male and female return to
the same nest site each year.*

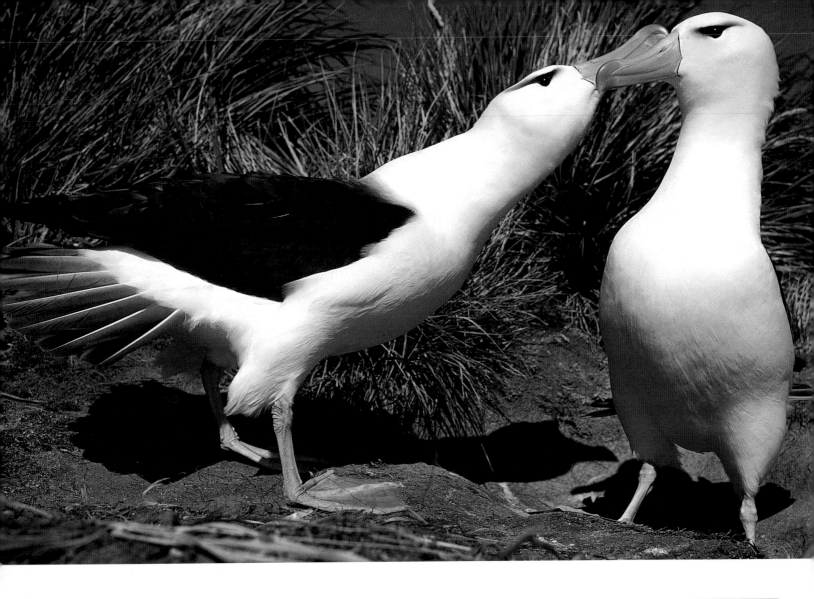

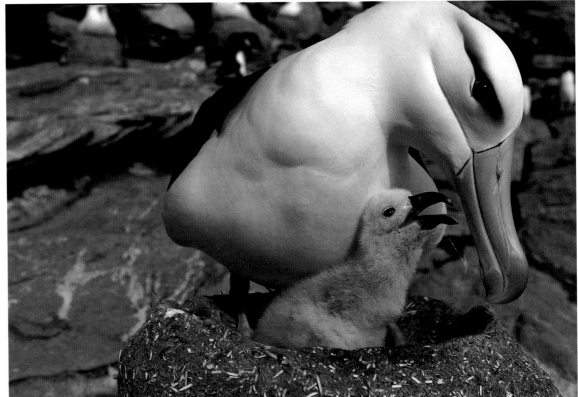

A hungry chick pecks at its parent's beak to receive regurgitated food. A parent returns from a long foraging trip with a big load of predigested food and squirts large dollops of this high-energy mash into the chick's gullet.

A courting couple of black-browed albatrosses. Young birds begin to court when they are about five years old. They come to land, then perform a very elaborate dance of love. Pairs form and for a year or more the young birds are "engaged." They dance together, establish territories, even build mock nests. Once they are fully mature, they mate and breed and then remain mated for life.

The powerful hooked and plated bill of the black-browed albatross is perfect for snapping slippery squid from the sea. Albatrosses drink sea water, then excrete salt in the form of concentrated brine through tubular nostrils on the upper bill. Since these beautiful birds have no enemies on the remote islands where they breed, they have no fear of humans.

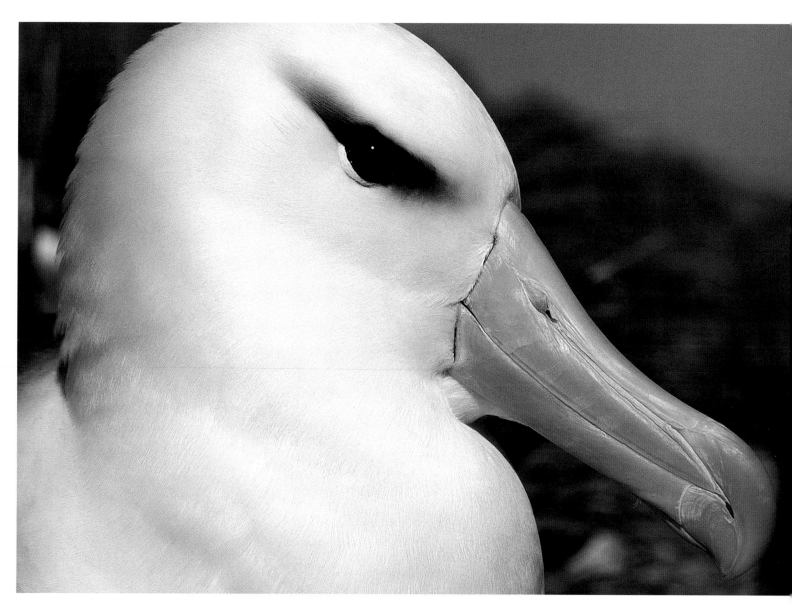

the energy-devouring flapping of most other birds. Thus from a food-gathering trip of 930 miles (1,500 km), they can return with a large volume of concentrated, semiliquid, predigested foods for their chicks.

To elicit feeding, the chick taps its parent's massive beak. Chick and parent then place their bills crosswise, and the adult spurts food into the chick's gullet. A single feeding can consist of a quart of food. Once a chick has consumed this amount, its belly usually bloats up like a balloon, and it squats immobile on the nest.

On this energy-rich diet, the chicks grow tall and strong and start to flap their wings. At four months, the black-browed albatross juveniles begin to leave the land and learn how to ride the winds. They must be able to soar and glide over storm-tossed seas in the midst of howling gales. To be an albatross, said the famous British ornithologist James Fisher, "is probably the most exacting occupation in the bird world."

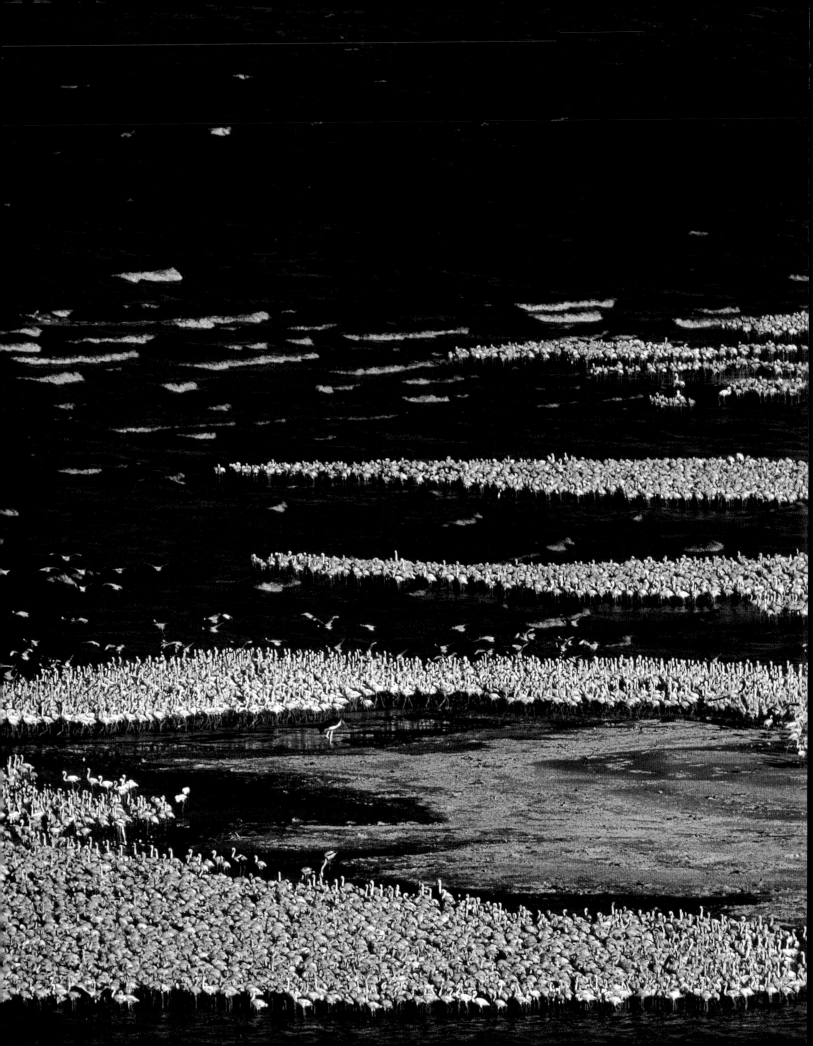

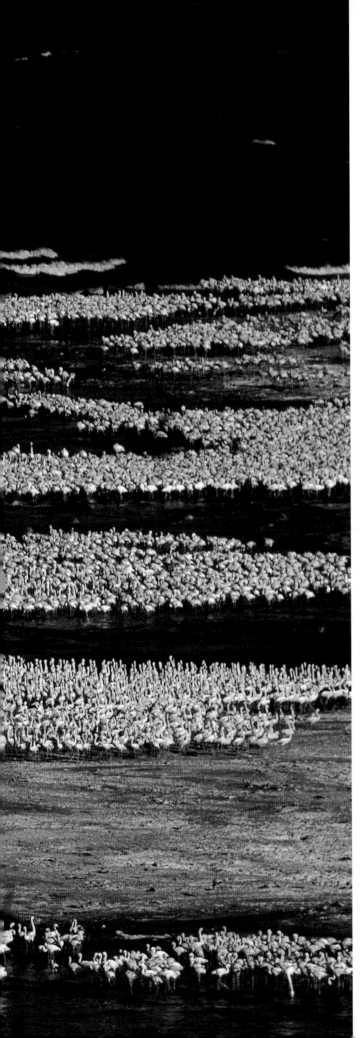

Lesser Flamingo,
Kenya, Africa

The name "flamingo" comes from the Latin for flame, *flamma*. In medieval markets in Europe the flaming red feathers of this bird were passed off by sly merchants as the plumage of the phoenix, that mythical bird that burned itself every hundred years and then rose flame red from its ashes.

Flamingos do nothing this dramatic, but they are still one of the wonders of our world, especially when more than a million stand close together near the shore of an African lake.

Of the world's six flamingo species, the largest and the smallest live in Africa. The greater flamingo is nearly five feet tall, its plumage a delicate pale pink. There are about 50,000 of these in eastern Africa. The lesser flamingo is smaller but more flamboyantly colored, its body a deep flush of rose, its wing tips jet black. The bird's shoulders are a fiery red and its stiltlike legs a brilliant scarlet. At least three million lesser flamingos live in eastern Africa.

Both species inhabit a chain of lakes in the Great Rift Valley, the giant earth fault that cuts through eastern Africa. Several of these lakes are highly alkaline and saline, their water a caustic concentrate. This is due to the fact that they are landlocked in extremely hot regions and fed by subterranean mineral-rich springs. But certain blue-green algae and diatoms thrive in these waters and provide food for myriad tiny mollusks, copepods, fly larvae, and crustaceans.

The greater and the lesser flamingo divide the food available in these brackish lakes between themselves. The former uses bill lamellae to sieve out the mass of tiny mollusks and other miniature animals from mud and water. The lesser flamingo

One million lesser flamingos mass near the shore of Kenya's Lake Bogoria. The most numerous of all flamingos, the lesser flamingo feeds in the algae-rich alkaline lakes of Africa's Great Rift Valley. Most of these birds breed far from shore on soda flats, which are inaccessible to humans and predators.

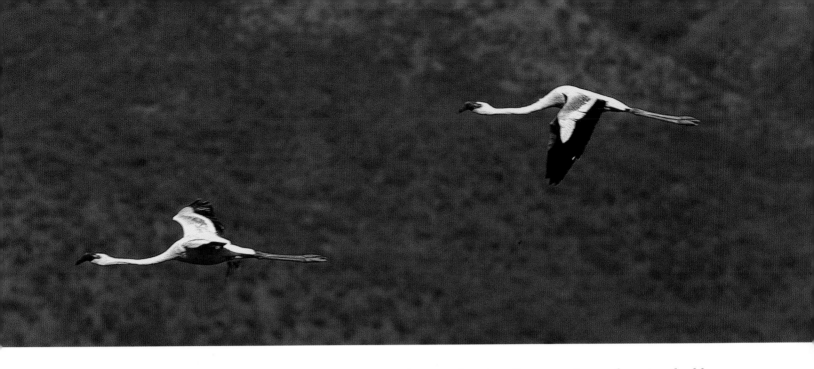

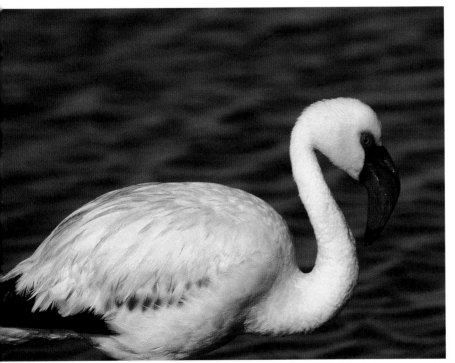

Top: Flamingos fly above Kenya's Lake Bogoria, which is now home to the densest population of lesser flamingos in the world. Some years ago these birds were massed in Lake Nakuru, another alkaline lake in Africa's Great Rift Valley. However, they have since left Lake Nakuru and now feed in mountain-girt Lake Bogoria.

The one million flamingos of Lake Bogoria strain 200 tons of blue-green algae and diatoms from the alkaline, saline lake on a daily basis. These microscopic plants flourish in the lake in such abundance that its salty water is as thick as soup.

is primarily vegetarian and strains the blue-green algae and diatoms from the salty soup. The one million lesser flamingos of Lake Bogoria eat 200 tons of the microscopic algae every day. This is made possible by their large bills, which essentially serve as efficient sieves, retaining the algae and releasing the salty water. The flamingo holds its bill upside down in the water and its large fleshy tongue acts as a piston, pumping the rich broth through the bill. Its specialized bill allows it to exploit an abundant food source that no other bird or mammal is equipped to consume.

When I first visited eastern Africa, the great concentration of lesser flamingos was gathered in Kenya's Lake Nakuru. Lately this lake has fallen out of favor with the flamingos and for reasons known only to them, most of the birds have migrated to mountain-girt Lake Bogoria.

There I love to watch them from a flat-topped tor high above the lake. Directly beneath me at the lake's edge several geysers spout scalding water high into the air. Throughout the day groups of flamingos approach the geysers to drink the nearly fresh but very hot water from these springs.

On calm days the flamingos swim far out onto the lake (unlike most wading birds, they have large webbed feet). With their long necks curved and their bills in the water, they filter the upper layer of the dark green lake water, straining algae from the broth.

When it becomes windy and waves ripple the lake, making this way of feeding difficult or

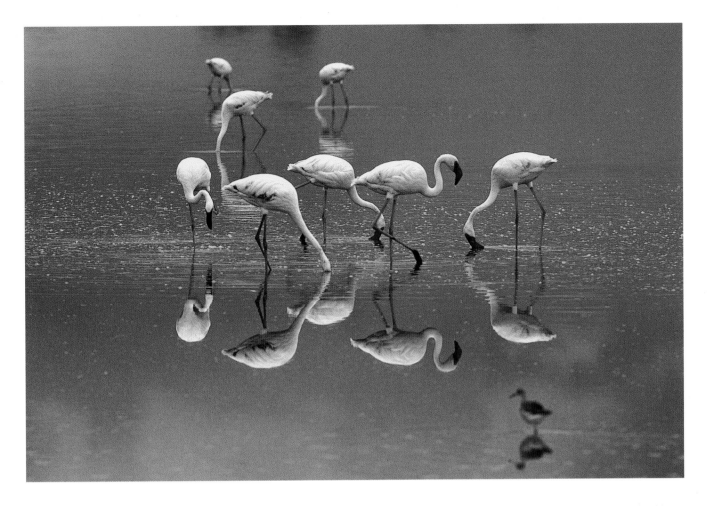

Lesser flamingos feed in an alkaline lake of Tanzania's Serengeti in the soft light of dawn. While immense flocks of nonbreeding birds gather in Kenya's Lake Bogoria, small groups of lesser flamingos are common at many of the algae-rich saline lakes of eastern Africa.

impossible, the birds begin to mass in shallow water near shore. From on high, it looks like the stately dance of a million long-legged ballerinas in pink tutus. These gatherings have a practical purpose. The sheer dense mass of stiltlike legs breaks the waves and creates calm water in the center of the group, where the flamingos can continue to feed.

To make this system equitable, the well-fed birds from the center drift outward toward the edge of the crowd so that the hungry birds from the periphery can begin to stalk to the best feeding areas in the center. Rose red against the dark waters of the lake, the vast mass of slowly moving flamingos becomes a miragelike image of entrancing beauty—"the most spectacular show in the entire bird kingdom," as one observer has called it.

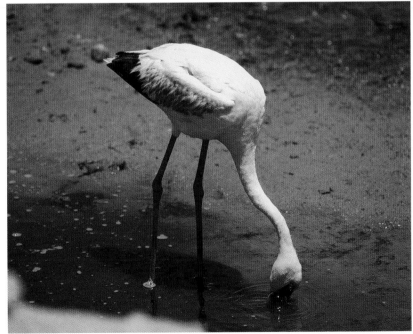

Holding its specialized bill upside down, a lesser flamingo strains masses of microscopic blue-green algae from a food-rich alkaline lake. Flamingos are an ancient group of birds: fossils of a primitive flamingo have been found in Scandinavia. And 50 million years ago a flamingolike bird stalked across a mudflat leaving tracks; the fossilized tracks were found some time ago in Utah.

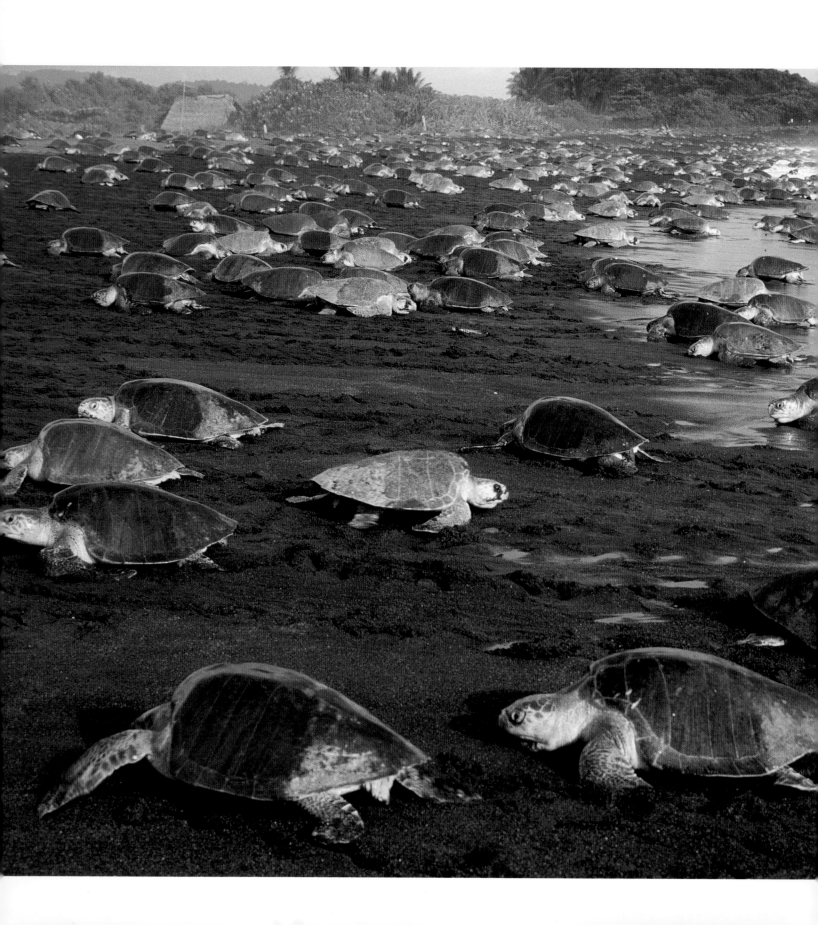

Olive Ridley Turtle,
Costa Rica

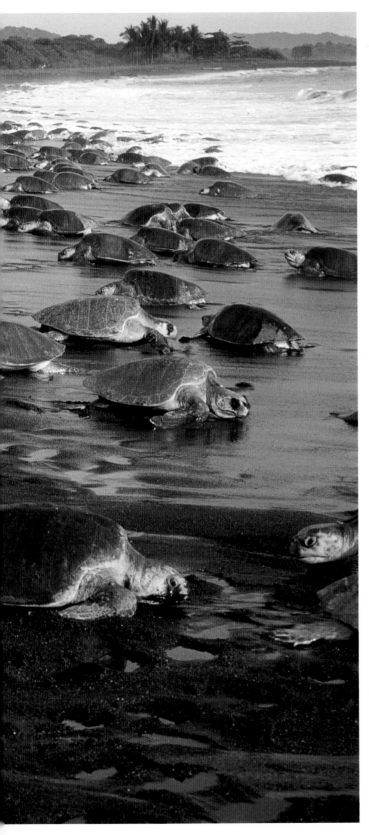

The turtle armada arrives with the high tide in the gray light of dawn. Slowly and ponderously, first hundreds, then thousands of female olive ridley turtles march up the beach. In Spanish this is called *la arribada*, "the arrival." The synchronous nesting of more than 200,000 sea turtles represents the largest mass gathering of turtles in the world.

Of the world's eight sea turtle species, only the olive ridley—the most abundant of all marine turtles—and the much rarer Atlantic ridley stage such *arribadas*. Their most important breeding site is a remote beach on the Pacific Coast of Costa Rica, known as Playa Ostional.

The turtles have migrated for months across thousands of miles of ocean, from Peru in the south, from Mexico in the north, and from the open ocean, to reach the small beach, which is only about half a mile long. They arrive during the rainy season. Before coming ashore, they mass and mate. For two carapace-encased creatures to make love in a wave-tossed sea is evidently difficult. But as the marine biologist Archie Carr writes, "Sea turtles in love are appallingly industrious." While they slip and grip, a couple of miles from shore, I wait on the beach for their great arrival.

At first, on dark nights at high tide, a few female turtles venture ashore. They are timid, skittish and afraid of light; a sudden movement or the flame of a match will scare them back into the sea.

Slowly the momentum builds. On successive nights we count 20, 50, then more than 100 turtles. At the time of the three-quarter moon, our resident biologist says, "Tomorrow the *arribada* will begin."

The next day, at high tide, the turtles hit the beach in serried ranks, struggling through the surf

Massed olive ridley turtles on Playa Ostional on the Pacific Coast of Costa Rica. This beach has the greatest concentration of sea turtles in the world. About 200,000 females come ashore here to lay their eggs in the sun-warmed sand.

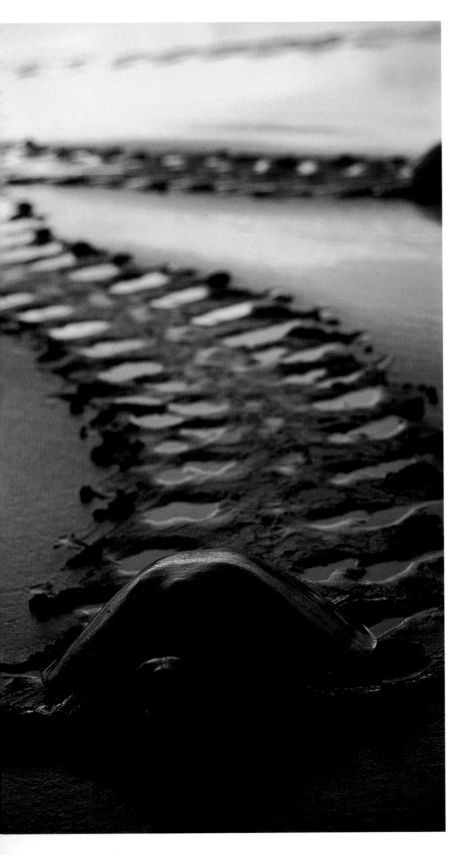

A female olive ridley turtle comes ashore at sunset, leaving deep tracks in the wet sand. The 80-pound (36-kg) turtles move slowly up the beach, select a suitable site for their eggs, and then dig chambers for them in the moist, warm sand. Once they have laid their eggs, they cover their nests with great care and return to the sea.

and crawling laboriously ashore. Now they have no fear. Nothing deters them from their mission to lay eggs in this narrow strip of fine-grained obsidian and pumice sand.

Wave upon wave of turtles land, an army of reptilian tanks. They struggle onward and upward, frequently dipping their noses into the moist sand as if to confirm that this is, in fact, their ancestral beach. After a while, parts of Playa Ostional appear to be paved with 80-pound (36-kg) turtles.

This sight is marvelous and deeply moving, a vision of ages past, for turtles are the oldest living group of reptiles. They existed in the Triassic Age, 190 million years ago—the time of the earliest dinosaurs.

Each female turtle on the beach before me selects a spot to bury her eggs and then begins an age-old sequence of motions. This ritual has been repeated faithfully for millions of years.

With her front flippers, she uses a sweeping motion to create a shallow "body pit." Then, using her hind flippers alternately, she scoops out sand and flings it aside. When she begins to wheeze and grunt from the exertion, she stops briefly, then continues to dig, creating a flask-shaped egg chamber. It goes down as deep as her hind legs can possibly reach.

After about half an hour, the egg chamber is complete. The female's hind flippers encircle the hole, the rear end of her carapace covers it (to discourage vultures that want to steal eggs), and she begins to lay her clutch of eggs. The soft-shelled, gleaming white eggs look like Ping-Pong balls, and there are about a hundred of them.

Once she has laid all her eggs, the turtle rests briefly, then pushes sand into the chamber with her hind flippers. She rocks from side to side, packing the sand down with her lower shell; scatters sand with flailing flippers to erase all signs of her presence; and slowly lumbers back to the sea, her ancient task accomplished. Some of the females are more than 100 years old.

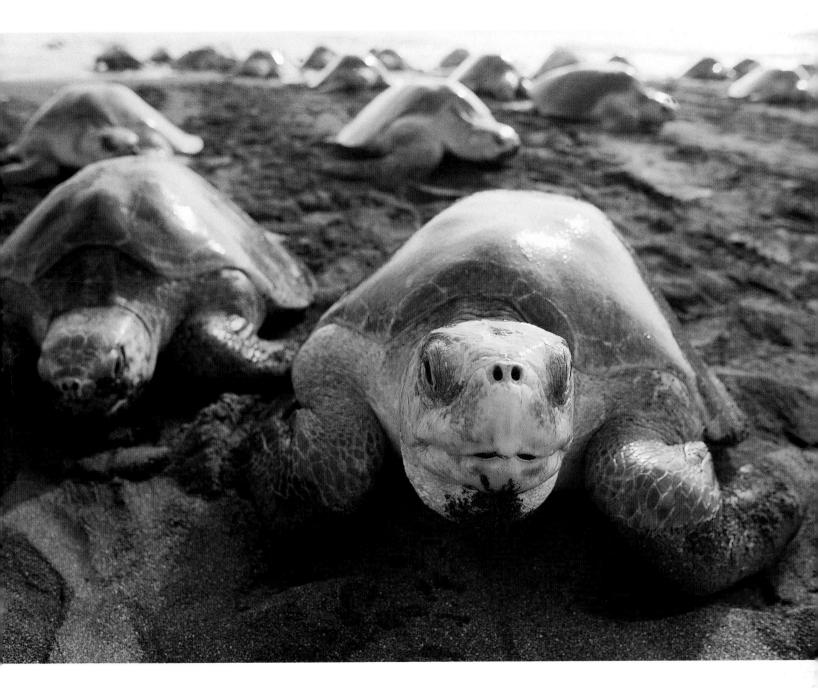

In four days and nights, about 200,000 olive ridley turtles have swarmed ashore and have laid 20 million eggs. Then, as suddenly as it began, the *arribada* ends. On the fifth day, not one turtle remains on the beach.

Wheezing and gasping, the turtles march up the beach. Their armored bodies are no longer supported by water, and this makes breathing difficult. Although there are many splendid beaches on the Pacific Coast of Costa Rica, each year vast numbers of these turtles come to the relatively small beach called Playa Ostional.

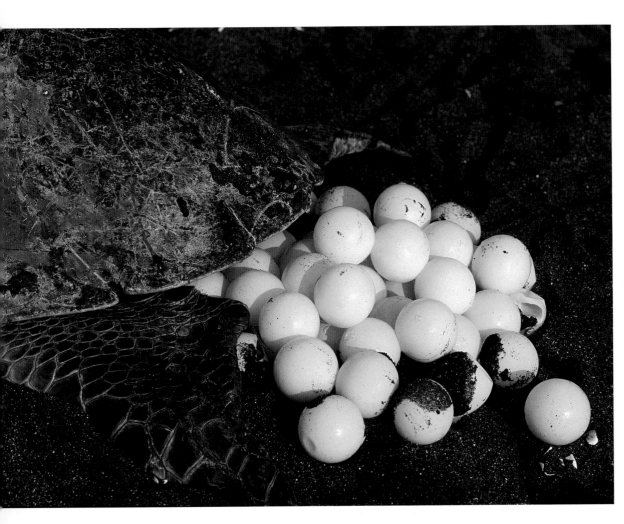

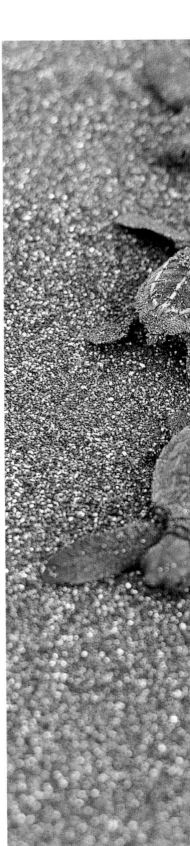

Each female olive ridley turtle lays about 100 soft-shelled gleaming white eggs, the size of Ping-Pong balls. One hundred is a magic number. Any more would put too great a strain on the turtle. Any fewer and predators could prevail, and the species might possibly vanish.

About six weeks after the turtle eggs are laid, the hatchlings emerge. Twitching and twisting, the entire brood slowly works its way upward in the sand. When the hatchlings are just beneath the surface they stop to rest and to wait for night, when it is safest to come out. Once night falls, they emerge nearly simultaneously, and rush toward the sea.

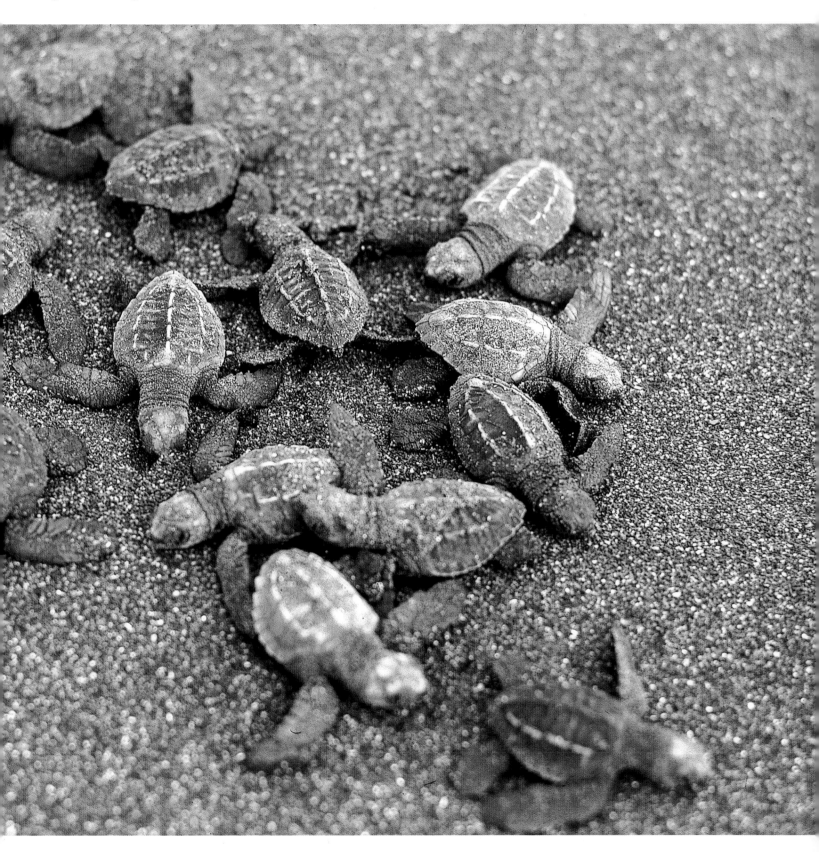

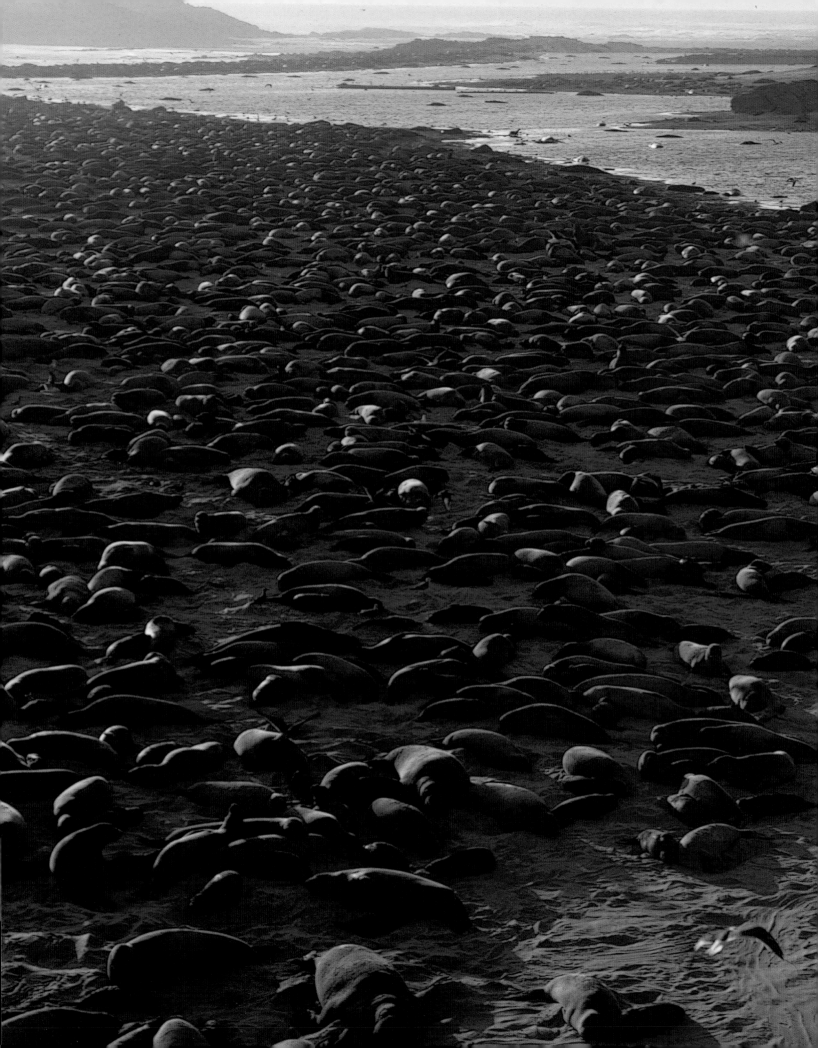

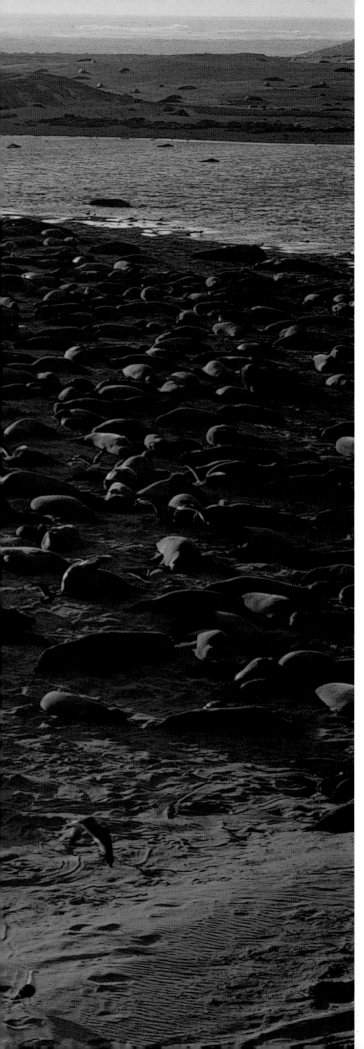

Northern Elephant Seal, California, U.S.A.

The giant northern elephant seal has barely evaded extinction. It once bred from Cabo San Lázaro, near the southern tip of Baja California, Mexico, to Point Reyes, just north of San Francisco—a distance of slightly more than 990 miles (1,600 km). The original population exceeded 100,000 animals, which lived mainly on offshore islands.

In 1810, hunters, known as "elephanters," began to arrive—first Russians (Russia then owned a portion of California), then Spaniards and Americans. These hunters turned the blubber-sheathed, lethargic seals into valuable oil. In the next 70 years, they killed about 250,000 elephant seals. Then they stopped, because none were left. A 19th-century biology book called the northern elephant seal "one of the bygone wonders of the animal world."

But a few elephant seals did survive the slaughter on a remote, uninhabited volcanic island in the Pacific. This Mexican-owned island, known as Isla de Guadalupe, is 150 miles (240 km) west of Baja California. Unfortunately, the remaining seals weren't safe for long. Museum hunters soon rushed out to kill them so that they could enshrine their stuffed skins as exhibits. However, Mexico, fortunately, put a stop to this. It gave total protection to the *elefante marino*, and, to emphasize the point, the government stationed soldiers on Isla de Guadalupe, giving them orders "to shoot anyone molesting the animals."

Scientists now believe that in 1892, no more than 50 northern elephant seals survived. Since these seals are polygamous, it is possible that one alpha bull ruled all the remaining females and sired

In 1892, only about 50 northern elephant seals survived on the remote Mexican-owned Isla de Guadalupe, which lies far out in the Pacific. Once Mexico decided to provide them with total protection, the great seals pulled back from the edge of extinction. They now number more than 120,000 and have re-occupied their ancestral breeding grounds. Here they lie packed upon the great beach of California's San Miguel Island.

A hungry pup yells for its mother. Fed with the richest milk in the world (it is thick as cream and 55 percent fat), the pups gain about 10 pounds (4.5 kg) every day and weigh more than 300 pounds (136 kg) when they are weaned at the age of one month. A few very lucky ones nurse from several females and balloon into "super weaners" that weigh 600 pounds (272 kg). They become so obese they can barely waddle.

The battle of the bulls. Despite their two-ton weight, the giant bulls are amazingly flexible. They rear high, then hack at each other's necks and chests, using their great yellow canines with lightning speed. Battles are often bloody but rarely fatal. Winners become beachmasters and mate with the massed females upon their territories.

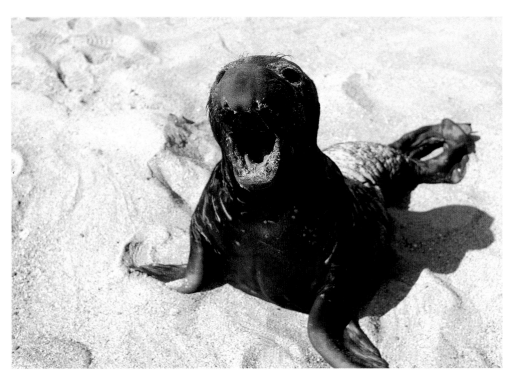

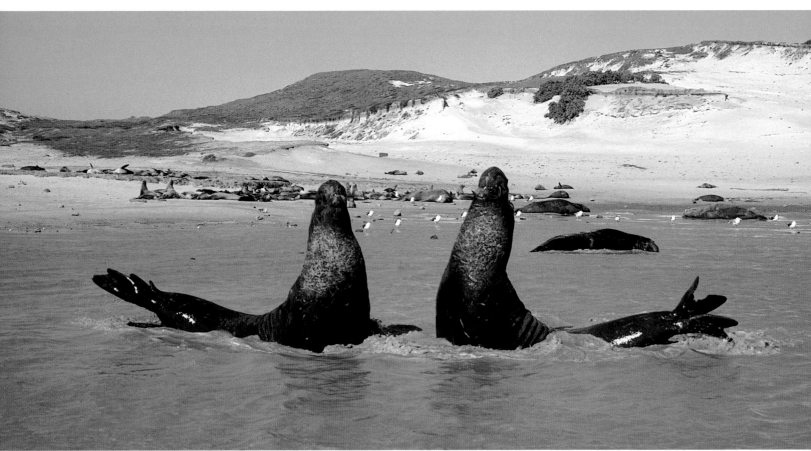

Scram! A young male elephant seal protests loudly when approached, but that's about all he does. On land, elephant seals are slow and lethargic. Most of the time they sleep, conserving energy. This is what made them so easy to kill and nearly led to their extinction.

Elephant seals get their name from the male's nearly one-and-a-half-foot-long trunklike schnozzle. It serves as a resonator for the loud, metallic-sounding calls of challenging bulls. As the number of elephant seals increased and the animals spread to new colonies, they developed regional "dialects." The calls of males in each colony vary considerably from all others in terms of pulse rate, pitch, intensity, and timbre.

their offspring, thus becoming the Adam of all present-day elephant seals.

Snatched from the edge of extinction, the totally protected elephant seal population increased, growing slowly at first, then mushrooming. The number of seals grew from an estimated 50 in 1892, to 1,500 in 1930, 13,000 in 1957, 48,000 in 1976 and 70,000 in 1984. Now the total population exceeds 120,000, and elephant seals breed again on all the islands within their former range.

One of the largest colonies is on San Miguel Island, the most westerly of California's Channel Islands. It is now home to more than 30,000 elephant seals. I watched them there for several seasons.

As I recall, the first to arrive in early December are large bulls, two-ton males swathed in fat and fury. Soon mighty battles for the breeding beaches begin. Despite their great weight, the bulls are amazingly flexible. A male rears high, flops its foot-and-a-half-long nose (to which it owes its name) over its mouth and trumpets a metallic-sounding challenge. The bulls clash and hack and bleed until, finally, only a few widely spaced alpha-bulls rule the breeding beaches and all the females that mass upon these hard-won territories.

The females, who are only a third as heavy as the colossal males, haul out in late December and shortly after give birth to dark-furred 80-pound (36-kg) pups. The newborns nurse frequently and with blissful concentration. Their mothers feed them with the richest milk on record: it has the consistency of thick cream and a fat content of 55 percent. On such a diet, the pups grow rapidly gaining an average of 10 pounds (4.5 kg) each day.

In four weeks, the pups balloon to about 300 pounds (136 kg) and look like blimps with flippers. They gather in chummy "weaner" groups. Most of the time they sleep.

Fat is fortune in seal society. The fattest pups are most likely to survive and produce future generations of elephant seals, who will gather again in vast numbers on their ancestral breeding beaches.

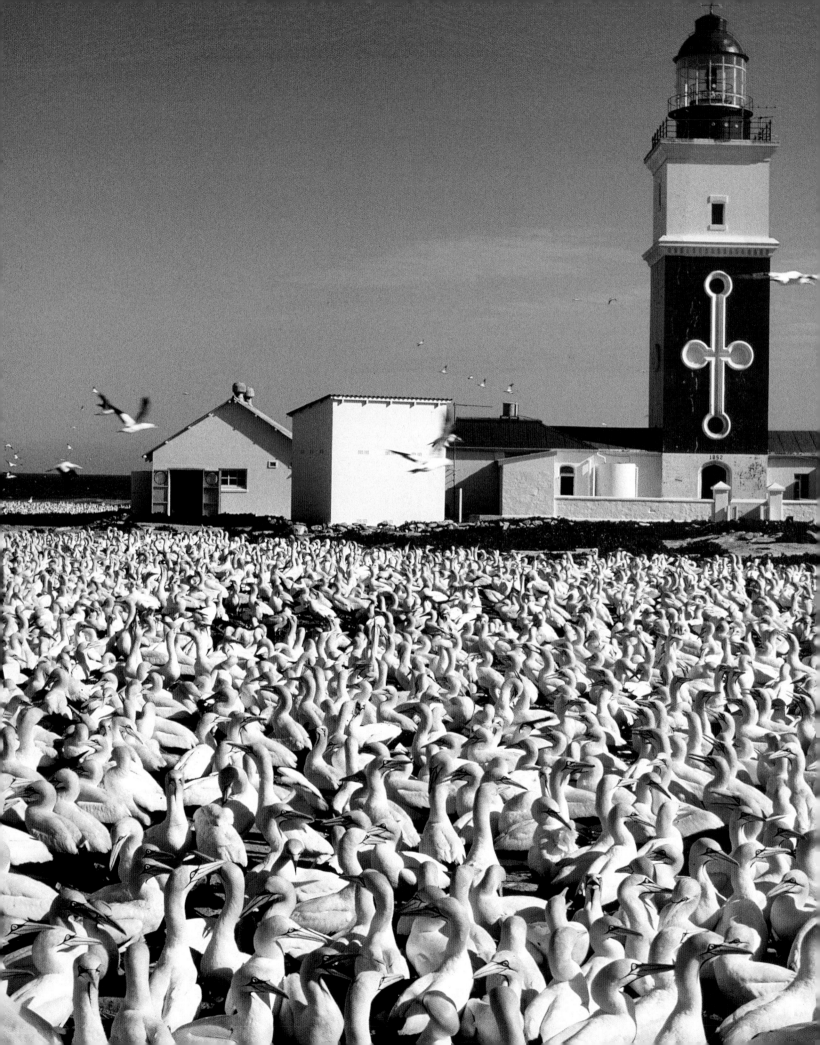

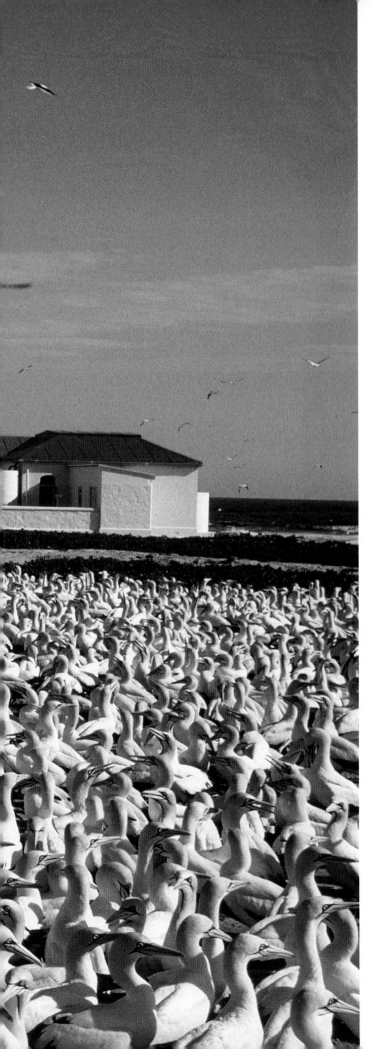

Cape Gannet,
South Africa

There are very few islands off southern Africa, and space is precious for island-breeding seabirds and fur seals. Cape gannets breed on only six islands, three off Namibia and three off South Africa. The biggest colony of gannets is on remote Bird Island in South Africa's Algoa Bay.

It is early November and the entire southeast corner of the flat 40-acre island is covered with a gleaming white blanket of closely spaced breeding gannets. The total number of these elegant goose-sized birds is about 150,000.

At this time of year, the gannet is in its breeding finery and looks beautiful: the entire body is a shimmering, glossy white, the wing tips and tail deep black, and the neck and head a warm orange. The bird's widely spaced eyes are encircled by a bright blue band and are as clear as glass. The sharp, olive gray bill is outlined in black.

Togetherness has its advantages—at least for the older gannets. The more experienced birds nest in the center of the great colony. Young birds, especially the inexperienced first-year nesters, breed at the edge. The greedy, ever-present Dominican gulls rarely dare to snatch an egg or a chick from among the closely spaced birds in the center. If they do, they are likely to be stabbed by the gannets' stiletto beaks. For the gulls, it is safer and more effective to harass the less protected birds on the periphery.

If the more mature birds in the center of the vast colony benefit from the safety provided by their close-by neighbors, the same neighbors can become a major nuisance during take-off and landing because they are intensely territorial and well-armed. On very windy days there is no problem: the gannet faces into the wind, and with a few

Massed Cape gannets on Bird Island in Algoa Bay off South Africa's east coast. With about 150,000 birds, this is the largest colony of Cape gannets in the world. The lighthouse, built in 1854, was automated in 1968 and during the breeding season only scientists may visit the remote island.

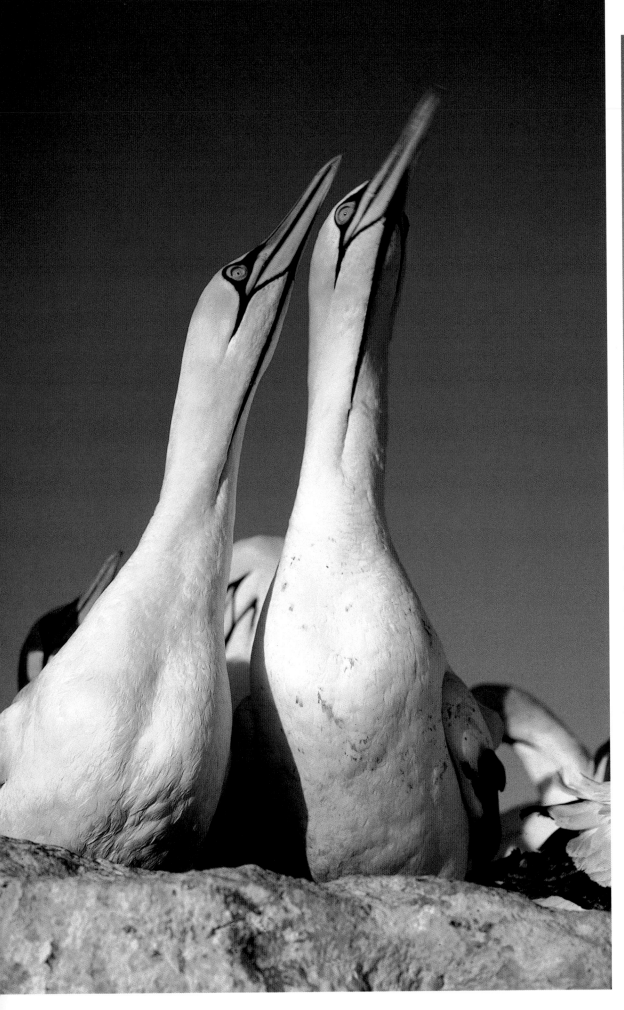

Mates meet and greet. The Cape gannets' greeting ceremonies are elaborate, ecstatic, and noisy. Crying harshly, the mates bow deeply, then rub their necks together and "sky-point," with their necks extended and bills pointed up. This is part of their complex bonding and mating ritual.

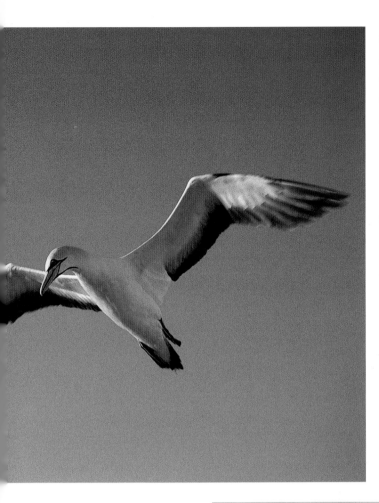

Glowing in the light of the setting sun, a Cape gannet picks out its nest and mate in the densely packed colony. Landing is tricky. The gannet brakes abruptly, with its wings, tail, and large palmate feet, and flops down as accurately as possible. Angry neighbors usually greet the arriving birds with harsh cries and stab them with their sharp beaks.

strokes of its powerful wings it is airborne. But on calm days, it must march to the edge of the colony, running the gauntlet of stabbing beaks. At the edge of the colony there are "runways"—long flat corridors where birds do not nest. Facing into the wind, the flat-footed gannets race down the runway, their wings flap wildly, then suddenly they are airborne.

Landing is nearly as painful. A gannet passes over the colony, pinpoints its mate and nest and flops down to a chorus of insults and pecks from aggrieved neighbors. The reunited mates stand close to each other, rub necks, bow deeply several times, and call to each other in raspy ecstasy, which sounds like "warr-warr-warr."

While one partner incubates the single egg and

A gannet pair early in the breeding season. Their nest site on Bird Island is the center of their mutual bond. The male arrives first and claims the site. Shortly after, the female joins him, reuniting with her mate, following months at sea. The birds greet each other with an elaborate display of bowing, crying, and mutual preening, and another breeding season begins.

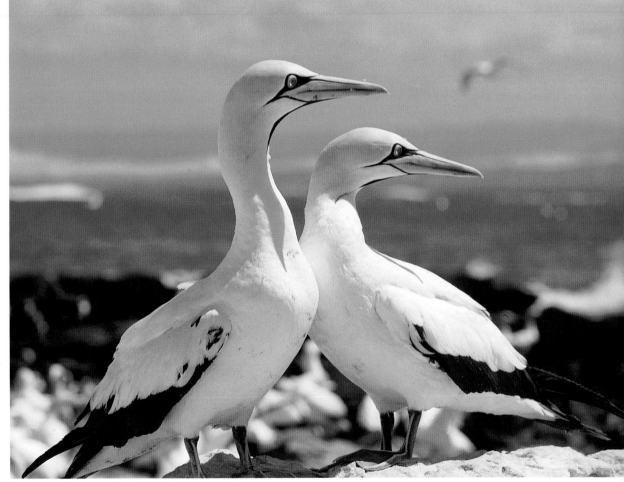

later protects the chick, the other forages for food, often far from their home island.

Sleek and deadly, the gannet is a master diver. (In Cornish, the ancient but now extinct Celtic language of Cornwall, this bird was aptly called *saithor*, which means "arrow.") Flying at the high speed of 180 wingbeats per minute, its head angled down, the gannet scans the sea from on high with binocular vision. The instant a gannet spots fish, it begins its arrowlike power-dive. It folds its wings and plunges with enormous force and precision, hitting the water at about 60 miles an hour (100 km/h) and catches fish up to 30 feet (10 m) deep in the water.

While I was at the colony, the birds caught mainly pilchards and regurgitated the rich fish for their fast-growing chicks. Just after hatching, the chicks look pathetic. They are tiny, black and naked, with bloated bodies and snaky necks, which wave weakly. Later they acquire a nice white down. Then, before leaving the nest, they molt into a dark brown plumage.

These immature Cape gannets have one great advantage over their cousins, the northern gannets of Europe and North America. The latter often nest on the ledges of high cliffs, which means that fledglings learning to fly must jump into the void, where it's either fly or die. On Bird Island, however, the young gannets leave the nest at three months and waddle toward the coast, where they can practice flying in less dramatic circumstances. One whiff of breeze and they all flap wildly and exuberantly. Some rise, then crash-land, but slowly their flying skill improves and they soar out over the sea to learn the art of fishing.

By April, all the gannets have left Bird Island, but they leave a precious annual legacy: sun-baked excrement, which is highly prized as fertilizer. Soon workers arrive with brooms and shovels to remove the 600 to 1,000 tons of guano.

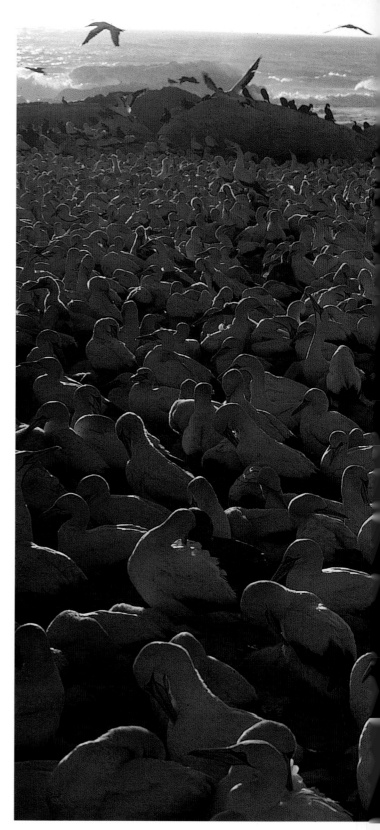

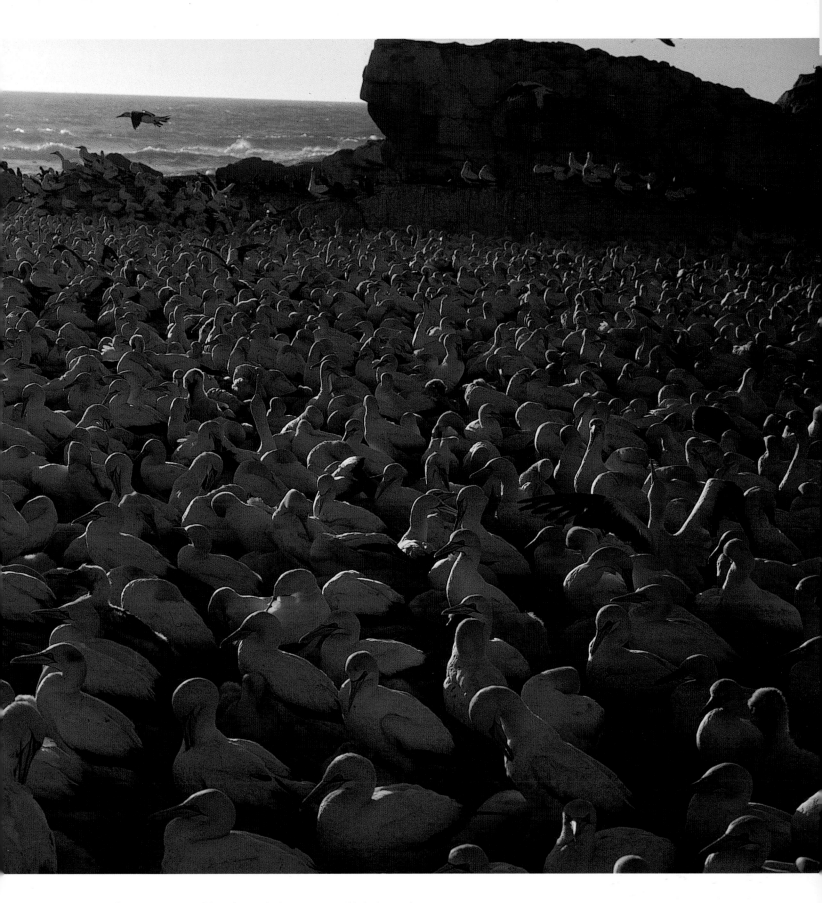

Cape gannet colony at sunset. This colony of about 14,000 birds is on tiny Bird Island (not to be confused with its larger namesake) in Lambert's Bay and is linked by a causeway to the South African mainland. Visitors can view the colony from a tower, but they are not allowed to come close to the massed birds.

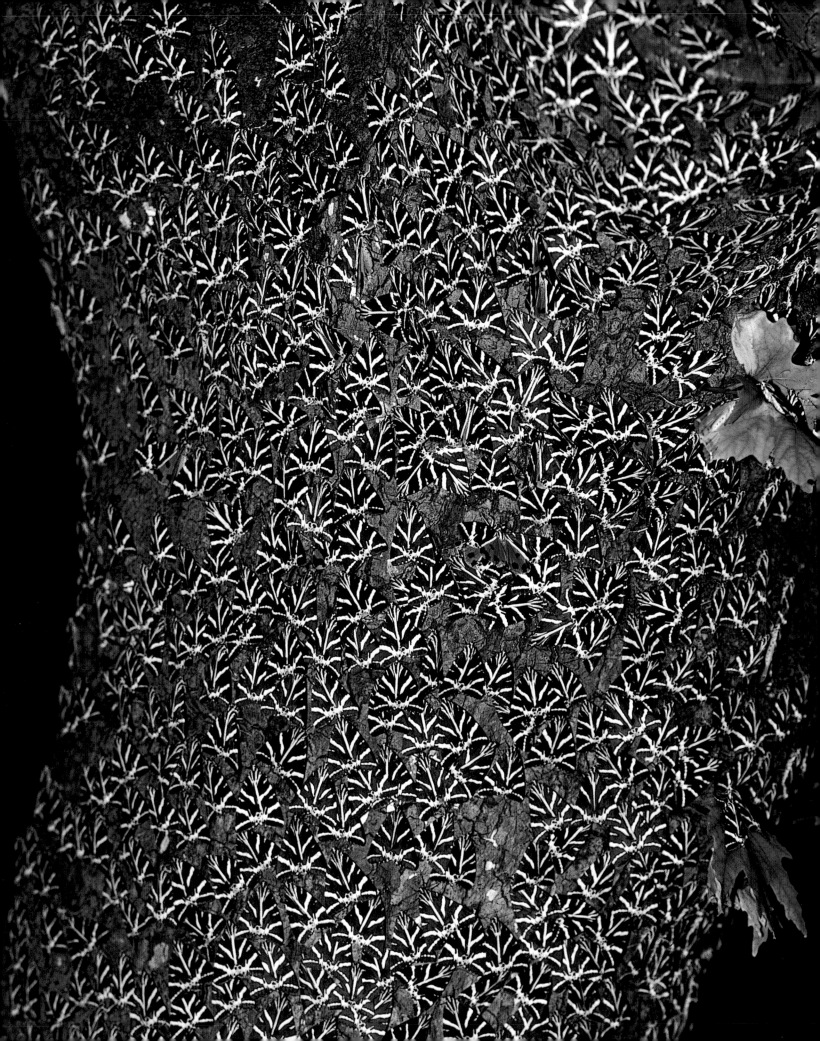

Jersey Tiger Moth, Rhodes, Greece

The Jersey tiger moth is quite common and has an extensive range: from northern Europe to North Africa, from Great Britain east to southern Russia, Asia Minor, Egypt, and Iran. However, the largest concentration of these moths is found on Rhodes, the easternmost of the Greek islands. The island is 48 miles (78 km) long and up to 22 miles (35 km) wide.

Here the moths lives are ruled by the rhythm of the seasons. At the beginning of the rainy season in October, plants begin to grow in profusion and the island becomes lush green, no longer dry and arid as it is in summer. Soon, the Jersey tiger moth caterpillars hatch. They eat voraciously all winter, growing very large and fat. In early May, they pupate, and as spring turns into summer, they emerge from their shiny chocolate brown chrysalises in the form of lovely fat-filled moths.

Jersey tiger moths like it warm, but not too warm. Their preferred temperature is between 70°F (21°C) and 73.5°F (23°C). But on Rhodes the temperature soars well past 104°F (40°C) during the summer. To escape this deadly heat, the moths fly at night to an eight-mile long valley, known as the Valley of the Butterflies. (This name is a misnomer as these are not butterflies, which fly during the day, but rather nocturnal moths. The misnomer exists not only in English but also in the Greek name for the valley, which is *Petaloudes*, meaning "butterfly.")

In this valley, there is a small stream, called the Pelecano Creek, which is fed by a continuously flowing spring. The stream runs down the valley

Tens of thousands of densely packed moths coat a tree trunk on the island of Rhodes in Greece. Unless disturbed, the massed moths remain motionless during the hot summer months, expending a minimum of energy. At the beginning of the rainy season, they mate and the females disperse across the entire island to lay their eggs on plants that will nourish their caterpillars.

and supports a dense grove of huge trees, some of which are centuries old. These cool, moist, and shaded conditions make this spot the perfect summer resort for the massed moths. They sit on the trees or the valley's boulders in densely packed formations. There are so many of them that they appear to form a gorgeous tapestry. Unless disturbed, these creatures remain motionless all summer, expending a minimum of energy and living off their fat reserves.

The Jersey tiger moths are beautiful. Their forewings are a rich deep brown, with a transverse pattern of cream-colored lines. Close up, one can see that these lines glow with a faint metallic-blue iridescence. The hind wings, which normally remain hidden, vary from a startlingly brilliant carmine to an ocher red and are usually marked with four black-velvet spots. The furry body is soft yellow, with brownish spots and lines.

When the resting moths are disturbed by a predator, they flash their brilliantly colored hind wings to startle the intruder. This is also a warning, which says: "Don't eat me! You'll be sick!" The moths' bodies are, in fact, only mildly poisonous. The guardians of the valley told me bats hunt them occasionally and dying moths that flutter helplessly to the ground are often eaten by the clay gray toads that love this moist valley.

In fall, the massed moths mate. The females disperse across the island. Using the last of their fat reserves, each one lays about 100 white eggs on plants that will nourish their caterpillars. Their duty done, the adults die.

And then a new generation of Jersey tiger moths is born. In the summer they will fly to their ancestral valley and sit on tree trunks, rocks, and mossy cliffs, all facing in the same direction, each moth with head and folded wings forming a perfect isosceles triangle, thus illustrating the appropriateness of their Greek name, *Calimorpha*, which means "the beautiful form."

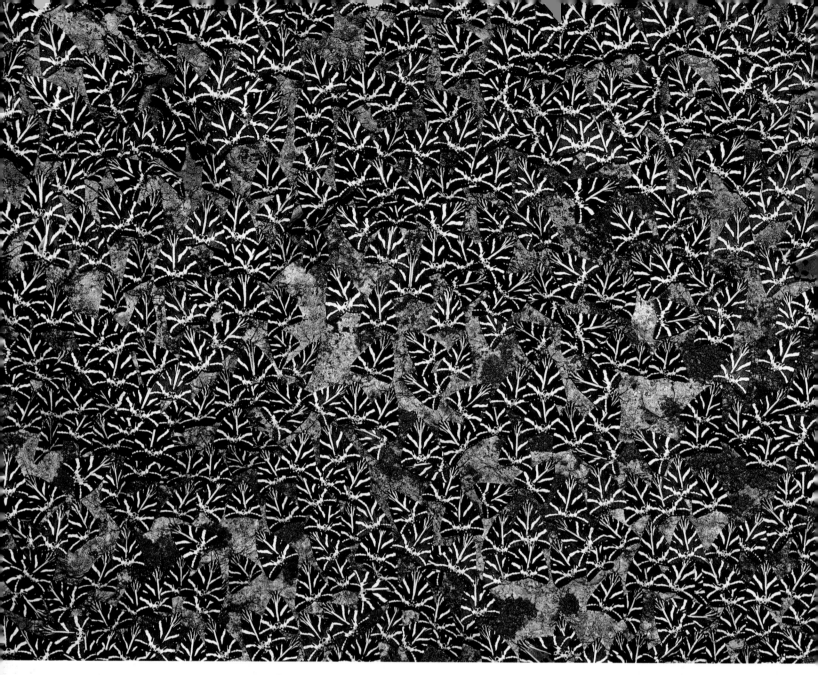

Neatly aligned and densely packed, more than a million estivating Jersey tiger moths cover a rock wall in the Valley of the Butterflies in Rhodes. To escape the heat and dryness of summer all the Jersey tiger moths on the island fly to this cool, moist, shaded valley.

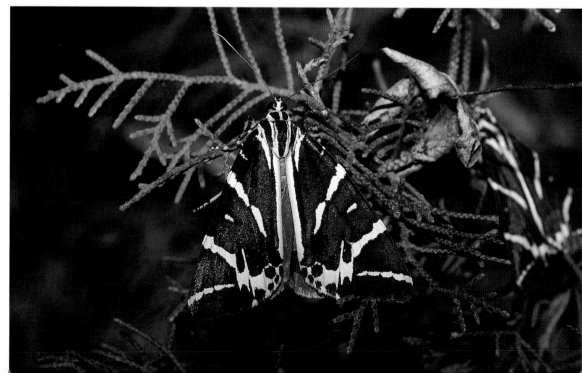

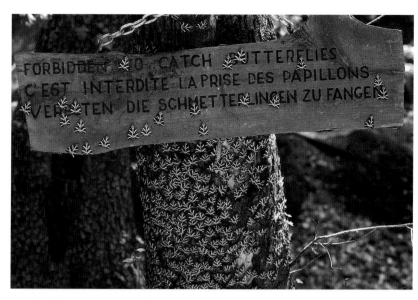

A trilingual sign in the Valley of the Butterflies asks visitors not to try to catch the massed moths. Despite this sign and the presence of guards who ask tourists to move slowly and be quiet, some people do disturb the moths. If startled, the moths fly up. In doing so, they burn up their precious fat reserves and die without mating before the end of the summer.

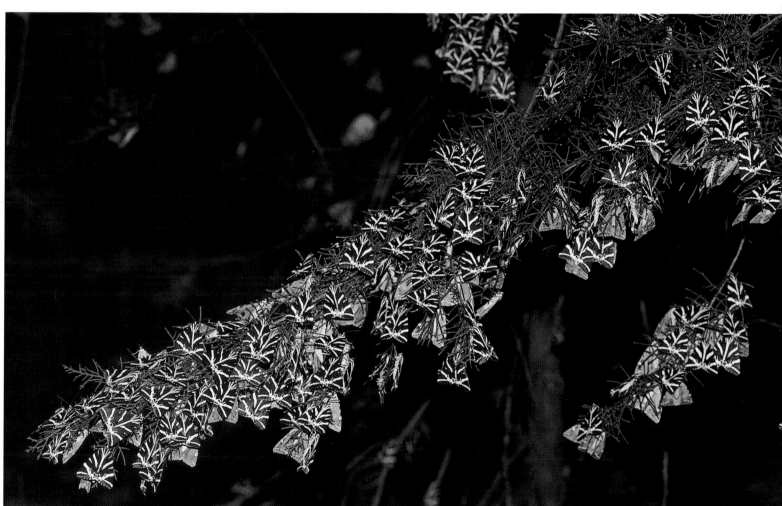

When threatened, a Jersey tiger moth flashes its brilliant carmine hind wings to startle the enemy and to warn it. The moths are slightly poisonous. Birds rarely eat them, and bats only occasionally catch the night-flying moths. Apart from the danger of being disturbed by humans, the massed moths are fairly safe in their summer sanctuary.

The Jersey tiger moths prefer to perch on boulders, tree trunks, and on branches, which are deeply shaded. Caterpillars can be found all over the 48-mile (78-km) long island. They feed voraciously on a variety of plants during the warm, moist winter and store energy in the form of fat. Once spring turns into summer, they become adult moths. As the temperature soars, all the Jersey tiger moths fly to their ancestral valley.

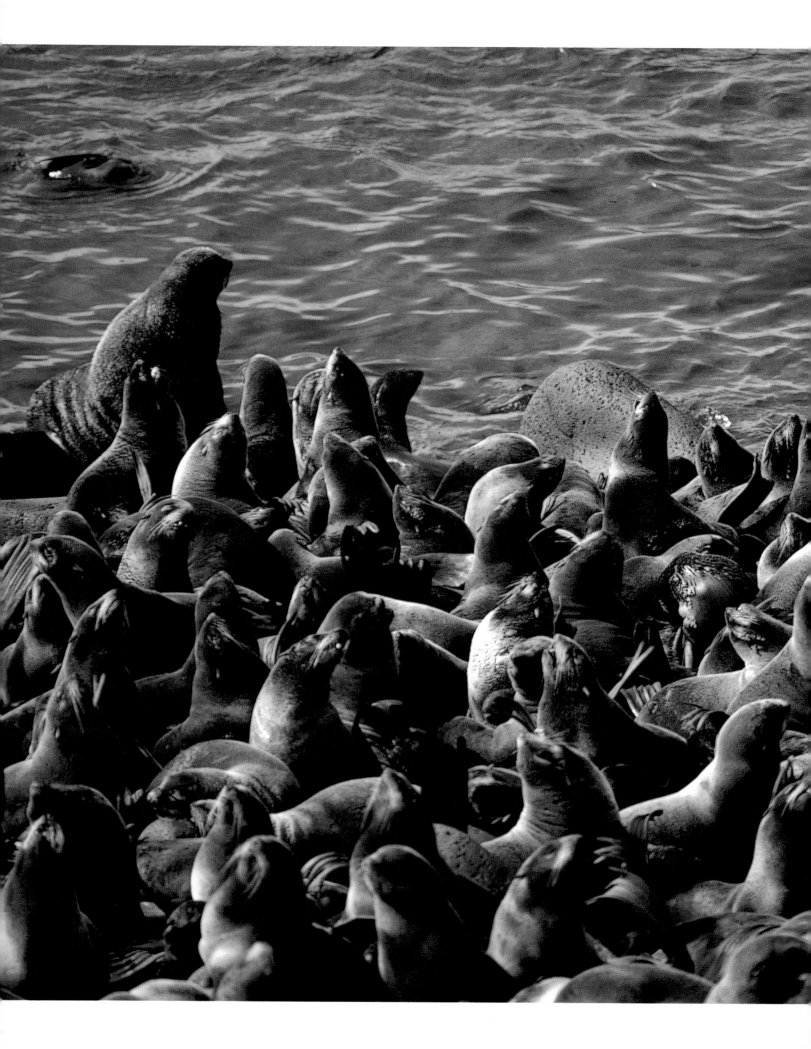

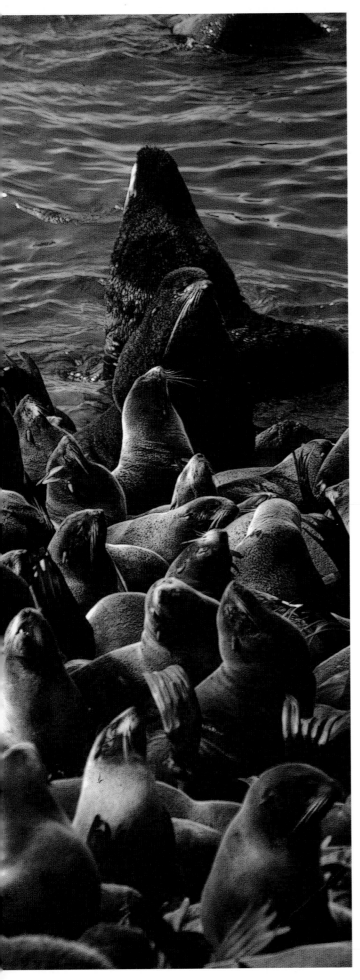

Northern Fur Seal,
Alaska, U.S.A.

Vitus Bering, the explorer extraordinaire for Russia's tsars, discovered the Alaskan mainland and the Aleutian Islands in 1741. In his wake, lured by tales of an abundant seal population, came the *promyshlenniki*, the Russian trader-trappers of Siberia. They were a breed of northern conquistador—greedy, rowdy, brave, brutal—and here the gold was furs. First they killed the sea otters for their silky-soft fur, which was sought after by wealthy Chinese. Then they went after the fur seals, whose fur is nearly as warm and luxurious as the sea otter's.

Each spring about two million fur seals could be seen to swim through the straits separating the Aleutian Islands only to vanish mysteriously into the fog-shrouded vastness of the Bering Sea. Somewhere out there lay the islands where they bred.

A Russian explorer called Gerassim Pribilof searched for the seals' breeding islands for years. On June 25, 1785, the dull roar of a great seal rookery guided him through the fog to a small island, which turned out to be the animals' breeding ground. He named the island St. George, after his ship. The next year, on the feast day of St. Peter and St. Paul, he discovered a larger island, which he named after St. Paul. There, the fur seals "came and went in legions that darkened all the shore," as Rudyard Kipling wrote. However, the seals' paradise soon became a place of carnage.

For the next 200 years first Russians, then Americans and the Aleuts in their service, killed millions of fur seals. The great commercial kills finally ended in 1973 on St. George Island and in 1985 on St. Paul Island. After two centuries

Part of the great rookery of northern fur seals on St. Paul Island. This is one of the Pribilof islands, situated in the chilly, foggy Bering Sea off Alaska. Great 800-pound (363-kg) males stake out beach territories here in late May. The much smaller females arrive later and mass there.

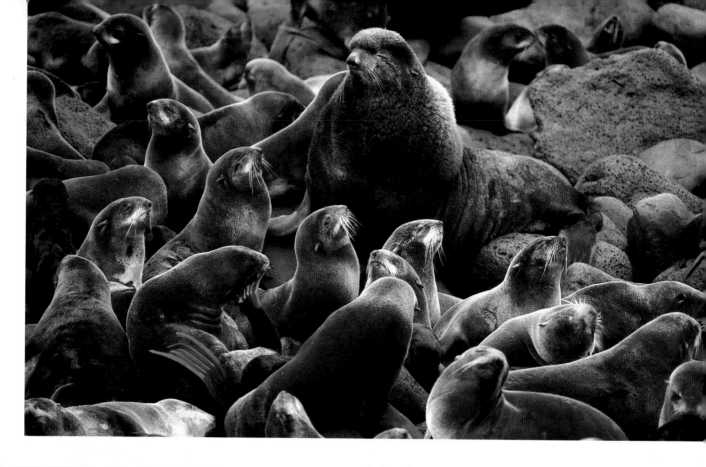

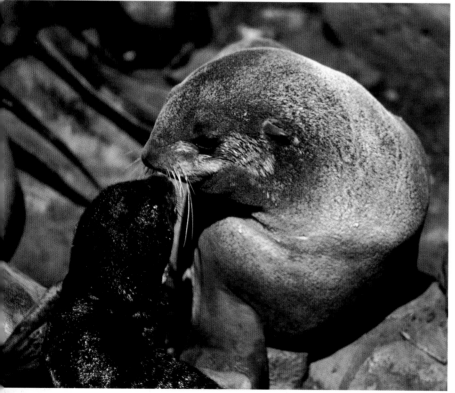

The kiss of recognition. A female, who has returned from the sea, sniffs her pup to make certain it is her own before feeding it. Among the roar of thousands of seals and the lamblike bleating of hungry pups, a female unerringly finds her own pup. She is guided by location, then by the answering call of her pup, and finally by smell.

of slaughter, peace has returned to the islands.

I spent a summer on St. Paul Island, living with an Aleut family. The island is lovely but the weather is dismal. It drizzles and rains all summer. In winter it snows. Sunny days are very rare. But thanks to the continuous rain, the island's vegetation is a lush deep green and its gentle slopes are carpeted with flowers. More than a million seabirds breed on St. Paul's cliffs. The cool climate suits the fur seals. About 800,000 northern fur seals now breed on the Pribilof Islands.

The great males arrive at the end of May and fight for territories on the ancient breeding beaches. They are in their prime—usually 10 years old—and weigh about 800 pounds (363 kg). Their battles are fierce, often bloody, but they rarely prove fatal. The victors sit for a month upon their hard-won turf and wait and hope.

The small sleek females (they weigh only 90 to 120 pounds [40 to 54 kg]) arrive in late June or early July and haul out upon a "beachmaster's" property. The male guards his growing harem with huffy jealousy. Most pups are born within 24 hours of their mothers' coming ashore.

When you first watch a great rookery, the situation appears quite idyllic (at least to the old-fashioned human male). The proud pasha lords

it over a harem of adoring, demure bewhiskered wives, and he gloats with paternal pride over all those glossy black big-flippered pups they have produced.

The reality, however, is less romantic. Though gregarious, the females are an ill-tempered snarly lot, forever bickering with one another. Each female behaves maternally toward her own pup but nips any other pup that comes near. Females are forever sneaking off and the bull is nonstop busy, rounding up wandering wives and arguing with acquisitive neighbors. As he does this, he huffs and growls and shakes his head, his normally droopy Genghis Khan whiskers abristle.

The 10-pound (4.5-kg) pups soon leave the chaos of the rookery, where they are liable to be steamrollered by rushing bulls. They form dense pup pods at the colony's periphery. When a mother returns from a lengthy fishing trip, she calls loudly; her pup awakens instantly and answers eagerly. She sniffs the pup, then stretches out to let it nurse.

When the storms of early winter hit the islands, the seals begin to leave. They spend the next eight months at sea, but in spring they return to their ancestral islands.

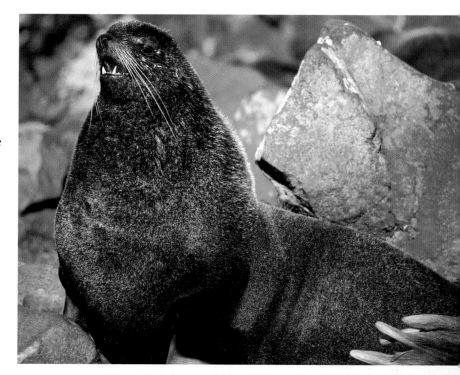

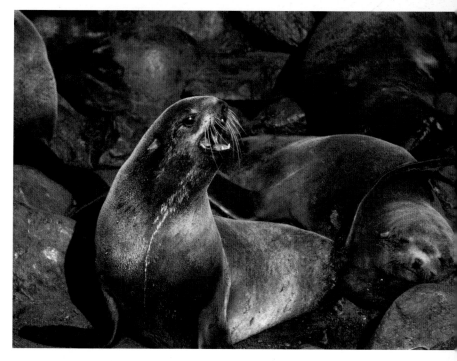

Having returned from the sea, a mother calls her pup. To escape the chaos of the rookery and the danger of being crushed by rushing bulls, pups cluster at the colony's edge in tight pods and sleep. A mother's call means milk. Her pup wakes instantly and rushes off to nurse.

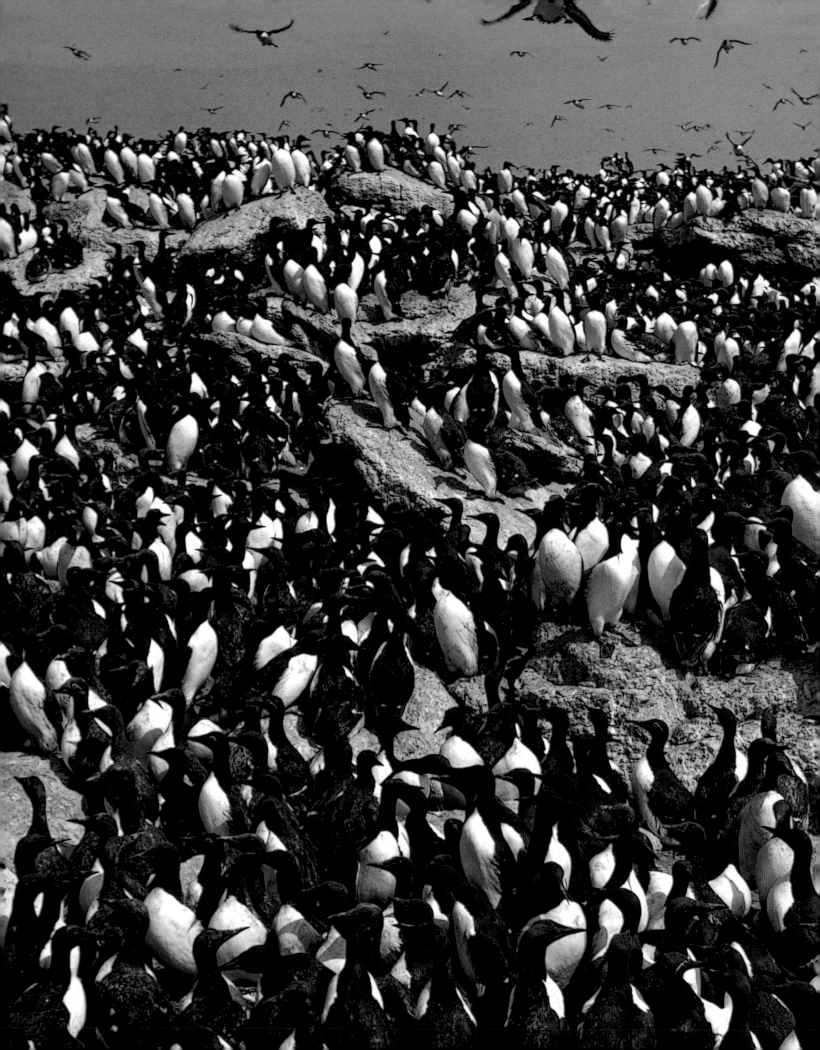

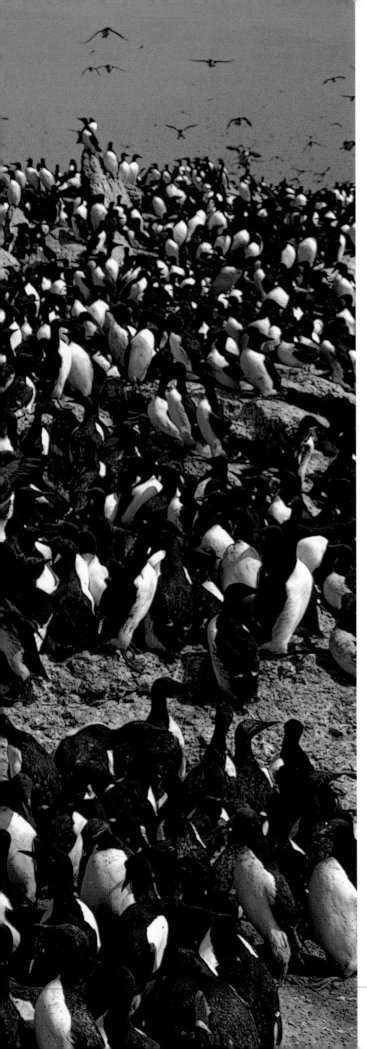

Common Murre,
Newfoundland, Canada

Forty miles (65 km) east of Newfoundland, in the icy Labrador Current, lies a grim hunk of granite, 2,600 feet (800 m) long, 1,300 feet (400 m) wide, and 150 feet (46 m) high at its highest point. Guarded by dangerous reefs, this piece of rugged rock is known as Funk Island. It was once the home of the now-extinct great auk, as flightless as today's penguin and a relative of the common murre.

The French explorer Jacques Cartier visited the island in 1535. He wrote that it was "so exceedingly full of birds that all the ships of France might load a cargo of them without one perceiving that any had been removed." Soon the French did, in fact, begin to exploit this abundance of birds. Fat, slow, and clumsy on land, the great auks were an easy target for sailors. In 1578, numerous French, Spanish, and English vessels caught fish in the vicinity of Funk Island. And as a writer of that time noted, the fishermen "doe bring small store of flesh with them, but victuall themselves always with these birds."

For three centuries, Funk Island had the largest colony of great auks in the world and was thus the larder of Europe's fishing fleets. However, by 1800 the great auk had been exterminated on Funk Island. A few of the birds still existed on remote islands off Iceland. But the last great auk was killed on Eldey Island on June 3, 1844. Now all that remains of these beautiful birds is 78 skins in the world's museums.

Once covered with great auks, Funk Island remained virtually bare for nearly a century. When Frederick A. Lucas of the U.S. National Museum

Massed common murres on a remote island, Funk Island, east of Newfoundland. The birds stand shoulder to shoulder in groups, which cover acres of the small granite island. This was once the home of the great auk, which fed Europe's great fishing fleets. By about 1800, the last great auks on Funk Island had been killed.

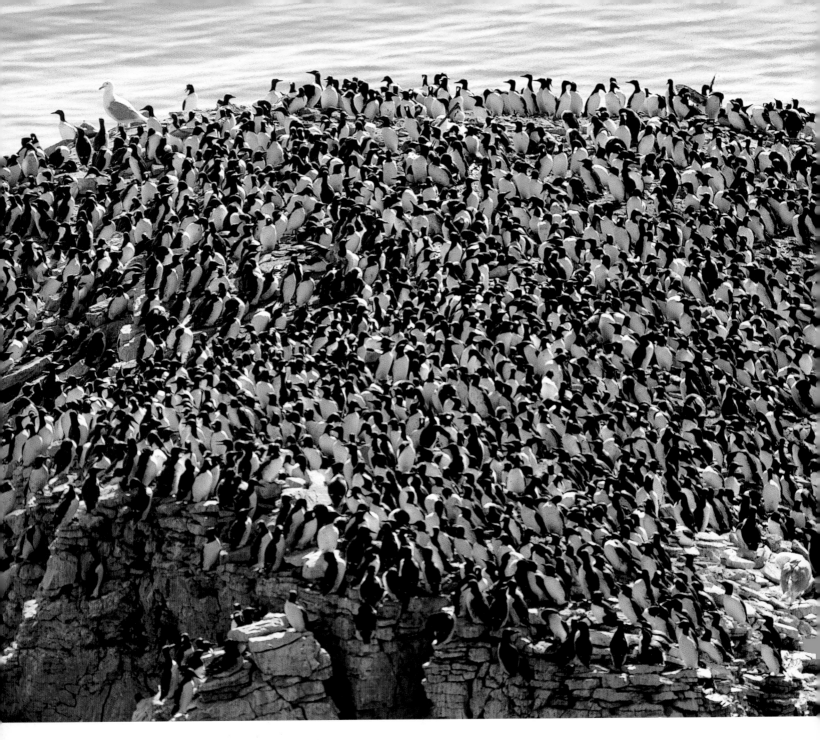

visited the island in 1887, he found birds only in "insignificant numbers."

Fortunately, birds have returned to Funk Island since then. They came back slowly at first and then with spectacular speed. A few gannets arrived in the 1930s. Now there are several thousand. Common murres arrived at about the same time as the gannets, and soon their numbers soared: there were 15,000 pairs in 1945, 50,000 pairs in 1952, 150,000 pairs in 1956, and then 500,000 pairs in 1959. Now the murres crowd together in colonies and cover acres of the island's smooth, rounded rock.

I visited Funk Island with scientists in the 1970s. It was a rolling-pitching seven-hour trip by long-liner from the fishing village of Badgers' Quay on the east coast of Newfoundland. A dory brought us to shore, and, as the boat rose on the crest of a wave, we jumped for "the Bench"—a broad shelf on the cliff that was the best place to land.

As we clambered to the top of the island, a pungent smell of phosphate and nitrate enveloped us: guano. It has been estimated that birds dump 100 tons of excrement daily on Funk Island. Rains wash most of it into the sea, and, for miles around the island, the water is a murky gray. The name

Common murres on a sea stack off Alaska. These birds breed on inaccessible sea stacks and on the cliff ledges of remote islands. In this way, they are safe from all land predators except humans. The density of birds in a large colony and their sheer mass makes it difficult for avian predators to get at the chicks or eggs.

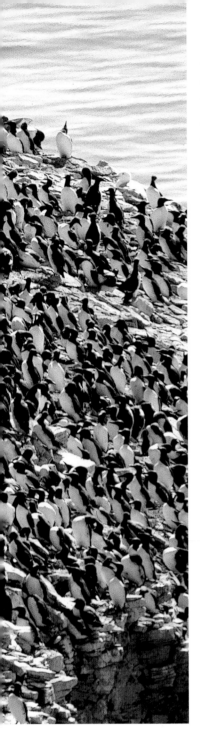

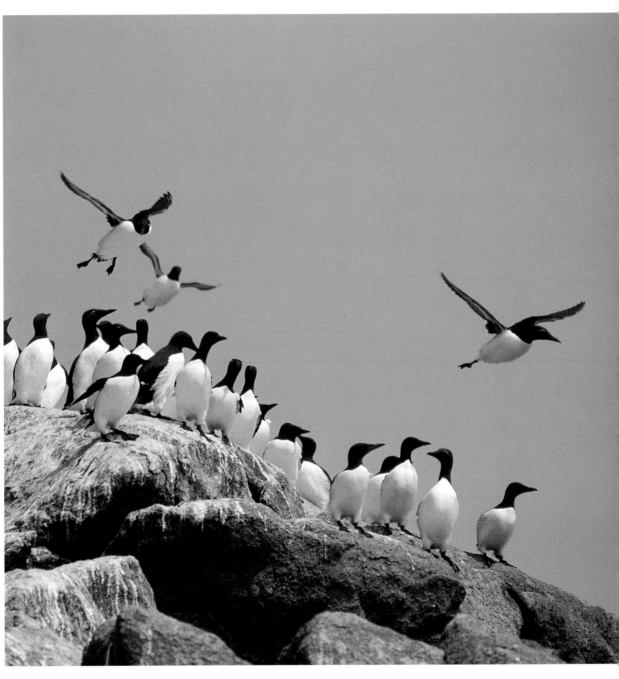

Off-duty murres gather on a rock ridge. At three feet tall, the great auk was the largest of the alcids. After it was hunted into extinction, the common murre became the largest alcid. It weighs two to three pounds (1 to 1.4 kg) and flies well, unlike the great auk.

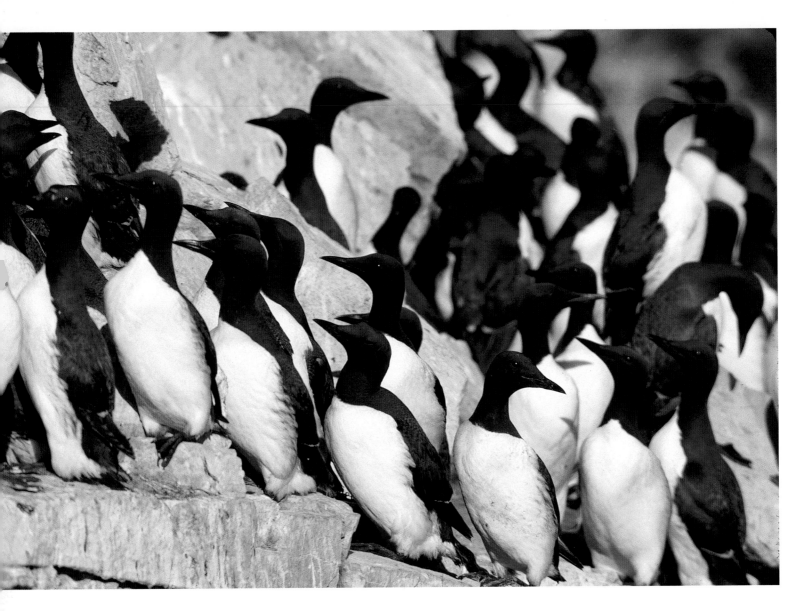

Funk comes from the Old English for "evil odor or vapor."

At the time of my visit the air was filled with murres. Legions of them flew to the sea or returned from it, their bullet-shaped bodies hurtling along with the harsh whir of narrow wings. Tens of thousands of them raced past us, leaving the sound of a great storm in their wake. Others stood shoulder to shoulder in groups that covered acres, a vast shifting sea of life.

One murre alone can be a very loud and disputatious bird. But on the island a million of them engulfed us in a mighty chorus. The harsh *arrg, arrg, arrg* of the adults blended with the shrill cheeping of the chicks into one throbbing mass of sound.

About one fifth of Funk Island appears to be covered by a one- to three-foot (.3- to 1-m) thick layer of earth. Puffins tunnel their nest burrows

Common murres like togetherness. The dense colonies they form provide protection from predators. Because they are so numerous, murres have a considerable influence on the sea life near their colonies. Rich in nitrates and phosphates, their excrement is the food of phytoplankton. One ornithologist has said that murre colonies "are in many respects the fertilising factories of the northern seas."

into it. I looked closely at the earth thrown up by the puffins. It was full of frail, brownish bones. I soon realized it was not earth. It was the decomposed bodies of millions of great auks. From the graveyard of the great auk one of the world's most magnificent bird colonies has risen.

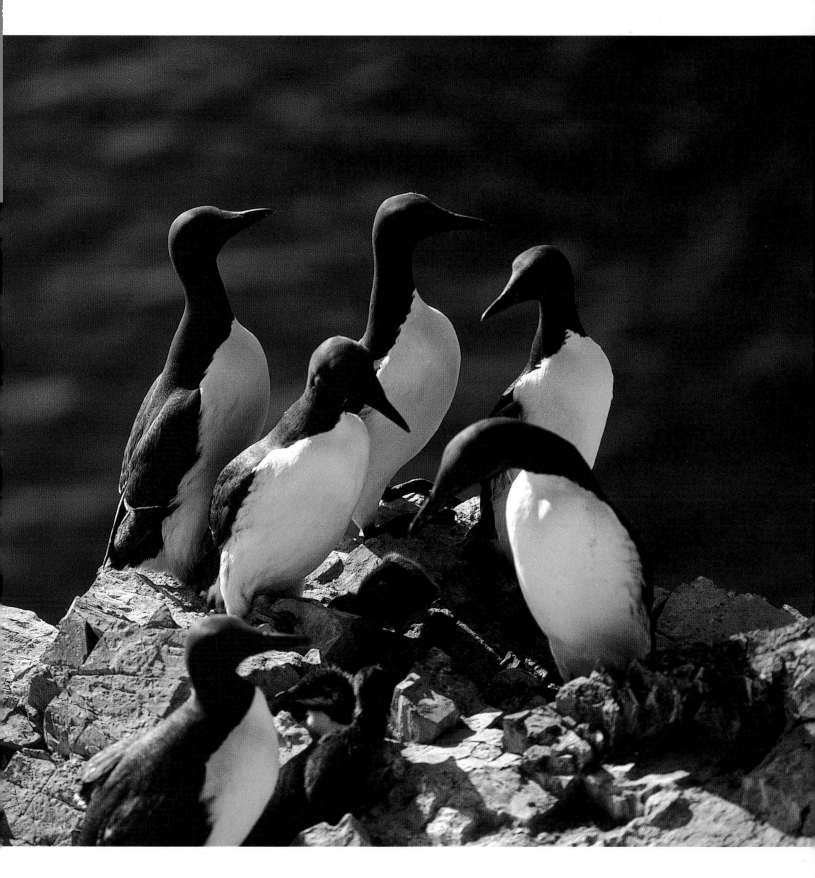

Adult murres and chicks on a rock pinnacle high above the
sea. The chick is brooded by one of its parents during the first
six days of its life. The other parent flies off in search of fish
and returns with several each day. The chick soon grows fat.
Chicks fledge when they are about 20 days old.

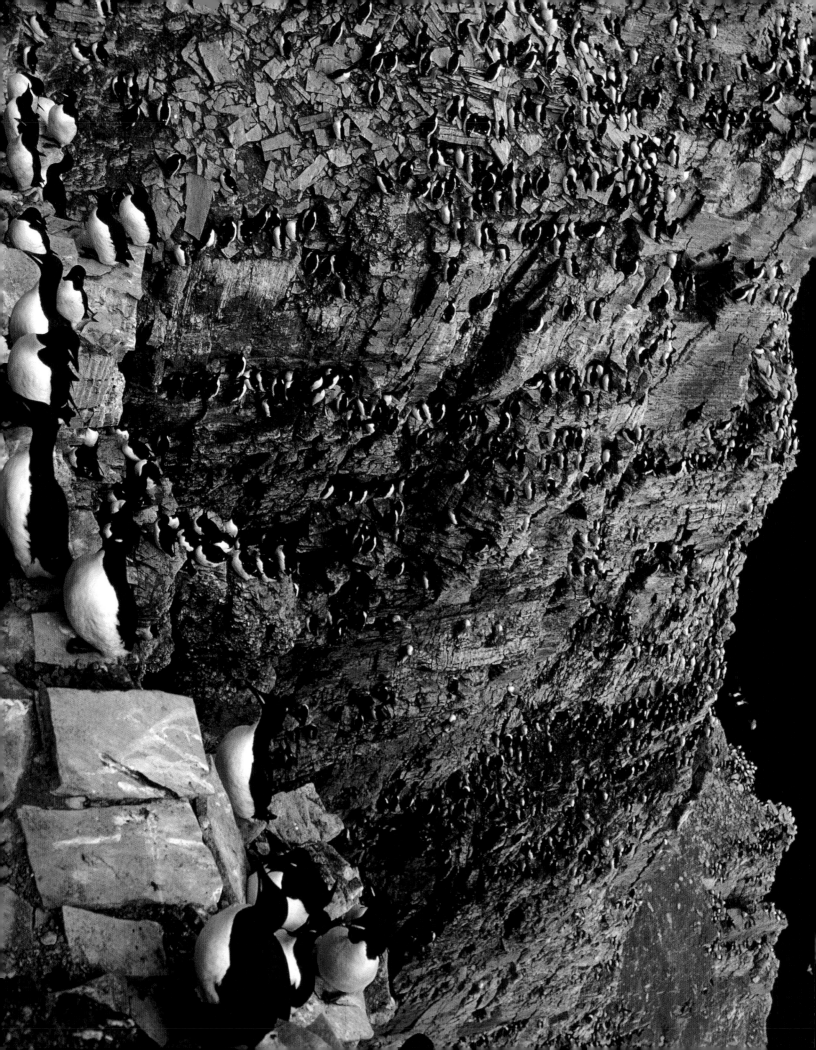

Thick-Billed Murre, Arctic Canada

The Inuit of Ivujivik, a village on the northwest tip of Arctic Quebec, call it *Qirkartarsik*, "the tall island," the home of *akpa*, "the murre." The soaring cliffs of this island, situated eight miles (5 km long) off the Ungava Peninsula at the entrance to Hudson Bay, and of neighboring Cape Wolstenholme, are home to the biggest colonies of thick-billed murres in Canada. More than 800,000 murres breed here.

The first European to see the island and eat its murres was Henry Hudson in 1610. He named it Digges Island, after Sir Dudly Digges, a scholar, diplomat and businessman, and one of the patrons of his ill-fated expedition.

The breeding cliffs on Digges Island are nearly perpendicular. They are 650 to 1,000 feet (200 to 300 m) high and two and a half miles (4 km long).

The murres arrive at the Digges Island breeding ledges in late May and early June. Each bird claims the same small space along the multitiered cliff where it incubated its egg the year before; it is at this exact spot that each murre meets its mate after a separation of about nine months.

Murres tend to do things en masse. They crowd together on the cliffs. They find the sight and sound of thousands of their neighbors courting and screeching highly stimulating. They work themselves and each other into a frenzy. As a result, most murres mate at about the same time and lay their eggs within a week to 10 days of one another; most chicks reach fledging age (approximately 20 days after hatching) at about the same time in the latter part of August. This breeding synchrony is essential to the murres' survival.

Good space is precious. Thick-billed murres crowd the narrow ledges of sheer cliffs, standing at one-foot intervals from one another. They don't build nests. The female simply lays a single egg upon the narrow ledge. The egg is pear-shaped and, when jostled, pivots in a very tight circle. If it does drop early in the season, the female usually lays another one.

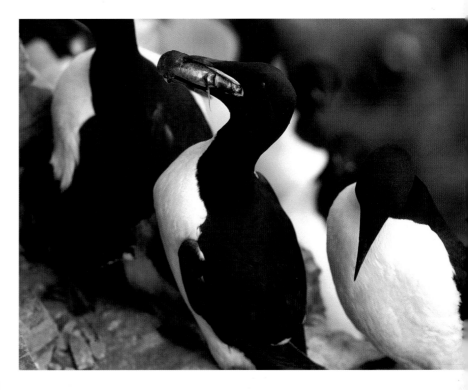

A thick-billed murre arrives on the home ledge with a fish for its chick in its beak. One of the parents flies out every day to catch fish and brings three to four back for its youngster. While one parent forages, the other guards the chick.

Murres don't build nests. The female lays her single egg upon a narrow rock ledge high above the sea. But this egg is a marvel of natural design. It is pyriform, or pear-shaped, so that if it is touched, it pivots on its pointed end in a very small circle, and that's vital on narrow ledges.

Both parents take turns incubating the egg and later take turns brooding and guarding the chick, the male usually assuming the night shift. The foraging mate returns with a fish (often an arctic cod), held lengthwise in its beak, settles next to its mate on the narrow ledge and bows in rapid jerks. The chick instantly begins to beg, cheeping loudly until it gets the fish. It swallows it headfirst with convulsive gulps. Often the fish is longer than the chick, which sits there, potbellied and strained, the fish's tail protruding from its bill. After a while, the chick gulps again, and the fish disappears. It digests the fish rapidly.

The fish a parent brings for its chick are often arctic cod, which are sometimes longer than the chick. The chick gulps down the fish headfirst, then sits with the fish's tail protruding from its beak, its stomach bloated. The chick rapidly digests its food. After a short while, it gulps again and swallows the rest of the fish.

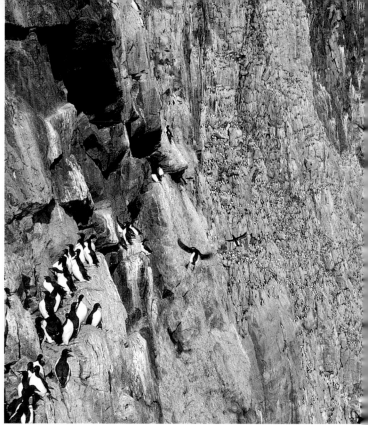

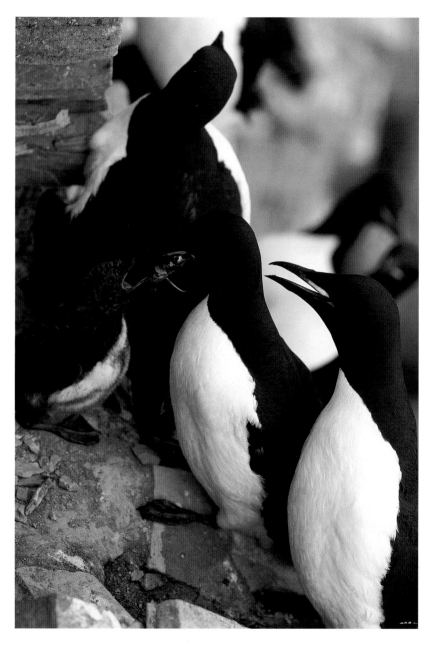

The chicks grow fast and at the age of 20 days look like miniature replicas of their parents, with one important exception: their primaries are not yet developed and they cannot fly, which is, of course, awkward since they may sit 1,000 feet (300 m) above the sea.

In the latter part of August, as the time for departure approaches, the excitement in the great murre colony increases. The volume of noise, already immense, rises to an even more frenetic pitch. Then comes the perfect night—gloomy gray but calm—and the chicks get ready to leave in droves.

When a chick is ready to take the great jump, it shuffles along the ledge of the cliff, its parent (usually the male since it is night) following closely behind. The chick approaches the edge of the ledge and, seeing the ocean looming far beneath it, backs off in fright.

Anxious and undecided, the little chick patters back and forth. Then, suddenly, with a special shrill "launching call," it hurtles into the void, its tiny, poorly feathered wings beating frantically. The chick tumbles, flutters, then glides. An instant after it jumps, the parent follows, slightly behind and to one side of the falling youngster. Ideally, both the parent and chick should land on the sea below nearly simultaneously and close together, and then both swim out to the open sea.

When morning breaks, flotillas of fathers and chicks swim away from Digges Island, east through Hudson Strait, then down the coast of Labrador, helped by the south-flowing Labrador Current. They swim 600 miles (1,000 km) to their wintering grounds off northern Newfoundland, the mothers following soon after. After the marvelous fuss and fury of summer, the great cliffs of Digges Island become strangely quiet.

Digges Island, near the entrance to Hudson Bay in the Canadian Arctic, is home to hundreds of thousands of thick-billed murres. They nest on narrow cliff ledges along two and a half miles (4 km) of the island. Densely packed, loud and excitable, the massed murres make such a noise that on calm days one hears the colony from miles away.

Murre parent and chick. The little chicks are fed with big fish and thus grow fast. Wrapped at first in baby down, the chicks soon molt (like this one) into plumage that is similar to their parents'. There is, however, one important difference: the chicks don't yet have flight feathers. At fledging time, the chick must jump from the cliff without being able to fly. It is the riskiest day of its life.

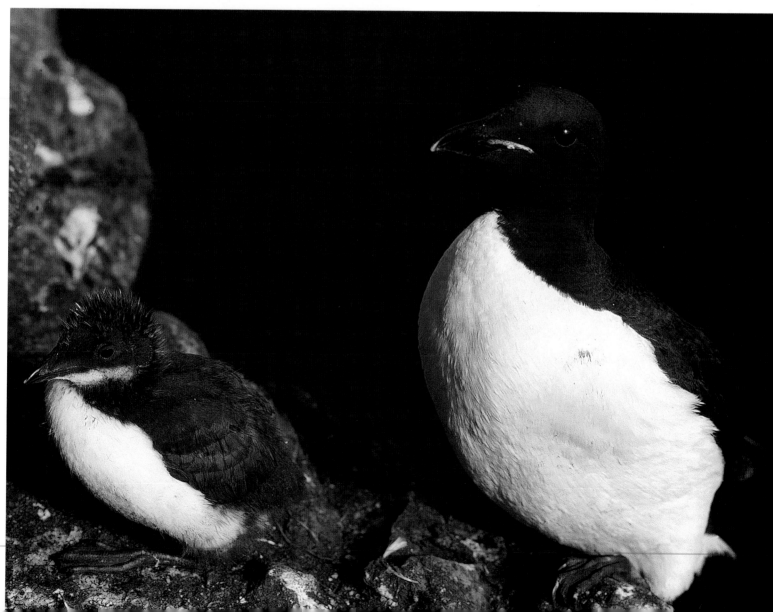

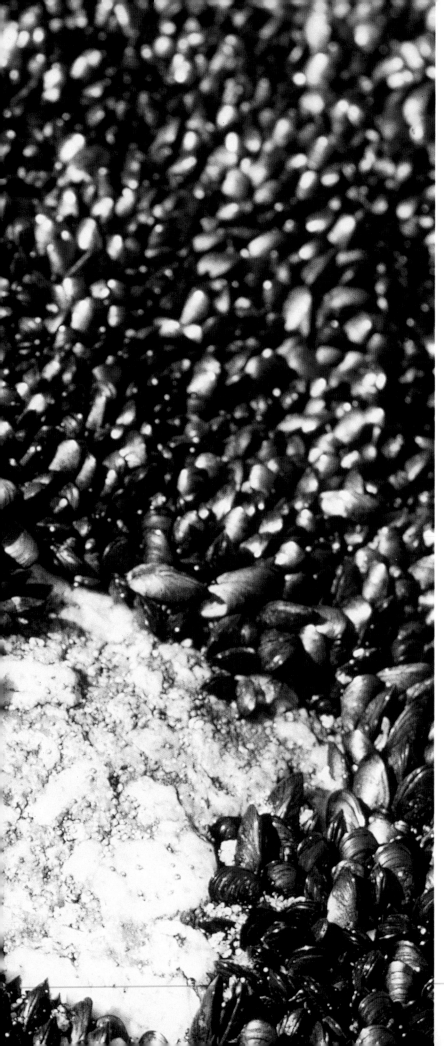

Mussels,
New Zealand

When I visited Cape Foulwind on the northwest coast of New Zealand's South Island, it lived up to its name. The wind screeched around the rugged granite cape and huge waves battered the coast. While I was whipped around by the storm, I thought of Captain James Cook, England's greatest sailor and explorer. He described getting caught in a fierce storm just off this "cape of foul winds" in 1770.

I was at Cape Foulwind to photograph and observe a colony of New Zealand fur seals for a book. Once the storm ended, I had a wonderful time with the seals. In between photographing them, I admired the mussels that grew in a broad blue band along the coast. They were gathered in dense mats, or scalps, as mussel beds are called, in infinite numbers. I had never seen so many of them before. The intertidal zone was covered for miles and miles in acres of mussels, from tiny pea-sized blue-black baby mussels to thumb-long elder mussels, which were two years old or older.

The turbulent waters of the intertidal zone offer the mussel a relatively safe harbor from its prime predator, the starfish. Starfish usually avoid this zone because they risk

Massed mussels cover the rocks of the intertidal zone near New Zealand's Cape Foulwind. Here the densely packed mussels are safe from their main predator, the starfish. Most of these tiny blue-black mussels are only a few months old.

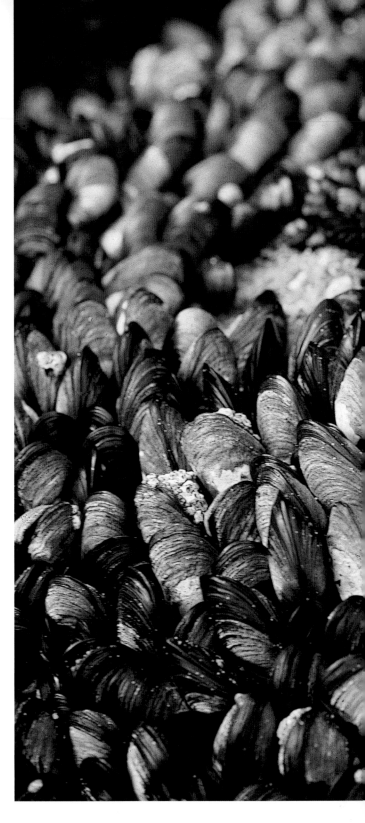

64

being stranded there at low tide. If this happens, they become dehydrated and die.

When a starfish does encounter a mussel on the sea floor, the latter suffers an unpleasant fate. The moment it finds a mussel it envelops it with its arms and tries to pull the mussel's two hinged shells, or valves, apart. The mussel reacts by holding its valves tightly shut with its adductor muscles. But this resistance often proves futile, for the starfish's pull is slow, steady, and inexorable. It can last hours. Slowly the mussel weakens, its muscles relax, and a gap appears between the valves. The starfish everts its stomach through its mouth and inserts it into the gap. It then dissolves the mussel's soft body with its powerful digestive juices.

Mussels can avoid this fate by living densely massed in the intertidal zone making it more difficult for wayward starfish to get at them. At high tide their shells are open and they feed. But at low tide, they close up, their moist vulnerable bodies hermetically sealed by the protective armor of their valves.

Forever in turmoil, the intertidal zone is immensely rich in minerals that nourish astonishing amounts of microscopic plants, known as phytoplankton. A myriad of tiny planktonic animals graze on these rich underwater pastures. And the mussels, in turn, feed on these creatures.

Mussels are very efficient feeders. A mussel is basically a pump with filters and a stomach. At high tide it opens its valves and sucks in the plankton-rich water through an inhalant siphon. The water passes over gills that retain the plankton; respirator gases are then exchanged, and the used water is exhaled by another siphon. A large mussel pumps and processes 42 quarts (40 l) of water a day.

Mussels are fast feeders and equally fast breeders. A mother mussel is prolific. She releases clouds of minute eggs into the sea. Once these are fertilized by sperm from nearby males, they

develop into larvae. There are up to 12 million larvae per female.

The mussel larvae roam the sea, forming part of the ocean's plankton. Once the larvae turn into minute mussels, the time has come to settle down.

It is aided in this process by a thread called a byssus. This is a silky, elastic, extremely tough filament, which is produced by a special gland near the mussel's fleshy foot. The mussel attaches these

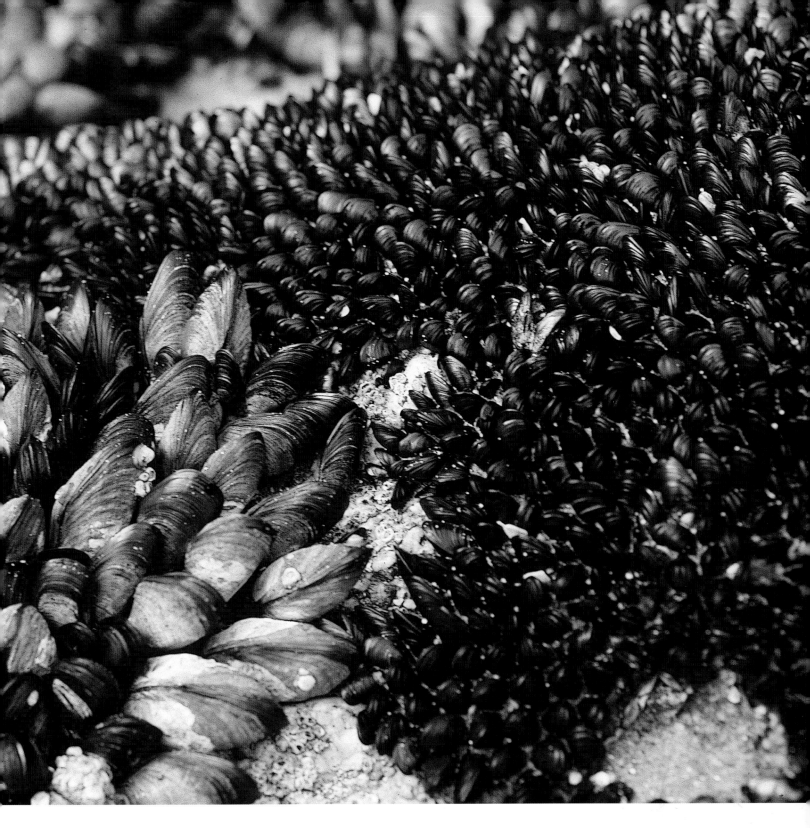

fluid strands one by one to the rock it chooses as its home within a particular colony. When they come into contact with seawater, these byssal threads harden into resilient yet slightly flexible anchors. The little mussel is now firmly fastened to the rock and will be able to weather battering waves. It is also protected by the close proximity of millions of other mussels.

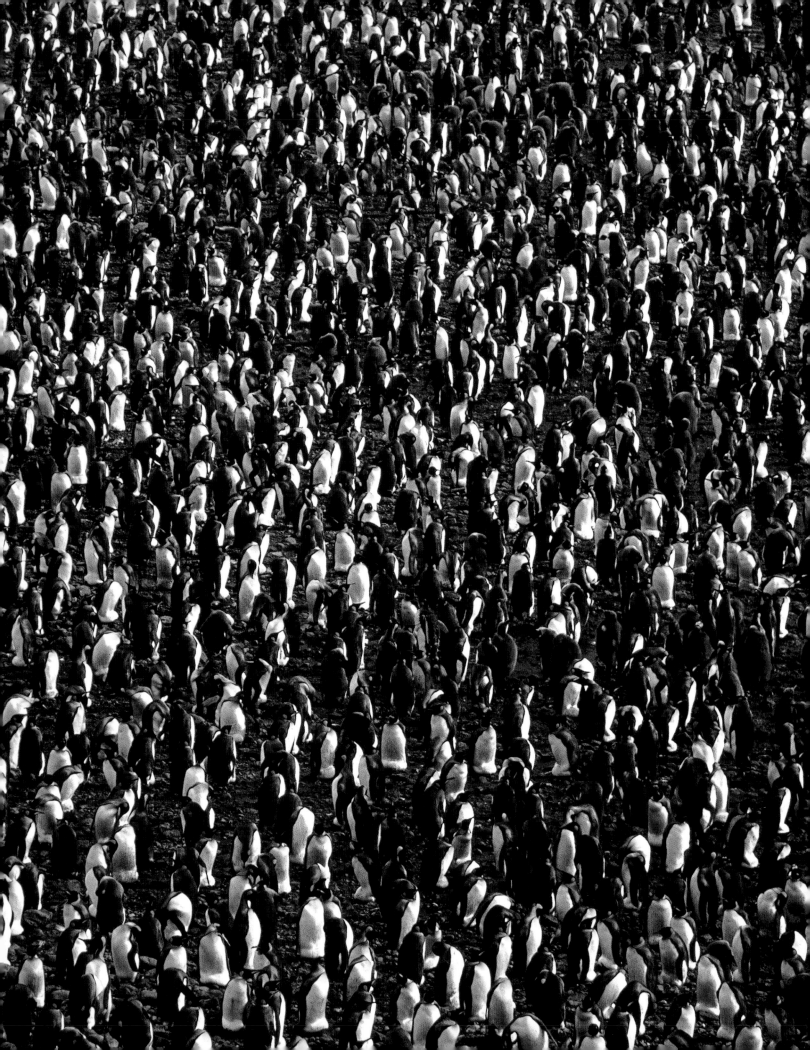

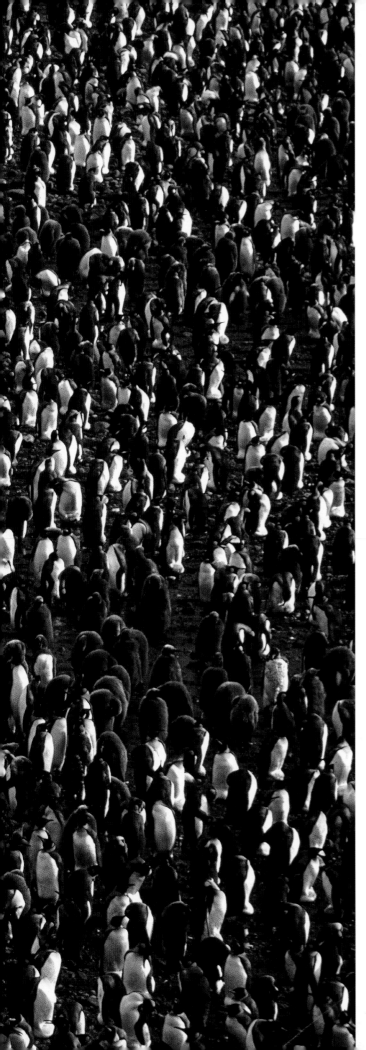

King Penguin, South Georgia Island, Subantarctic

"Penguins are habit forming," noted the American paleontologist George Gaylord Simpson. He started the habit by studying the bones of fossil penguins (one penguin of the past, *Pachydyptes ponderosus* was nearly as tall as a human and weighed about 180 pounds [82 kg]). Then Simpson encountered live penguins and he was hooked. He studied them for more than 40 years, enthralled, like all penguin addicts, with these "most curious and fascinating creatures on earth."

My (one-sided) love affair with penguins began many years ago on the subantarctic Auckland Islands, where I lived with some New Zealand scientists for several months. Our island, Enderby, was home to the yellow-eyed penguin, the rarest type of penguin.

On Enderby Island, the penguin parade began each afternoon as the birds emerged from the sea and scrambled up the rocks. They rested for a while, then headed inland to relieve their mates, who were brooding upon stick nests hidden in the forest.

I waited for the penguins near their main trail. A pear-shaped penguin waddled up on stout feet. He looked pensive and stooped slightly, like an elderly professor with worries. When he was about four feet (1.2 m) away, he spotted me and stopped, apparently nonplussed. He bowed and peered, advanced, recoiled, then shuffled back and forth, now appearing a little worried. Finally, he marched past me with a half-scared and half-defiant glare, then rushed toward the forest, his plump bottom swaying and bobbing. Enderby's penguins were our daily joy.

Years later I lived with the much larger king penguins for several weeks at the Falkland Islands'

Neatly spaced apart, about 100,000 king penguins brood eggs or small chicks on Salisbury Plain on the subantarctic South Georgia Island. The older chicks, in brown down, mass in crèches while their parents are feeding at sea.

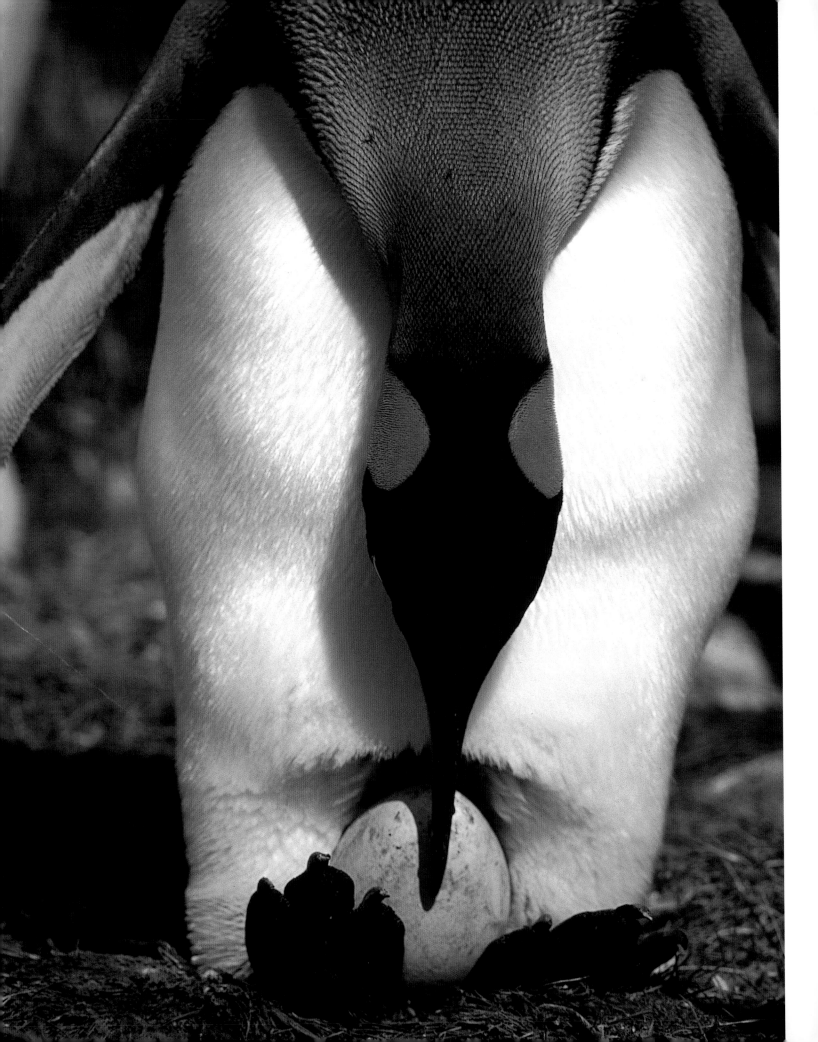

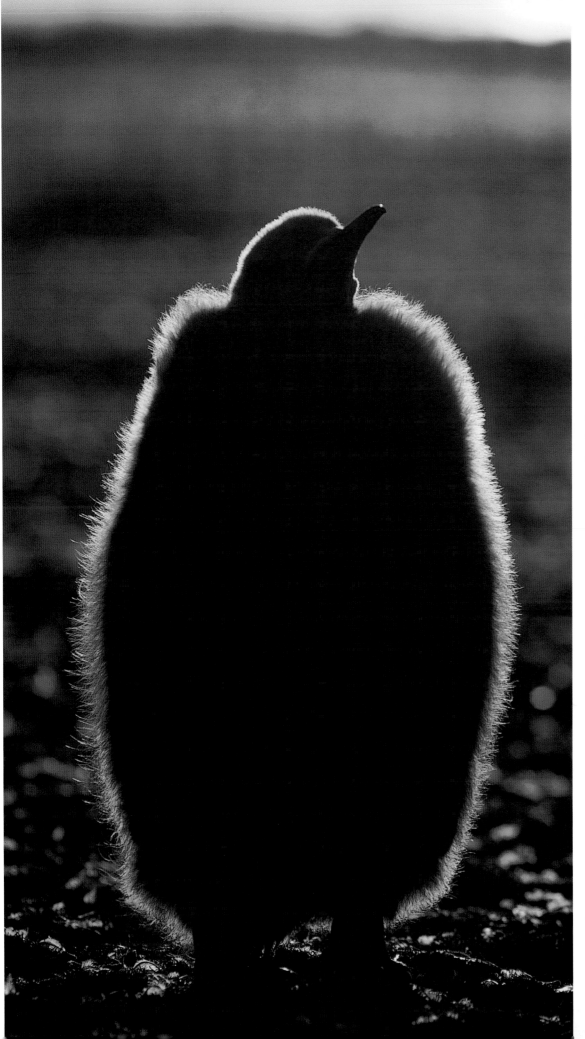

At sunset a plump king penguin chick, wrapped in thick warm down, stands at Volunteer Point, in the Falkland Islands. Both its parents are at sea, catching squid and fish, and return from time to time to feed their chick. The chick fledges and goes to sea when it is about 10 months old.

Both female and male king penguins brood the single egg. The bird holds the egg upon its slightly upturned feet. Then it covers it with a warm, densely feathered brooding pouch, which is a thick roll of skin. Incubation takes about two months.

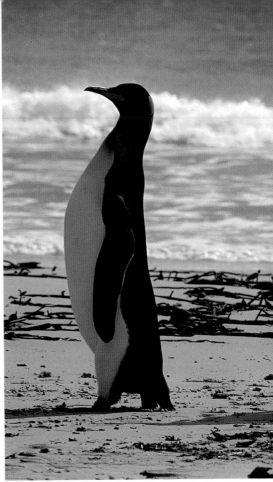

King penguins return from the sea. Intensely gregarious, they usually gather in small groups, rest for a while and then march inland together to feed their chicks at Volunteer Point on the Falkland Islands. This is their northernmost breeding colony.

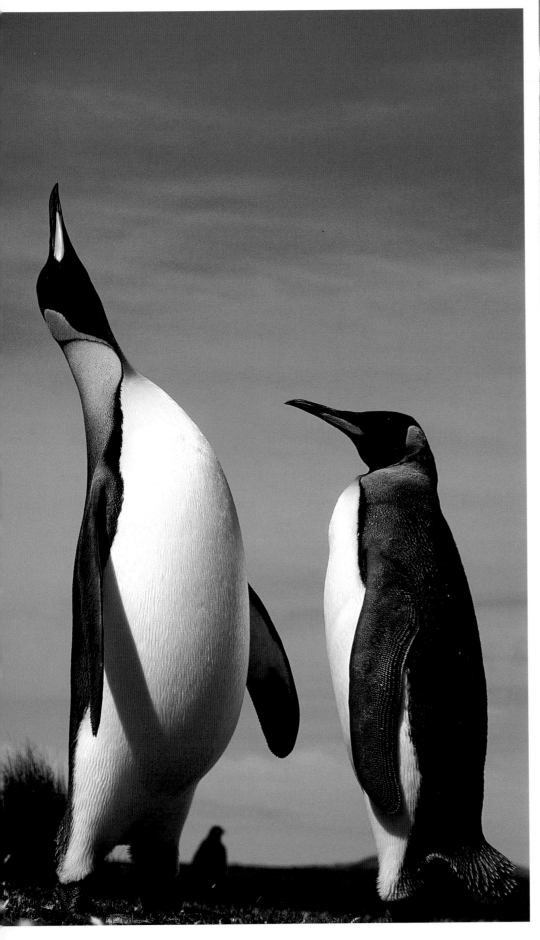

A courting male king penguin captured in a display of ecstasy. King penguins' courtship is lengthy and elaborate. Since raising one chick takes an entire year, king penguins lay an egg about every 14 to 16 months and thus are the only penguins that do not have a regular annual breeding cycle.

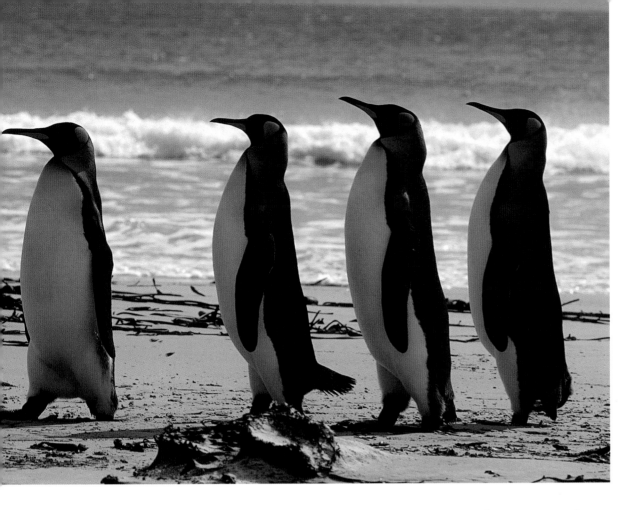

Volunteer Point, the most northerly and rapidly growing king penguin colony. The king penguin of the subantarctic islands is the second-largest penguin (the emperor penguin of the Antarctic being the largest) and the most beautiful of all penguins. Nearly three feet (a meter) tall, it is a majestic bird, its back a glossy slate blue, its breast and belly snow white, the head a deep velvet black, with brilliant golden orange, tear-shaped auricular patches on both sides of the head; these patches merge with a golden orange bib.

The trouble with watching penguins is that it is impossible to do it with any sort of scientific detachment. They are very much like humans. As we try to study them, they have the disconcerting habit of watching us, with mild and slightly puzzled interest, like society matrons observing a girl in an outré skirt.

Unlike all other penguins, the king penguin does not have a fixed breeding season. Consequently there were birds in all stages of penguin life at Volunteer Point: from young adults in the throes and woes of budding love to stressed parents trying to cope with the demands of teenage children.

Courting begins with the "advertising walk" and culminates in strident ecstasy. When a male wants to impress a female, he walks past her with majestic grace, turning his head from side to side to flash those golden auricular patches. If he's not her type, she just ignores him. But if he strikes her fancy, she follows him and wooing begins in earnest.

Their courtship begins with mutual preening. The birds also nibble gently at each other's neck and head. They rub their necks together, and, as passion soars, both male and female throw out their wings, raise their bill toward the heavens and cry in strident ecstasy. Soon after they usually mate.

The female lays a single egg, rolls it upon her feet and covers it with her brooding pouch, a thick densely feathered skin flap. Incubation lasts two months. The male also has a brooding pouch and the parents take turns incubating the eggs and brooding the chick once it emerges.

When a parent returns to its youngster with food, it is besieged by the ever-famished chick, which is in no hurry to grow up. King penguin chicks take 10 months from the time that they hatch to grow into waterproof plumage. Once they are fully fledged, they leave the colony to catch their own food in the sea.

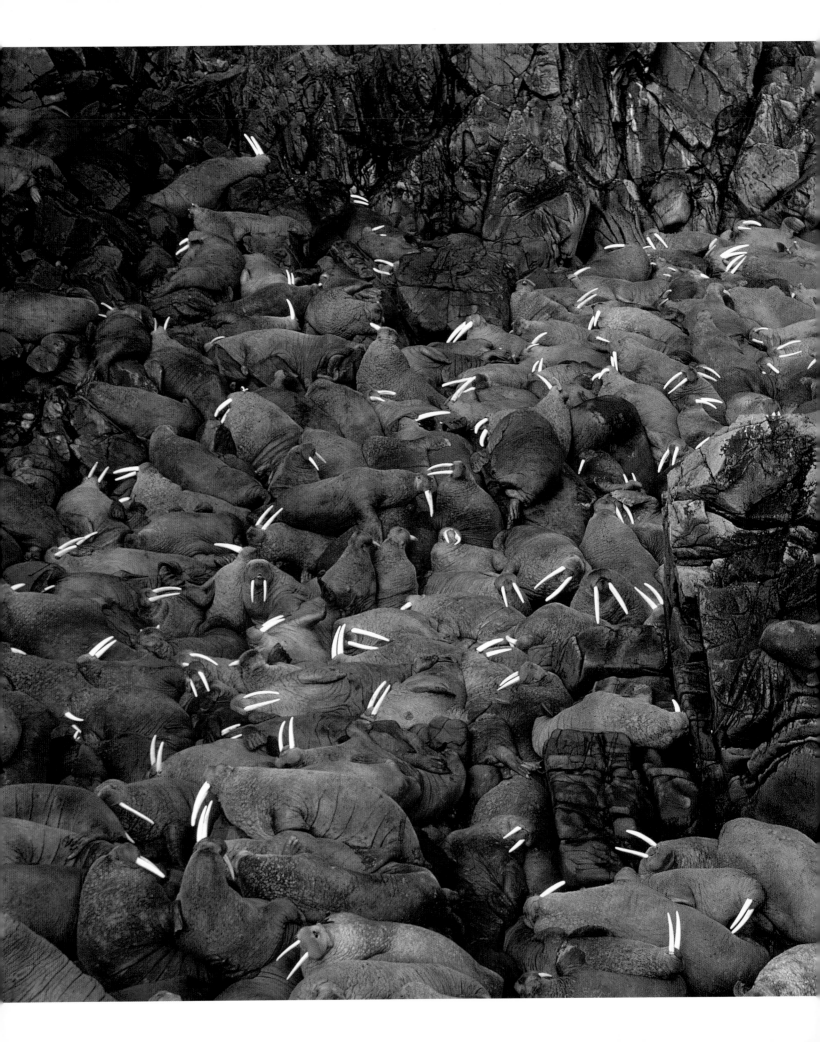

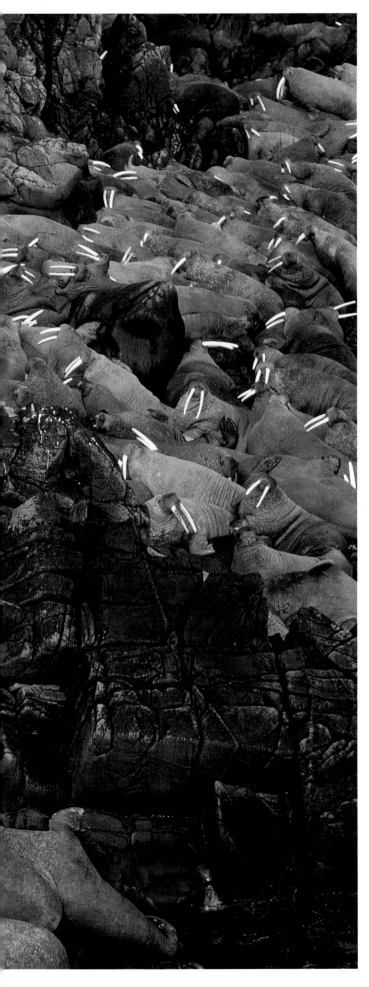

Pacific Walrus,
Alaska, U.S.A.

From a distance, Round Island, which lies in Bristol Bay, off Alaska's west coast, looks forbidding: a high, brooding, asymmetrical cone far out in the sea, its steep sides sloping down to broad beaches. In summer, these beaches are covered with walruses.

When I first visited the island more than 30 years ago, about 2,000 walruses summered there. Now about 12,000 of them lie densely packed upon the shingle beaches, lazing away the summer months. This is the largest concentration of walruses in the world. They are all males.

All Pacific walruses winter near the southern edge of the ice in the Bering Sea. In spring, nearly all the female walruses—along with their calves, immature animals, and some males—follow the receding ice and swim north through the Bering Strait; during the summer they scatter over the immense, shallow Chukchi Sea, which contains an abundance of food.

Most mature males, however, avoid this arduous 1,900-mile (3,000-km) return migration, opting instead for a life of laziness on the beaches, which have served as summer resorts for untold generations of walruses. Between bouts of feasting on shrimps, crabs, whelks, and mussels out at sea, the walruses clamber onto the beach and press against each other as tightly as possible, for walruses love togetherness.

When they first haul out on Round Island, following a long immersion in the icy sea, the walruses are a peculiar bluish white. But as they warm up on the beach, their color changes; they

Male walruses massed on a beach on Round Island off Alaska's west coast. Intensely gregarious, walruses like to lie close together in groups. While the majority of Pacific walruses migrate north in spring, most males do not. Instead, they gather on hauling-out beaches as their ancestors did for centuries. About 12,000 male walruses laze away the summer months on Round Island.

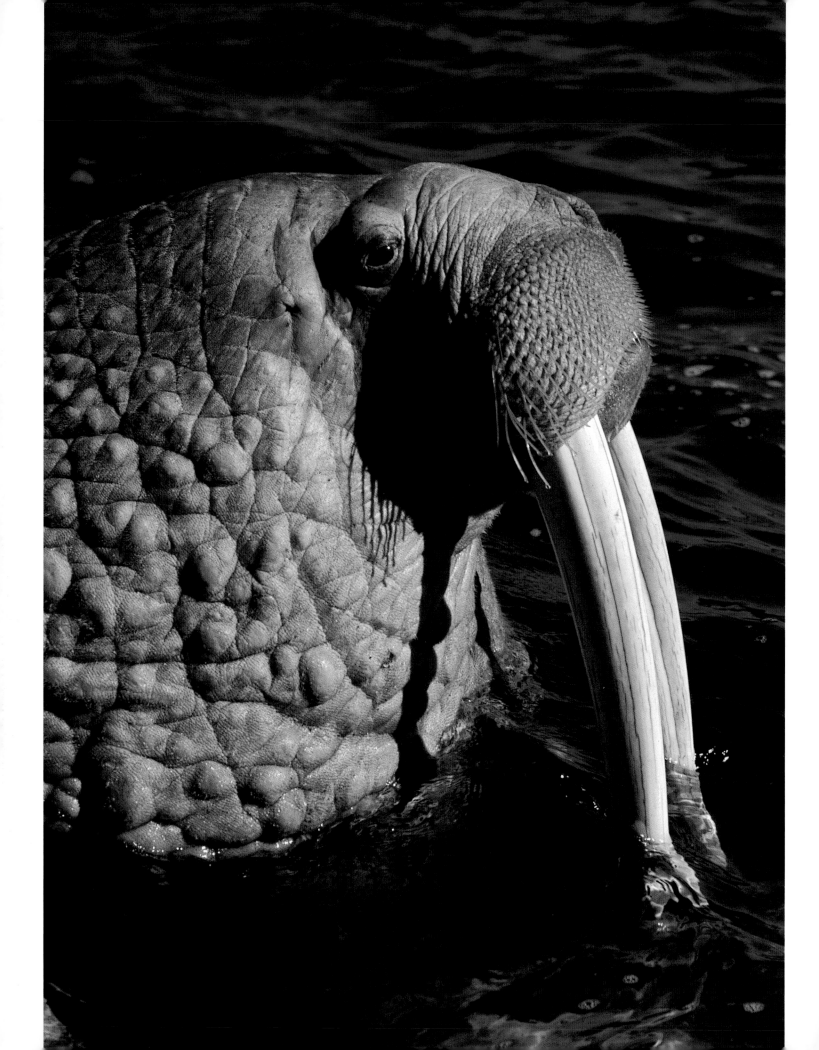

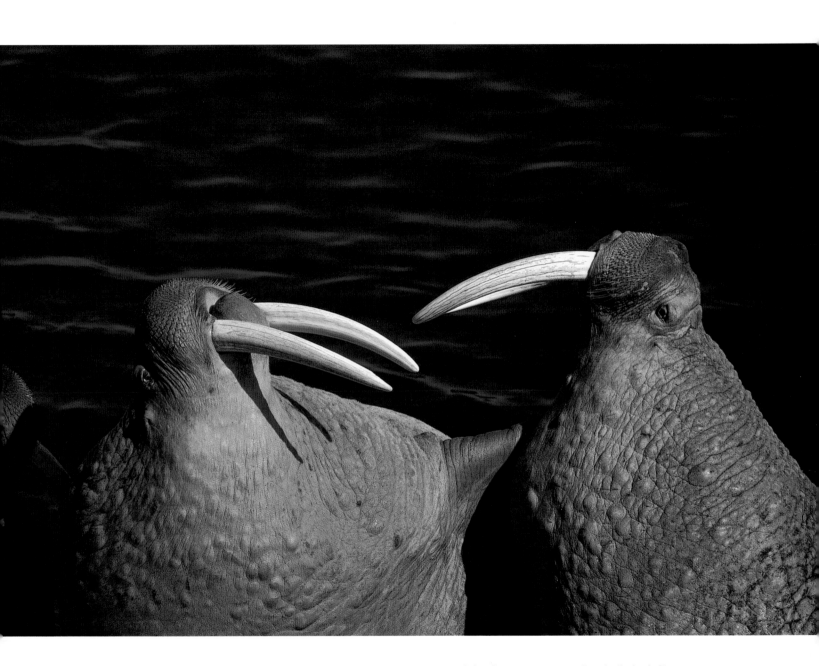

Walruses' magnificent ivory tusks led to their demise. They were prized by commercial hunters in the 19th century, and these men destroyed the once-vast walrus herds. Of about 200,000 walruses only 45,000 remained by 1958. Now only Inuit may hunt them. As a result the size of the herds has steadily increased and there are now again about 200,000 walruses.

Fights between great walrus bulls look fierce, but they are mostly for show. The size of a bull's tusks establishes its status within the hierarchy, so the male with the smaller tusks usually yields. Evenly matched males fight, but injuries are rare because their skin is more than two inches (5 cm) thick.

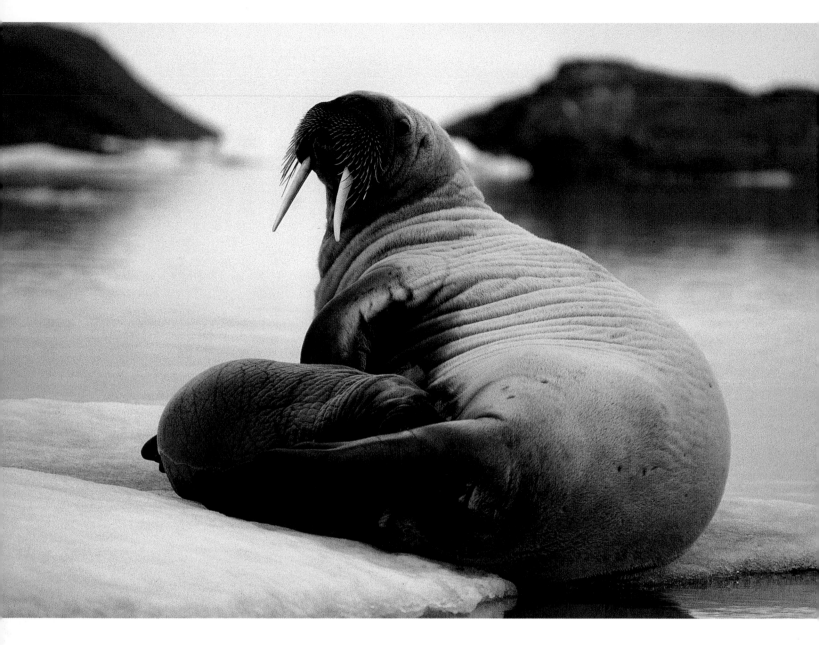

gradually turn russet, brick red, or piggy pink.

A sort of stinky peace pervades the beach, but it is often interrupted. As I sit on my favorite perch on the hill above the beach, a huge, two-ton male emerges from the sea. He stops, looks slowly left and right, then waddles ponderously ahead and jabs the nearest walrus on the butt to indicate that he should make space for him. The startled sleeper rears up, then both bulls throw back their heads and bellow angrily. Since the newcomer is larger and has bigger tusks, the other walrus backs up and jabs a neighbor, who, in turn, jabs his neighbor so that a shockwave of jabbing and jostling runs through the packed group. The large bull soon finds a place that suits him, and with a chorus of moans, the walruses all relax and fall asleep again.

Once there were about 40 hauling-out places, like Round Island, on the Siberian and Alaskan side of the Bering Sea. But in the middle of the 19th century commercial walrus hunting began on a large scale. Hunters sought the animals' skins, fat, and precious ivory tusks. Between 1860 and 1880, 200,000 Pacific walruses were killed. When the worst of the slaughter ended, the once-vast walrus herds had more or less vanished. By 1958, about 45,000 Pacific walruses were left.

Since then, thanks to conservation policies, they have made a remarkable comeback and now number about 200,000 again. Walruses have returned to many long-abandoned hauling-out places, and on Round Island the number of summer residents has increased steadily over the years.

Round Island is a sanctuary where the mighty males can rest in peace. Unless they smoke,

A female nurses her calf. The mother–calf bond among walruses is extremely strong. For about two years, mother and young are nearly inseparable. A newborn calf is about three feet (1 m) long and weighs 120 pounds (54 kg). It is covered with a coat of short silvery gray hairs. After the first molt, calves turn a rusty brown color.

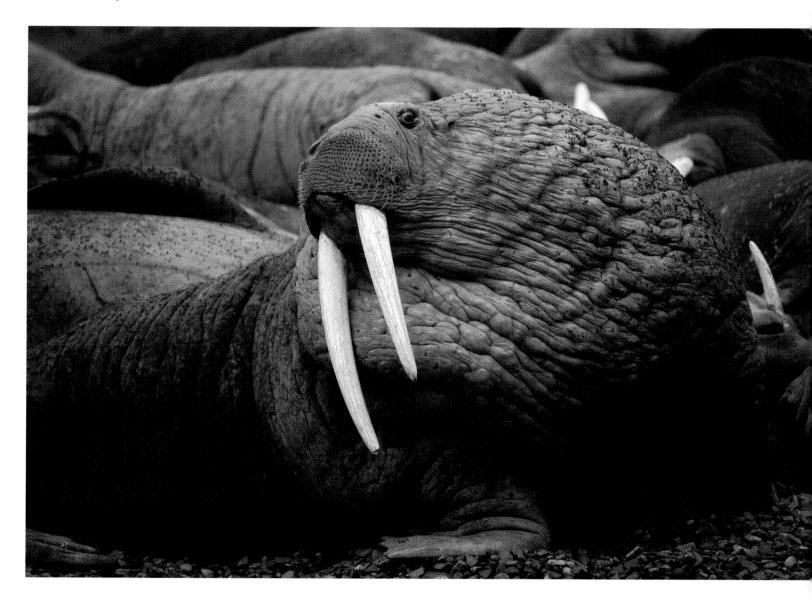

humans don't really bother the animals. For some unknown reason, walruses fear and detest the smell of smoke. A researcher told me that one cigarette can send the entire herd rushing into the sea.

Since I do not smoke, a huge bull at the edge of the pack wakes up but watches my approach with haughty indifference. Once I am six feet (2 m) away from him I stop cautiously. He looks me up and down with protuberant, red eyes and seems to judge me harmless. So he sighs lugubriously, closes his eyes, and sinks back into whatever reveries walruses indulge in.

A massive walrus bull rears up. Large males can weigh more than 3,500 pounds (1,590 kg). Consequently, no enemy, apart from man, dares to tackle them. Both males and females have ivory tusks, the male's are longer and heavier. Contrary to a long-held belief, walruses do not use their tusks to dig up clams from the sea-bottom. But tusk size determines a walrus's status within the hierarchy.

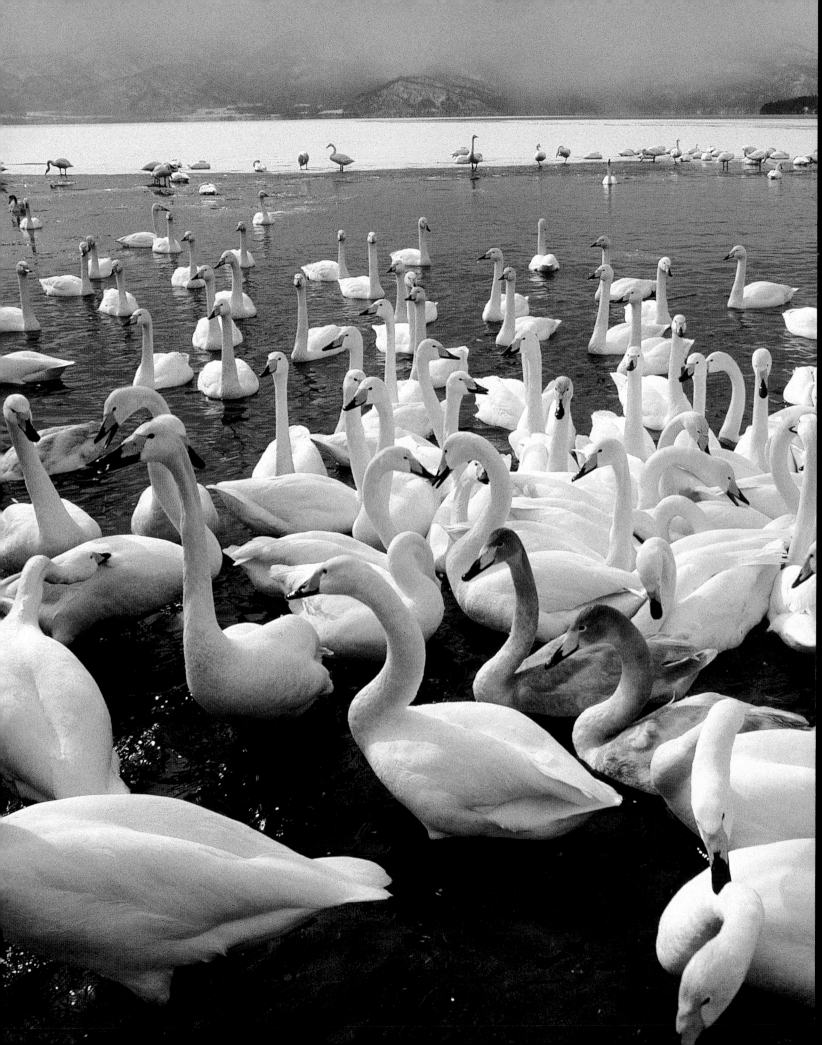

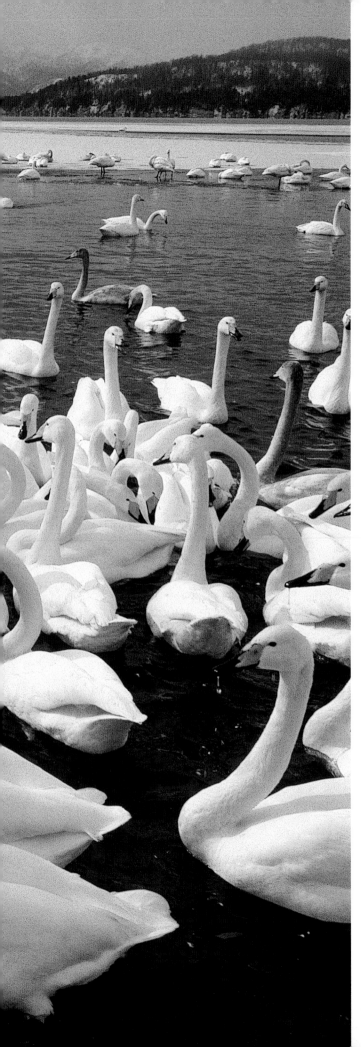

Whooper Swan, Hokkaido Island, Japan

Swans symbolize the best in humankind, but they also bring out the worst in us. Swans were once sacred in much of northern Europe and stood for purity and perfection. They became part of the legend of King Arthur and his knights of the Holy Grail, whose shining hero was Lohengrin, the Swan Knight.

The swan may have been revered, but this did not deter men from hunting these birds, or from rounding up molting swans, at a time when they could not fly, and roasting them for their supper. King Henry III of England once served 125 roast swans at a Christmas feast in Winchester.

In the 19th century, swan skins became an item of trade. These were mainly the skins of North America's trumpeter swans, magnificent snow-white birds. With a wingspread of up to eight feet (2.4 m), they were the largest swans in the world. Their lovely down was used in muffs and in powder puffs. Elegant robes were trimmed with swans' skins. The birds' hard yet elastic quills were used as pens. (They were the pens John James Audubon preferred to use when sketching the feet and claws of small birds.) Between 1853 and 1877, the Hudson's Bay Company alone sold 17,671 swan skins in London; in 1828, it sold 347,298 goose, swan, and eagle quills as pens.

In 1912, the famous American ornithologist Edward H. Forbush wrote: "The trumpeter swan has succumbed to incessant persecution in all parts of its range, and its total extinction is now only a matter of years." By 1916, there were only about 100 trumpeter swans left. Fortunately, a young farmer was about to come to their rescue.

Massed whooper swans on Lake Kussharo on Hokkaido, the northernmost of Japan's islands. These swans breed in Siberia, and about 13,000 of them spend the winter in Japan. Once avidly hunted, they are now protected. Hokkaido has a cold winter climate, but they like Lake Kussharo because it is warmed by thermal springs, which means it does not freeze over.

Whooper swans spend much time preening their glossy white feathers. They smooth them with their bills and carefully rub them with oil, to keep the plumage waterproof.

Two whooper swans rest on Japan's Kussharo Lake, their long necks gracefully bent and their heads tucked partly under their wings. Once hunted to near extinction in Japan, whooper swans received legal protection in 1925. Perhaps more importantly, they are now protected by Japanese citizens. Today, the Japanese revere the great swans, often referring to them as "the Angels of Winter."

In 1913, in a remote valley of northern British Columbia, a young man named Ralph Edwards built a log house in the wilderness, near a lake he aptly called Lonesome Lake. A third of the surviving trumpeter swans wintered at this lake. Edwards loved the swans. For him, the clarion-clear calls were the triumphant voice of the wilderness. He shared what little provisions he had with the birds. And slowly, over the course of many years, the number of trumpeter swans increased.

In 1972, Ralph Edwards received the prestigious Order of Canada in recognition of the part he had played in saving the trumpeter swan from extinction. In 1973, I visited Edwards on his farm. He was then 82. With his bushy eyebrows, flowing white hair and beard, the diminutive frontiersman looked like a friendly forest gnome. He showed me the hundreds of trumpeter swans massed at Lonesome Lake. As we walked toward them, they remained calm. "They know I'm their friend," Edwards said with a smile.

On the other side of the world another farmer was about to fall in love with an endangered species of swans known as whooper swans. The second largest of the world's seven swan species, the whooper swans bred in eastern Siberia and used to

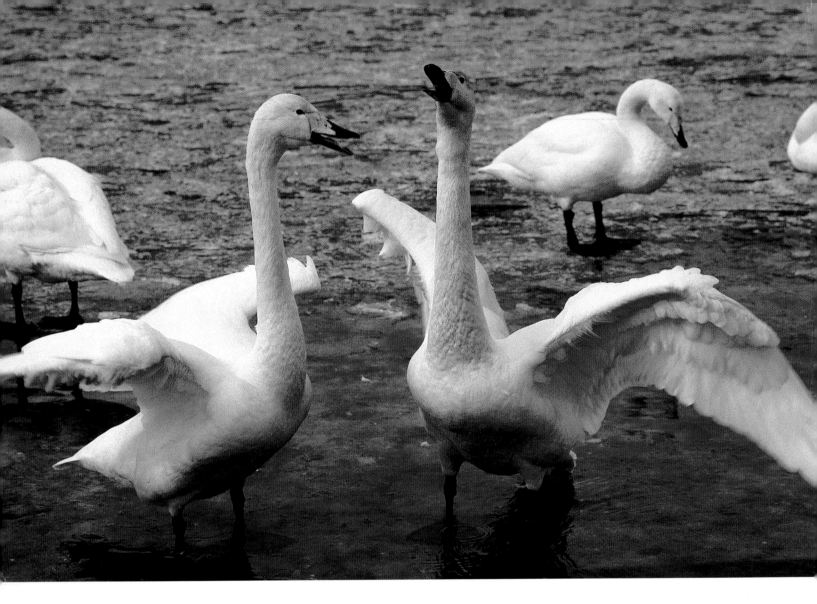

A cob and pen, as male and female swans are called, have just won an argument with their neighbors and celebrate their triumph with a ceremony. Both birds raise their heads, spread their wings and proclaim their victory with buglelike calls. They "whoop" and are therefore called whooper swans.

winter in Japan but the birds had been hunted there almost to extinction. They had become a protected species in 1925, but their numbers had not grown significantly. In the winter of 1950, some whooper swans rested at Lake Hyoko in northern Japan. A nearby farmer named Juzaburo Yoshikawa took pity on the tired, famished birds. He fed them and protected them.

Year after year Yoshikawa looked after the birds, and more and more swans came to the lake. Soon the story of how he'd rescued them spread. The swans of Lake Hyoko were proclaimed a natural monument. In 1959, Yoshikawa went out on a bitterly cold day to take food to the birds he loved, even though he was elderly and ailing. While feeding them, he died. His son, Shigeo Yoshikawa, became the next guardian of the swans.

About 13,000 of the whooper swans that breed in eastern Siberia now spend the winter in Japan. About half the swans winter on Lake Hyoko and

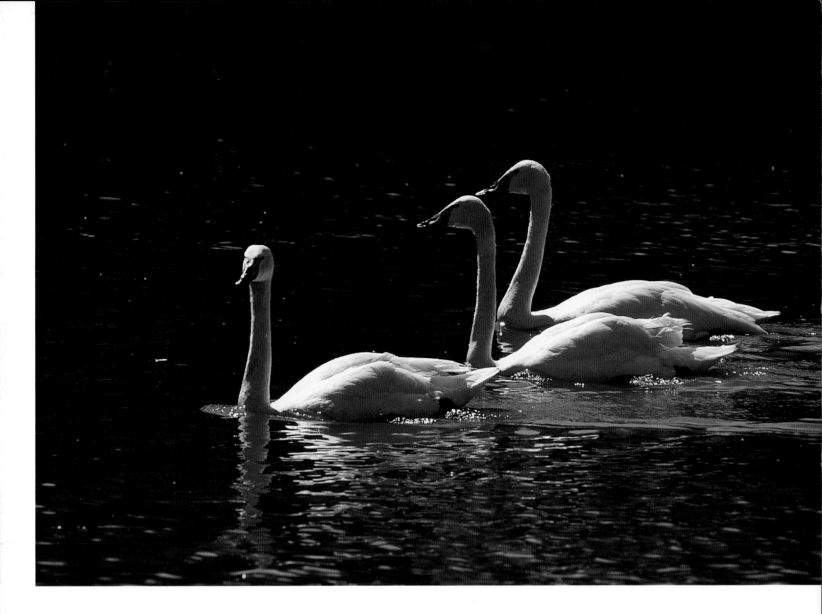

the other lakes of Honshu Island. The others fly to Hokkaido, Japan's northernmost island, and live on lakes kept open all winter by thermal springs. The largest concentration of wintering whooper swans is on Hokkaido's Lake Kussharo. The birds are lured there by the warm water of the lake, which is fed by thermal springs. The springs do not freeze, even in the coldest weather. Hundreds, sometimes thousands, of these beautiful birds gather on the lake. These "angels of winter," as the Japanese have affectionately dubbed them, are quite safe here as they continue to be a protected species.

The epitome of grace and beauty, whooper swans glide across a lake in northern Japan. They breed in northern Eurasia, from Iceland to eastern Siberia. Of the 13,000 whooper swans that winter in Japan, about half stay on the lakes of Honshu Island, the rest remain on lakes on Hokkaido Island in the north. These lakes do not freeze over as they are heated by thermal springs.

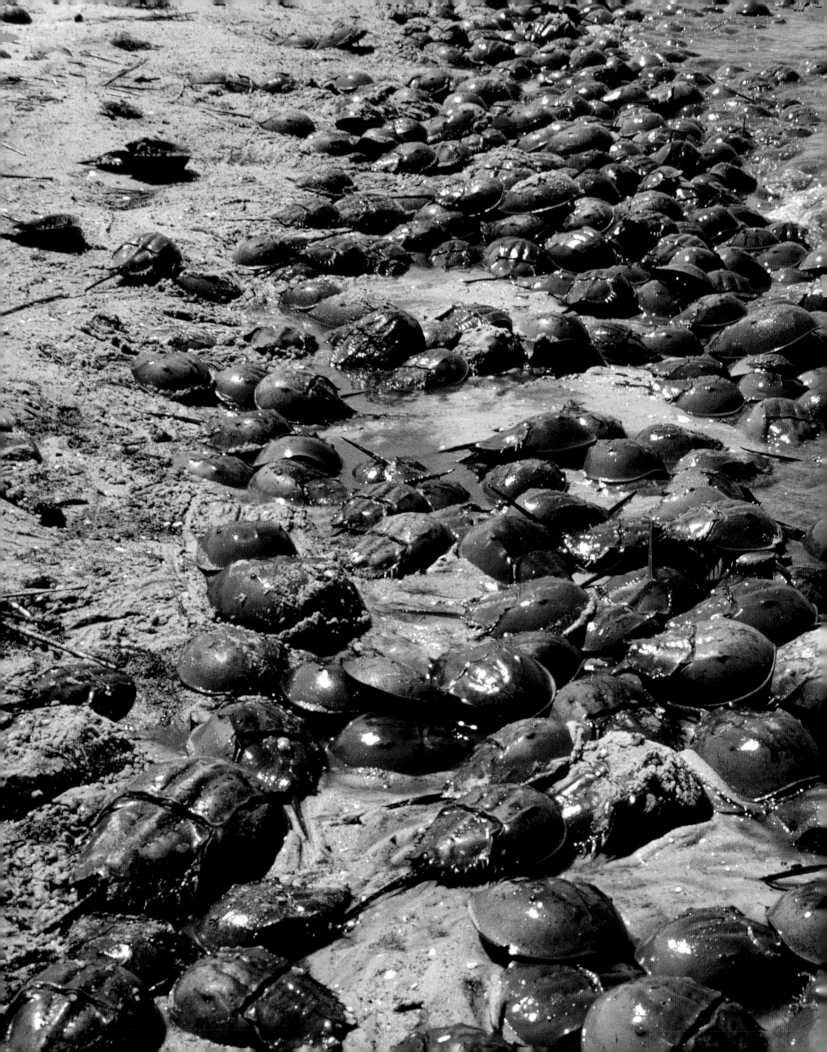

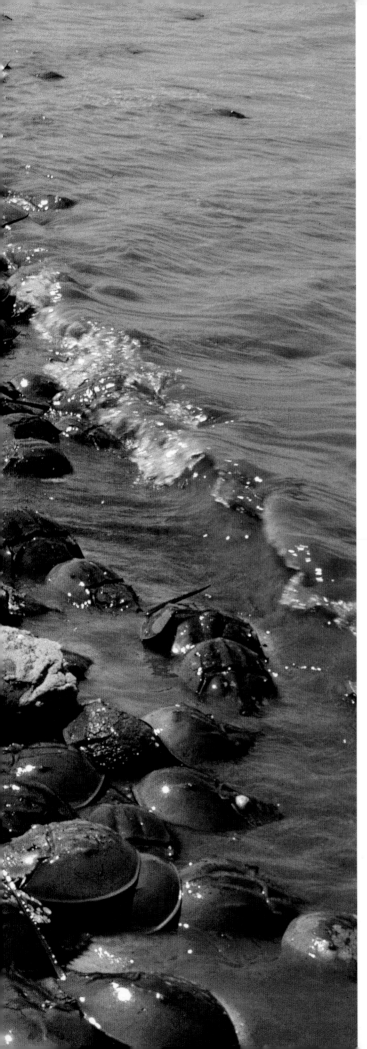

Horseshoe Crab,
Delaware Bay, New Jersey,
U.S.A.

Horseshoe crabs are among the oldest creatures in the world. They originated in the Ordovician period, more than 300 million years ago. They were ancient when the dinosaurs arrived, and they haven't bothered to evolve or change since. They're distinctly antediluvian; what was good for them 300 million years ago is fine for them today.

Horseshoe crabs are not really crabs but distant relatives of scorpions and spiders. They are descendants of the long-extinct trilobites, which swarmed through warm Cambrian seas 500 million years ago.

There are four species of horseshoe crabs. Three are found in Asia and one in North America. The Asian species, which breed on the coasts of Japan, Thailand, and Malaysia, are now rare. However, the North American species is prolific. It ranges from Mexico's Yucatan Peninsula north to Maine and is most numerous in New Jersey's Delaware Bay, where some three million adult horseshoe crabs live. The secret of their survival is twofold: females are immensely prolific, and horseshoe crabs taste so bad that even famished sharks won't eat them.

The horseshoe crab can swim, albeit upside down and propelled by flapping gills, but it is essentially a sea-bottom creature, equipped with a multitude of specialized legs. Its hind legs are long and strong, with flaps that splay and spread, making them perfect for digging into the sand. The horseshoe crab has four pairs of central legs, which it uses to walk, and to grind food, which it then shoves into its mouth, located at the base of the legs. In the male, the mitten-shaped front claws, or pedipalps, are designed to grasp a female and hang onto her smooth carapace. The male is much smaller than the female.

An armored armada of horseshoe crabs—among the oldest creatures in the world—creeps ashore at New Jersey's Delaware Bay to repeat their ancient rite of mass breeding. Neither the crabs nor their rhythm of breeding have changed in 300 million years.

Female and male horseshoe crabs travel up the breeding beach in tandem. As a large female emerges from the sea, a much smaller male grabs her with his specialized front legs, called pedipalps, and holds tight while she crawls up the beach. She digs a hole in the sand and deposits thousands of eggs in it, which the male fertilizes. She then covers the eggs with sand.

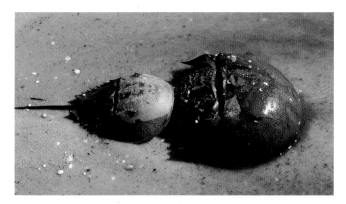

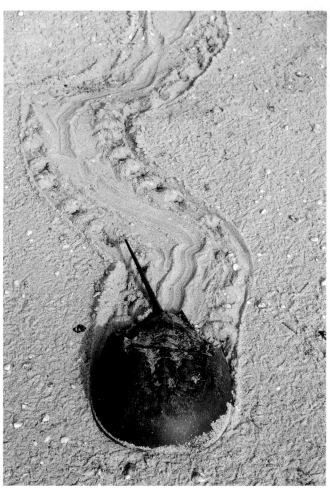

Having laid her eggs in the sand, a female horseshoe crab returns to the sea. The reason this ancient species has thrived for more than 300 million years is partly due to the fact that horseshoe crabs have no enemies apart from humans. Moreover, the females are immensely prolific. Each one lays about 80,000 eggs a season.

The horseshoe crab has nearly as many eyes as legs. Although it was named *Limulus polyphemus* after the Greek cyclops Polyphemus—the one-eyed monster of Greek myth—it actually has nine eyes: one large lateral eye on each side of its head; two tiny eyes on top of its shell, which react to polarized light; and five light-receptive organs beneath its shell.

Each May when the moon is full and the tides are high, an amazing spectacle occurs, one that has changed little in more than 300 million years: the mass breeding of horseshoe crabs. As the tide rises, hundreds of thousands of multilegged crabs emerge on Delaware Bay's long sandy beach. These flat-domed, armored creatures hearken back to an era that seems infinitely remote.

Male crabs lead the march ashore, mass on the beach, and await the arrival of the females. A female horseshoe crab then moves through the stag line and a male promptly clamps his pedipalps onto the edges of her shell. With the male in tow, the female continues to crawl up the beach.

Soon the female stops and digs a 4- to 8-inch (10- to 20-cm) deep hole in the moist sand. Here she lays a cluster of about 3,000 sticky, olive green eggs. As she deposits the eggs into the nest, the male fertilizes them. She will dig several more nests that day and return on subsequent days or nights to lay more eggs. In total she will lay about 80,000 eggs, enough to fill a one-quart (1 L) jar.

Coming ashore is risky for the crabs. Many get flipped over by waves and surf. As the tide recedes, thousands of crabs can be seen lying upside down on the beach. Considering that they have had 300 million years to practice, the crabs seem oddly inept at righting themselves. They desperately dig their serrated, rapierlike tails into the sand and twist. Sometimes this works, but often it fails and many of the crabs die.

My wife, Maud, takes pity on the flipped crabs and returns hundreds of them to the sea. She is not the only one to do this. Many birders come to Delaware Bay to watch massed waders and end up staying to help the crabs. When we were there two young New Yorkers told us that they spend a week each year at the bay to help the crabs. "Together we save about 2,000 crabs a day, or about 14,000 during our holiday," one says, adding, "It's a nice feeling."

Large females and smaller male horseshoe crabs pile on top of each other on Delaware Bay's surf-washed beach. The crabs come ashore when the tides are high and crawl up the beach to lay their eggs in the moist sun-warmed sand. Within about a month, billions of crab eggs hatch, and the larvae are washed into the sea.

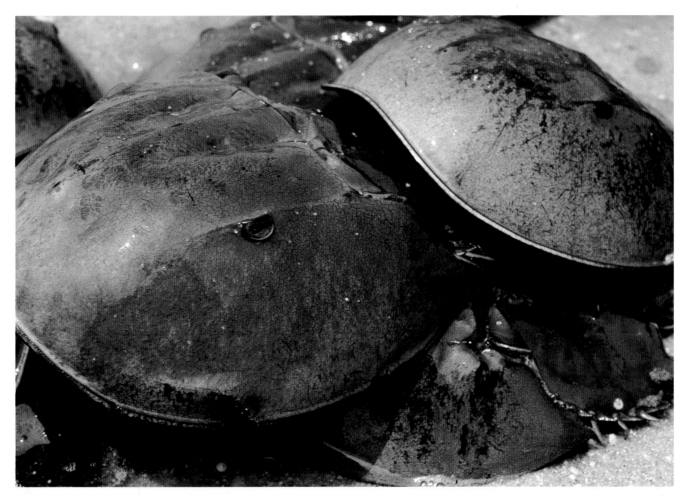

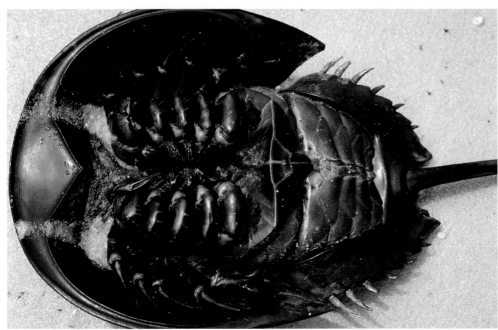

Horseshoe crabs have a multitude of legs and one long rapierlike tail called a telson. When flipped by a wave, a crab tilts the telson sideways, digs it into the sand, and, with a sharp twist, tries to right itself.

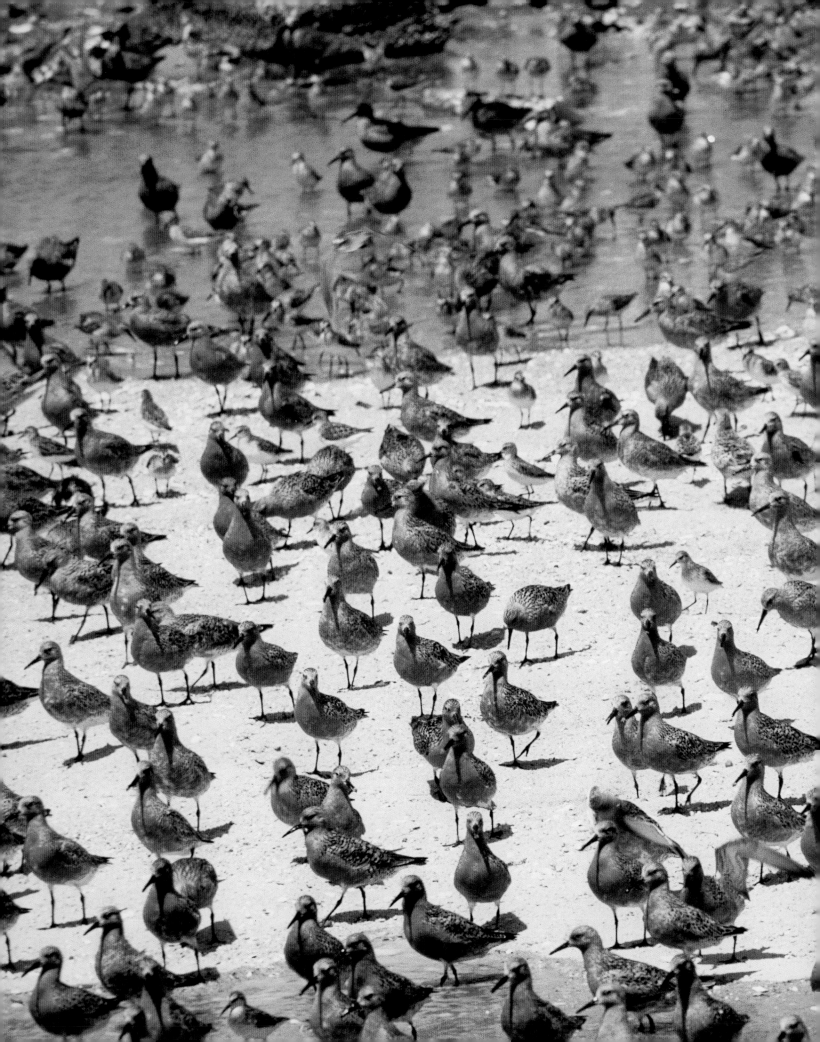

Red Knot,
New Jersey, U.S.A.

The red knots of North America are shorebirds. About the size of a robin but stockier, they are the biggest of a group of birds known as beach sandpipers. In their breeding finery in spring, they look magnificent: the sides of their head, neck, breast, and belly are a rich cinnamon red; their back is speckled with red, white, and black.

Champion fliers, red knots commute between the ends of the earth. They spend the winter along the coasts of Tierra del Fuego and Patagonia, at the tip of South America, and summer at the opposite end of the continent in the Arctic, where they breed.

Because they fly such a vast distance, the red knots of North America have to develop a store of fat in order to fuel their journey. At their winter quarters on Tierra del Fuego, the knots eat mainly spat, bite-sized baby mussels from immense intertidal mussel beds. Normally, mussels anchor themselves so firmly to rocks with byssal threads that birds cannot pry them off. But here the substrate is a soft sedimentary layer that crumbles easily so that the little mussels become easy pickings for the knots. They grind them, shell and all, in their powerful gizzards, using the mussel meat and excreting the shells.

As the austral summer wanes, the red knots become restless. They have molted into breeding plumage and they have converted mussels into stored fat, which will fuel their marathon flight to the Arctic. They're ready to go, and flock after flock takes off, heading north. The Chilean poet Pablo Neruda, once watched them leaving and

Bird banquet at New Jersey's Delaware Bay. In May, millions of horseshoe crabs crawl ashore here to lay their eggs. Red knots, on the way from their wintering grounds at the tip of South America to their arctic breeding ground, stop here to gorge on the mass of eggs. After about two weeks of feasting, they have doubled their weight and gained fuel for the long flight north.

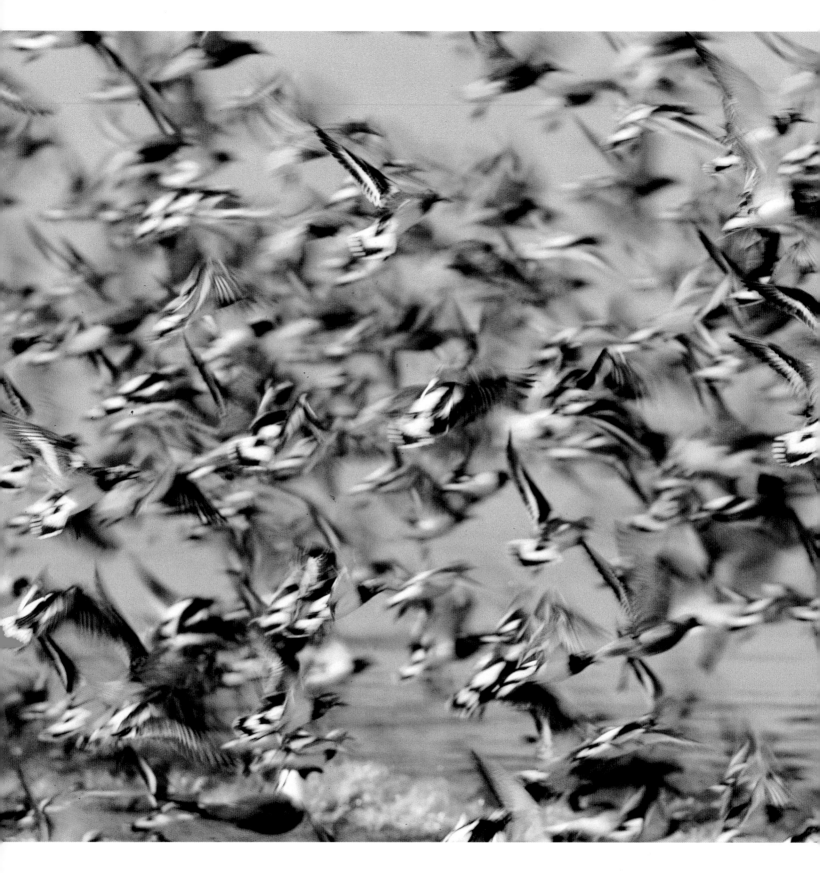

Red knots and some ruddy turnstones rise from a Delaware beach in a whir of wings. Powerful flyers, red knots migrate from the Arctic to the tip of South America. Their annual roundtrip adds up to more than 18,600 miles (30,000 km). At staging areas such as Delaware Bay, they feed voraciously to amass a reserve of fat, which will fuel the next stage of their marathon flight.

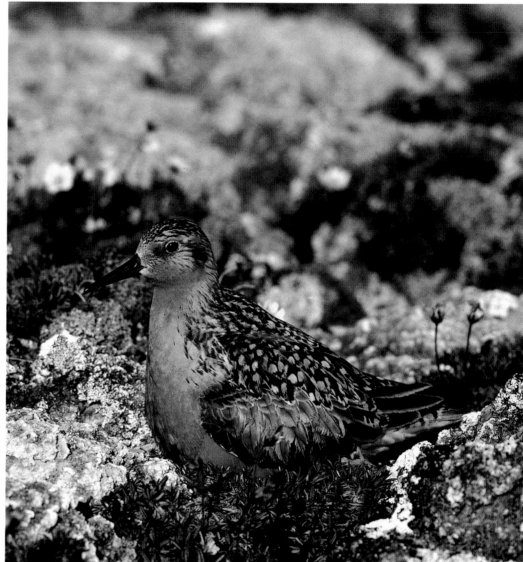

A red knot upon her nest in the Canadian Arctic. In summer, the Arctic contains an abundance of food for the knots. However, the summer is short, lasting only about 10 weeks. This means breeding time is very limited. The courtship period is therefore brief and the birds begin to build their nests soon after arriving. Within 10 days the female has laid four large eggs—a feat made possible by the fat reserves she amassed after feasting on horseshoe crab eggs during a two-week sojourn at New Jersey's Delaware Bay.

A cryptically colored red knot chick on the tundra in Canada's far north. The chicks are precocious. They leave the nest only a few hours after hatching and begin to feed on tiny insects and crustaceans. Quick growth is vital. In just seven weeks, the chicks must molt their baby down and grow wings and strong muscles for the long flight to their winter quarters in Tierra del Fuego.

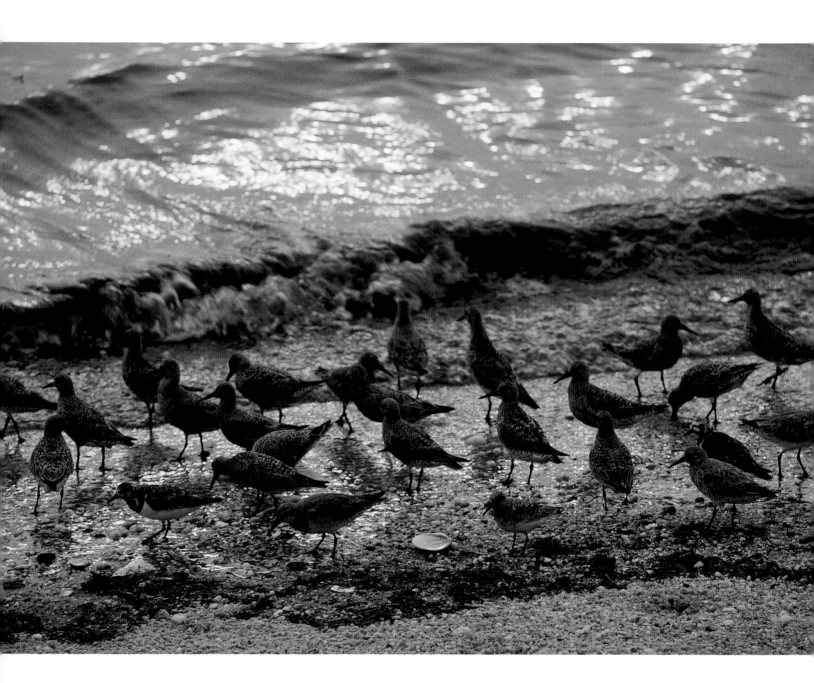

At dawn red knots busily feed on windrows of horseshoe crab eggs at Delaware Bay, New Jersey. Most of North America's 200,000 red knots come to this bay in May to eat the tiny but energy-rich eggs and amass a reserve of fat that will fuel the long flight to their arctic breeding grounds.

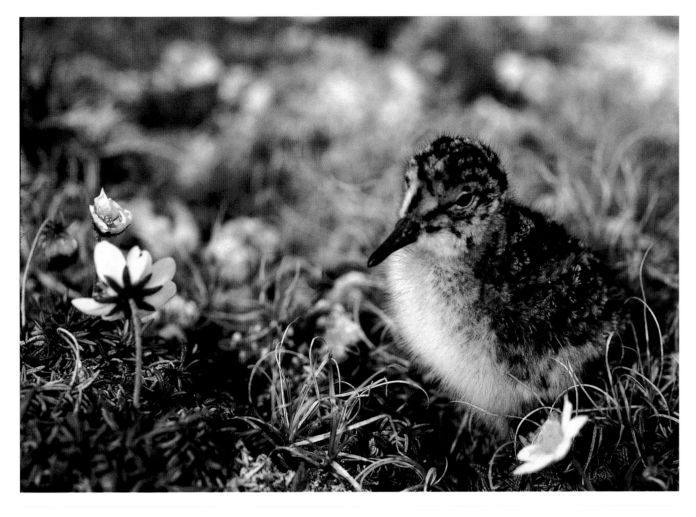

wrote, "Now they pass, filling the distance, a faint flapping of wings against the light, a throbbing winged unity."

With two refuelling stops along the way, the red knots fly 8,700 miles (14,000 km) to New Jersey's Delaware Bay. Here they take part in North America's greatest bird banquet, feasting on billions of horseshoe crab eggs lying on the bay's beaches.

Approximately three million adult horseshoe crabs live in Delaware Bay. They are immensely prolific. The females lay about 80,000 pinhead-sized eggs each.

The famished knots devour these eggs. In only 14 days each knot eats 135,000 of them and doubles its weight. At last, fat and fit, the birds leave in vast flocks, flying 1,240 miles (2,000 km) to their Arctic breeding grounds. They usually fly this distance without stopping, at speeds that vary from 40 to 50 miles (60 to 80 km) per hour.

The red knots' courtship here is joyful but brief, because summer in the Arctic is very short. Chicks that hatch too late will be killed by frost. Knots court, mate, and build their nests quickly. They build the cup-shaped nests into small tundra hummocks and line them with leaves and lichen. The female then lays four rather large eggs, a feat put vividly into perspective by the ornithologist Brian Harrington: "It is no exaggeration to liken her accomplishment to a woman's giving birth to a sixty-pound baby within ten days of completing a six-thousand-mile hike at altitudes higher than the Himalayas!"

Red knot chicks hatch after a 23-day incubation period. They are precocious and develop rapidly. They must grow quickly so that they will be ready to fly once the approaching winter arrives. The female knots leave by mid-July, the males three weeks later. The chicks feed frantically, grow feathers, and accumulate reserves of fat. In late August, they leave the Arctic and follow their parents to the other end of the world.

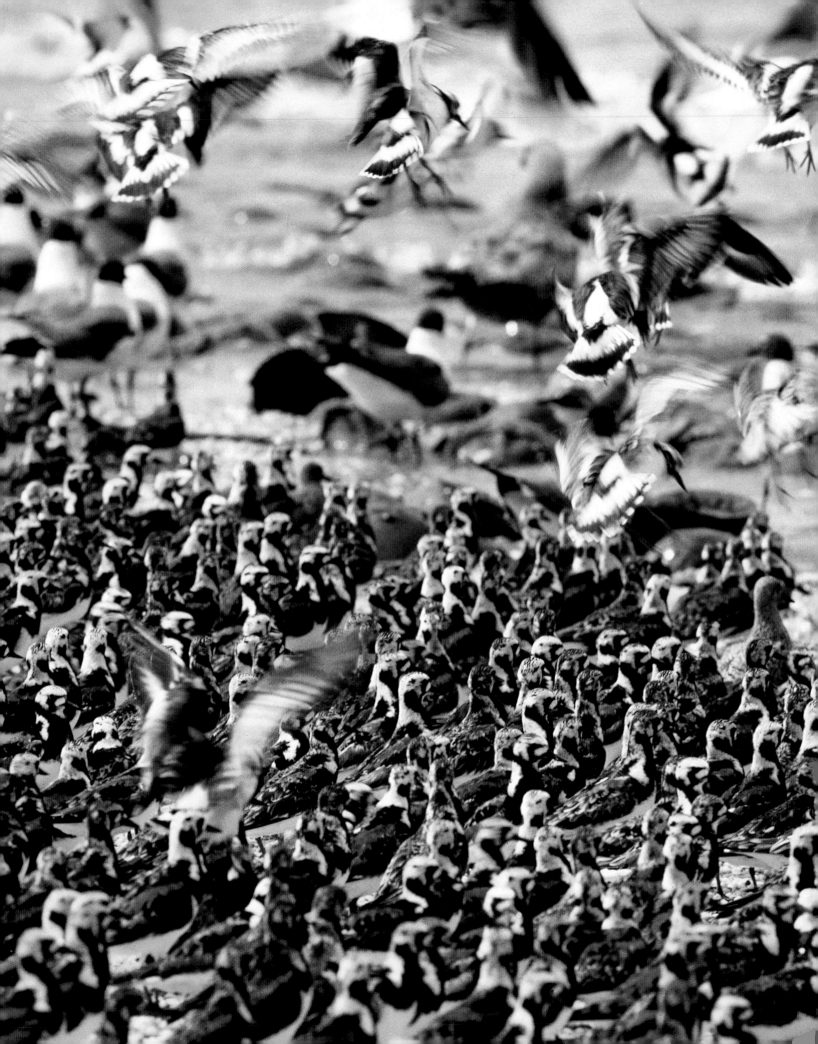

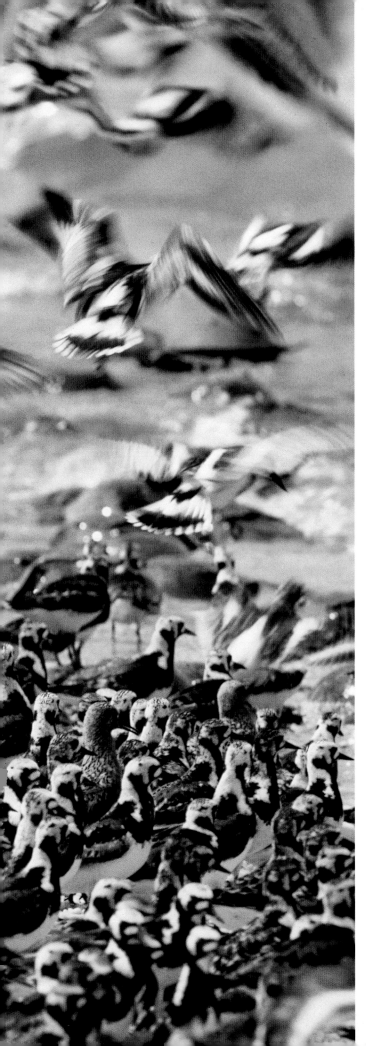

Ruddy Turnstone, Delaware Bay, New Jersey, U.S.A.

Ruddy turnstones breed in the High Arctic as far north as there is land. Their nests have been found near the north tip of Greenland, at 84° N, which is only about 370 miles (600 km) from the North Pole.

It seems like a grim place to raise chicks, especially since much of the High Arctic is a desert, which is as dry or drier than the Sahara. Yet within this austere polar desert there are oases where plants grow in profusion and animals abound. Although these oases are rare and usually small (in the Far North they cover less than 1 percent of the land surface), they are vitally important to many nesting birds, including ruddy turnstones.

One of the most beautiful of these High Arctic oases is the Truelove Lowland on Devon Island, in Canada's Far North. This 17-square-mile (43-sq-km) area is an arctic Eden. I spent a summer there at the research station of the Arctic Institute of North America studying nesting shorebirds.

Most of these birds kept a low profile, relying on their cryptic, dun-colored plumage to escape detection. However, this was not the case with the ruddy turnstones. In their russet, white, and black breeding plumage, with their dark beaks and carrot-orange stocky legs, they look like flashy harlequins. They attack all enemies, screaming zealously as they do so.

One pair of ruddy turnstones had made its nest between cushion plants on a sandy ridge not far from our camp. The female usually sat on the eggs. There were four of these and they were olive green with black streaks on them. The male kept guard upon a knoll some distance away. Both birds were extremely alert.

A flock of ruddy turnstones arrives at the beach on Delaware Bay, New Jersey, to feed on horseshoe crab eggs. The birds have wintered on the coasts of the Guianas and Brazil, where food is plentiful, but when they arrive at Delaware Bay after flying for more than 1,800 miles (3,000 km), they are famished.

A flock of ruddy turnstones covers the beach at Delaware Bay, along with herring gulls and laughing gulls. More than a million shorebirds make a vital stopover here to feed on the abundant horseshoe crab eggs. Most shorebirds double their weight within about two weeks and are then ready for the long flight to their arctic breeding grounds.

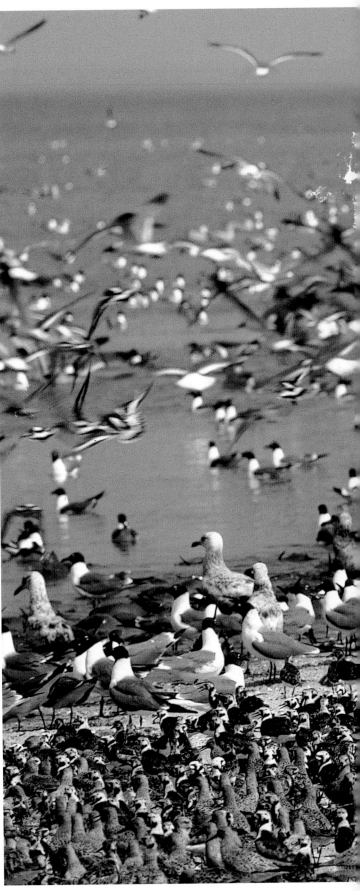

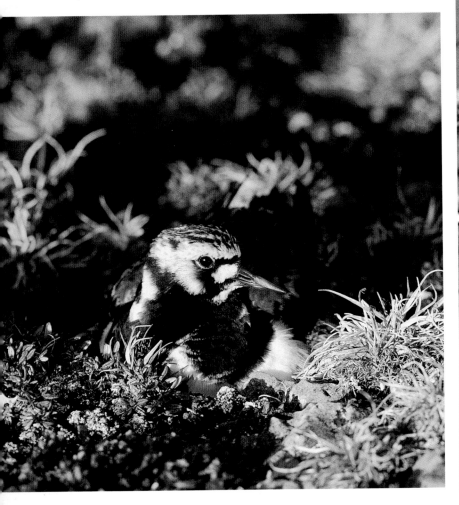

A ruddy turnstone on its nest in Canada's High Arctic. Despite their bright breeding plumage, turnstones blend in remarkably well with the tundra vegetation. They are also feisty birds that scream as they attack predators, such as arctic foxes and jaegers. As a result their chicks rarely die and their eggs remain intact.

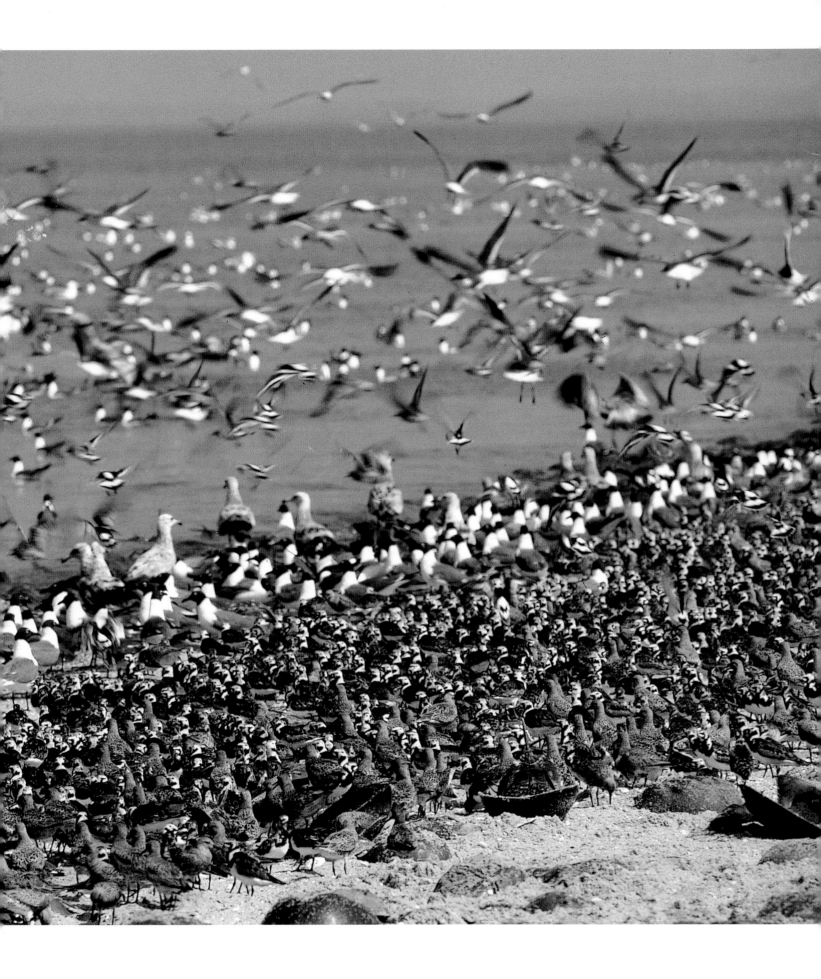

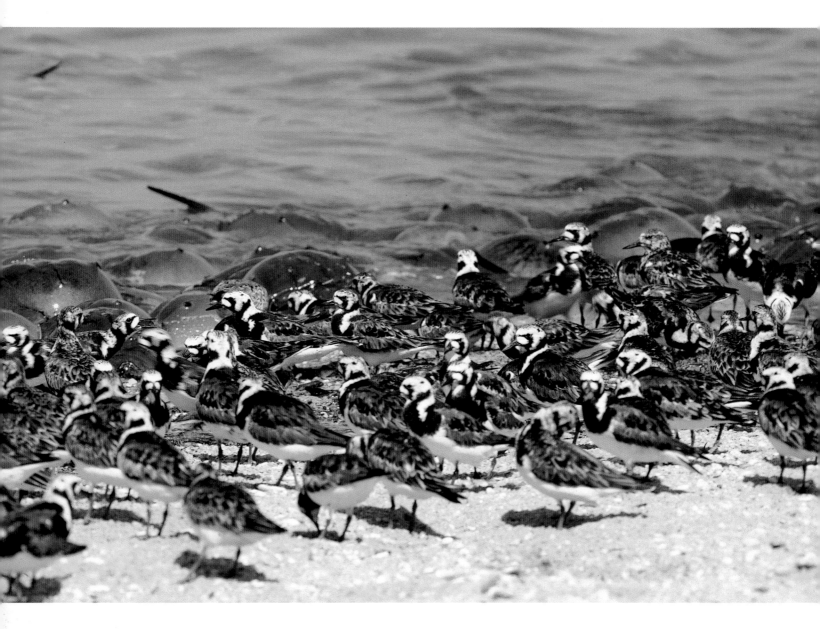

An arctic fox came moseying along, following whiffs of scent. He ran this way and that, then pounced on an oldsquaw duck. Fortunately, the bird had clattered off the nest just in time. However, the fox devoured its eggs. Next he slowly approached the turnstone ridge.

Long before the fox reached the nest, he was attacked by the two turnstones. These flying, screaming furies dove down upon the predator. Soon two of their neighbors came along. Now four turnstones screeched and swooped at the fox. The fox knew there were eggs nearby, but harried by these harpies, he rushed off to look for easier prey. The turnstones then resumed their brooding. Thanks to such concerted attacks on predators, few of these spunky little birds' eggs or young are destroyed.

The ruddy turnstones who breed in Canada's High Arctic fly via Greenland and Iceland to their wintering grounds. These extend from the British Isles all the way south to western Africa. The other turnstones from arctic Canada fly south to the warm beaches of the Guianas and Brazil, where food grows in abundance.

As their name implies, turnstones use a neat technique to get food. They use their sharp bills to turn over stones or pebbles on the beach, and before the exposed creatures beneath the stones know what has happened, they have become food. This is a quick and efficient way of getting food, and the turnstone's diet is varied: it consists of tiny crustaceans, worms, amphipods, snails, and other mollusks. The birds pry into clefts between rocks and skillfully extract these tiny creatures. Turnstones are fast and are not fussy eaters: they will even eat carrion if they come across it.

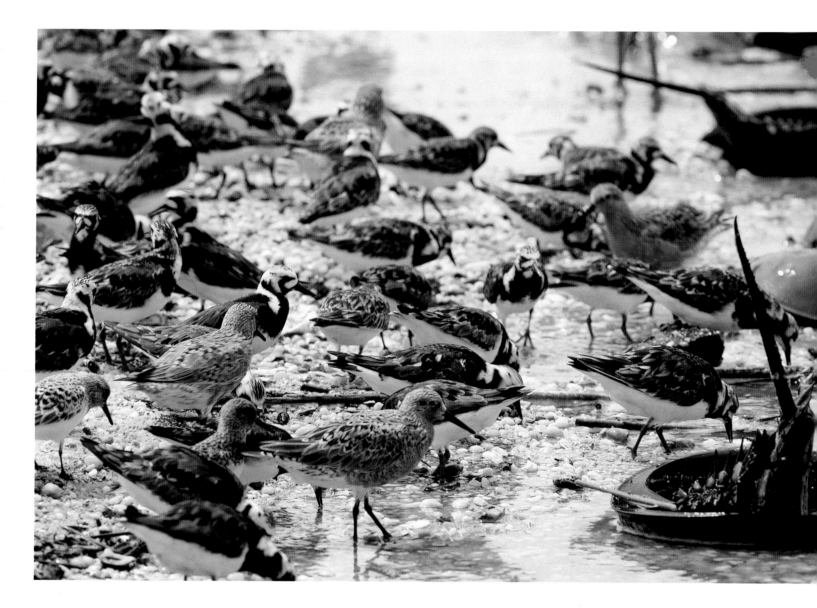

The greatest feast of the turnstones' year comes in May when they stop off, en route to their summer breeding grounds, to eat horseshoe crab eggs at New Jersey's Delaware Bay. In May, when the moon is full and the tides are high, more than a million horseshoe crabs crawl ashore here, and each female lays about 80,000 eggs in the sand. Billions of these eggs are eaten by the turnstones and a million other shorebirds.

But the most conspicuous shorebirds are the gaily colored turnstones, already in breeding finery. Like all the other birds, they gorge on the newly

Ruddy turnstones and a few red knots devour horseshoe crab eggs on the beach at Delaware Bay. Billions of pinhead-sized eggs often lie in thick windrows on the beach. Each turnstone eats about 135,000 of them in two weeks and accumulates vital fat reserves, which will fuel its flight to the High Arctic, where the turnstones breed.

laid horseshoe crab eggs in order to fuel the long flight to their northern breeding grounds. At times, the flocks of birds carpet the beach, creating "the greatest shorebird spectacle in North America," as one scientist has put it.

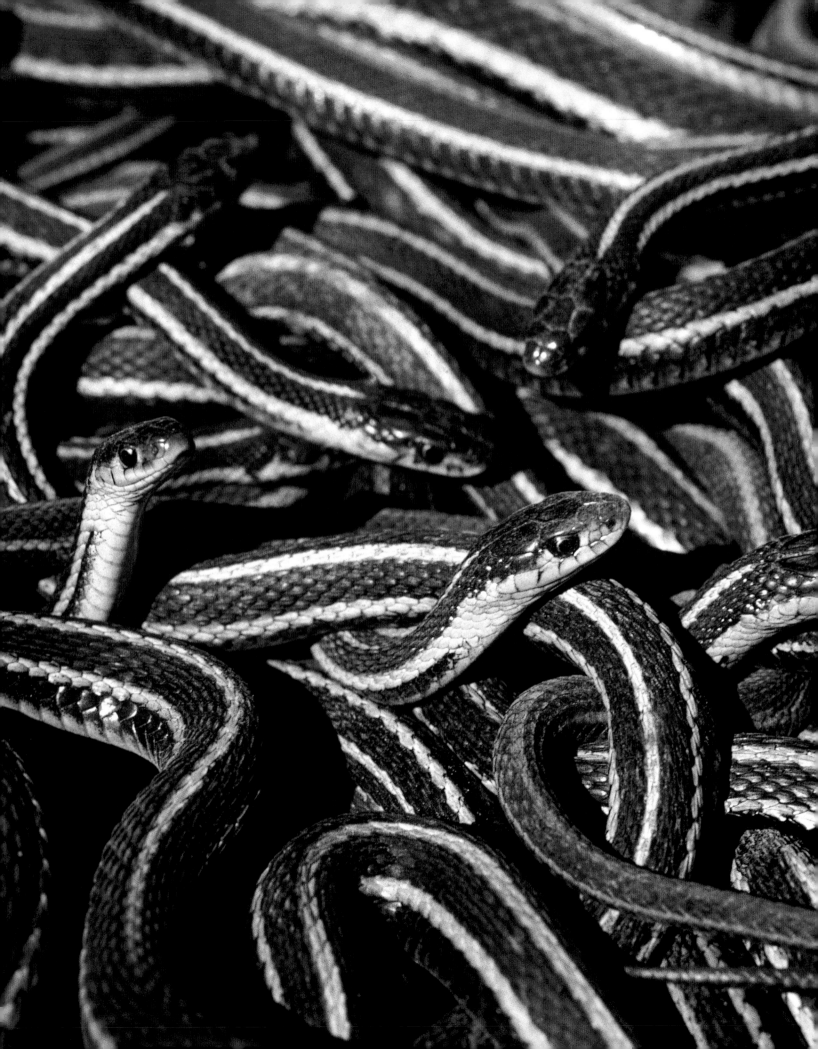

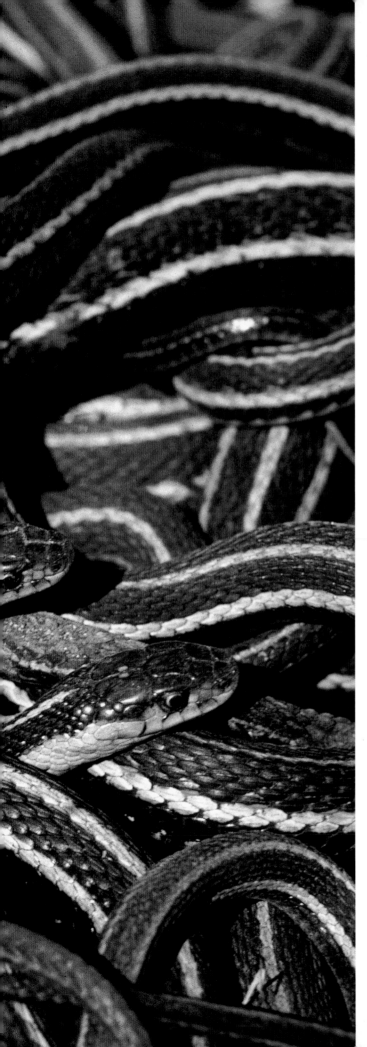

Red-Sided Garter Snake, Manitoba, Canada

The bottom of the shallow limestone pit beneath me is covered with a moving carpet of sliding serpents. This is the largest concentration of snakes in the world. However, it is not in the tropics, as one might expect, but in the Interlake region of Manitoba, north of Winnipeg.

The snakes are red-sided garter snakes. It is spring, and they are now emerging in tens of thousands from underground, where they spent the long cold winter in limestone caverns below the frostline.

For seven to eight months, the massed snakes lay deep in the earth. There they remained torpid, living off their accumulated fat reserves, their body motors barely idling. During winter, even their blood congeals and becomes "as thick as mayonnaise," according to a researcher.

The first snakes to emerge in the limestone pit are the males. They wait for the females. (The males are pencil thin, whereas the females are much longer and thicker.) The moment a female appears she is mobbed by these suitors. Sometimes more than a hundred males twist and twine around a female and plait into a mating ball. Each male tries to slide into a mating position, a difficult task when attempted by a hundred males at the same time. This mass onslaught of males does ensure that no female leaves the area unmated.

Shy and elusive in summer, the garter snakes now appear fearless. The slender males, who have climbed out of the pit, dart through the winter-withered grass and slide over my legs, oblivious of my presence. Some slide along like miniature cobras, their upper bodies raised in a female-seeking position, which researchers have dubbed "up periscope."

Red-sided garter snakes emerge from hibernation and cover the bottom of a limestone pit in Manitoba. This is the largest concentration of snakes in the world. At first, most of the snakes are males, who eagerly await the arrival of the much larger females.

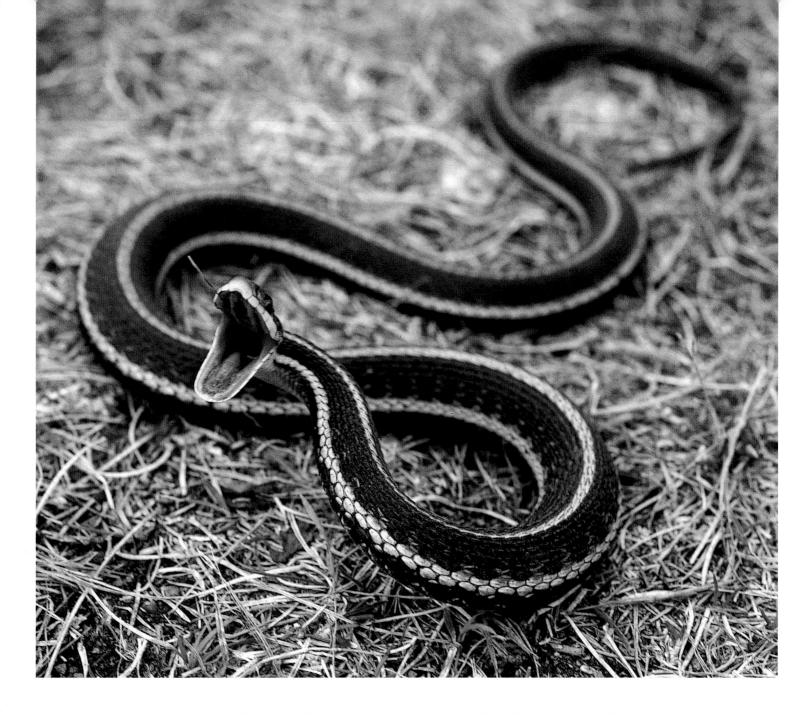

Visitors come and stare at the harmless snakes. Some are thrilled by them, others frightened. One long-haired nature-loving couple resolves the question of whether a fear of snakes is innate or learned. They have a four-month-old baby, who they lay gently on the ground among the rushing snakes. Dozens of snakes glide over the naked child, tickling her. In response the baby squirms and gurgles, but she does not show any sign of fear.

The female garter snakes emerge from the underground cavern, or hibernacula, over a period of two to four weeks. Each female exudes a pheromone, known as methyl ketones, which is designed to excite the males. As a male's black-tipped scarlet tongue flicks in and out, tasting the air, the alluring scent molecules are carried to the extremely sensitive vomeronasal organs in the roof of its mouth. Reacting to these scent messages, the males rush toward unmated females. On cool days, many of the females head for nearby bushes to soak up the sun's warmth. The males follow them there, and soon the shrubs become festooned with courting snakes.

Once a female mates, there is a subtle change in her body chemistry. She no longer exudes the come-hither pheromones and loses her sex appeal. Unhindered by males, the female leaves for distant meadows and marshes, where she will spend the summer feeding.

In late August, when a female is in peak

Trying to look ferocious, a red-sided garter snake goes on the "attack" with its mouth wide open. But this gesture is only for show. Garter snakes are harmless to humans. Even when handled, they hardly ever bite.

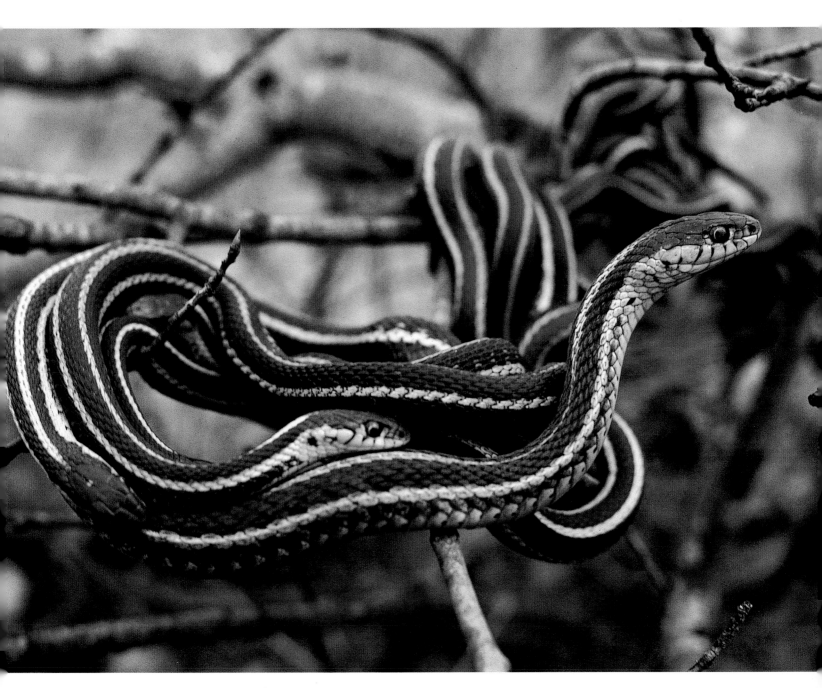

On cool spring days, female garter snakes often creep up bushes to bask in the warming sun. Hot on the trail of a female's alluring scent, dozens of males follow her, all trying to mate with her.

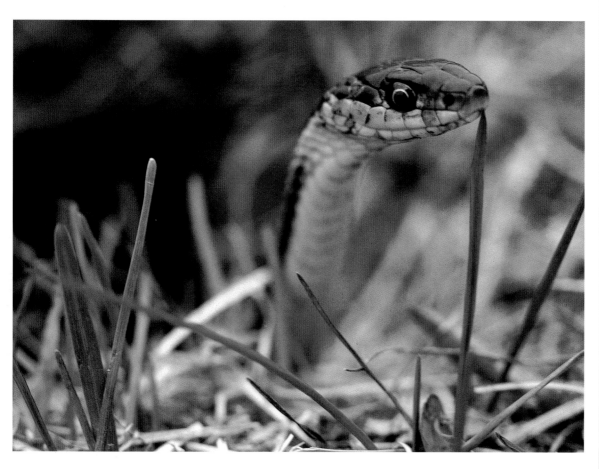

condition, she gives birth to glistening, finger-long snakelets. There are usually 10 to 40 of these per brood. The young snakes are left on their own almost immediately after they are born. They soon begin to hunt for insect larvae and pupae, worms, tiny newts, and small beetles, which they eat. They spend the first winter off on their own, often deep in ant colonies where it is warm. But in the autumn of their second year, they join the adult snakes in the communal hibernacula.

All the adult garter snakes from a radius of about 12 miles (20 km) head for these ancestral caverns. They bask in the last warmth of fall for a while. Then they all vanish underground, where they remain for the winter.

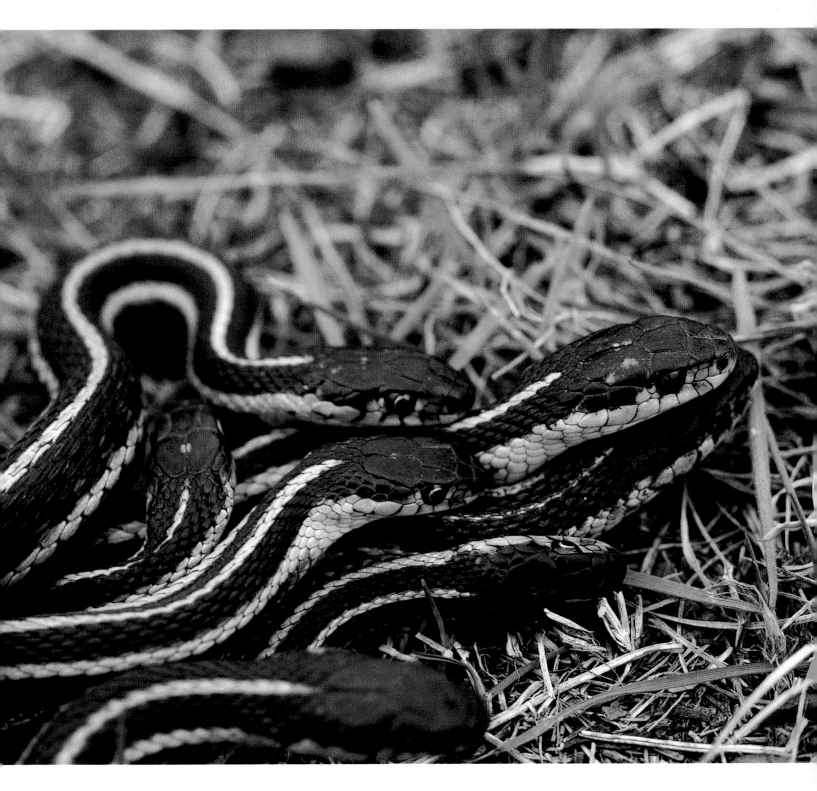

Eager males cling to a female, all hoping to mate with her.
This task is complicated by the fact that each male has about
100 rivals. Males of other snake species fight fiercely.
However, male garter snakes never fight. They ignore one
another, as each one in the mass of courting males, called a
"mating ball," tries to achieve coition.

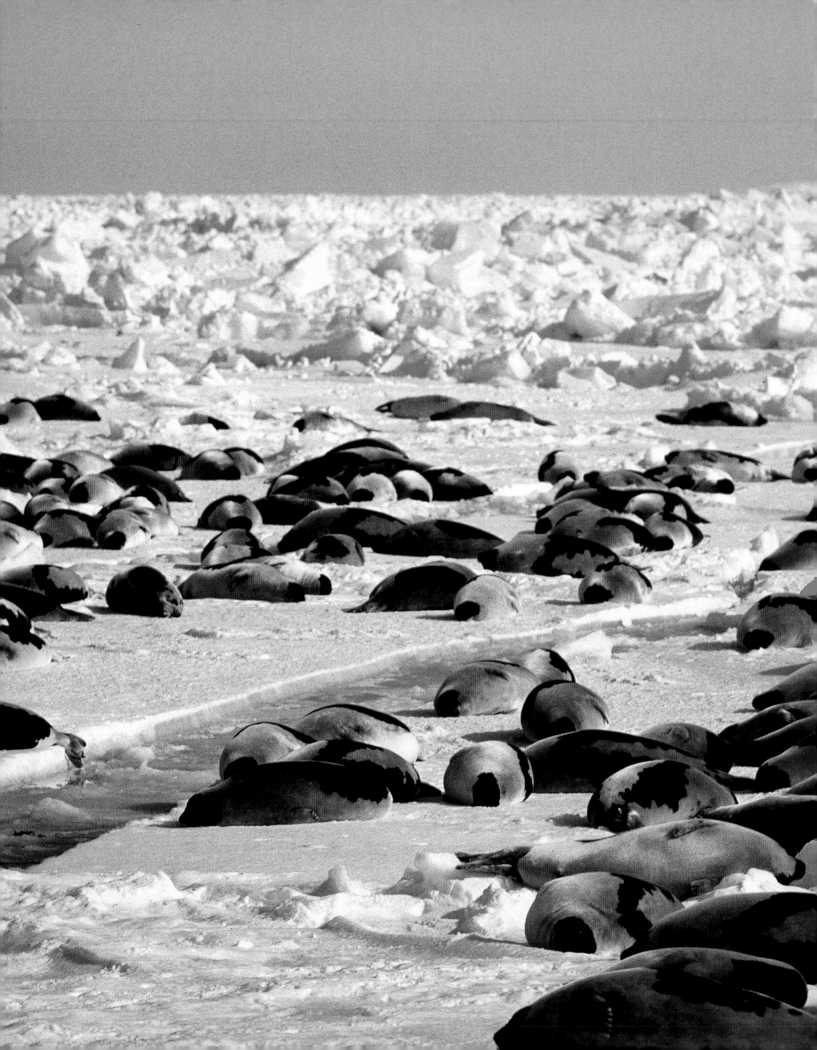

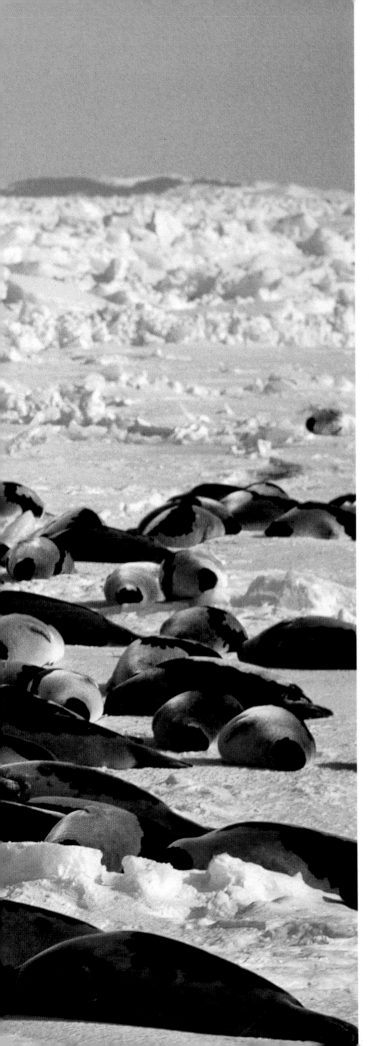

Harp Seal,
Gulf of St. Lawrence Ice,
Canada

If you fly above the vast ice fields of Canada's Gulf of St. Lawrence in March, you suddenly see dark spindle shapes on the ice far beneath you. These are harp seals and this is the immense nursery where the pups are born and raised.

I have flown to this spot by helicopter every spring for 27 years, and every time I see the seals again, it is a marvelous thrill. The glistening ice is speckled with female seals and their pups as far as you can see. Harp seals are intensely gregarious. But each female has a private sphere that no other female may transgress.

So when you glimpse harp seals widely scattered upon the ice, you know they are all females. But occasionally you come upon massed harp seals lying close together near a pool of open water. These are all males. For the moment, they are males-in-waiting, congregated in chummy bachelor groups. They sleep a lot and dream of mating with a female.

The females haul out upon the whelping ice in early March. They are swathed in fat. The blubber is up to two and a half inches (6 cm) thick and constitutes more than a third of the seal's total weight of 200 to 300 pounds (90 to 136 kg). The blubber serves as insulation and as metabolic fuel, which is converted into fat-rich milk for the pup.

The birth process must be an extraordinarily traumatic experience for the harp seal pup. It usually happens quickly and abruptly. The female shifts and moans. Then she suddenly lifts her abdomen, her hind flippers flare, and with one tremendous muscular contraction she expels the pup from her body.

The pup lies on the ice, quite still, wrapped

Massed harp seals on the spring ice of Canada's Gulf of St. Lawrence. The seals are all males. The females and their pups lie on the gulf's vast sheets of ice, each pair separated by a wide distance. The males gather in chummy groups and bide their time. As soon as the females come into heat, the males will range far in pursuit of them and fight off rivals.

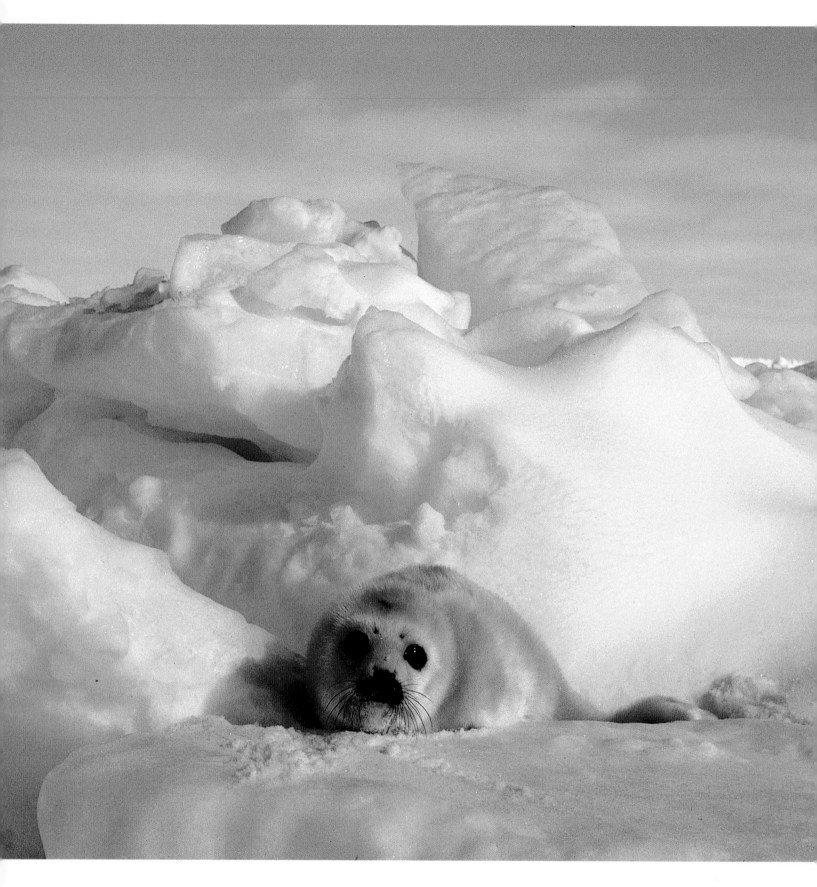

All curious innocence, a harp seal pup lies upon the ice of Canada's Gulf of St. Lawrence. After 12 days, the pups begin to shed the soft woolly white fur they are born with and molt into the dark short-haired fur of adults. They are weaned when they are about two weeks old.

A young female harp seal. A distinctive black harp-shaped saddle mark develops on the backs of older seals, giving them their name. Females keep breathing holes open in the ice and just before giving birth, haul out onto the ice.

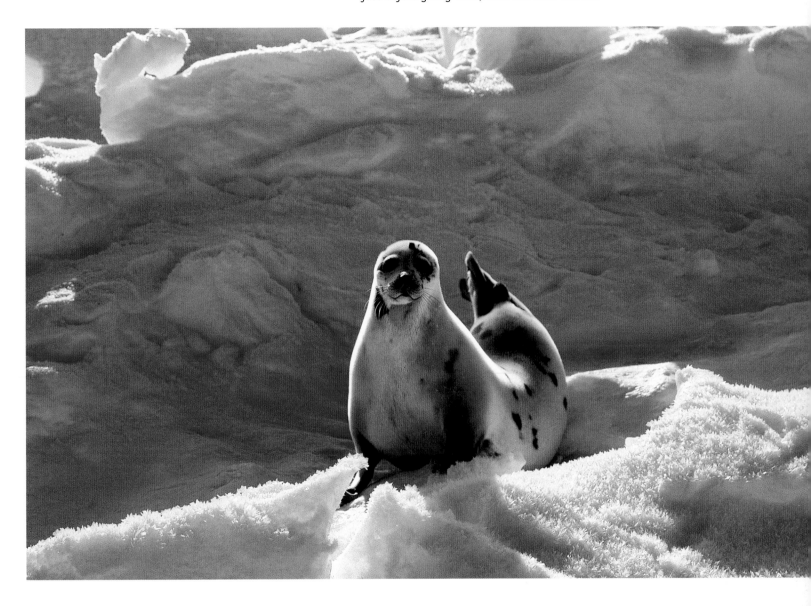

in its moist, glistening caul—a small, steaming parcel of life, delivered abruptly from its mother's dark, cozy womb into the icy blinding glare of a new world.

Cold penetrates the pup's moist fur. It shivers violently and mews feebly. The mother sniffs her pup and listens to its cries. From that moment on, she will be able to distinguish it from all the hundreds of thousands of pups born upon the shifting ice fields.

After desperately searching for its mother's nipple, the little pup finally finds it. The pup sucks and it emerges from the skinfold beneath the fur in which it normally lies hidden. The newborn pup suckles urgently, its eyes closed in blissful concentration. The female harp seal's milk is creamy, yellowish and viscous and contains 42.6 percent fat and 10.4 percent protein. (Cow's milk contains 3.4 percent fat and 3.3. percent protein.) The pups nurse frequently and soon grow fat on this rich diet.

They weigh an average of 18 pounds (8 kg) at birth. But after two weeks their weight triples and occasionally nearly quadruples. At this point most

A newborn harp seal pup plays with its flipper. About four hours old, its silky fur is still stained a yellowish color by the amniotic fluid. Pups nurse frequently. Their mothers' milk contains 42.6 percent fat and 10.4 percent protein. As a result most pups triple their birth weight within two weeks.

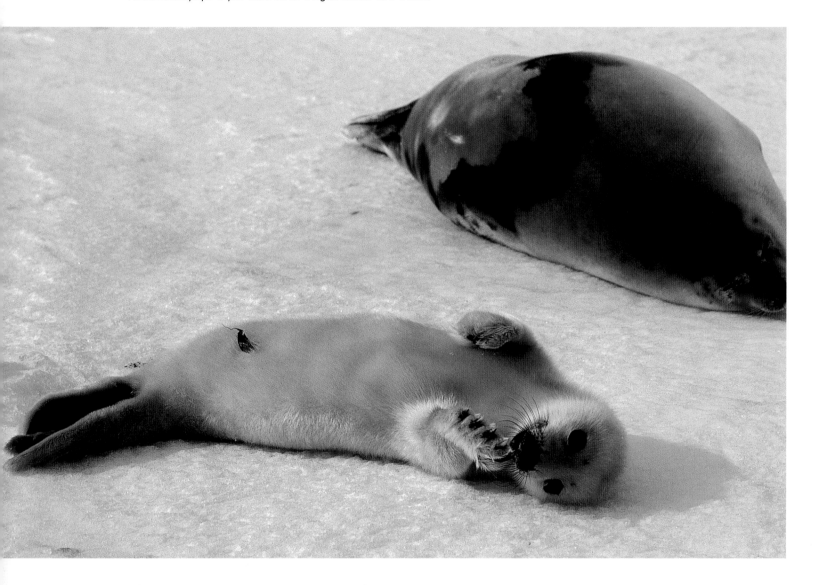

of the pups are weaned. Bulging with fat, they look like furry little blimps with flippers.

Soon after fulfilling their maternal duties, the females go into heat, or estrus, and the massed males shake off their lethargy and easy-going camaraderie. They chase and woo the females and scratch and bite their rivals. Within a week, most females have mated. They then swim north to molt on ice in the northern Gulf of St. Lawrence.

In the meantime, the plump and placid pups, sleep and live off their fat reserves—their mothers' legacy. But their idyll is short-lived. Spring storms

soon break up the great sheets of ice; winds and currents disperse the floes. Reluctantly, the pups slide from their ice floes into the sea and paddle. At first they do so timidly, holding their heads high out of the water. Then suddenly they discover the joy of swimming. They dive, chase small crustaceans underwater, and then surface with a snort. Soon they turn gracefully and dive under again. The pups have found the sea, their true element. They will soon follow the adults on the long migration to the Far North's food-rich seas.

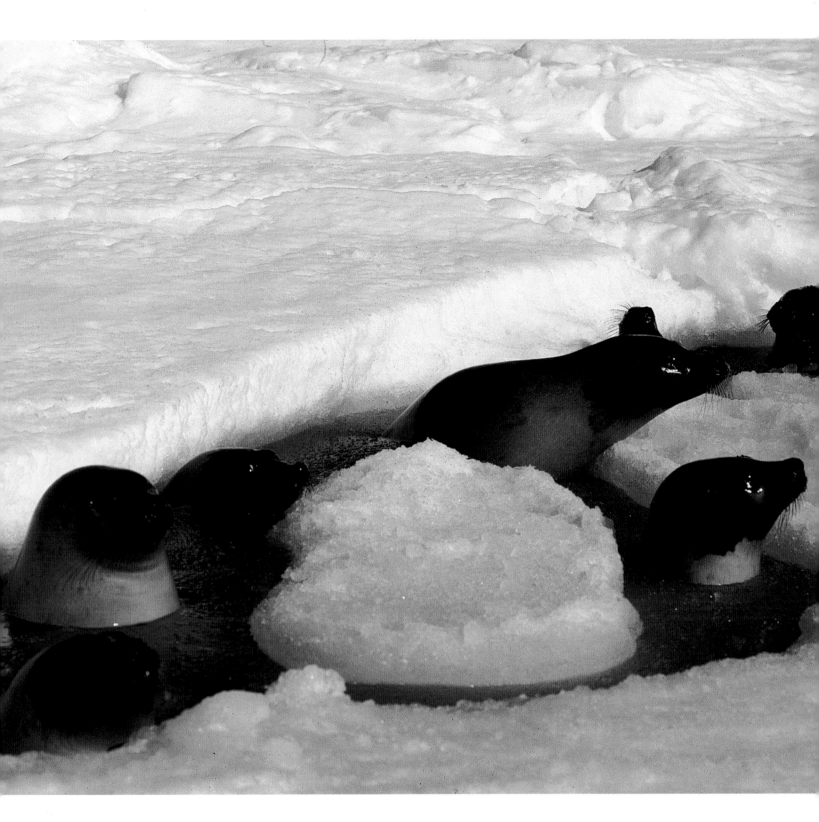

Male harp seals surface in the open water between ice floes.
Harp seals spend summers in the seas of the Far North. In the
fall, they swim south. Those from the Canadian North divide
into two herds: the Front herd, which breeds on the ice off
the coast of Newfoundland, and the Gulf herd, which breeds
on the spring ice of the Gulf of St. Lawrence.

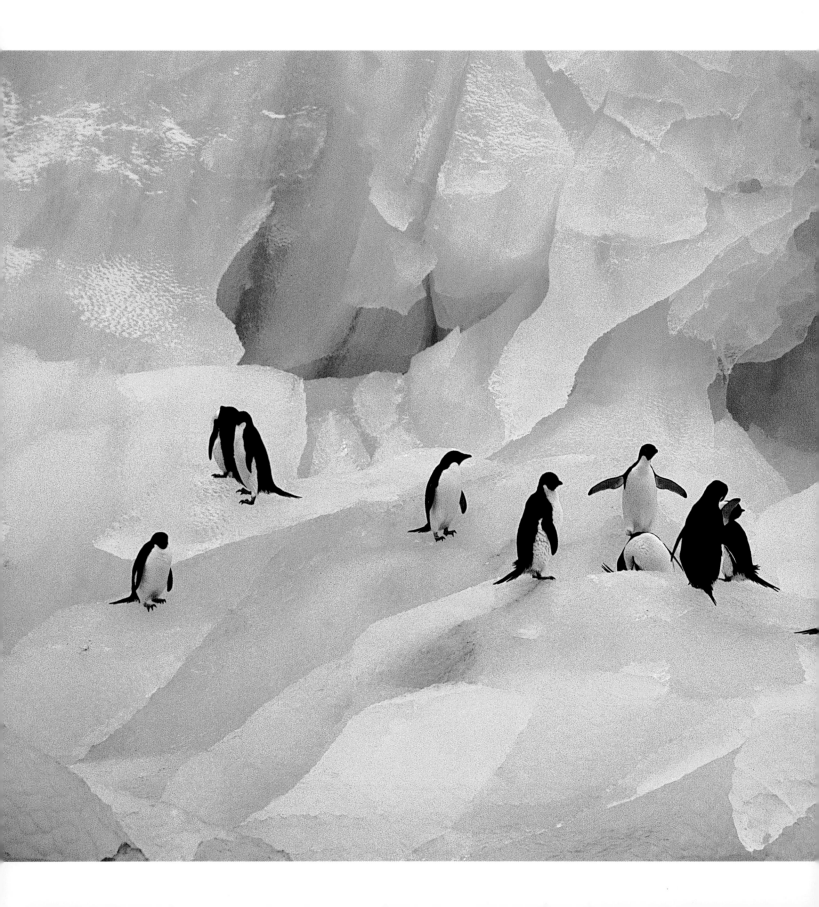

Adélie Penguin, Antarctica

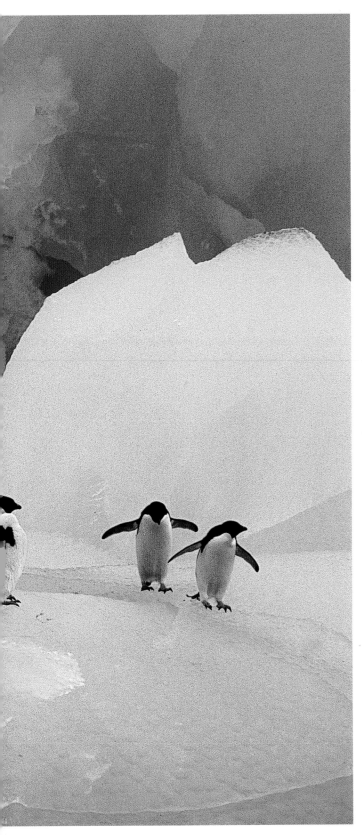

The Adélie is the archetype of all penguins, the serious little man in tuxedo loved by children and cartoonists. This penguin is small (about 27 inches [70 cm] high) and portly, with a black back, black head, and a gleaming white shirtfront. Its most distinctive feature is a vivid white ring around each eye.

However, the popular image of a cute, slightly aloof penguin is misleading. Adélies are tough little birds that live in a very tough region: Antarctica. There they are exposed to bitter cold, terrible storms, and deadly leopard seals. They breed farther south than any other penguins. One of their colonies on the Antarctic continent is only 800 miles (1,300 km) from the South Pole.

Despite the daunting weather of its home region, the Adélie is immensely prolific. It is the most numerous of the world's 17 penguin species. It's total population on the Antarctic continent and nearby islands may exceed 14 million.

The namesake of this species was Adélie Dumont d'Urville, the wife of the French explorer and naval officer Jules Sébastian César Dumont d'Urville. In 1837 he reached Antarctica, ran up the tricolor flag of France, and named the place Adélie Land and its residents Adélie penguins in honor of his wife.

Adélies are very busy birds. They spend months at sea, eating masses of food, most of which consists of krill. The latter are finger-long shrimplike crustaceans. As a result of all this eating, the penguins are swathed in fat and weigh up to 10 pounds (4.5 kg) when they return to their breeding sites in late October.

Off-duty Adélie penguins on a gleaming iceberg near the Antarctic Peninsula. When they are not feeding, Adélies like to rest on ice floes and icebergs. Here they remain safe from the enemy they most dread, the leopard seal. The birds' sturdy feet have rough soles and sharp claws, which makes it easy for them to climb slippery icebergs.

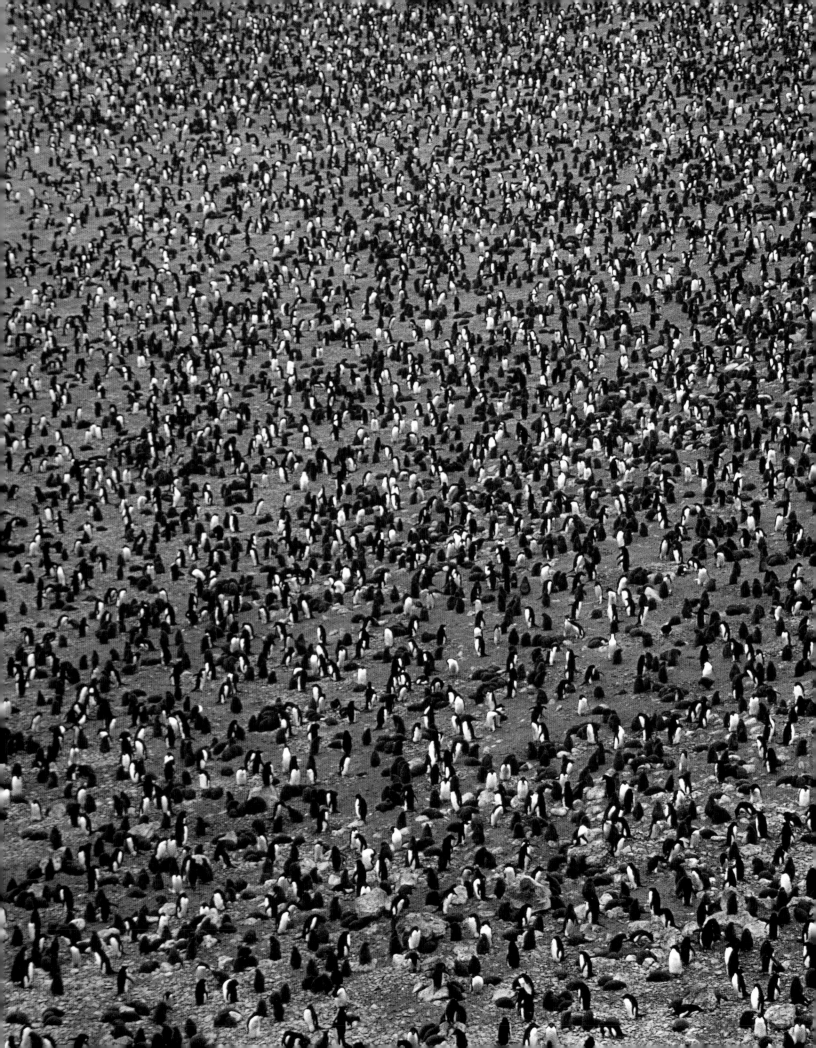

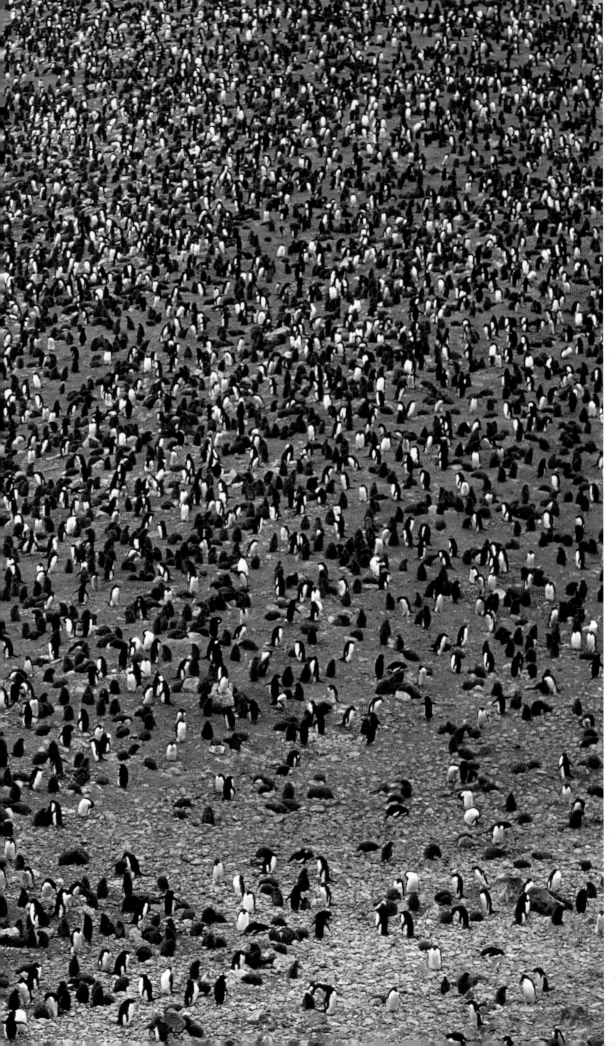

An immense colony of breeding Adélie penguins on Paulet Island. This small barren island lies off the tip of the Antarctic Peninsula. Of the world's 17 penguin species, the Adélie is the most numerous and has the farthest south breeding range.

An Adélie penguin with rare Isabelline coloring greets its conventionally colored mate and chick near America's Palmer Station on Anvers Island. This island lies off the west coast of the Antarctic Peninsula. Penguins with this rare coloring are not albinos and do not have the albino's red eyes. Since they have exactly the same behavior pattern as normally colored Adélies, they have no trouble finding mates.

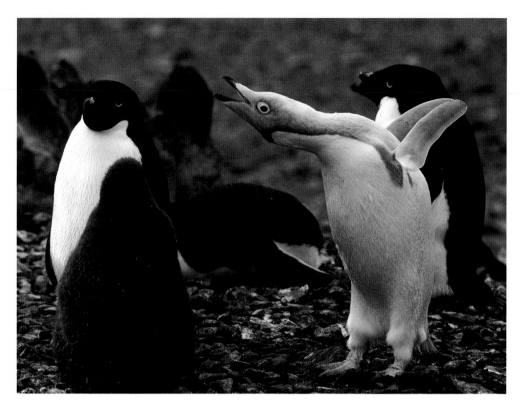

The first arrivals, which are mostly males, head straight for the sites where they bred the previous year. These sites consist of disorderly mounds of pebbles. To the penguins these pebbles are extremely precious. In human terms, they are a symbol of hearth and home, of domesticity and procreation. They also show other penguins that a male can hold and defend a nest. A successful male, with a pile of pebbles to prove it, is attractive to a female. The pebble nest mound, hemmed by a low rim of pebbles, also ensures that runnels of icy meltwater will not touch the eggs. They collect them avidly and try to steal them from neighbors. An Adélie penguin rookery is constantly noisy, and much of the fuss and furore involves fights with pebble thieves.

Most females arrive after the males and also head for their previous breeding spots. There they meet their mate of yesteryear and a joyful reunion takes place. He bows deeply and presents her with a pebble. She then reciprocates. They are like a king and queen who give each other diamonds as a symbol of their love.

This charming, ritualized courtship of the Adélies may change abruptly if last year's female fails to return. When this happens, the male has to advertise his availability with loud calls. If one female answers, all is well. They meet, court, and mate. But if many females respond to the single male's call, the courtliness vanishes. Rival females fight furiously, for a single male with property and pebbles has immense allure.

Once all have wed and bred, the colonies become calmer. Each female lays two bright greenish white eggs and then turns them over to her mate. While she goes to sea to feed, he incubates the eggs. Once she has replenished her fat reserves, which takes about two weeks, the female returns. Her mate rises stiffly and she takes over. Before he leaves, he usually brings more stones for the nest.

Once the chicks hatch, one parent guards them while the other goes out to sea to get food. When the chicks are big, they gather in tight crèches and both parents haul in food. At the height of the feeding season, the ever-hungry chicks require a lot of food. Scientists have estimated that the five million Adélies on the South Orkney Islands require 9,000 tons of krill and larval fish per day to feed their young. By March, the great annual cycle of Adélie renewal is ending. The brief austral summer is nearly over. The adults and the chicks, who are now fully fledged, depart from the great colonies, leaving behind the myriad piles of precious pebbles that they have gathered and fought over so intensely.

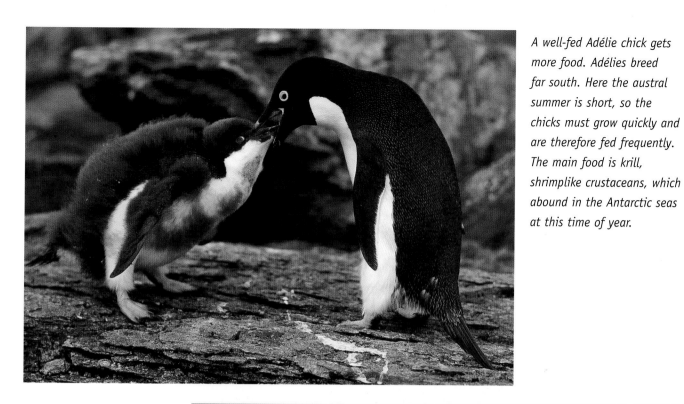

A well-fed Adélie chick gets more food. Adélies breed far south. Here the austral summer is short, so the chicks must grow quickly and are therefore fed frequently. The main food is krill, shrimplike crustaceans, which abound in the Antarctic seas at this time of year.

An Adélie chick must run for its supper. When a parent returns with food, both chicks beg frantically for it but at first get nothing. Instead, the adult runs so that both famished chicks must pursue it. The faster of the two chicks gets the first meal. As it gets fuller, it becomes slower, and the second chick obtains food. By running, the chicks gain strength.

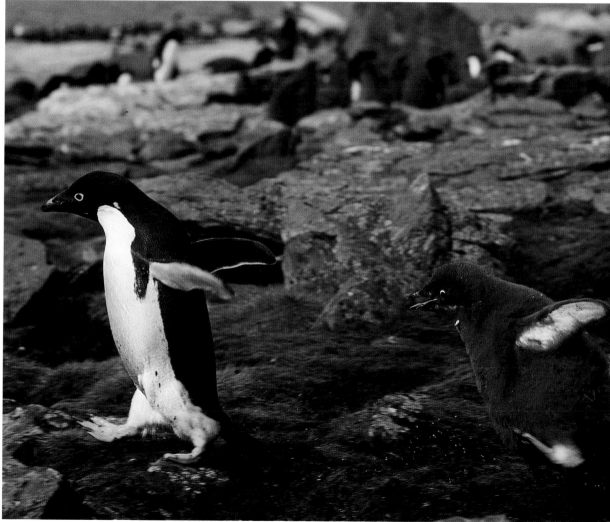

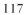

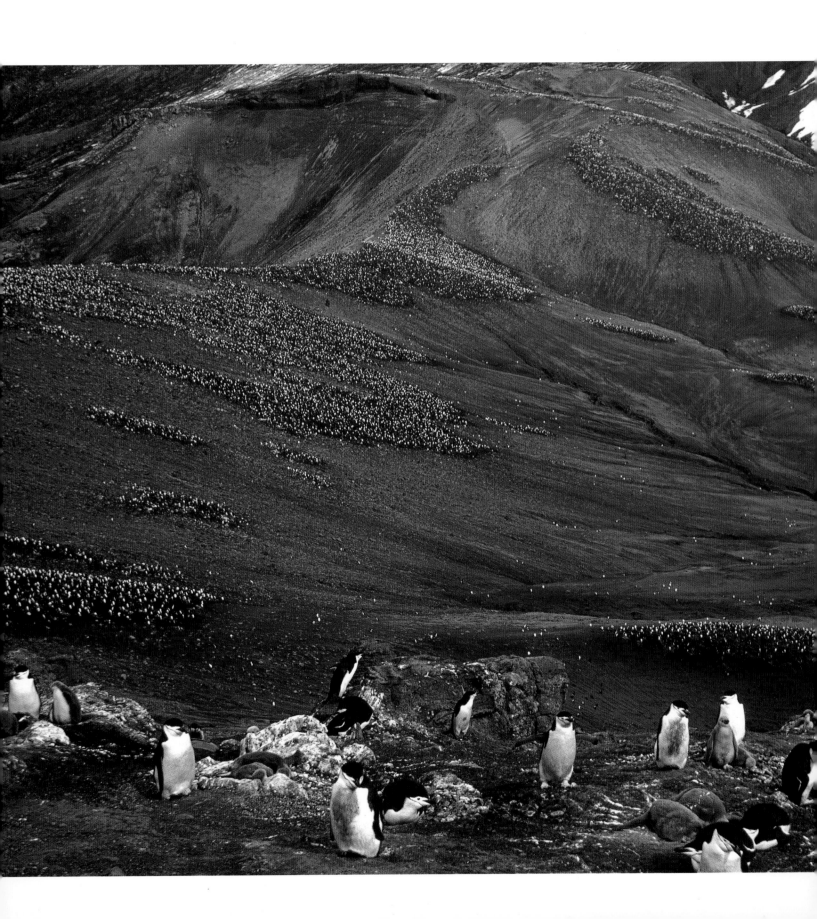

Chinstrap Penguin, Antarctica

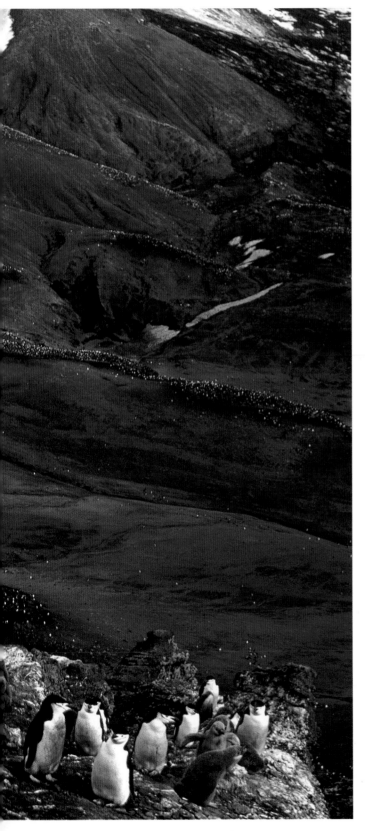

***Euphausia superba* is well named:** it is the marvelous shrimplike creature that forms the basis of much of Antarctica's wildlife wealth. Its common name is krill, an old Norwegian word meaning "small fry." It is a reddish finger-long, semitransparent creature, which can be found in swarms that cover the ocean for miles, turning it a deep blood red.

The total amount of krill in the Antarctic is huge. Some scientists estimate there are six billion tons of it—a quantity that would fill 60 million 100-ton mining trucks. Moreover, krill feeds thousands of whales, including blue whales—the largest animals in the world. In addition, it feeds millions of seals and tens of millions of seabirds in the Antarctic regions. Krill is also the principal food of several penguin species, including the Adélie and the chinstrap.

The Adélie and chinstrap penguins have a lot in common: they are both about 27 inches (70 cm) tall and weigh about 10 pounds (4.5 kg); both of them feed on krill, nest in immense colonies, and vie for the number one spot on penguin population charts. There are about 14 million Adélies. The chinstraps are a close runner-up with an estimated total population of 13 million. It is the superabundant krill that makes such a big bird population possible.

One great chinstrap colony is on Deception Island, one of the South Shetland Islands, west of the Antarctic Peninsula. It is a strange volcanic island, shaped like a doughnut with a piece bitten out of it. That passage, known as Neptune's Bellows, leads to the finest harbor in the Antarctic

A great chinstrap penguin colony on Deception Island, west of the Antarctic Peninsula. Here bright green areas are covered by algae that thrive on penguin guano. While one parent guards the two chicks, the other fishes in the sea for food, which is mainly krill. It then returns to the ever-hungry youngsters with its catch.

A chinstrap penguin contemplates its rugged realm. Like the Adélie and emperor penguins, the chinstraps nest far south, even on the Antarctic mainland, though most breed on islands off Antarctica. Numbering about 13 million, the chinstraps are the second most numerous species of penguins.

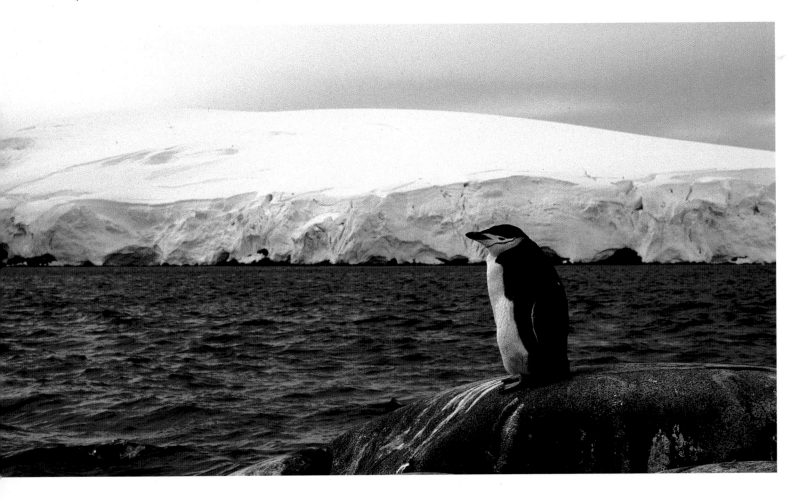

A chinstrap penguin incubates its eggs at Hannah Point on Livingston Island, one of the South Shetland Islands west of the Antarctic Peninsula. After a brief but ardent courtship, the female lays two eggs. She then turns them over to her mate while she heads to sea to catch masses of krill. She replenishes her fat reserves with this shrimplike crustacean. Then she returns to the island to incubate the eggs while her mate goes to sea.

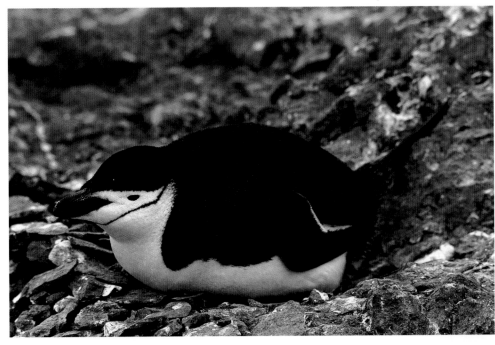

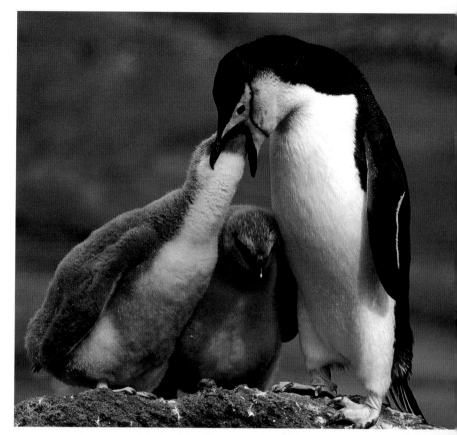

region—a circular sea-filled caldera, surrounded by spectacular 2,000-feet- (600-m-) high mountains. Unfortunately the volcano that formed the caldera and the rest of the island is still active.

Chinstrap penguins arrive at their rookeries on the island in mid-November, about three weeks after the Adélies. Their nests are usually located on the mountain slopes. This may be because Adélies prefer flat areas and occupy them earlier in the season.

Chinstraps are spiffy-looking birds that resemble miniature London bobbies. They stand very erect, wearing black helmets and black chinstraps to which they owe their name. Since they arrive somewhat late in the austral summer, they are in a hurry to raise families.

Landing at Bailey Head, on the outer rim of Deception Island, is no joy. The steeply sloping beach, covered with black lava sand, is pounded by massive waves. The chinstraps mass just offshore in the roiling surf and wait for a wave to carry them ashore. The moment they touch ground they rush up the beach so they will be out of reach of the next wave. They are very good at this. When I visited the island, our boat was carried to shore on the crest of a big wave, but before we could scramble out of the boat and up onto the beach, like the penguins, a much bigger wave hit the boat, knocked us out of it, and nearly sucked us out to sea.

My clothes soaked with grit and seawater, I squelched along with a group of chinstrap penguins. They looked neat and clean and appeared utterly unfazed by their crash landing. Beyond me, the hillside was covered with masses of penguin parents and chicks. Large areas of the colony were covered with bright green algae, which thrived on the ubiquitous penguin guano, and appeared to be the ultimate beneficiary of the ocean's abundant krill.

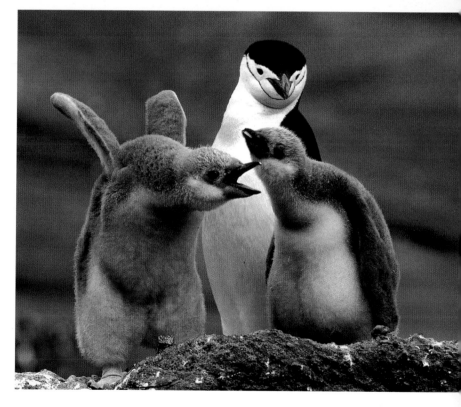

Chinstrap penguin chicks beg for food. Laden with krill when it returns from the sea, the parent regurgitates food for its chick. Since chinstraps hunt near their rookeries, they return frequently to feed the youngsters. As a result they grow even faster than the chicks of Adélie penguins.

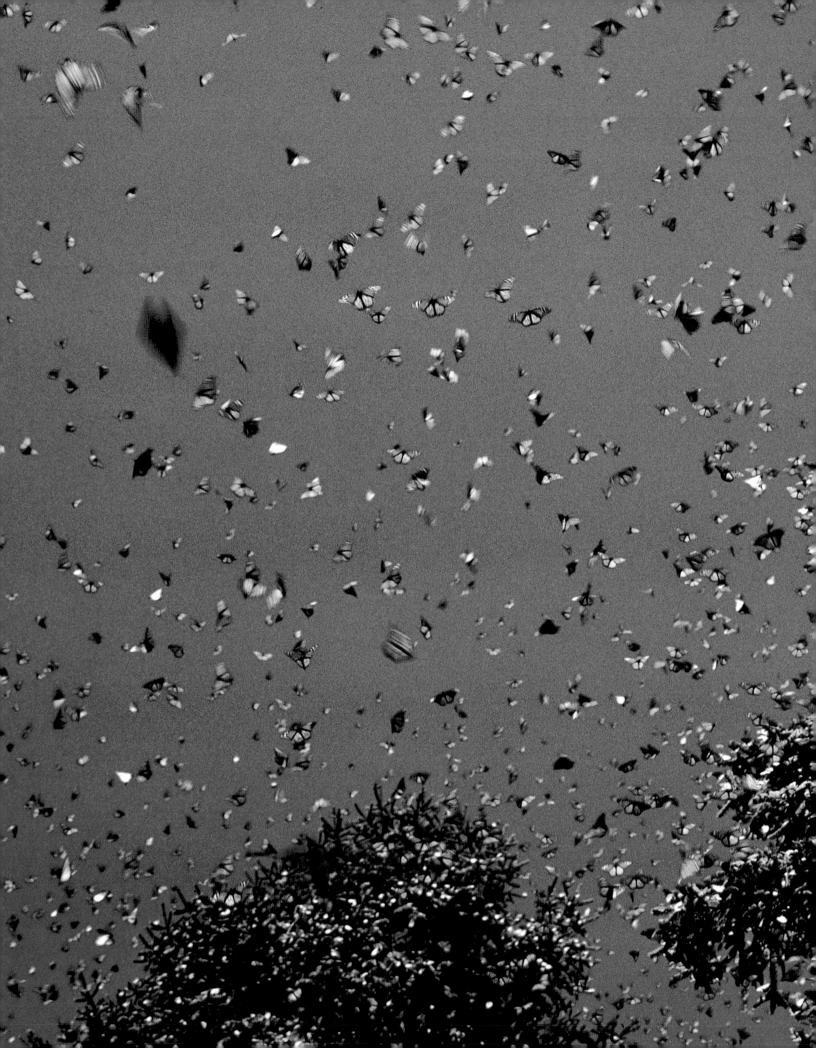

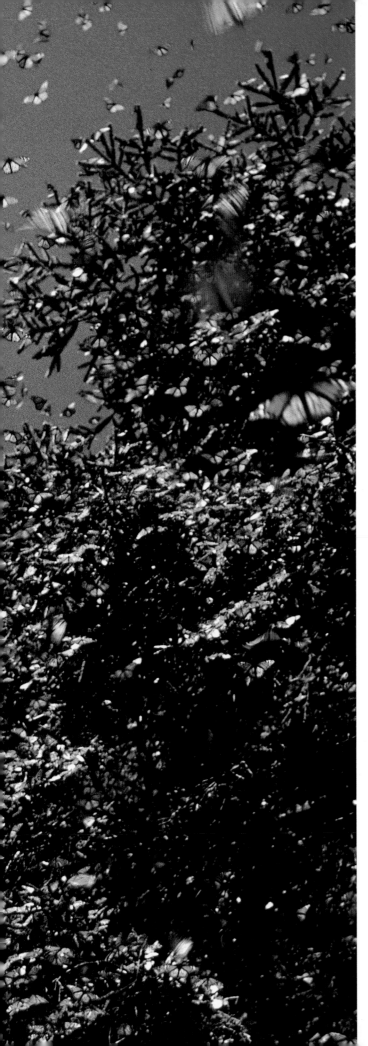

Monarch Butterfly, Mexico

Toward noon in February it gets warm in the high mountains of Mexico's Transvolcanic Range, west of Mexico City, and millions of monarch butterflies awake. Suddenly the clear mountain air is full of flying butterflies that glitter in the sun. The silky rustling of millions of fluttering wings sounds like the gentle sighing of distant surf.

It is the greatest concentration of monarch butterflies in the world. More than 100 million monarch butterflies spend the winter in semi-dormancy here. They rest in less than a dozen roosts in the tall oyamel firs on these cool mountains tops. To reach their winter havens, some of these delicate butterflies have flown 2,500 miles (4,000 km).

That monarchs migrate was known for a long time. The monarch population of northwestern North America winters in a few well-known roosts in California.

The much larger monarch butterfly population of eastern Canada and the eastern United States flies south in the fall. However, until the 1970s it was not known where their winter sanctuary was. More than a hundred million of these large butterflies flew south and then appeared to just vanish. It took a patient and persistent Toronto entomologist nearly 40 years to discover where they migrated to. Over the years, Dr. Fred Urquhart and a small army of his enthusiastic research associates tagged more than 400,000 monarch butterflies. Slowly their migration routes emerged. The butterflies flew south and then west, across Texas and into Mexico. Urquhart's search began in 1937. It ended in January 1975, when one of his assistants discovered the monarch's Mexican winter quarters.

Millions of monarch butterflies take flight on a warm day in February, rising from their wintering roosts on oyamel firs in the mountains of central Mexico. They arrive there in December. Some of the butterflies have flown 2,500 miles (4,000 km); a few will make the entire return migration, flying another 2,500 miles (4,000 km) from Mexico to southern Canada.

Monarch butterfly caterpillars eat only poisonous milkweed leaves. The poison does not harm them. They store it and, in turn, become poisonous themselves. They signal this danger to other creatures with brilliant warning colors. The caterpillars eat a lot and grow very fast: in two weeks a caterpillar weighs about 3,000 times its birth weight. If a six-pound (2.8 kg) human baby grew at the same rate, it would weigh eight tons within two weeks.

In March the wintering monarch butterflies head north. They fly all day, taking advantage of thermals and tail winds. In the evening they land on flowers and sip their nectar, which gives them the energy they need to continue flying. They fly about 125 miles (200 km) every day, in what is ultimately the greatest insect migration on earth.

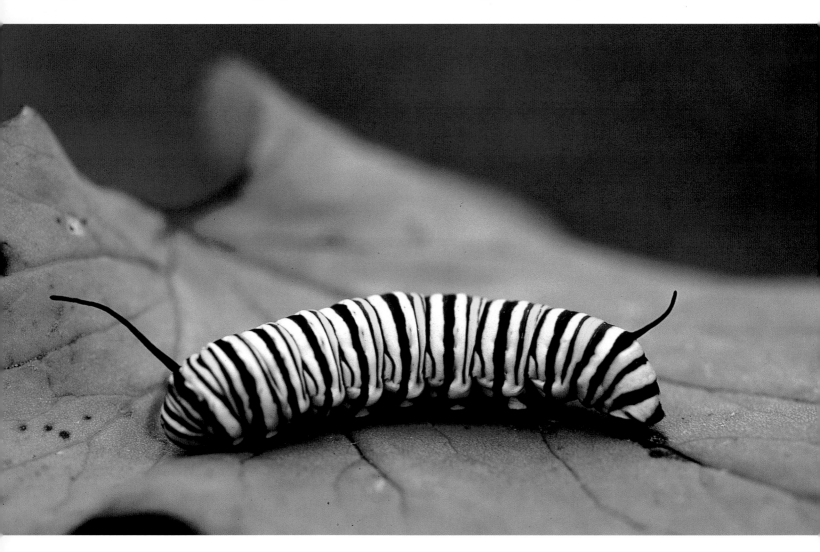

In 1976, Fred Urquhart and his wife, Norma, who by this time were both elderly, traveled to Mexico to climb the high mountain of the wintering butterflies. Utterly exhausted by the altitude and the tough climb, Urquhart feared for a moment that he might perish just short of his goal. But he reached the end of his 40-year quest. Filled with wonder, he said, "I gazed in amazement at the sight. Butterflies—millions upon millions of butterflies. They clung in tightly packed masses to every branch and trunk of the tall, gray-green oyamel trees. They swirled in the air like autumn leaves and carpeted the ground in their flaming myriads...What a glorious incredible sight."

The winter roosts high in the mountains of Mexico are perfect for the butterflies, which must survive for many months on a tiny drop of stored fat. Severe frost, which would kill them, is rare here, but it is always cool. This temperature allows the butterflies to remain torpid and semidormant and to expend a minimum of energy.

On warm days in February the monarchs begin to fly for an hour or two, usually around noon. In March they begin to migrate north. They fly at a high altitude, their journey helped by thermals and tail winds. In the evening they settle and sip nectar, which is the only food of adult monarchs. Then they rest. In the morning the butterflies resume

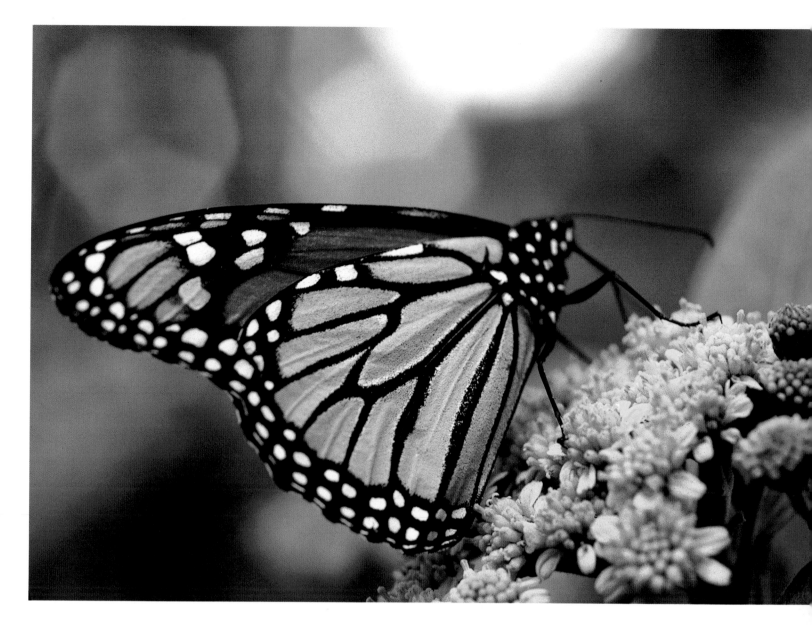

their migration. A few fly all the way back to Canada, a return flight of 5,000 miles (8,000 km).

Most monarch butterflies mate when they reach milkweed patches in the southern States. The female lays about 400 eggs on the underside of milkweed leaves and then the adults die. The eggs hatch into caterpillars, which live exclusively on milkweed leaves. These leaves contain toxic alkaloids that the caterpillar absorbs and stores. The caterpillar passes these alkaloids on in the final phase of metamorphosis to its imago, the mature butterfly. The brilliant orange color of the mature butterfly signals to other creatures that it is poisonous.

Before it pupates, the caterpillar eats a lot of milkweed leaves. It grows quickly and pupates after about 14 days. Soon it becomes an adult butterfly and migrates farther north with the new generation of adult monarchs.

These adults live for about a month, mate, lay eggs, and then die. And so on throughout the summer. Generation follows generation. The last one, in fall is different. Its mating is put on hold. Instead of mating, the fall monarchs suck in all the nectar they can get and transform its sugars into lipids as fuel for the long flight to Mexico.

And now what I consider the greatest miracle of all begins. Not one of the more than 100 million monarch butterflies has ever made this flight before. But somehow the precise coordinates of that small grove of towering oyamel trees on the remote mountains of central Mexico are encoded in each of these butterflies' microscopic brains. A mysterious instinct, which scientists still do not understand, allows the monarchs to navigate with pinpoint precision to their winter roosts, 2,500 miles (4,000 km) away. They finally arrive there in early December.

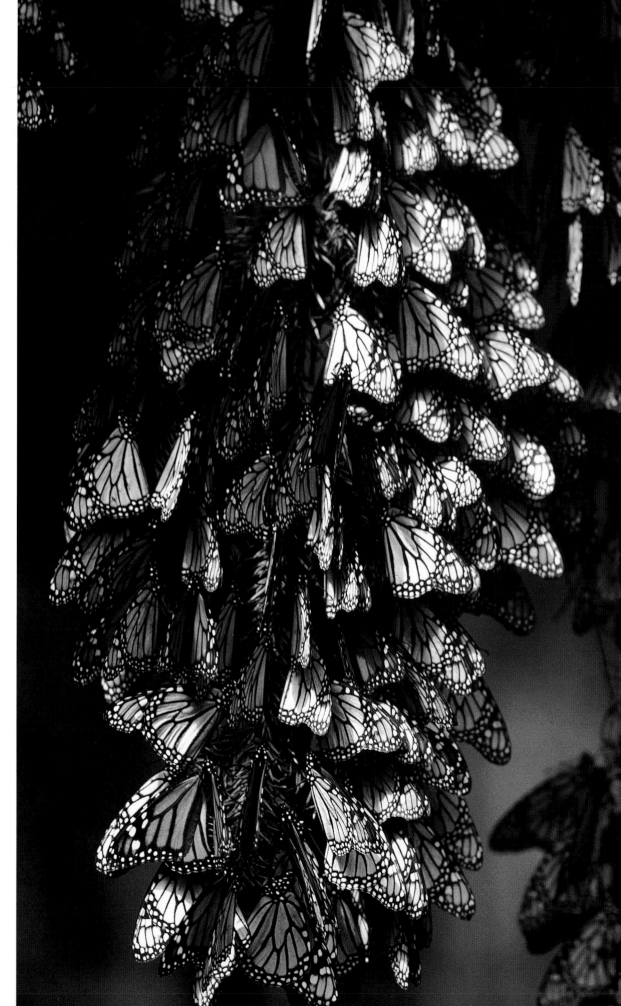

Their wings folded, millions of densely packed monarch butterflies hang from the branches of oyamel firs, where they roost in winter. These roosts are in Mexico, and as far as scientists know, there are only a dozen of them. Most of the roosts are surprisingly small: they consist of less than a thousand trees on 10 to 20 acres (4-8 ha). All the roosts are havens for the wintering butterflies. At the largest roost, more than 60 million monarchs spend the winter months in semidormancy.

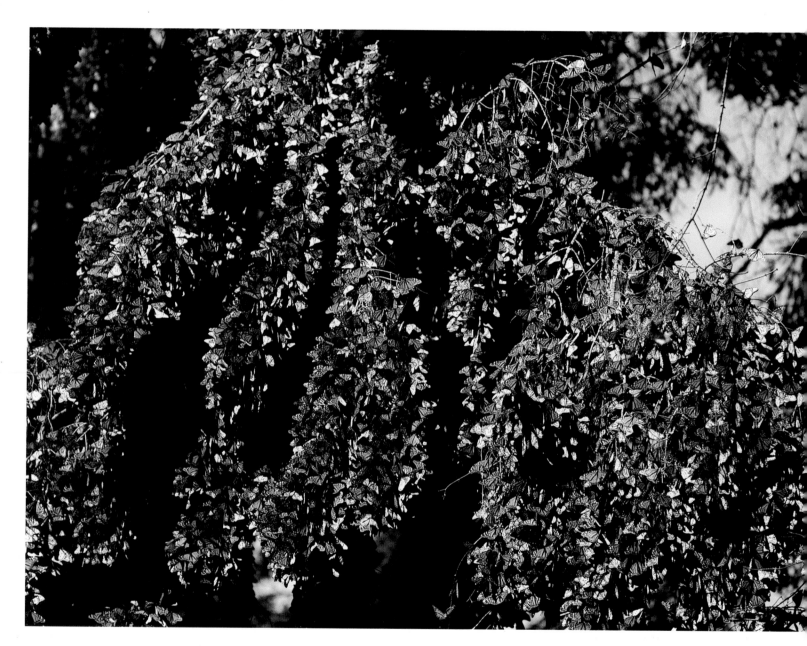

Monarch butterflies cover the trunks and branches of the trees they roost in, in the mountains of Mexico. The climate atop these mountains is perfect for the wintering butterflies: not so cold that they will die, but cool enough to induce torpor and semidormancy. The still butterflies can conserve their fat reserves for the long return migration.

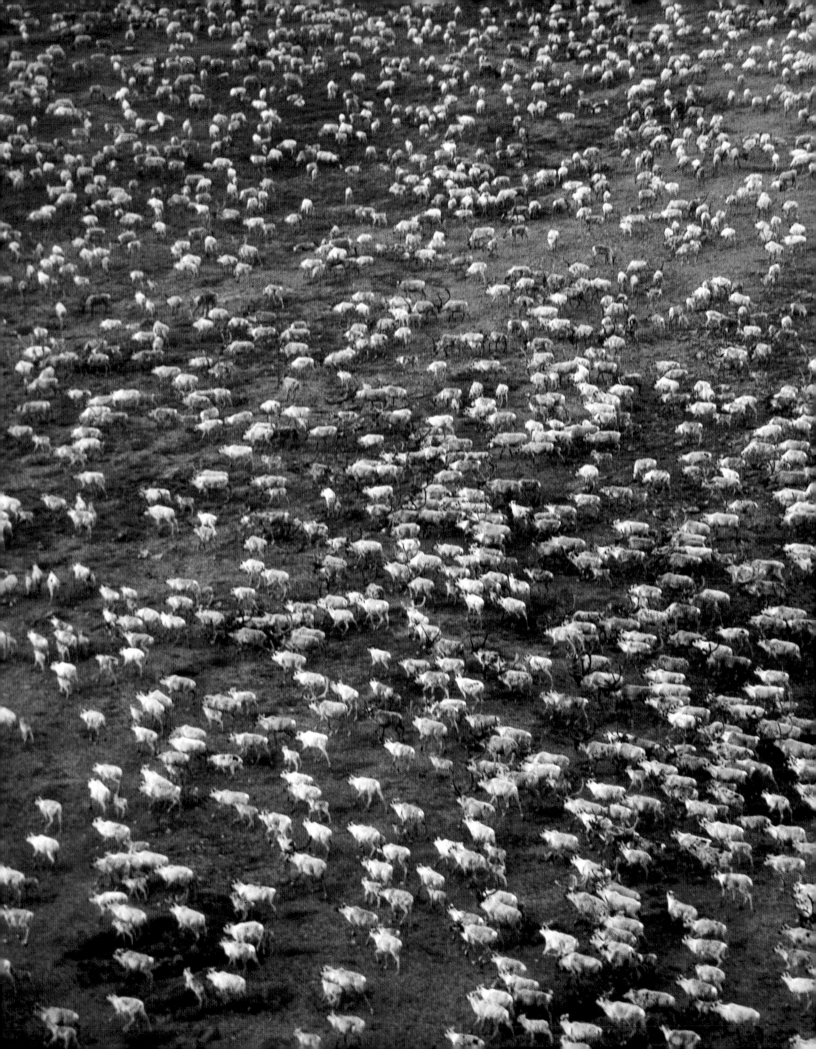

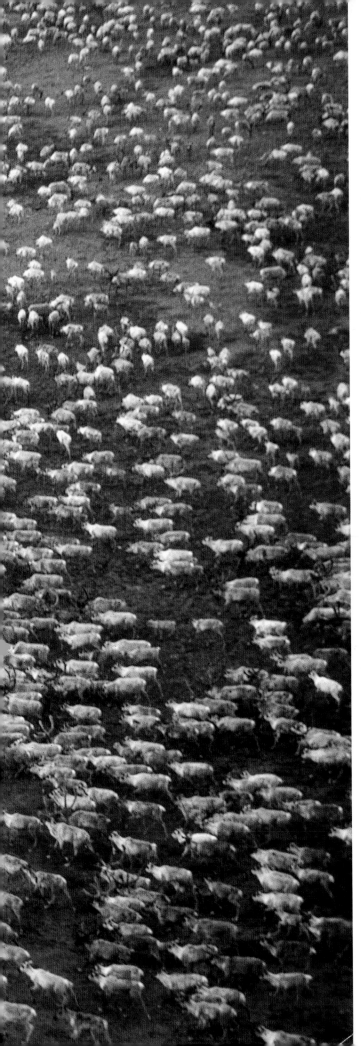

Caribou,
Canadian Arctic

Glorious it is to see
The caribou flocking down from the forests
And beginning
Their wandering to the north.
Glorious it is to see
The great herds from the forests
Spreading out over plains of white,
Glorious to see.

This Inuit poem, recorded by the famous Danish ethnologist Knud Rasmussen in the early 1920s conveys the awe and joy with which Inuit and northern Indians once greeted the immense herds of migrating caribou on which their livelihood often depended. If the caribou came, it meant food and survival. If the caribou failed, it meant famine and death.

The Barren Ground caribou spend the winter scattered across Canada's northern forest belt. Here they scraped away the deep snow with broad sharp-edged hoofs to get at the lichen on the forest floor below. Their name is derived from this habit: "caribou" comes from a Micmac Indian word meaning "the shoveler."

In April a great restlessness overcomes the animals. Small groups join together and begin to move northward, picking up other herds along the way. The trickle of animals becomes a stream, and the stream a torrent. These creatures are all possessed by the same powerful urge to move north. They travel onward at about 30 miles (50 km) each day, the cows large with calf far out in the van.

In the past some herds numbered hundreds of

An immense herd of caribou marches northward across Canada's tundra to its summer grazing grounds. The female caribou have recently given birth and their small calves trot near them. These are the last of North America's great wildlife herds. During their annual migration, from winter forest to arctic tundra and back in fall, some herds cover more than 3,700 miles (6,000 km).

Caribou cross a shallow coastal lake during their migration. Through these vast migrations, the caribou are able to increase their food supply. In the winter, in the shelter of the northern forests, they feed primarily on so-called caribou moss, which is really an abundant but slow-growing lichen. In spring they travel to the tundra calving grounds and then they head farther north to graze on the immense arctic plains.

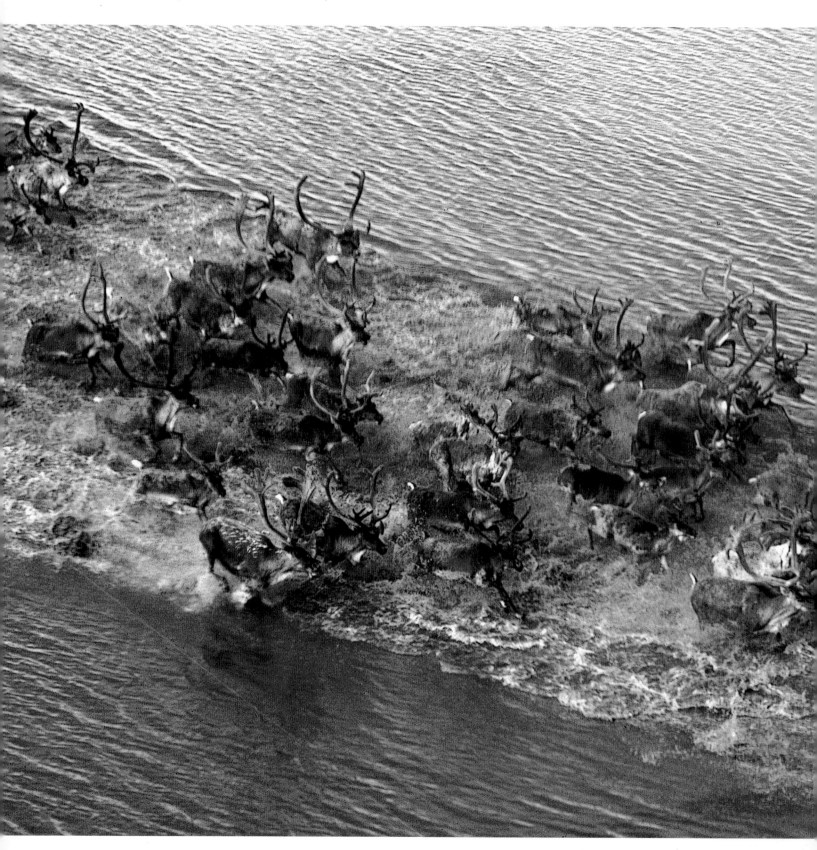

Calves are usually reddish brown, but some, like this one, are a delicate yellowish fawn. During its first week, a calf nurses often, plays and runs to gain speed, then rests. At this time, it is still in danger of being attacked by predators. But by the end of its first week, the little calf can run as fast as its mother.

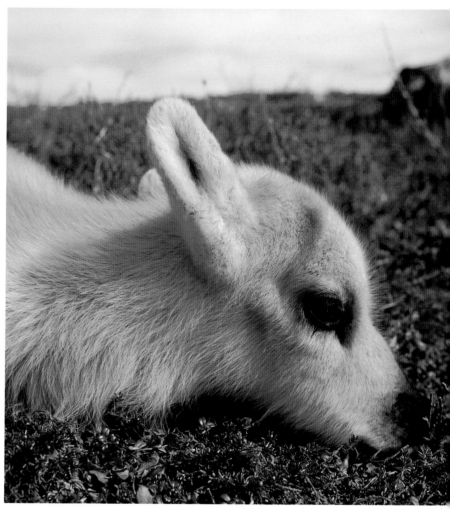

thousands of animals. J.W. Tyrrell of the Canadian Geological Survey met one such herd in 1893 when he explored the Barrens, a tundra region twice the size of France. "The valleys and hillsides for miles appeared to be moving masses of caribou. To estimate their number would be impossible. They could only be reckoned in acres or square miles." When Tyrrell walked into the path of the herd, the vast throng parted and flowed past him, as a river streams past a boulder.

Unlike most such marvelous tales of massed animals of the past that end with the somber coda "these animals are now very rare," or, worse, "extinct," the caribou story has an unusually happy ending.

Their total number in the past has been estimated at three million, and they probably number three million now. There are more than 100 distinct caribou herds in North America, usually named after their calving grounds. Eight of these herds have populations that exceed 100,000. The George River herd of arctic Quebec soared from 15,000 in 1958 to about 800,000 in the

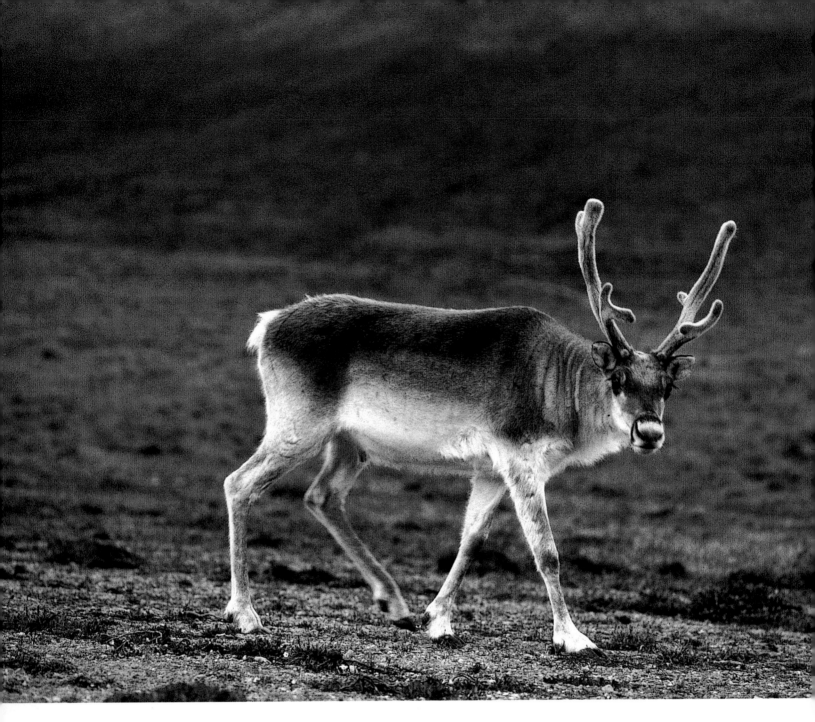

1990s. These are the last great wildlife herds of North America.

I have spent many seasons on the Barrens, mostly with Inuit hunters. But many years ago, during my very first season, I lived with biologists on a remote region of tundra west of Hudson Bay. This was the ancestral calving ground of the Kaminuriak caribou herd for thousands of years.

The first cows arrived in June after a march of more than 808 miles (1,300 km) from their wintering grounds in the northern forests, and soon after the calves were born in the rugged, rocky country near our camp.

The calves were lovely: their coats reddish brown, their muzzles black, their undersides creamy white. Some were a lighter color, a soft fawn, and once we saw a sand yellow calf. They had large, lustrous eyes, shaded demurely by long curved lashes. Standing, the long-legged calves looked awkward and gangly, but once they were two days old, they easily outran us, which proved both humbling and annoying since we were supposed to tag them.

Two weeks later, the scattered herd re-formed and continued its march to its summer grazing grounds on the northern tundra. The caribou returned in late fall to the boreal forest, completing the great cycle of their annual migration.

An adult male caribou, its antlers still in velvet, near
Canada's arctic coast. During summer, on the vast and verdant
arctic meadows, the caribou grow sleek and fat. In regions
where they are hunted, caribou are shy. In the Far North,
some animals can be very curious. This bull circled for a
while, then became frightened and raced away.

Exhausted from a long migration march, a caribou calf rests
on the ice of a tundra lake. When they first walk, minutes
after being born, the calves appear awkward and gangly. But
at the age of two days, they can outrun a human, and at six
days they have the speed and stamina to outrun a wolf.

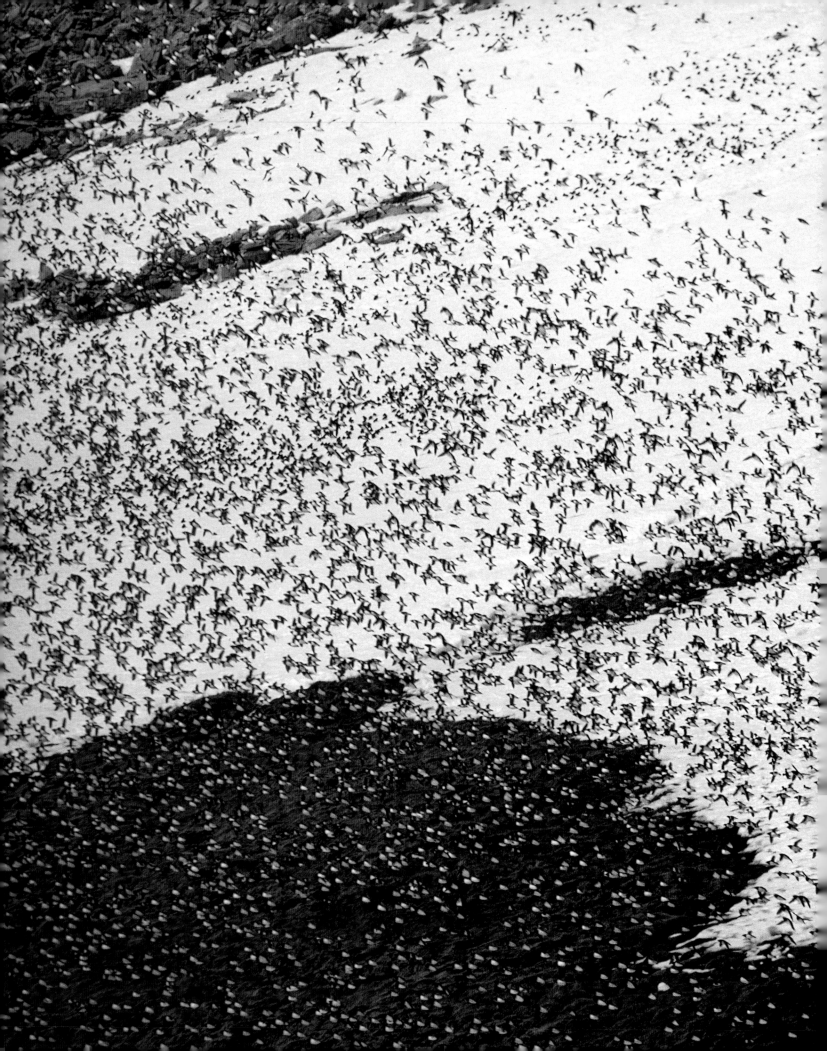

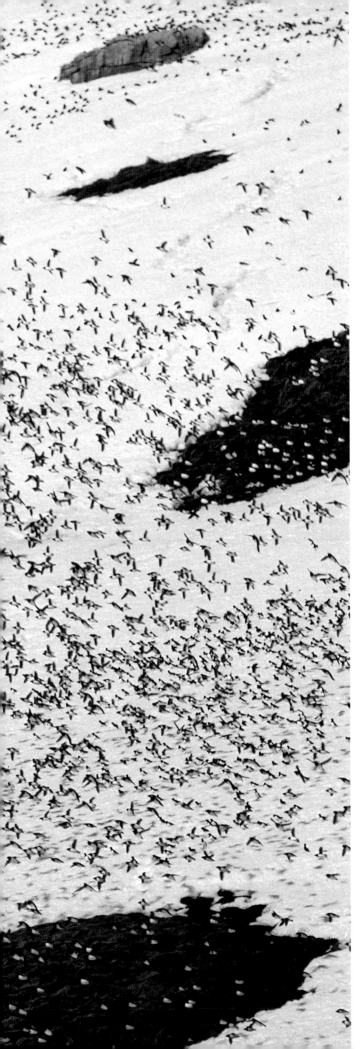

Dovekie, Greenland

Dovekies are small alcids, which are about the size of starlings but chubbier. Their heads and backs are black, their chests and bellies white. They have short, stout beaks and dark webbed feet. In flight, dovekies look like fat cigars with wings. They love company and usually crowd together in vast breeding colonies in the circumpolar High Arctic. Their total population is believed to exceed 80 million.

One spring a long time ago, I had the opportunity to observe dovekies firsthand and to learn more about them. I lived with the Polar Inuit in Siorapaluk, Greenland, the northernmost village in the world. It was May, and in the dialect of the Polar Inuit this month is called *agpaliarssuit tikarfiat*, which means "the dovekies are coming." Traditionally the dovekies (or little auks, as they are called in Britain) arrive on May 5 at their breeding cliffs near Savigsivik, the southernmost of the Polar Inuit settlements. Three days later they are expected at the immense breeding slopes of the Siorapaluk–Etah area.

As May turns into June, the dovekies spend more and more time on the steep talus slopes near Siorapaluk. They sit close to one another on snow drifts or crowd together on their favorite rocks, poking into clefts and crevices in them. Sometimes the birds will suddenly soar into the air in a peculiar butterflylike display. Then they may sit together cozily again, warbling the dovekie love-song. The millions of individual trills and chirps, and occasional shrill cries, blend into one great enveloping, throbbing sound. From a distance this sounds vaguely like a 10,000-piece chamber

Alarmed by a passing gull, massed dovekies pour down the slope where they breed in northwest Greenland. These mass flights, which are often called "mobbing" by scientists, make it difficult for a predator to concentrate on one victim. The dovekies breed beneath stones and in the crevices of steep talus slopes to protect their eggs and, ultimately, their young.

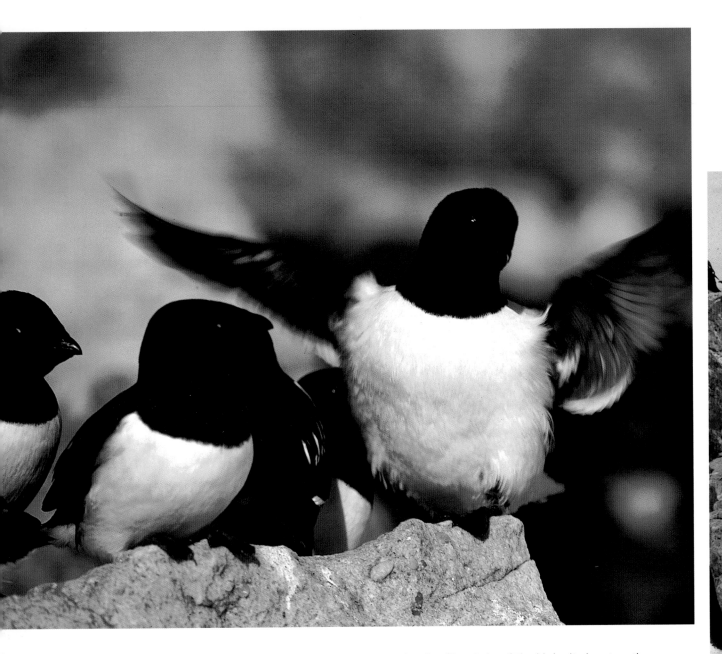

Courting dovekies. Pairs of the birds sit close together, chirping and trilling. From time to time, a dovekie rises and flutters like a butterfly. Then it settles near its mate again. For such a small bird, the dovekie lays a very large egg. In the past Polar Inuit mothers would tie a dovekie's foot to new-born girls so they would have large babies when they grew up.

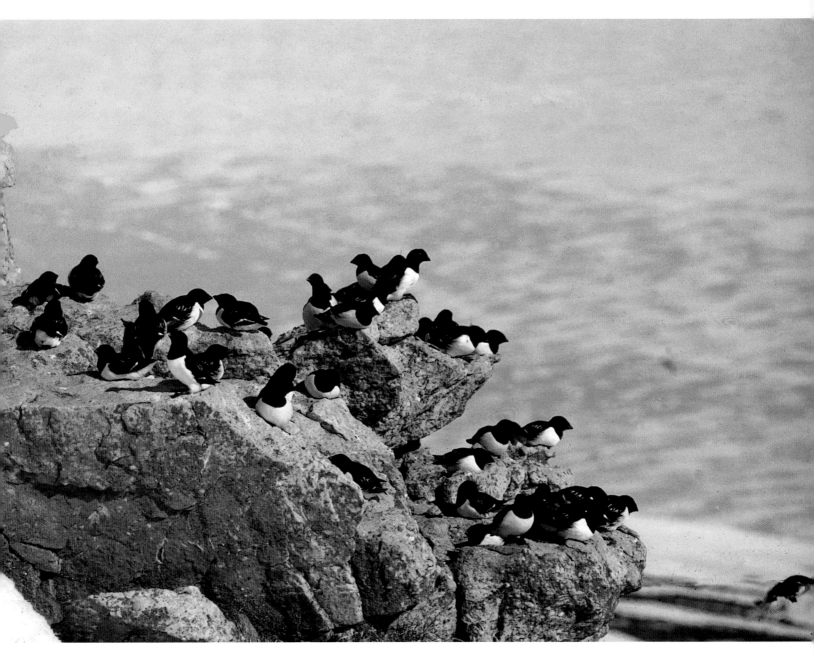

In early May, the dovekies arrive at their breeding slopes in
northwest Greenland. Open sea areas within flying distance
make it possible for the dovekies to feed. The birds sit
together in groups on rocks and snowfields. They do not lay
their eggs until late June.

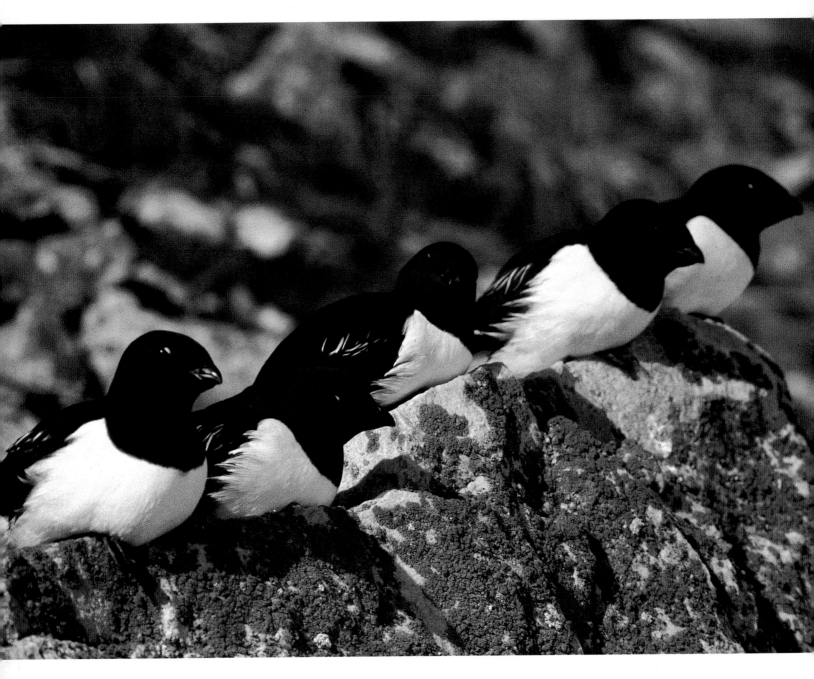

orchestra playing away industriously but not very harmoniously.

The dovekie does not build a nest, but instead lays its egg on the ground under rocks or in a suitable crevice. After a 24-day incubation period a dark-downed voracious chick emerges from this place and keeps its parents busy for the next three weeks. They must stuff the little glutton with plankton.

The High Arctic seas are extremely rich in nutrients. During the constant daylight of summer, the phytoplankton proliferates and the myriad planktonic animals that feed on it swarm through the polar seas in dense masses. These little creatures, in turn, provide food for the dovekies.

They consist mainly of tiny crustaceans and pteropods. Dipping down into the water, the dovekies look like corks pulled under. They swim with their feet and wings and quickly devour this rich harvest before bobbing up again. Or they may decide instead to carry it home to their chicks in cheek pouches so swollen that it looks as if they have the mumps.

Toward the end of August, the chicks are fledged and try to fly out to sea with their parents. At first they wobble, but then they get the hang of it. In the fall and winter the birds migrate south, choosing to keep close to the edge of the ice. The Danes have a lovely name for the dovekies. They call them *søkonger*—the sea kings.

The rocks of the many-mile-long talus slopes where the dovekies nest are covered with bright orange lichen, known as Caloplaca elegans. The Polar Inuit have a less elegant name for it: sunain anak, which means "the sun's excrement." The hills and valleys near large dovekie colonies are well fertilized and so plants grow abundantly here.

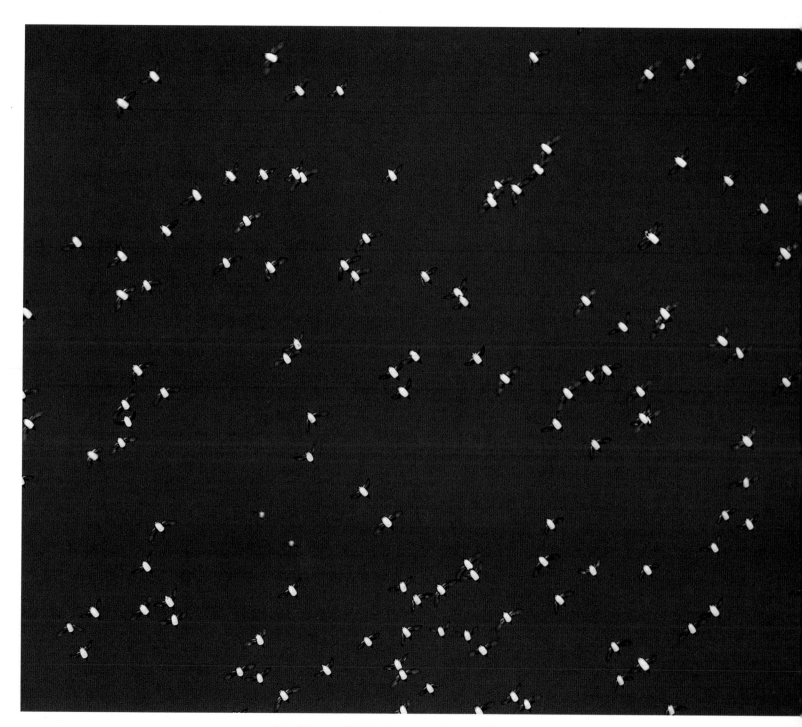

Dovekies speckle the sky. More than a million of them breed at the colony near Siorapaluk, Greenland, which is the northernmost village in the world. The birds' total population in the circumpolar High Arctic is believed to exceed 80 million. In summer the High Arctic seas contain an abundance of food for the birds, which makes it possible for them to breed and for their numbers to multiply.

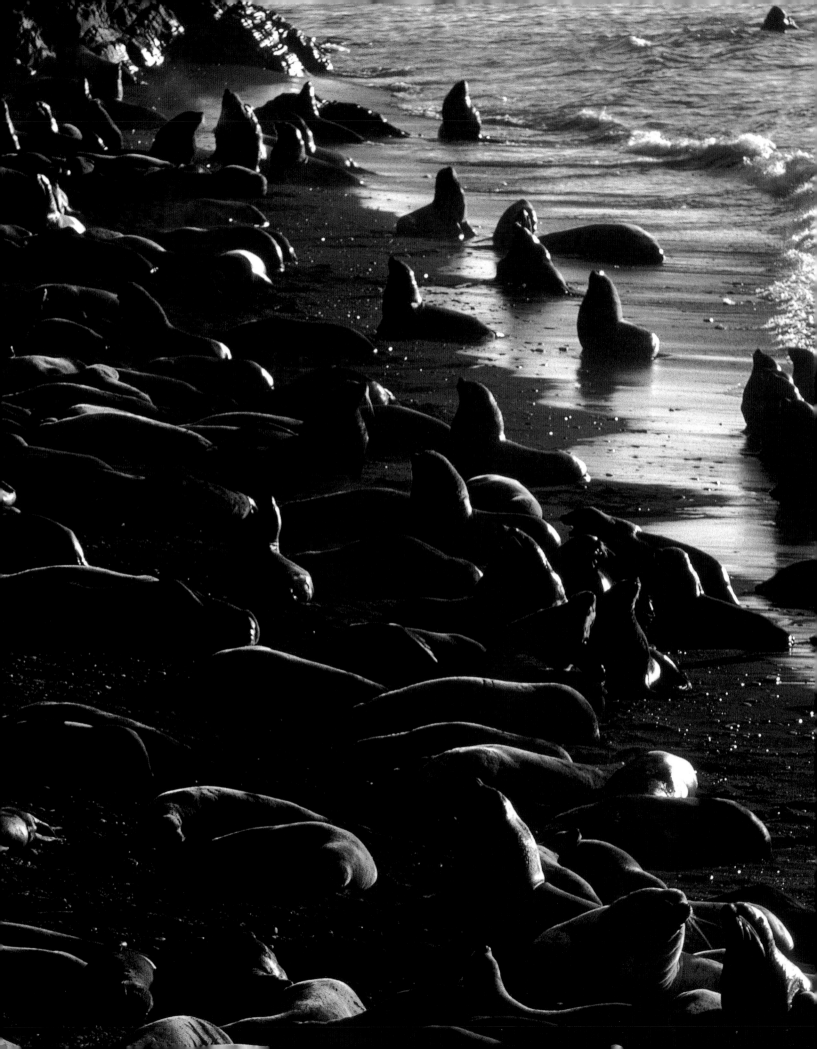

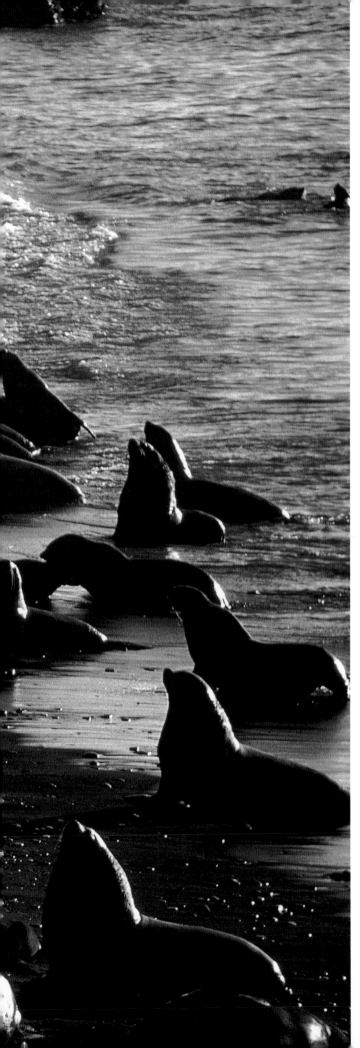

Steller Sea Lion, Alaska, U.S.A.

The Steller, or northern, sea lion is the largest of the world's five sea lion species. Males in their prime are nearly 13 feet (4 m) long and weigh more than a ton. Compared with the massive males, the females are much smaller and sleeker but not meeker. Males fight other males to become lords of the breeding beaches. Females bicker with other females about favorite spots on a beach. Because of all the ranting and roaring and the golden manes of the males, explorers called the animals sea lions.

I spent a summer with the Steller sea lions on rugged, densely wooded Marmot Island, which lies off Kodiak Island in the Gulf of Alaska. At the time Marmot Island had the biggest Steller sea lion rookeries in the world. Since then, the numbers have declined, due to overfishing by humans, but the sea lions' range is still immense. It stretches in a vast arc from Hokkaido in northern Japan, the Kuril Islands, and part of Siberia, to the Aleutians and then goes south along the coasts of Alaska, British Columbia, and Oregon, all the way down to California's Channel Islands.

During the spring and summer of my visit, 10,000 Steller sea lions massed on seven beaches of Marmot Island. Six of the beaches were breeding rookeries, ruled by "beachmasters," the mightiest males. The seventh was a "bachelor beach." There young males jousted and acquired the skill and speed and strength they would need to some day be rulers of a portion of beach and of all the females on their territory. Near the feisty young males lay tired old bulls, who had been defeated in battle and slept on the black sand in quiet resignation.

Steller sea lion rookery in Alaska in the golden light of dawn. Sea lions are very vocal: the males and females roar and the pups bleat like lambs. One can hear a great colony from more than half a mile (1 km) away. Great males arrive at the traditional breeding beaches in May to stake out territories and defend them against rival males.

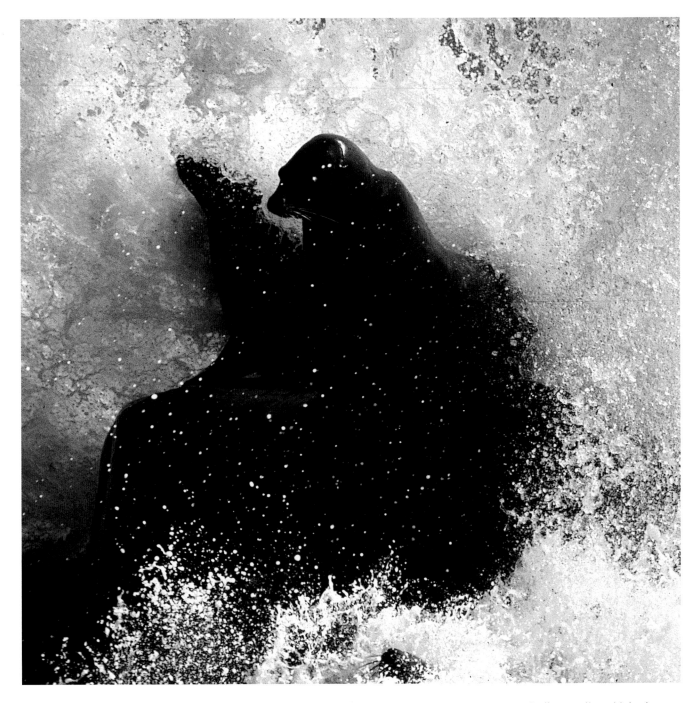

Two young male Steller sea lions perch atop a rock in the path of violent waves. They cling to the rock with their rough-soled flippers and don't mind getting drenched when a wave explodes in spray against their rock. When a wave is very big, they turn, duck low, and let the wave rush over them.

Steller sea lions high above a shimmering sea. They are skilled and determined climbers. Their fore- and hind-flippers are large with soles as rough and coarse as sandpaper. The sea lions like to climb onto big rocks or up the sides of cliffs to bask in the sun.

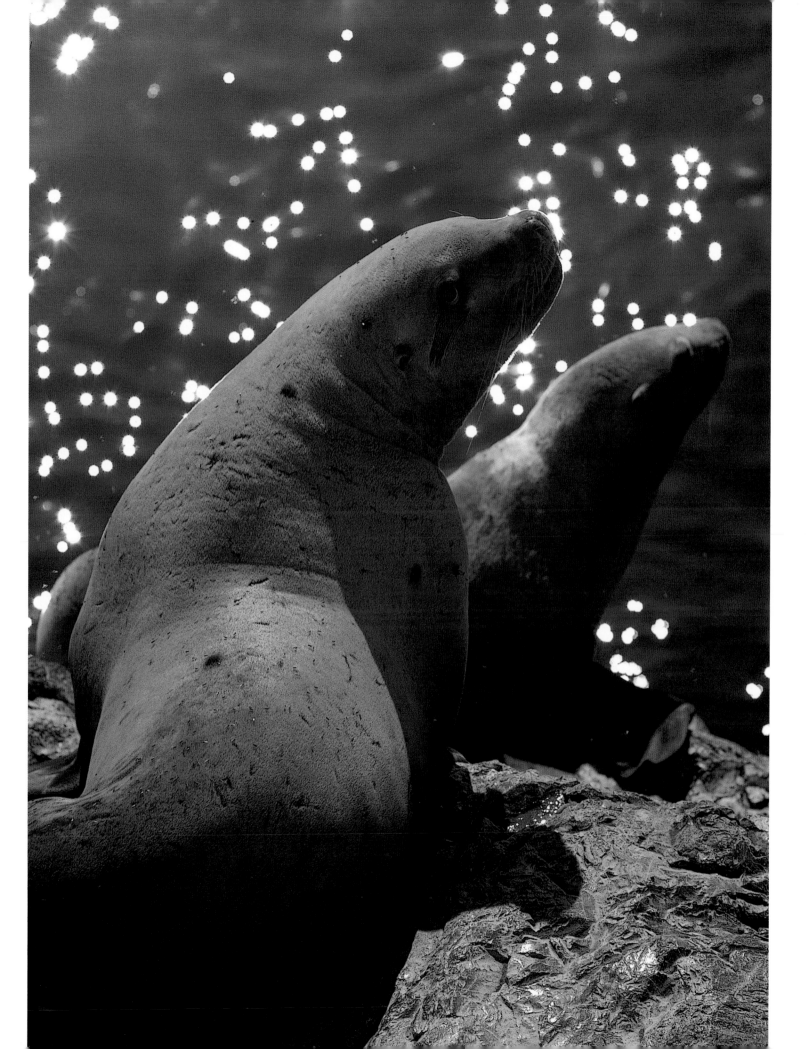

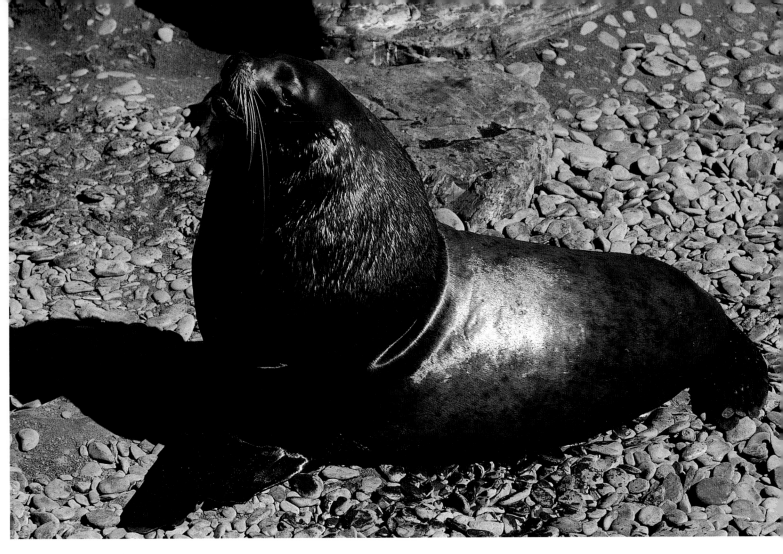

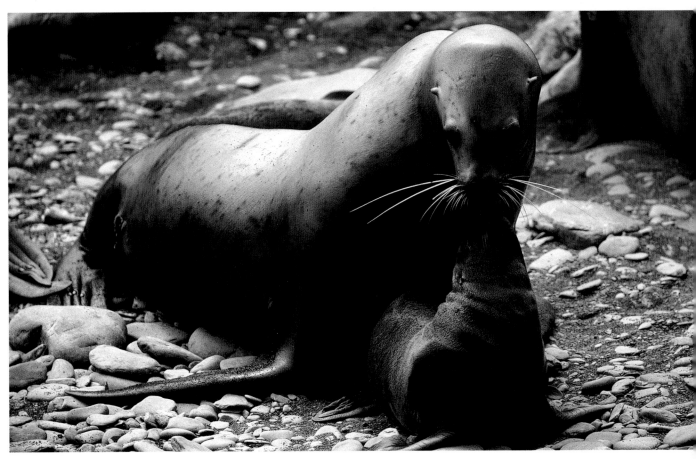

A one-ton Steller sea lion male. The Steller sea lion is the largest of the world's five sea lion species. After violent fights in May, the most powerful males become "beachmaster." They control territories on the beach and all the females in them. Property is everything, because females will not mate with males that have no territories.

In May the large males arrived upon the ancestral breeding beaches. The females, who arrive later, have a finely honed instinct for real estate: they greatly value certain portions of the beaches and will mass there. They disdained other areas of the beach that appeared every bit as suitable to me. The males knew exactly where the females would gather and that's where the greatest battles were fought.

A huge buff-brown bull with a coarse-haired bristly mane waddled slowly ashore and settled with a satisfied snort on a section of beach known to be highly pleasing to female sea lions. His peace was brief. Another bull of about the same size hauled out. Soon both males reared high, roared, and glared at each other. They then hacked at each other's neck and chest with their long yellow canines.

They collided, chest to chest, then heaved like one-ton sumo wrestlers, attempting by sheer weight and might to bulldoze each other off the desired property. Once the females arrived, the beach had been divided among the winning males. The losers retired to the bachelor beach.

Once territories have been won, defended, and held, the resident bulls usually rule for the rest of the season, because constant fighting would seriously weaken the males, who neither eat nor drink for two months and very rarely sleep.

One frequent cause of commotion in the great rookery is the incursion of young males on the make. Driven by hormones and hope, these five- or six-year-old bulls know that they have two things in their favor: a beachmaster with 50 wives is often preoccupied, and the young males resemble adult females in size, shape, and color.

A young male cruises back and forth along a beach, looking for a good spot. He rushes ashore, galloping madly across the densely packed, loudly protesting females and lies low on the landward side of the beach before the resident male has spotted him. Slowly, cautiously, he sidles up to a female and tries to mate with her. The female invariably loudly rejects the advances of the immature male, at which point the beachmaster rushes over to annihilate the young male. Yammering with fear, the lothario takes refuge in the sea or, if cornered, assumes the submissive posture of a female. This action stops the beachmaster, his urge to kill colliding with his urge to mate. While he dithers, the young bull can escape and join his comrades on the bachelor beach.

Returning from a feeding trip at sea, a female Steller sea lion identifies her pup, then greets it. Immediately after birth, a female lifts her newborn pup two to three feet (almost a meter) high, then lets it drop upon the rocks. This is the sea lion equivalent of a slap upon a human baby's bottom. The pup cries and the mother will henceforth be able to distinguish her pup from all the other pups by its cry and its smell.

Heermann's Gull,
Baja California, Mexico

The "Heermann's gull," wrote the ornithologist William L. Dawson, the author of the classic 1923 work *The Birds of California*, "is an inveterate loafer and sycophant. Of southern blood, he comes north in June only to float and loaf and dream throughout the remainder of the season.

"Visit the `Bird Rocks' of Rosario Straits early in July and you will find a colony of Glaucous-wings distraught with family cares and wheeling to and fro in wild concern at your presence, while upon a rocky knob at one side, a white-washed club room, sit half a thousand Heermann's, impassive, haughty, silent.

"If you press inquiry, they suddenly take to wing and fill the air with low-pitched mellow cries of strange quality and sweetness."

Heermann's gulls are easy to identify because they sound and look different from all other gulls. When gulls are angry with one another or with humans, they are strident. But the calls of Heermann's gulls are a soft catlike mewing. The color of other gulls is predominantly light, whereas Heermann's are predominantly dark and the only gulls with a uniformly dark underside.

In late summer, fall, and winter Heermann's gulls range far along the Pacific coast of North and Central America. They regularly fly to Puget Sound in the north and a few even head to Vancouver Island. They go south as far as Panama.

In spring, all adult Heermann's gulls head toward one small, sun-scorched island off Baja California in Mexico's Sea of Cortez. This island is called Rasa Island. There are about 300,000 Heermann's gulls in the world and 95 percent nest

Heermann's gull is the only predominantly dark gull in the world. It ranges along the Pacific coast of North America from Vancouver Island, in the north, to Panama in the south. During the breeding season, 95 percent of the world's Heermann's gulls gather on Rasa Island, a small island off Mexico's Baja California in the Sea of Cortez.

on this island, along with about 45,000 elegant terns and 17,000 royal terns.

I travelled to Rasa Island with some Mexican fishermen. The journey was pure magic. The motor purred smoothly, the sea was full of life. Great schools of dolphins "porpoised" past our boat, their sleek backs shining in the sun. We skirted small islands covered with California sea lions. When I spotted some rare Craveri's murrelets, the fishermen wondered how the crazy gringo could be so excited about such small birds.

The basis of all the marine wealth in this area is sardines. The strong winds that stir up the ocean's surface and the powerful currents that churn up mineral-rich waters from the deep combine to make the Sea of Cortez immensely rich in plant plankton; the zooplankton that feeds on it is, in turn, the food of fishes, especially the immensely numerous sardines. The sardines, in turn, feed the gulls and other seabirds as well as the dolphins and sea lions.

The moment we hit Rasa Island my fishermen vanished into the research building used by Mexican scientists who work on the island. It was 140°F (60°C). And there was not one tree on the island and hence no shade.

The Heermann's were medium-sized with white heads and grey mantles. They stood in the blazing sun above their eggs or chicks to shade them from the dry, killing heat.

Despite the stifling heat, there was no peace on Rasa Island. Both species of terns—royal and elegant—are super-active and excitable, and they make life miserable for the quieter, gentler Heermann's gulls (who, despite being quiet and gentle, happily eat tern chicks, which is one reason why the terns are so excited).

All three species are intensely gregarious and breed in dense colonies. A major cause of strife between them is "real estate." Although the island is small, it would have plenty of space for all, if the terns and gulls didn't have a strong and belligerent

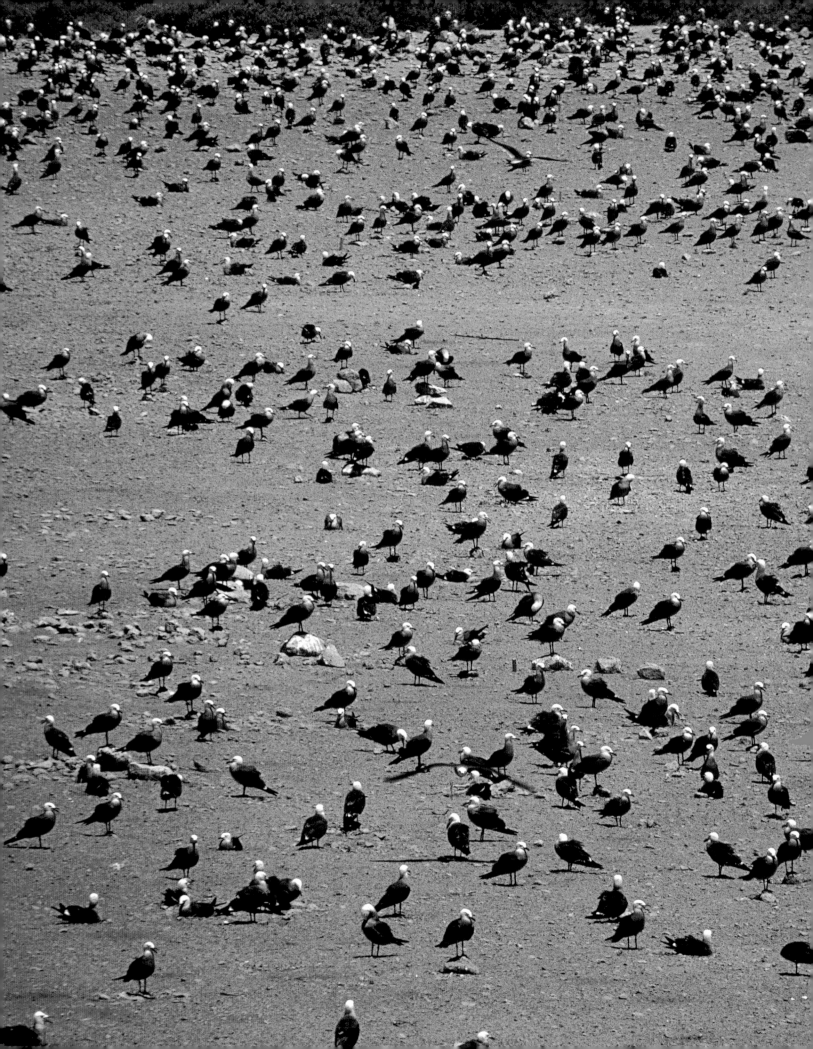

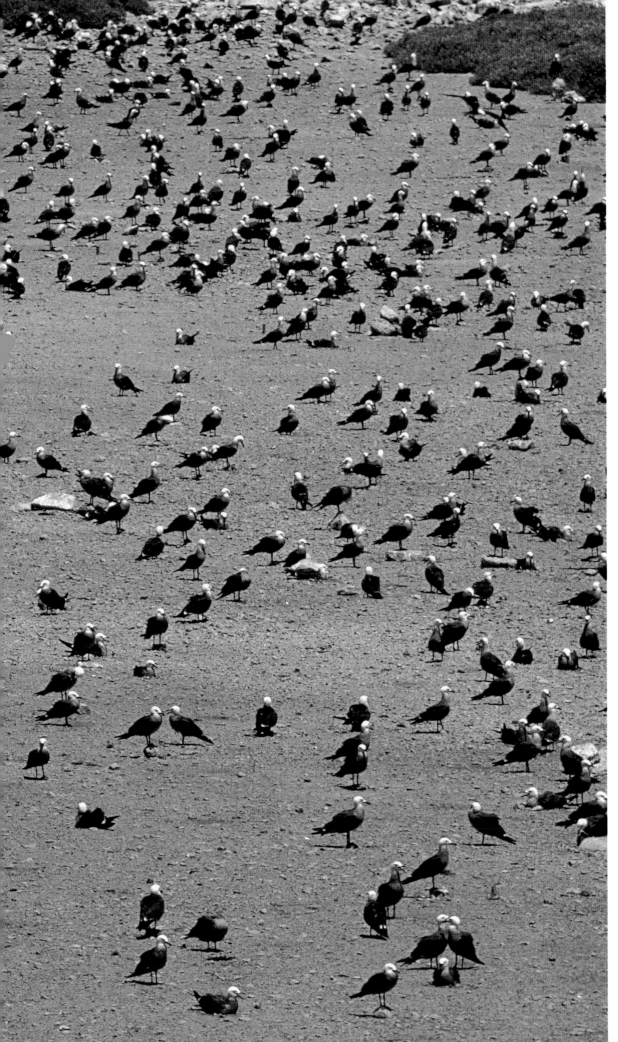

Heermann's gulls on Rasa Island, off Mexico's Baja California in the Sea of Cortez. Ninety-five percent of the world's 300,000 Heermann's gulls come to this one small sun-baked island to breed. Its big attraction is sardines, which abound in the surrounding sea. These fish are the Heermann's gulls' principal food during the breeding season.

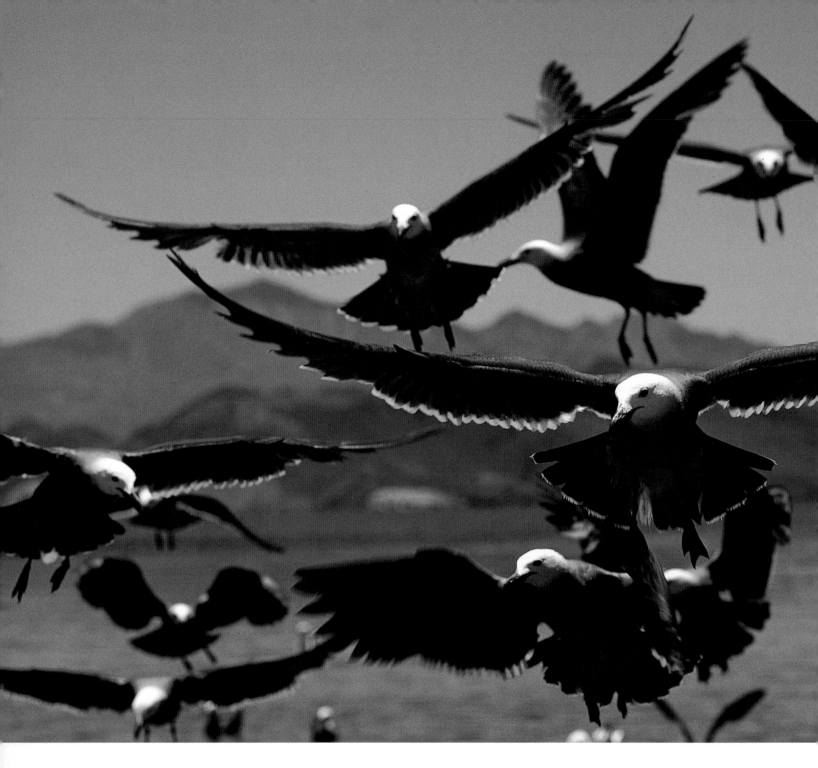

preference for certain flat-bottomed valleys, flanked by low, rocky hills.

The Heermann's gulls are the first to arrive on the island. They get there in March and soon establish territories. At this time they get to know their neighbors, court at night, and in the morning they all fly out to sea to feed. They then begin to spend more and more time ashore. Colonies form and the birds build disorderly stick-and-seaweed nests, or refurbish a nest from the previous season. They then lay their eggs and settle down to quiet domesticity.

And then the noisy terns arrive. The larger royal terns usually establish separate colonies. But the numerous elegant terns are pushy and desire territories already occupied by the brooding gulls. And what these terns desire, they usually get. Their strategy is effective but not nice. They arrive in screaming hordes and simply ruin the neighborhood. The quiet Heermann's gulls hold out for a while. Then they vacate their nests and move onto less desirable but more peaceful properties, where they begin to nest again. However, they get a revenge of sorts later in the season by eating some of their pushy neighbors' children.

Heermann's gulls share Rasa Island with about 17,000 breeding royal terns and 45,000 breeding elegant terns. The royal terns usually form separate colonies. But the aggressive elegant terns covet the flat land where the gulls already nest. Using noise and the pressure that comes from their large numbers, these terns force the meeker gulls to move. Displaced from their original nests, these gulls nest a second time, away from the noisy terns.

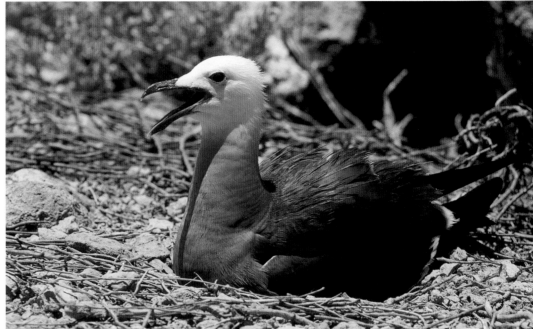

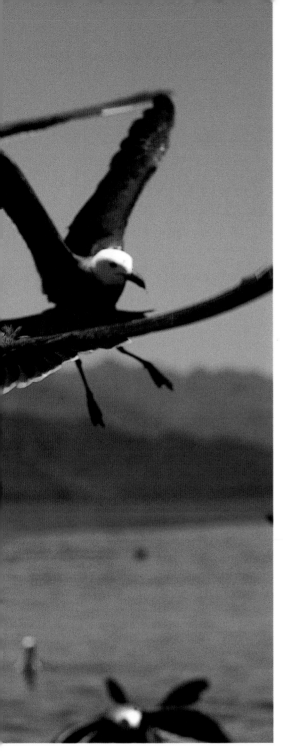

Eager Heermann's gulls flutter above a beach where Mexican fishermen are cleaning their catch. These gulls live mainly off sardines, which are the main fish food of seabirds, dolphins, and sea lions in the Gulf of Cortez. Unlike other gull species, whose cries are usually loud and shrill, the Heermann's gulls' calls are a soft, catlike mewing.

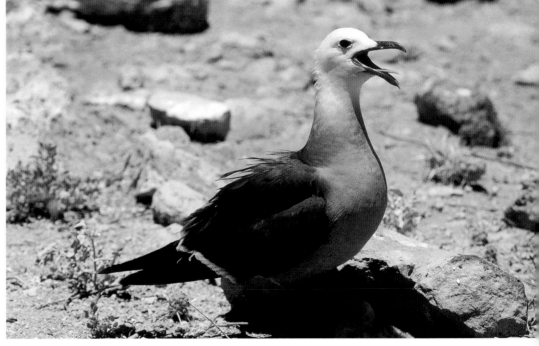

Rasa Island, where 95 percent of the world's Heermann's gulls nest, can be brutally hot during the breeding season and much too hot for newly hatched gull chicks. The adults stand above the chicks and protect them by creating shade. Apart from panting, the adult birds show no sign of stress in the intense 140°F (60°C) heat.

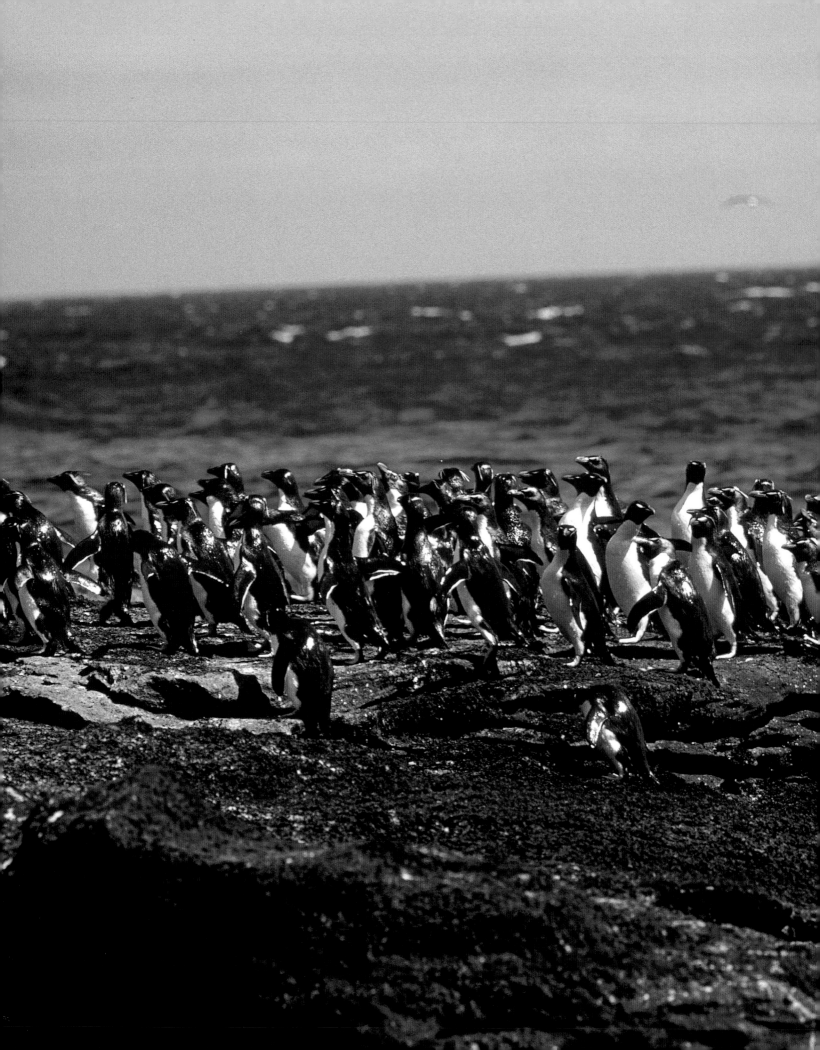

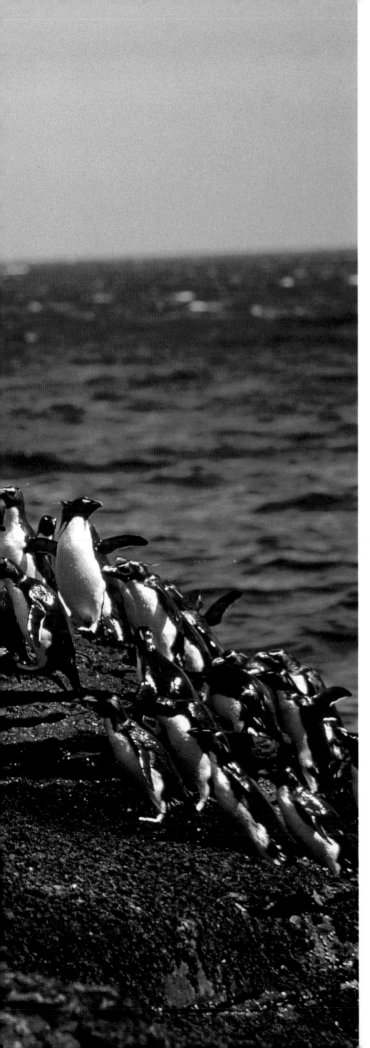

Rockhopper Penguin, Falkland Islands

People who think they have problems should watch rockhopper penguins trying to land on a rocky shore in a storm. "I have seen them battling to land," writes Falkland Islands' author Tony Chater, "in terrible gales when the sea is blanched with boiling surf and massive waves send sheets of spray 330 feet (100 m) into the air."

I watched these awe-inspiring landings on the Falklands' small Sea Lion Island. This island has a sheer-cliffed east coast, which is exposed to the full power of the subantarctic sea. Great waves roll in from the sea and shatter against the cliff. As each wave recedes, a dozen birds cling to the wave-polished rock with their strong beaks and long sharp claws; then they struggle upwards with their narrow, flailing hard-edged wings.

Some make it, but others are washed out to sea as the next wave crashes against the cliff; they soon try to get up the cliff again. No human could survive even a minute in that raging sea, or claw his way up that steep slope, but the rockhoppers do it routinely. Once they have reached the top, they rest, preen, argue with their neighbors, and then hop jauntily to their cliff-top colony to greet their mates and feed the chicks.

The rockhopper is the smallest and most widespread of the six species of crested penguins. The largest colonies of these birds are on the Falkland Islands, where they gather in masses at 33 sites, many of which have been used for thousands of years—for so long that distinctive penguin paths lead to the rookeries, the hard rock scoured and deeply grooved by the rough soles and sharp claws

Rockhopper penguins rush ashore on a granite shelf at New Island, one of the Falkland Islands. They cruise offshore in what look like happy porpoising groups. But they are, in fact, looking for signs of sea lions, which may lie waiting near the shore, ready to prey on them. Once they are sure that the coast is clear, the penguins dive en masse, then rush ashore with a large wave, and quickly hop up the rock shelf.

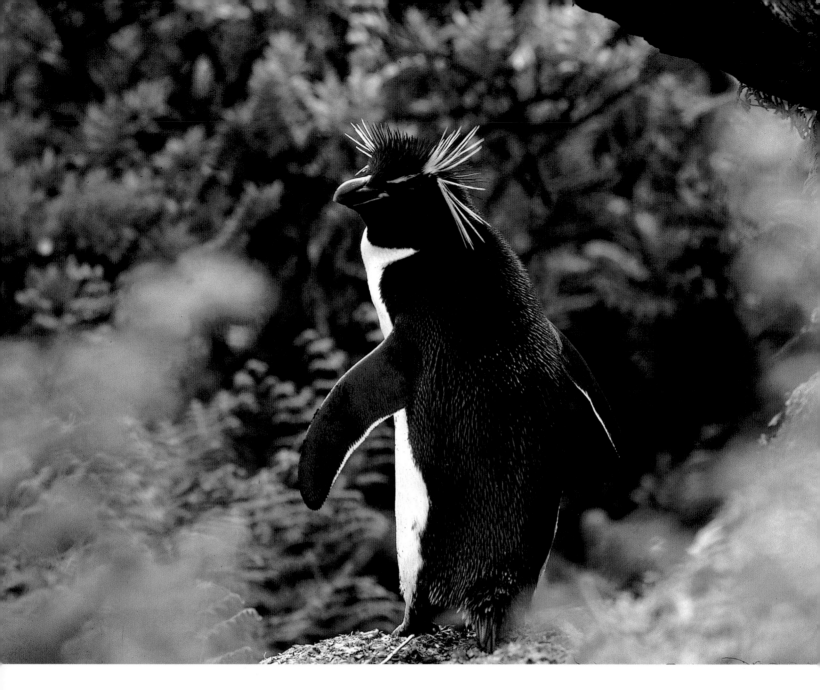

Rockhoppers are the smallest and most widespread of the six species of crested penguins. They nest on many subantarctic islands, including the forested Auckland Islands south of New Zealand. Here a rockhopper penguin pauses in the rata forest before heading for the small rookery on open ground.

Taking the plunge. While other rockhoppers look on with interest and apprehension (their turn is next!) a one-foot- (30-cm-) tall rockhopper penguin plummets 16 feet (5 m) down onto granite—the equivalent of a person jumping 10 stories and landing on a cement sidewalk. Rockhoppers do this routinely and on a full stomach, as they are laden with food for their chicks.

of endless penguin generations.

Rockhoppers are dapper, energetic birds, but they are also rough, tough, and quarrelsome. In a large colony there are constant arguments and lots of commotion, which create a mighty roar. Arthur Cobb, a Falkland Islands farmer, once compared the sound of massed rockhoppers with the noise of "thousands of wheelbarrows, all badly in need of greasing, being pushed at full speed."

Small, elegant penguins, rockhoppers stand about one foot (30 cm) tall and weigh five pounds (2.3 kg). A rockhopper's head, chin, and back are glossy bluish black, its chest and belly pure white. The strong bill is reddish brown, the powerful sharp-nailed feet fleshy pink, the foot soles black, the eyes a vivid geranium red. Above each eye is a

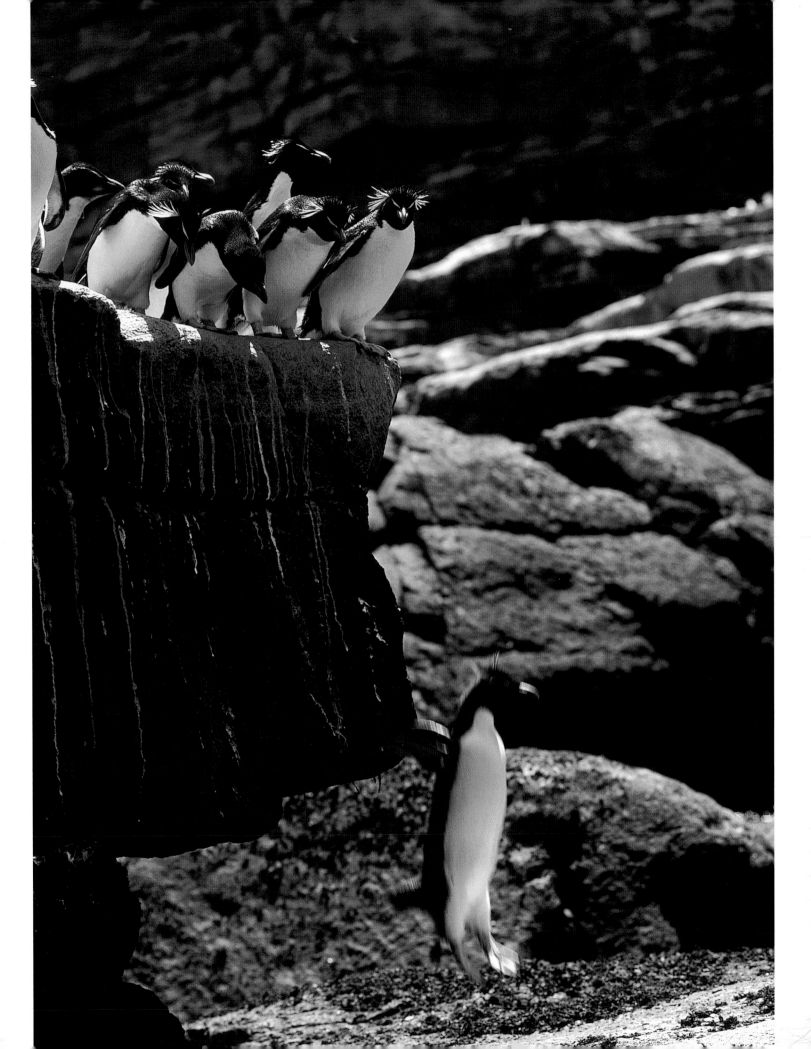

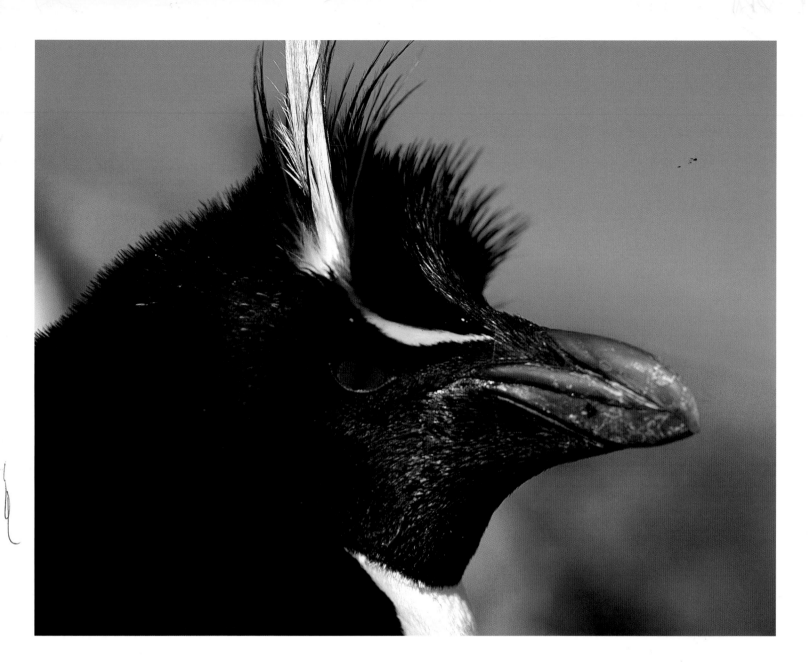

brilliant yellow stripe that flows backward into long golden tassels. In addition, rockhoppers have shiny black feather crests, which they can raise when they become agitated.

As their name implies, rockhoppers are bouncy birds. They can rocket nearly 3 feet (1 m) out of the water onto land and jump their own height forward and upward with each bound, legs together, like children in a sack race. On the Falkland Islands, they are called "jumping jacks."

Some of their jumps are spectacular. I lived with Tony Chater on New Island for a while. (As well as being a writer, Chater is a naturalist and an artist.) A mile (2.2 km) from his home on a plateau is a major rockhopper rookery. To reach their rookery, the portly little penguins, who are stuffed with food for their hungry chicks, must crash-land on rocks.

Landing here is relatively easy. Large groups of penguins dive deep, swim flat out toward land, surge ashore in the foamy crest of the largest wave and instantly scramble up a large sloping granite shelf.

The first stretch is easy. They hop along, hurtle with ease across a few clefts, but then they suddenly come to the spot where the granite shelf ends in a sheer 16-foot (5-m) drop to the rock below. This is where they must make the *big jump*. The penguins cluster apprehensively along the rock edge, lean forward, peer down into the void and back off. (A human would, too, if asked to make an equivalent jump: from the roof of a 10-story building onto a cement sidewalk, without a parachute.)

The little platform becomes more crowded. The penguins jostle and prod each other and finally one

A dapper, excited rockhopper penguin. One of the world's six crested penguin species, the rockhopper has a brilliant yellow stripe above each eye, which flows backward into a long golden tassel. In addition, rockhoppers have a crest of shiny black feathers. When annoyed with their neighbors, they get excited and raise both tassels and crests.

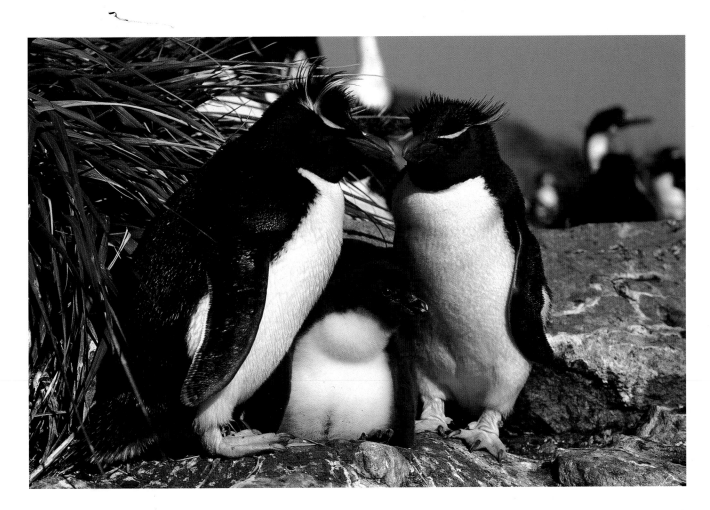

jumps: feet first, wings held high, the body peculiarly elongated. Then the bird lands with a plop. The others follow in quick succession. Nearly all the birds land upon the same spot. The granite there has been worn away and polished by the falling bodies of millions of penguins over the course of thousands of years.

One would think that such a fall would kill or cripple the birds, but their short, stout legs and the layer of ample fat that covers their bodies act as shock absorbers. Thus, having made the leap, they hop nonchalantly to a nearby rock pool. There they splash and wash exuberantly; then they sit to preen and oil their feathers before heading for the hills.

A narrow cliff-edge path leads to their colony.

Rockhopper penguin parents and their pear-shaped chick, stuffed with food. The female normally lays two eggs. The first one is usually smaller and weaker than the second and often gets crushed. On rare occasions, it does hatch and produces a weak but viable chick. Generally, though, rockhoppers raise only one chick. While one parent guards the precious chick, the other hauls in food from the sea.

Two streams of penguins pass each other. Struggling upward in the ancient grooved trail are fat, clean, shiny penguins filled with food for their chicks. Hopping downward are lean, bedraggled penguins. Empty, dirty, and exhausted, they rush out to sea to replenish their fat reserves and to get more food for their chicks.

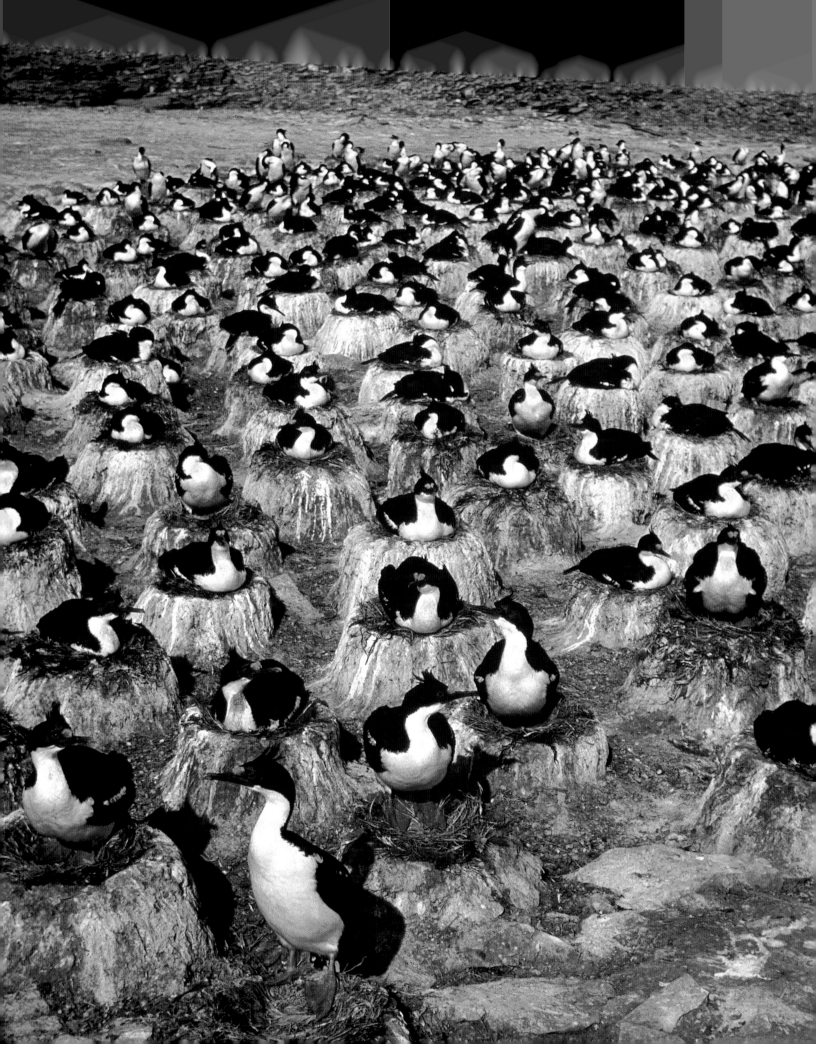

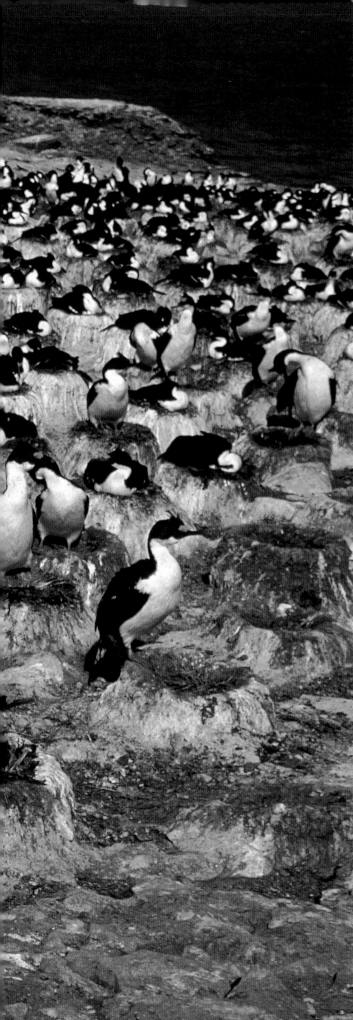

King Cormorant,
Falkland Islands

Poor cormorants. They are not humankind's favorite bird. The name-calling starts in the Bible, where the birds are branded unclean and an "abomination among the fowls." They are dark, with snaky necks and their worst sin is that they eat lots of fish. To Chaucer, cormorants were symbols of gluttony, and Queen Elizabeth I authorized a bounty on cormorants because they were deemed "ravening birds and vermin." Warming to that theme, Shakespeare described Time, that devourer of life, as an "insatiate cormorant." And to John Milton, the dark bird was the very devil. In *Paradise Lost* he writes that Satan "sat like a cormorant" on the Tree of Life, preparing to bring evil to the Garden of Eden.

On closer acquaintance, one finds these aspersions to be untrue. Cormorants form affectionate couples and are hard-working, devoted parents. Some of them live in large colonies that are fairly harmonious. Most of the world's 30 cormorant species nest in trees or on cliff ledges. The king, or imperial, cormorants of the far south usually breed on cliff-top rookeries, their nests in neat rows, slightly beyond pecking distance from one another. King cormorants have many colonies on the Falkland Islands, and these hardy, adaptable birds have colonies on many subantarctic islands and even on the rim of Antarctica.

I watched king cormorants, or king shags as they are known in Britain and on the Falkland Islands ("shags" because their plumage tends to look shaggy after they dive), for weeks at several Falkland colonies. They were in their breeding finery when they arrived in October during the austral spring. At

King cormorant colony on the Falkland Islands. The cormorants use mud to build elaborate pillar-shaped nests, which are about a foot (30 cm) high. They line the nests with grass, moss, and sometimes feathers. Their nests are arranged in a neat checkerboard pattern, the distance between nests just slightly beyond pecking range.

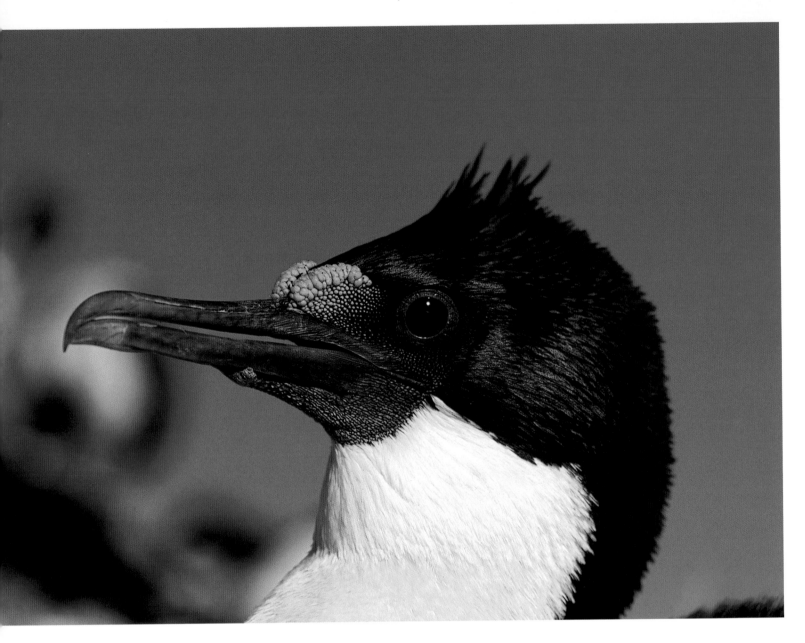

A king cormorant in breeding finery. The purple blue eye ring and bright orange caruncles above the base of the upper bill are at their brightest during the courting season in spring, and fade during summer.

this time their plumage is a metallic blue-black and the eye-ring a bright purple blue. The caruncles above the base of their bills are deep orange, and both males and females sport pert feather crests. As the breeding season advances, the birds' initial ardor fades and so do the bright colors of their spring plumage.

King cormorants seem obsessively fussy about their nests. Where possible, they use mud to build foot-high (30-cm) pedestals with saucer-shaped depressions at the top. They line these nests with grasses, moss, and feathers, if they can find them.

The cormorant grass harvest is fun to watch. Within easy flying distance from one of the Falkland colonies there are thick mats of spiky grass. The cormorants arrive in dark, energetic

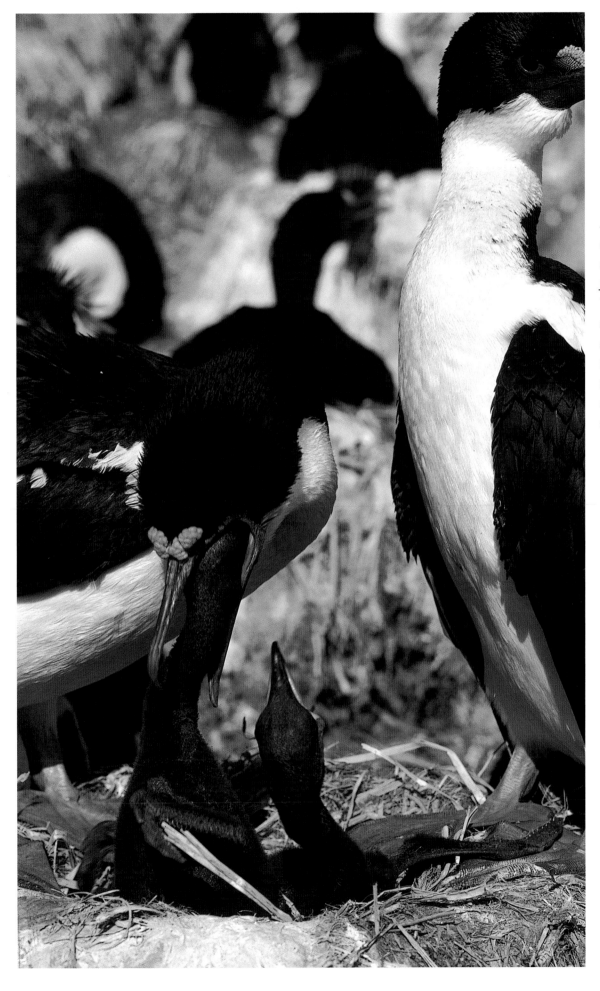

In the vicinity of the Falkland Islands king cormorants hunt for small fish to feed to their chicks. They often spear fish as they swim and then surface to swallow their catch, which they later regurgitate for their young. Each pair of cormorants normally raises two to three chicks.

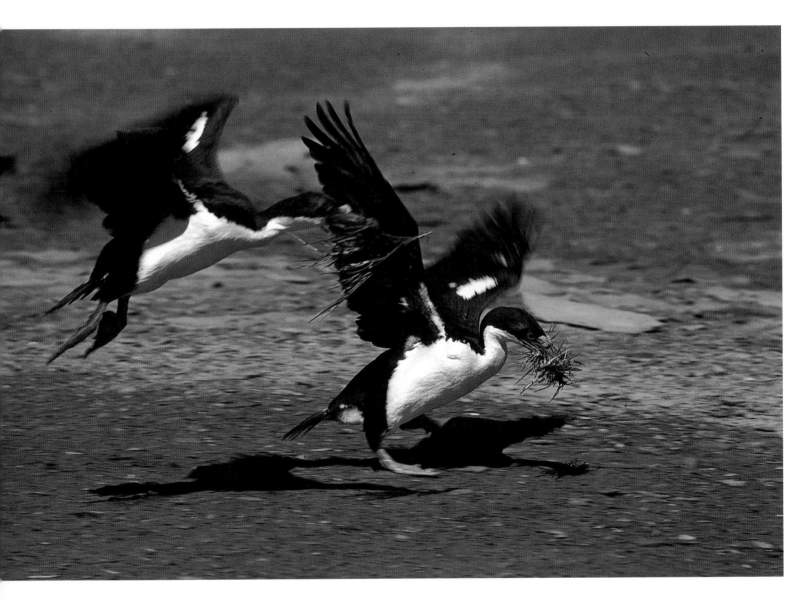

Two king cormorants head home with beakfuls of spiky grass for their nests. Where possible, the birds use mud to build nests that are about a foot high. They then line the top of the nests, which are cup-shaped, with grass, moss, and feathers.

droves. A bird grabs a tuft of the prickly grass with its sharp, strong slender bill and tugs with all its might. It loves to collect more and more grass, but then suddenly realizes it can't fly with such a mass of grass. It stands there, puzzled and annoyed, grotesque garlands of grass dangling from its beak. Finally, it reluctantly leaves some grass behind, and flies off to its nest and mate.

The two birds fuss and fret about that nest for nearly a month and yet a cormorant's nest is almost always a disheveled mess. However, it suits them and they raise two to three chicks in it. The latter

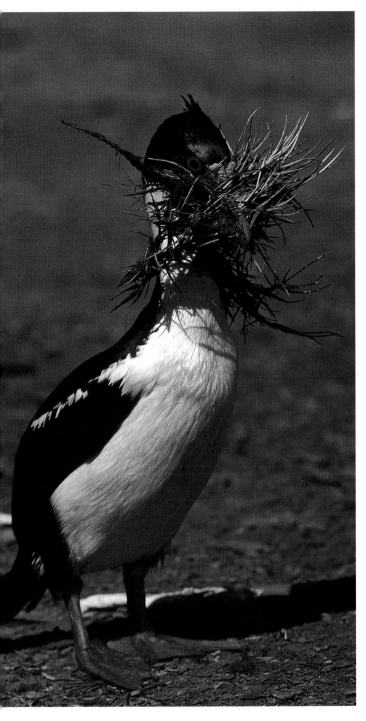

are black with reptilian necks and look bloated, due to their insatiable appetites.

One parent guards the chicks while the other catches fish for them. To make themselves less buoyant when they are fishing, cormorants expel air from their plumage and lie so deep in the water that they look like mini-submarines with raised periscopes. They dive expertly and often deeply, propelling themselves with their broad webbed feet. They use their rapierlike beaks to capture small fish.

Because their plumage is designed for diving and underwater speed, cormorants do not cover it with as much water-repellent oil as do most other seabirds. So between trips to the sea, the birds must dry their feathers. To do this, they sit in groups on their favorite rocks, wings akimbo, like an assemblage of heraldic birds.

The fish-rich waters near the Falklands are the main source of food for the large cormorant colonies. The adult birds feed their chicks with this fish frequently. As a result, the chicks grow quickly. They shed their baby down and fledge when they are about two months old. The adults then return to sea, having fulfilled their parental duties. Their nests, built with so much love and labor, soon become torn and scattered by the Falklands' violent winds.

Its beak crammed with spiky grass, a king cormorant can barely see where it is going. This sharp-edged grass grows in dense mats on the Falkland Islands' hilltops. The cormorants spend considerable time and energy ripping up bunches of grass and carrying them home to line their nests with.

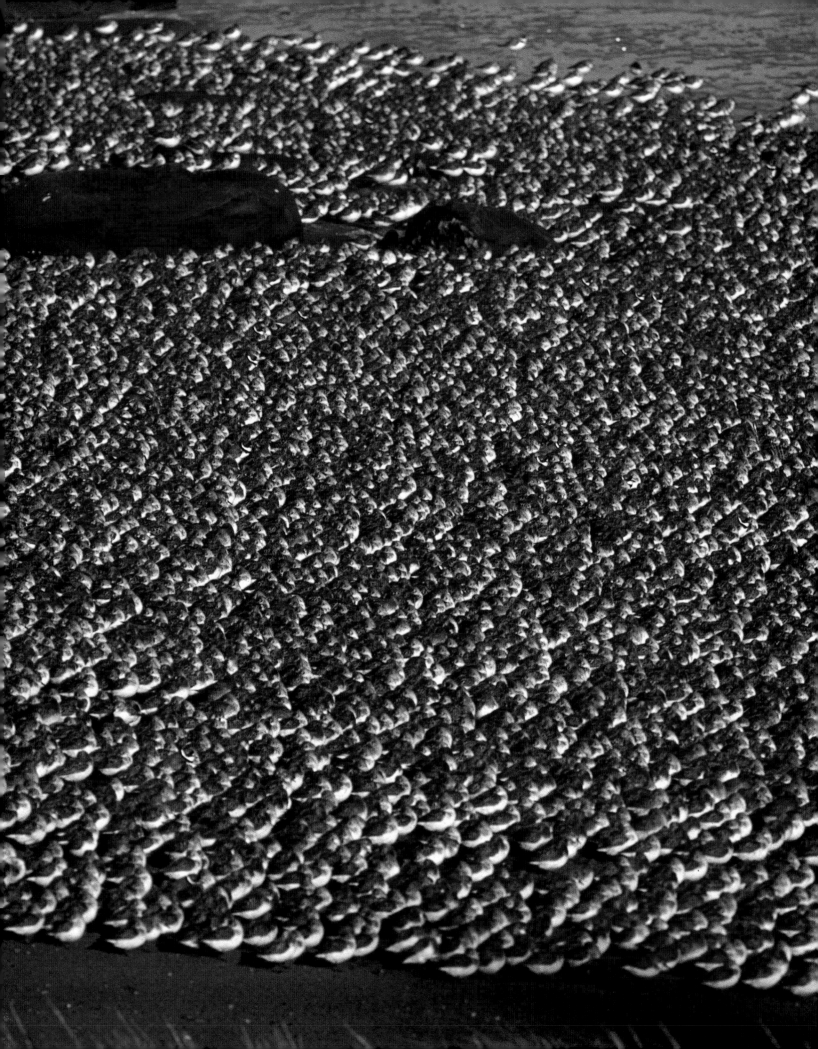

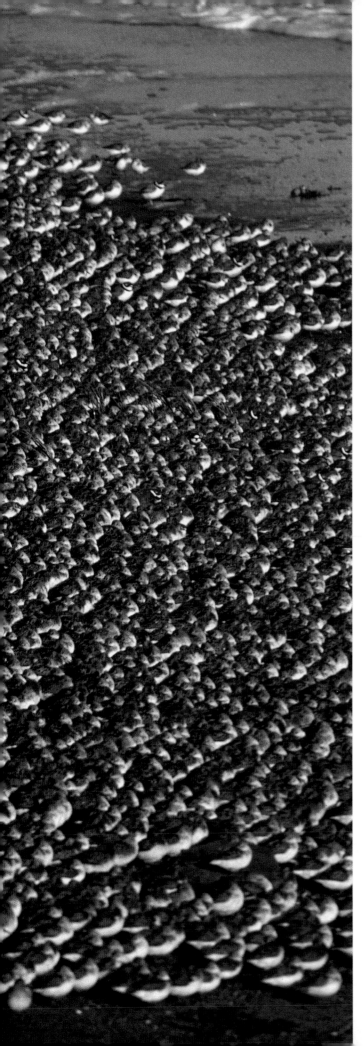

Semipalmated Sandpiper, New Brunswick, Canada

The tides in New Brunswick's Bay of Fundy are among the highest in the world. Twice each day, the rising tide carries 100 billion tons of water into the bay and its basins, which reach far inland, and the water level rises by as much as 50 feet (15 m). And twice each day, at the ebbing of the tide, that immense volume of water streams out of the bay, leaving behind vast mudflats. Every August about 1.5 to 2 million shorebirds feed upon these intertidal mud fields; 95 percent of these birds are semipalmated sandpipers.

The mudflats are home to a host of scavenging amphipods, commonly called mud shrimp. These creatures graze on the rich layers of diatoms and plant detritus deposited twice daily by the receding tide. They are tiny creatures, only one-fifth of an inch (5 mm) long, and they are fussy. To create their home burrows, they need mud of just the right consistency, containing an ideal combination of coarse sand, fine silt, and clay particles. They find this in abundance in the Bay of Fundy, and they live only in this bay and in the Gulf of Maine. With a population density of up to 60,000 mud shrimp per 10 square feet (1 sq m) these lipid-rich crustaceans provide a vital banquet for migrating shorebirds, who stop over in the Bay of Fundy on their way to their wintering grounds.

Most semipalmated sandpipers spend winter along the food-rich coasts of Suriname and the Guianas. On their northward migration in spring, they stop at New Jersey's Delaware Bay to feast on the mass of horseshoe crab eggs, which lie on the beaches there. After about two weeks of feasting,

In the fall about a million semipalmated sandpipers come to New Brunswick's Bay of Fundy to fatten on the immensely numerous mud shrimp. The Bay of Fundy has 50-foot- (15-m-) high tides, and the daily surge of water provides nutrients for the tiny crustaceans, which are the main food of shorebirds. The birds stop over at the bay on the way from their arctic breeding grounds to South America.

they double their weight. Once they have fattened up, they fly nonstop to their arctic breeding grounds.

The male arrives first and tries to set up home at or very close to the exact spot where he and his mate reared a family during the preceding summer. He makes a shallow nest in the tundra soil, lines it with bits of moss, lichens, and leaves, then waits. If all is well, his mate will join him in about five days at the nest site, which is a symbol of their life-long matrimony.

The female lays four eggs, and both parents incubate them for 18 to 21 days. Within hours of hatching, the chicks become self-supporting. They rush through the tundra grass, where they occupy themselves by eating tiny insects. When the chicks are between 4 to 10 days old, the female leaves and heads for the Bay of Fundy. The father remains for a few more days with the chicks and huddles them when they are cold. The males then fly south. As soon as the chicks have acquired enough fat and feathers to make the flight, they follow their parents to the shrimp feast on the Bay of Fundy's mudflats.

Once the chicks arrive, there are a million or more semipalmated sandpipers (more than half the world's population) at the Bay of Fundy. As the tide ebbs, the birds follow the receding water and peck up greedy shrimp that fed too long on top of the food-rich mud instead of crawling into their burrows. The birds are busy. Each one consumes 20,000 to 40,000 mud shrimp every day. When the semipalmated sandpipers arrive at the Bay of Fundy, they weigh a meager .7 ounce (20 g). After two weeks of feasting on shrimp, each bird will have doubled its weight. Most of the weight gain is fat: fuel for the 2,500-mile (4,000-km) flight to its South American winter quarters.

At high tide, the sandpipers mass on their favorite sandbanks and beaches, to rest and digest the masses of shrimp they have gobbled up. They stand close together. Roosting on one leg with their

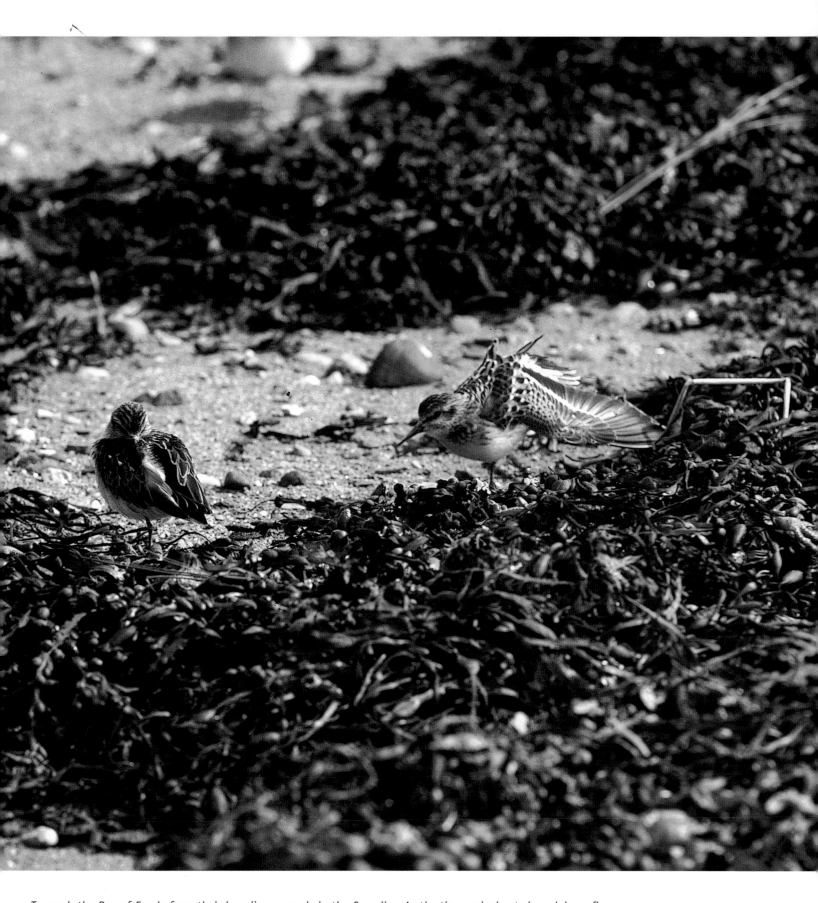

To reach the Bay of Fundy from their breeding grounds in the Canadian Arctic, the semipalmated sandpipers fly 930 miles (1,500 km) nonstop. When they arrive at the bay, after making this arduous flight, most of the birds weigh about an ounce (28 g). However, within 10 to 20 days of feeding on the numerous and fat-rich mud shrimp, the birds double their weight. They use their new reserve of fat to fuel their flight to Suriname, where they will spend the winter.

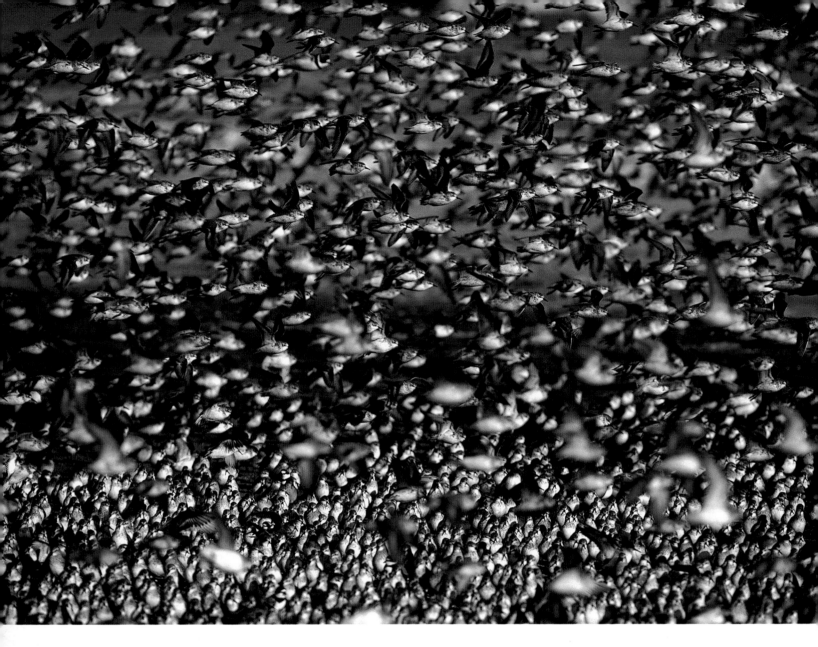

heads tucked over their shoulder, they form a grey-brown speckled carpet of birds. Yet some birds in the roost always remain alert. If these guards spot an approaching enemy, such as a falcon, the entire flock will suddenly take flight; these intricate mass flights are a wonder to behold.

During the August I spent at the Bay of Fundy's Cape St. Mary's, a favorite roosting area of semipalmated sandpipers, the flock there numbered about 150,000. Dr. Mary Majka, a famous ornithologist who lives at Cape St. Mary's, told me she had once seen a flock of more than half a million birds.

The sandpipers peel off the beach with a whir of wings that rises to a crescendo. A hundred thousand birds fly in unison with uncanny precision. They rise and fall wing tip to wing tip. They veer and sheer just above the water in total

synchrony. This cloud of birds turns from dark to flashing white as backs or bellies are turned to the observer. It is an exquisitely choreographed aerial ballet—with a cast of 100,000.

It is precisely this whir and blur of rushing birds that makes it nearly impossible for a predator to concentrate upon a single victim.

The sandpipers arrive at the Bay of Fundy en masse, starting in late July, and they leave en masse within 10 to 20 days, having doubled their weight. In the evening flock after flock rises, flying higher and higher, sometimes to an altitude of three and a half miles (6 km). The birds head far out above the Atlantic to seek the help of trade winds. Keeping on a south–southeast course and maintaining an average air speed of 37 miles per hour (60 km/h), they fly the 2,500 miles (4,000 km) to Suriname nonstop in 50 to 70 hours.

With a stormlike whir of their wings a large flock of sandpipers rushes into the air, having been alarmed by an approaching peregrine falcon. These mass flights of densely packed birds make it nearly impossible for a raptor or a gull to zero in on one victim. For the sandpipers, there is thus safety in numbers.

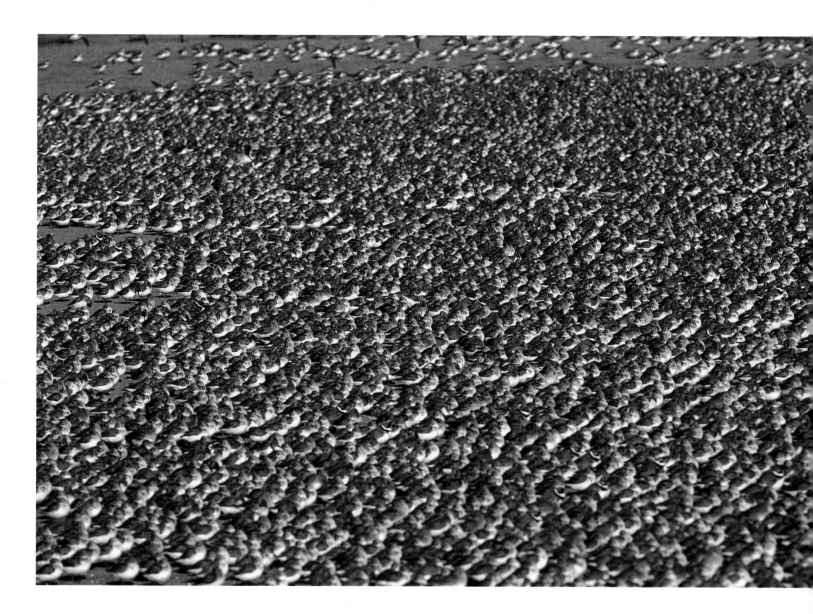

A large flock of semipalmated sandpipers covers the beach roost at Cape St. Mary's in the Bay of Fundy. Such flocks often number 100,000 birds and, on rare occasions, a single flock may consist of more than half a million birds.

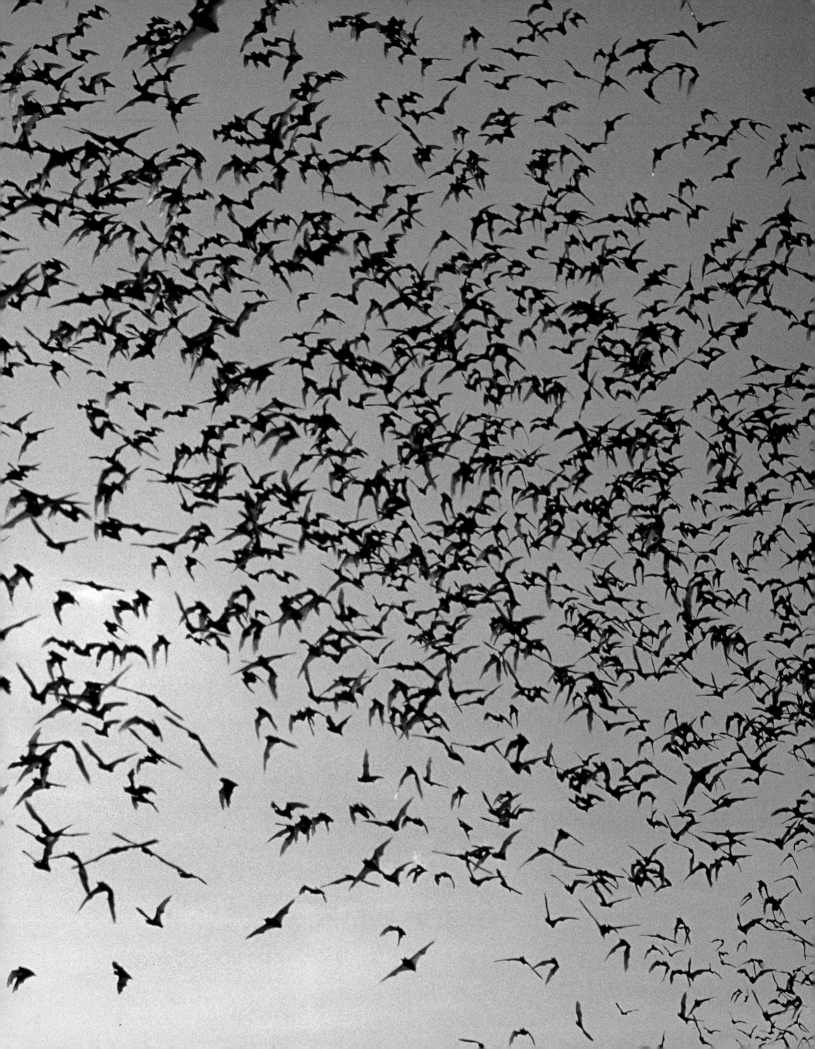

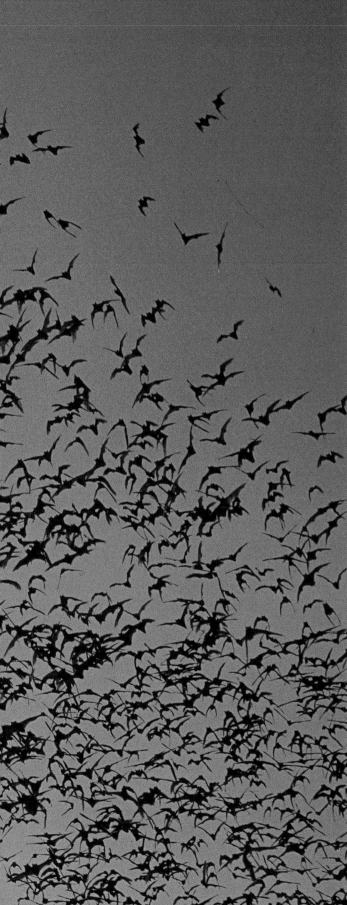

Mexican Free-Tailed Bat, Texas, U.S.A.

At dawn about four million female bats return from a night's foraging to their maternity cave in central Texas. They have come back to nurse their tiny pink pups, as baby bats are called. I stand in the oval entrance to the cave, which is not quite as big as a barn door, and as the sky lightens, millions of bats streak toward me at speeds of up to 60 miles per hour (100 km/h), brake at the last moment, and rush past me into the cave with a sibilant rustling of wings.

This is both an eerie and a marvelous spectacle. It represents precision flying at its best. It's as if a thousand lanes of high-speed traffic have converged upon the mouth of a single tunnel. The bats very rarely touch one another, and they rarely touch me, despite the fact that I am an unexpected obstacle in their flight path.

These are Mexican free-tailed bats—among the fastest flyers of all bats and probably the most numerous bats in the world. They winter in Mexico and in the spring the pregnant females return to the bats' age-old maternity caves. About 10 of these caves are in Texas, the most important of which is the Eckert James River Bat Cave near Mason in central Texas. This is the cave I visited.

For half an hour after birth the minute, hairless pup clings to its mother. She cleans it, nurses it, and bonds with it, absorbing its distinctive smell and sound. Then she adds her tiny pup to the fast-growing crèche upon the cave walls, which is covered by several million other baby bats; they are packed together at a density of about 2,000 pups per 10 square feet (1 sq m).

I did not enter the maternity cave. It disturbs the bats, and it could result in a particularly

Millions of Mexican free-tailed bats rush out of their cave in central Texas. They are all females. They will hunt insects throughout the night, flying as high as 10,000 feet (3,000 m). At dawn they all return to the maternity cave to feed their tiny pups, as baby bats are called.

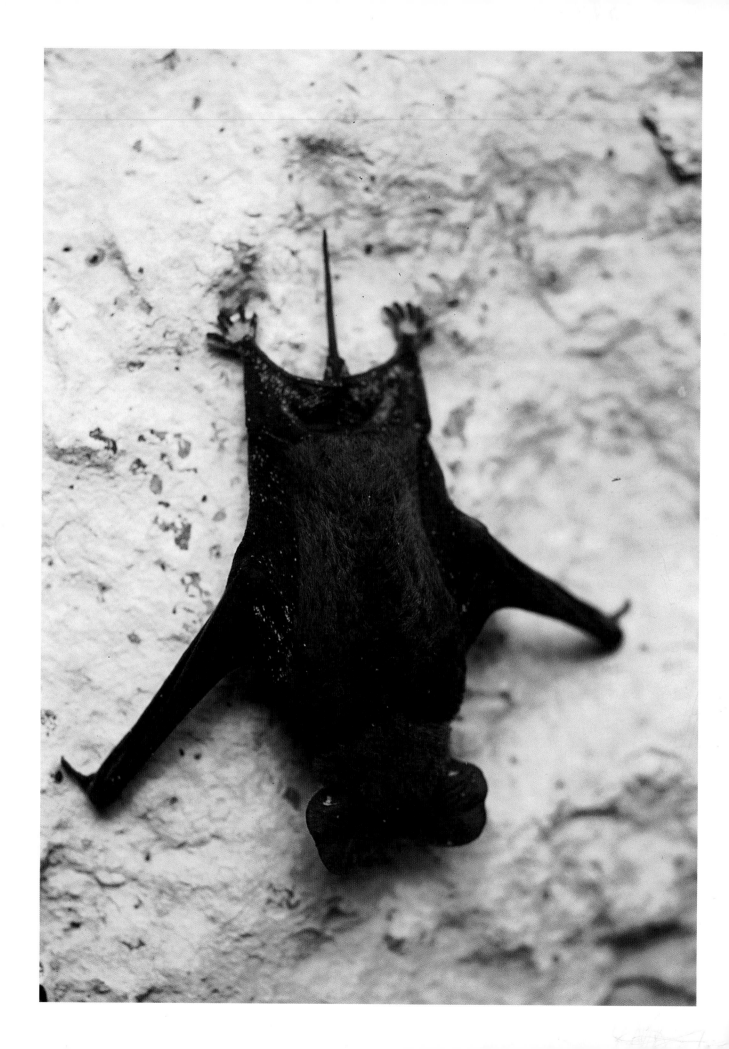

A Mexican free-tailed bat clings to the limestone wall near the entrance to her cave. The body of these bats is only thumb-sized, but they have an 11-inch (28-cm) wingspan. They are the fastest bats in the world, built for high-speed flight over long periods of time.

Four million female bats soar high into the evening sky, making a sound like a rushing river as they do so. During the night, each bat will eat its weight in insects. This adds up to about 4,000 insects per bat. In total all the bats of this colony eat roughly 50 tons of insects every night and are thus a great help to the farmers of the region.

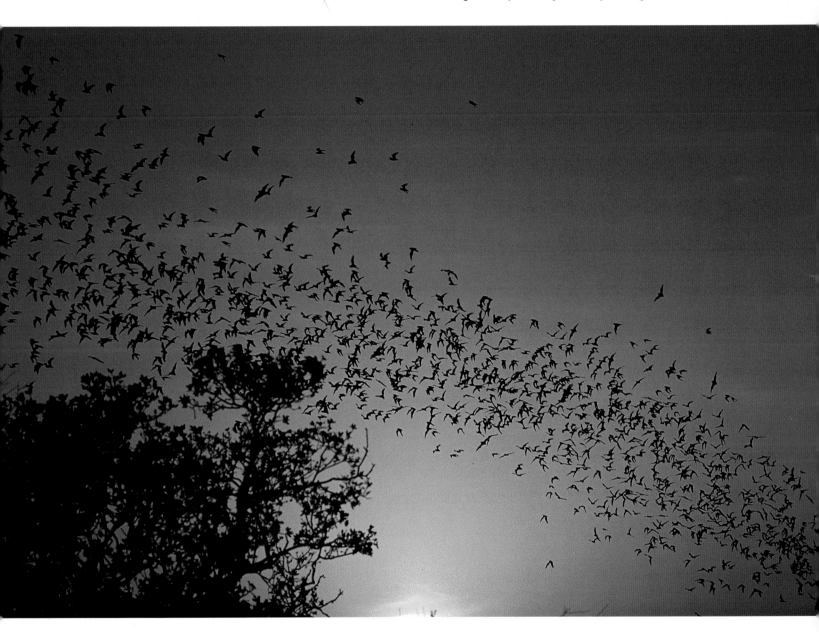

unpleasant death: ammonia fumes from bat guano and urine can be lethal or cause a human intruder to faint. The cave floor is covered with black carnivorous beetles and their equally carnivorous larvae. Any bat that falls is consumed in minutes. In the case of a fainting human the beetles would first eat the softest body parts, starting with the eyes.

During the day, the female bats rest and periodically nurse their pups. At about 7:00 p.m. masses of excited bats begin to circle the walls of the high-domed cave, flying counterclockwise. Their high-pitched chittering fills the evening air. Once the swirling mass of bats has become densely packed, the bats rush up and out of the cave mouth. They form a dark whorling mass, which looks like a column of smoke from a distance.

They fly fast and high, rising rapidly into the night sky. The bats prefer to hunt at an altitude of between 2,300 and 10,000 feet (700 and 3,000 m). They eat high-flying insects like corn borer moths.

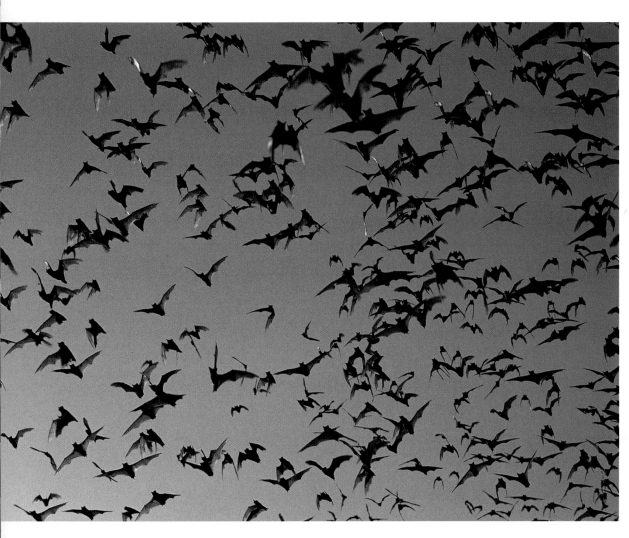

Immense clouds of bats emerge from the maternity cave in Texas at dusk. They rise into the sky in columns that are so dense, they look like smoke from miles away. Precision-flyers, the densely packed bats very rarely touch one another. They spread over an area of more than 390 square miles (1,000 sq km) and hunt nocturnal insects, including moths, beetles, flying ants, and mosquitoes.

Nearly free-falling from an altitude of more than half a mile (1 km), four million female bats rush at dawn to the narrow entrance of their maternity cave. Here millions of hungry baby bats wait for them.

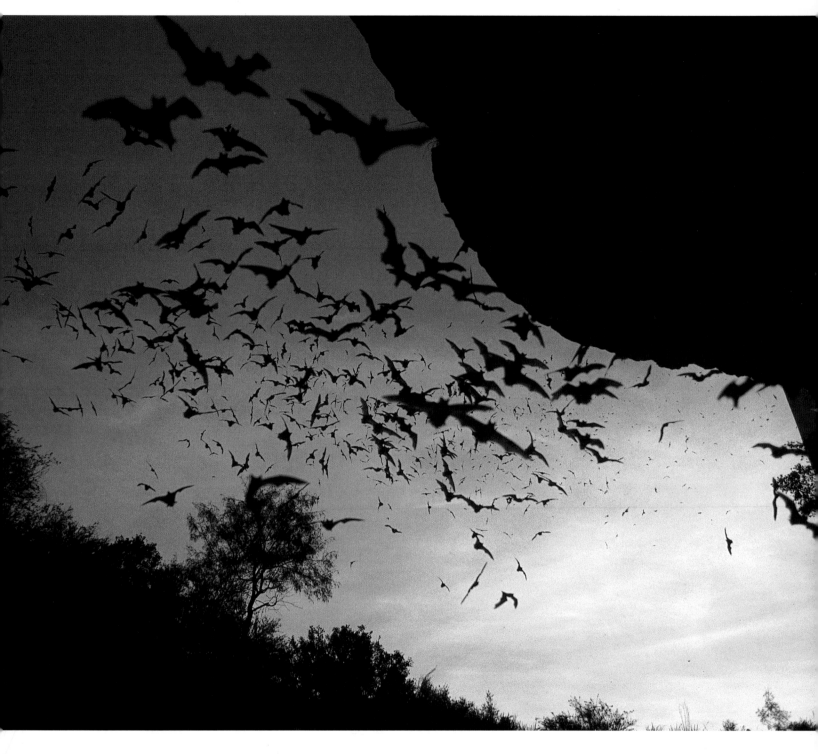

Each bat consumes about its weight in insects; in their millions, the bats of this one colony eat roughly 75 tons of insects every night, many of them agricultural pests.

Once pursued with superstitious fear and loathing (bats' breeding caves were sometimes dynamited in the past), the bats are now seen as marvelous animals and as a farmer's best friend, since they eat insects that would otherwise destroy crops. As a result, most caves are now rigorously protected.

The Eckert James River bats hunt high and far above the farms and ranches of central Texas, flying for about eight hours every night at a rate of ten wingbeats per second. With the first gray light of dawn, they race back to their cave. From a height of nearly half a mile (1 km), they drop toward the entrance of the cave, a mere hole in a modest hill. The scattered legions now form a dense stream, and the black column of bats that rushed out at night is sucked back into the cave again, where millions of hungry baby bats are waiting for their mothers.

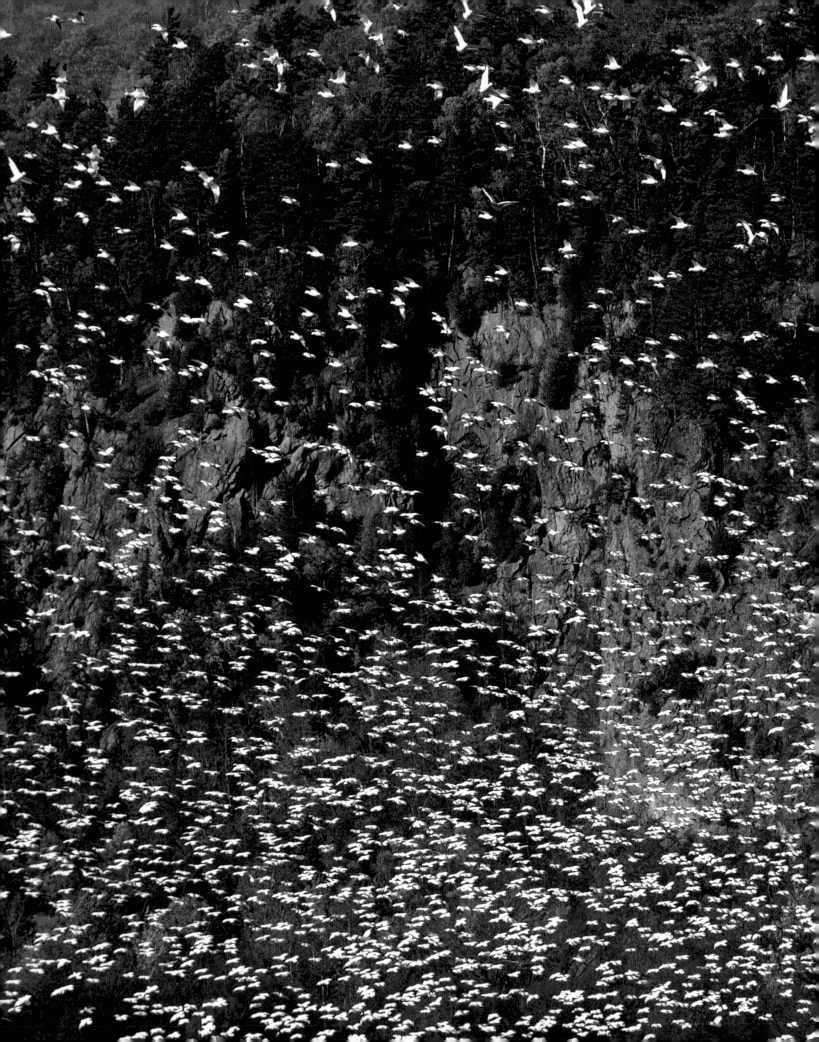

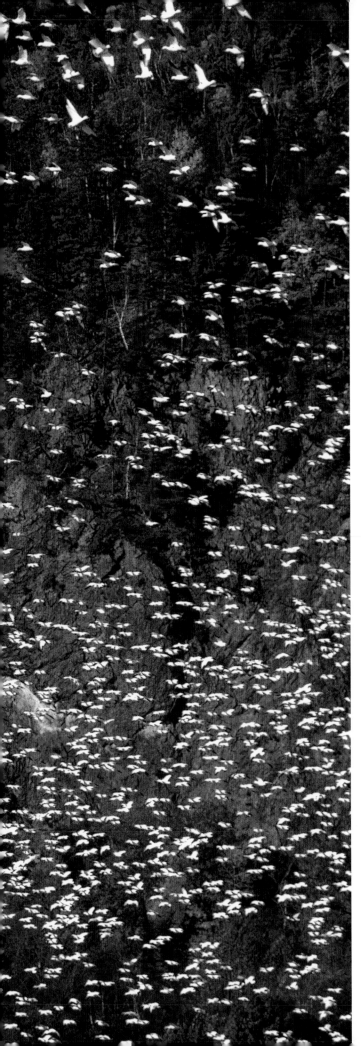

Greater Snow Goose, Quebec, Canada

A century ago, the greater snow goose seemed fated to follow the dodo, the great auk, and the Labrador duck into extinction. Once it had existed in vast numbers. When Jacques Cartier ascended the St. Lawrence River in 1534, he was awed by the spectacle of geese and other waterfowl "beyond count." But later, though safe in their high arctic breeding grounds, the greater snow geese ran a deadly gauntlet of gunners in Quebec and in the New England states, where they spent late fall, winter, and spring. The snow goose, wrote the famous bird painter John James Audubon, "affords good eating when young and fat." (Unlike most artists, Audubon sometimes ate his models.) By 1870, the greater snow geese were rather rare in New England, and by 1900, only about 3,000 of these magnificent birds remained. "Their chances for extinction are good," concluded the American ornithologist Edward Howe Forbush.

Fortunately protection from the U.S. and Canadian governments came just in time, and with that help, the prolific and long-lived greater snow geese staged a comeback: their numbers rose from 3,000 in 1900 to 10,000 in 1937, to 200,000 in 1976, to about 300,000 in 2001.

Taxonomists divide the snow goose, into two subspecies: the greater and the lesser snow goose. The lesser snow goose is smaller than its cousin and inhabits different areas. It breeds in the central and western Arctic and winters in the southern States. Intelligent and opportunistic, lesser snow geese have recently discovered the blessings of agriculture—they like to harvest farmers' fields.

A blizzard of greater snow geese above Cap Tourmente on the north shore of the St. Lawrence River, 40 miles (65 km) east of Quebec City. Greater snow geese breed in the High Arctic of eastern Canada and northwest Greenland. The adult birds and fledged goslings migrate in stages to the food-rich St. Lawrence River valley, where they usually arrive in early October.

A plump immature greater snow goose on a field near Cap Tourmente, Quebec. The young birds migrate here with their parents, who remain on the look-out for predators while the young feed.

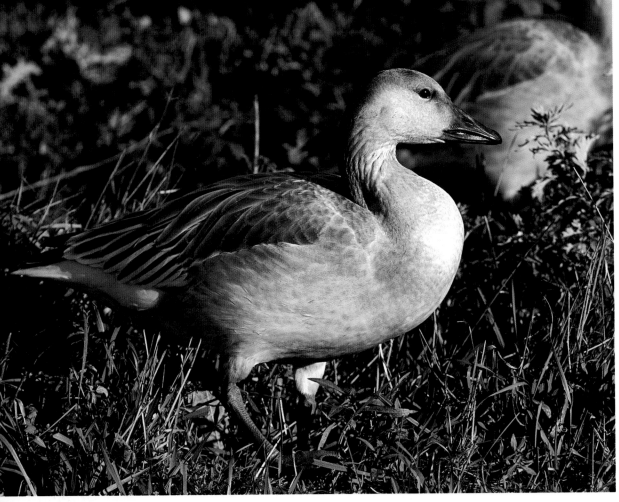

Greater snow goose parents and their recently hatched downy goslings on Somerset Island in Canada's High Arctic. The adults lead their young up a small brook to a tundra lake, where they can feed on the sprouting grasses and sedges that surround the lake.

Thousands of greater snow geese fill the sky at Cap Tourmente. They feed on nearby fields or, at low tide, on the extensive mudflats of the river. Here they cut marsh grass with their strong, serrated bills, or tear out the nutrient-rich rhizomes of sedges.

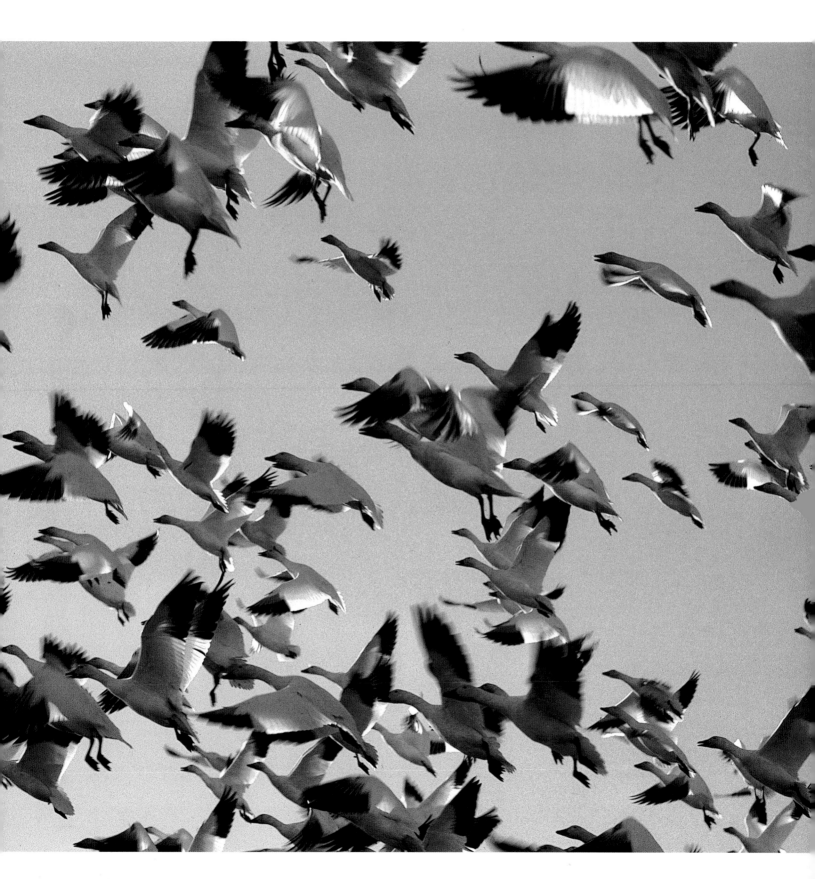

Thanks to this abundant food source, their numbers have soared from one million in 1970 to six million in 2001.

The greater snow goose is a powerful bird: males weigh up to seven and a half pounds (3.4 kg) and have a wingspread of slightly more than five feet (1.5 m). Adults are almost pure white, only their wing tips are black. Their bills are rosy pink and sharply serrated to cut the roots and hard marsh grasses the geese like to eat. These serrations form a dark arc in the bill, which is called a "grinning patch."

As their population figures indicate, life has been good for the greater snow geese lately. During the summer they nest in the High Arctic, right up to northern Ellesmere Island and northwestern Greenland, less than 1,000 kilometers from the North Pole. The female builds the nest, lines it with warm light gray down from her breast and belly, and then incubates the eggs. The gander stands on guard nearby ready to batter any brash arctic fox that ventures too near the nest.

The goslings hatch between July 10 and July 15 after an incubation period of about 25 days. They are little tufts of golden brown down with dark legs and dark bills. As soon as they are dry, they leave the nest and begin to eat tender grasses. They feed for about 20 hours every day and grow as fast as they can, for summer in the very Far North is extremely short. Six weeks after they hatch, they must be ready to fly south with their parents.

The geese's main staging area is on both sides of the St. Lawrence, downriver from Quebec City. One of their favorite spots is Cap Tourmente on the north shore, a 1,570-foot- (480-m-) high outcropping of rock overlooking the St. Lawrence River. (Cap Tourmente is 40 miles [65 km] east of Quebec City.) Beneath the Cap are fields and lush tidal flats, which contain the birds' favorite food, the nutrient-rich rhizomes of the sedge *Scirpus americanus*. The geese use their serrated bills to cut

the harsh sedges, and they plunge their heads deep into the muck to yank out the rhizomes. After a while, the iron traces in the mud turn their heads a rusty orange color.

Across from Cap Tourmente, on the south shore of the St. Lawrence, is the town of Montmagny, another favorite spot of the greater snow geese. At low tide, they feed far out on the immense tidal flats here—white birds with muddy heads, plucking rhizomes out of the ooze. High tide pushes them to shore and thousands of the birds mass near the pier. People stop and stare, but this does not worry

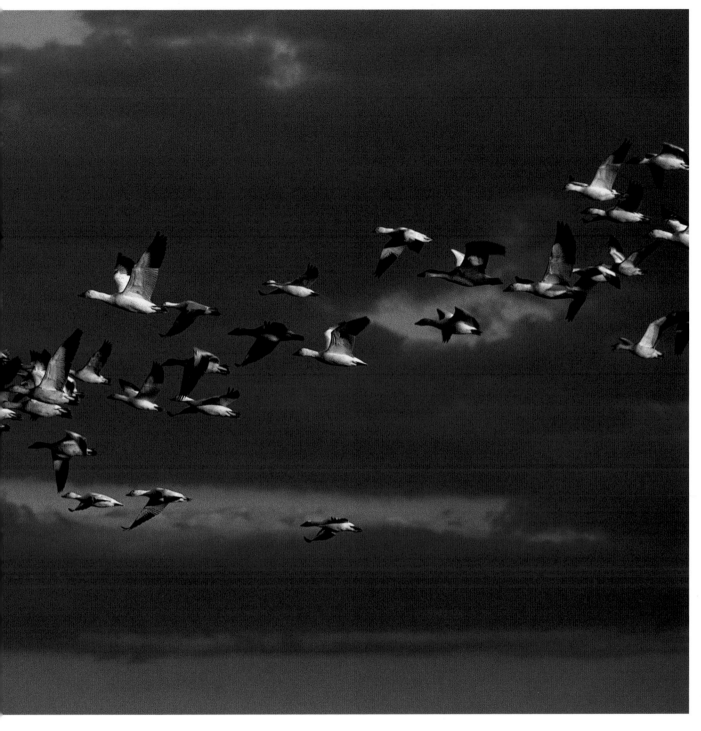

the geese. They know that people on piers tend to be harmless. At high tide a ferry leaves from this pier for an island in the St. Lawrence. In 1663, a Jesuit priest passed this island and, because it "appear[ed] completely covered with geese," he called it *L'isle aux oyes blanches*, "the island of the white geese." The geese still stop there on their southward migration, and the name of the island is now *L'île aux Oies*, "the island of geese."

Geese return to the Cap Tourmente sanctuary at sunset. Most greater snow geese arrive at this feeding region in early October. They leave in early November, heading south to spend the winter along the eastern seaboard of the United States.

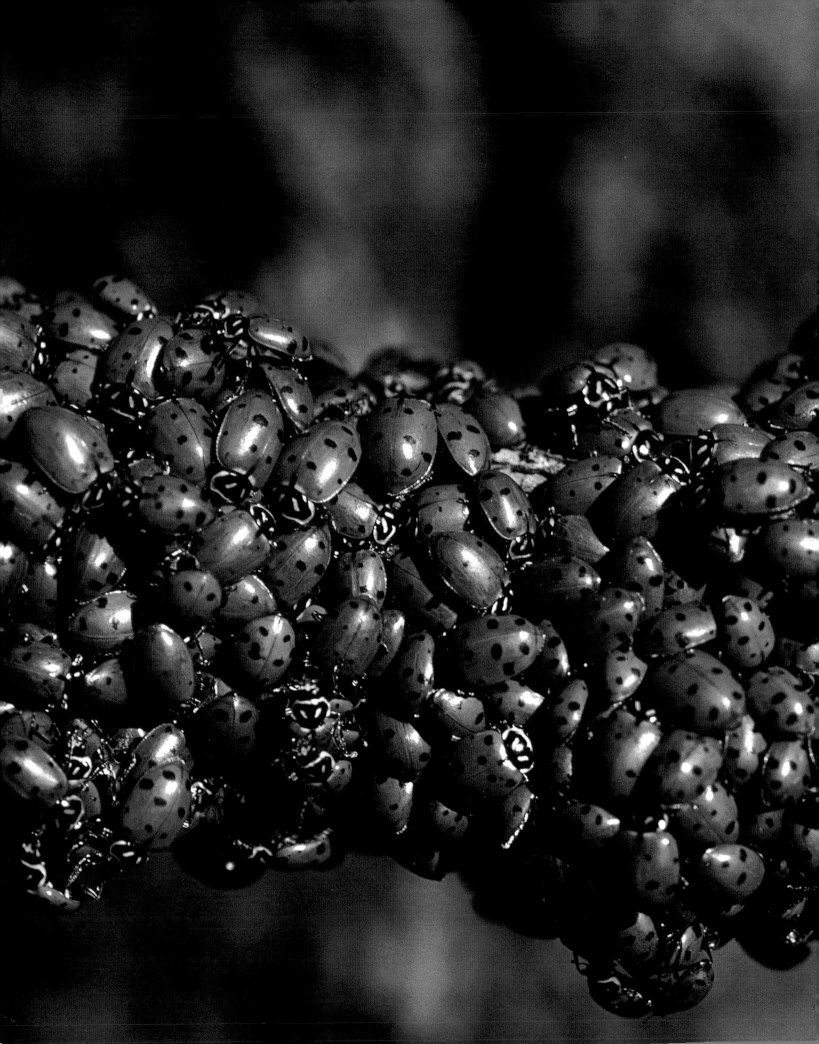

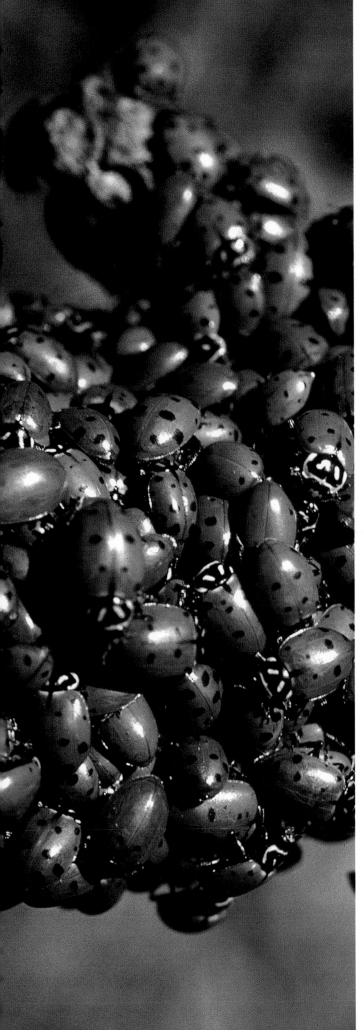

Ladybird Beetle
or Ladybug,
Arizona, U.S.A.

Summers are hot in Arizona. By mid-June,
humans rush from their air-conditioned homes in
air-conditioned cars to their air-conditioned offices.
When the temperature soars past 104°F (40°C)
and stays there for at least three days, ladybird
beetles leave the deadly heat of the desert and fly
by the millions to their cooler summer quarters in
the Santa Catalina Mountains. There they rest
quietly, or estivate, in comfort near the summit
of Mount Lemmon at an altitude of 7,500 feet
(2,500 m).

It was 118°F (48°C) on the day in June when I
set out from Tucson to observe the beetles at their
summer quarters. As the road switch-backed high
into the mountains, it became pleasantly cool. The
ladybird beetles usually gather near clearings in the
forest. Each beetle is only .16 to .23 inches (4 to
6 mm) long. But millions of them gather together
and cover branches, leaves, rocks, and the lower
trunks of the stately Ponderosa pines in a solid
layer. From afar it looks like a lacquered forest,
wine red in the shade, a brilliant scarlet when
touched by a ray of sunshine.

The beetles prefer shaded areas at the edge of
clearings, and mountain men tell me the insects
return each year to exactly the same location.
They are immensely numerous. In one study,
entomologists gathered 600 gallons (2,270 L)
of ladybird beetles, with about 70,000 beetles
per gallon, or about 42 million beetles from a
single group, or aggregation.

It is lovely in the forest. The wind soughs softly
in the tall pines, birds search for insects in the
trees, ants scurry busily across the forest floor. But
none of these creatures touches the massed beetles.

*To escape the intense summer heat of Arizona, ladybird
beetles fly up to the cool Santa Catalina Mountains. There
they rest in tightly packed groups, which contain millions of
them. They move sparingly and live off their fat reserves. Here
the beetles cover the dead branch of a Ponderosa pine.*

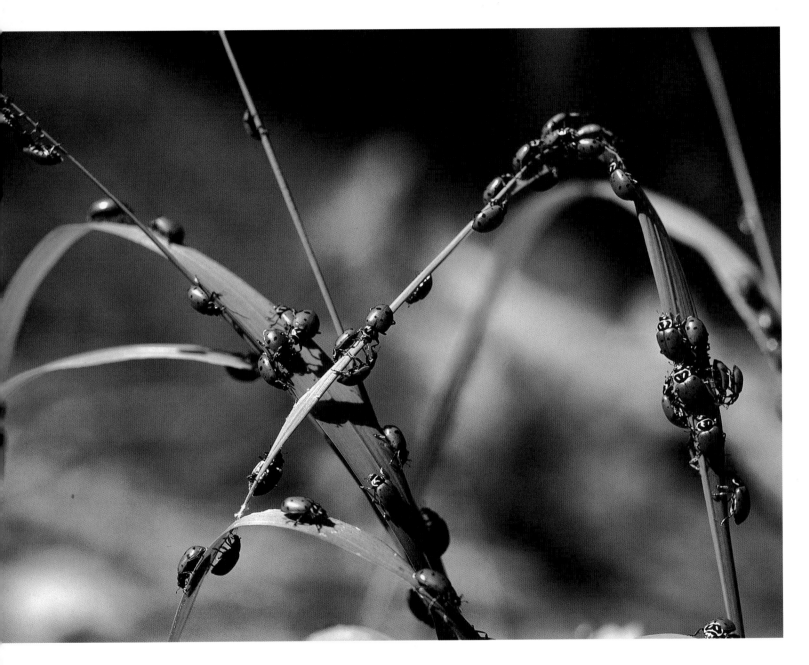

Ladybird beetles in a maze of grass blades. On warm sunny days in the mountains, some of the millions of estivating beetles become active, disperse and crawl up blades of grass. The beetles are small, only .16 to .23 inches (4 to 6 mm) long, and their legs are tiny; yet they move so quickly that they seem to glide up the blades.

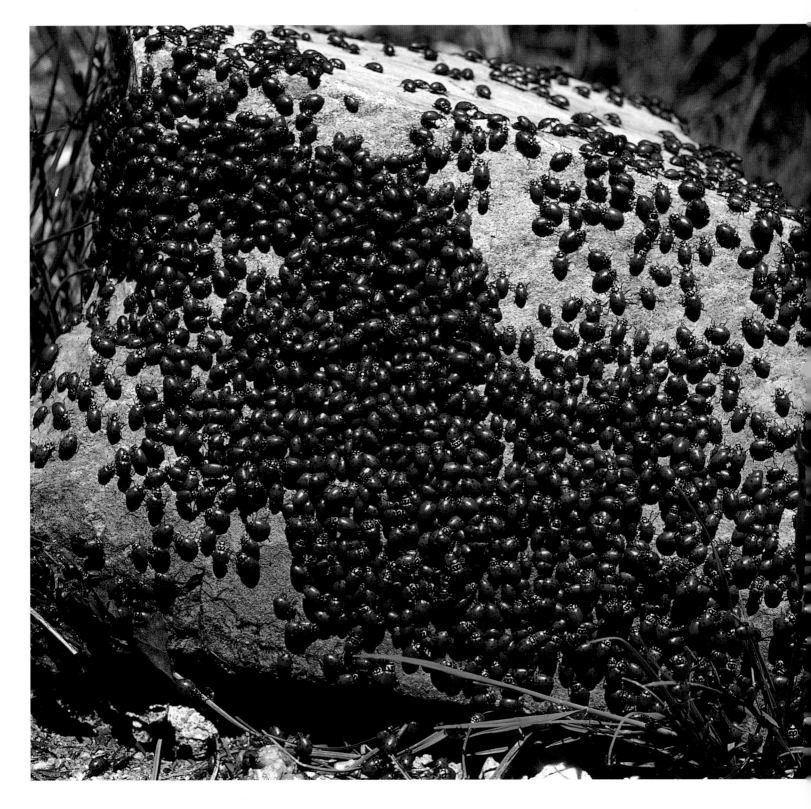

Ladybird beetles return to the identical estivation sites in
Arizona's Santa Catalina Mountains each year when the
plains' temperature begins to rise above 104°F (40°C). Before
migrating, the beetles feed voraciously on aphids to amass
fat, which will fuel their flight to the mountains and provide
an energy reserve during the foodless months of estivation.

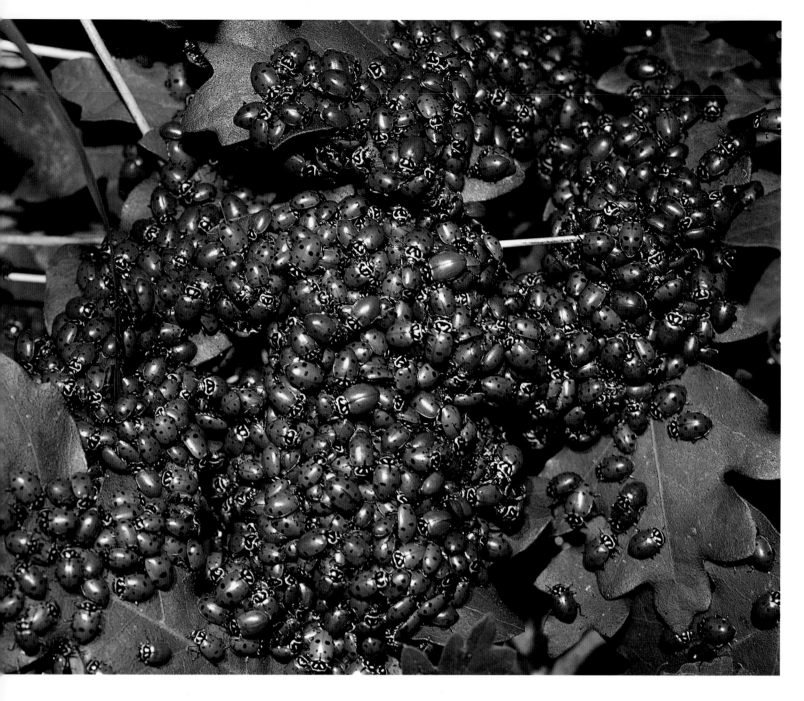

Ladybird beetles cluster upon oak leaves near the summit of Mount Lemmon in Arizona's Catalina Mountains. Escaping the heat of the plains, the brightly colored beetles summer on the cool mountains in dense aggregations that number tens, perhaps even hundreds, of millions.

Their vivid color carries a warning: "Don't eat me! I taste awful!"

To emphasize the message, a threatened ladybird beetle exudes tiny droplets of yellowish blood from its knee joints, between the femur and tibia. It has an acrid smell. I touch a beetle with my tongue and the blood does indeed taste vile.

Ladybird beetles are nature's premier pesticides. There are about 4,000 species of these beetles in the world. A few species eat plants, including one with 24 spots and a tongue-twisting Latin name, *Subcoccinella vigintiquatuorpunctata*. The latter dines on clover. Most species are carnivorous, and their favorite food is aphids, which makes these

End of the road. Thousands of ladybird beetles, who become active on warm days in the mountains, scurry up grass blades. At the tip they cluster, as if uncertain what to do next. Then some descend and others fly off. In the cool of the evening, all the active beetles return to their estivation aggregations and snuggle so close to other beetles that they form a layer and become immobile.

ladybirds the darlings of aphid-plagued farmers and gardeners. They also feed on other pests, especially scale insects and noxious mites. Both adult beetles and their brightly colored larvae are voracious.

The female ladybird lays her yellow, elliptic eggs in tight clusters of 25 to 50 on the underside of leaves, favoring plants infested with aphids so that when her larvae hatch they will have lots to eat. In the three weeks before it pupates, each larva eats several hundred aphids and the 10 million larvae that may live upon one acre (.4 ha) of alfalfa consume a huge mass of aphids.

The ladybird's beneficial role was recognized early on. During the Middle Ages, these beetles rid gardens and grapevines of pests. In appreciation the French referred to them as *la bête du bon Dieu* ("the creature of the good Lord"). In Britain they were named after "Our Lady," the Virgin Mary.

Most of the estivating ladybird beetles form tight clusters and remain inactive in the mountain clearings, harboring their fat reserves. Toward noon it becomes quite warm, and thousands of the insects leave the aggregations. Many crawl busily up grass blades. Despite their tiny legs, they move quickly. As I lie in the grass and watch them, they crawl onto my hands, reach my fingertips, hesitate a moment, and then fly off. There is an ancient belief that ladybugs bring luck.

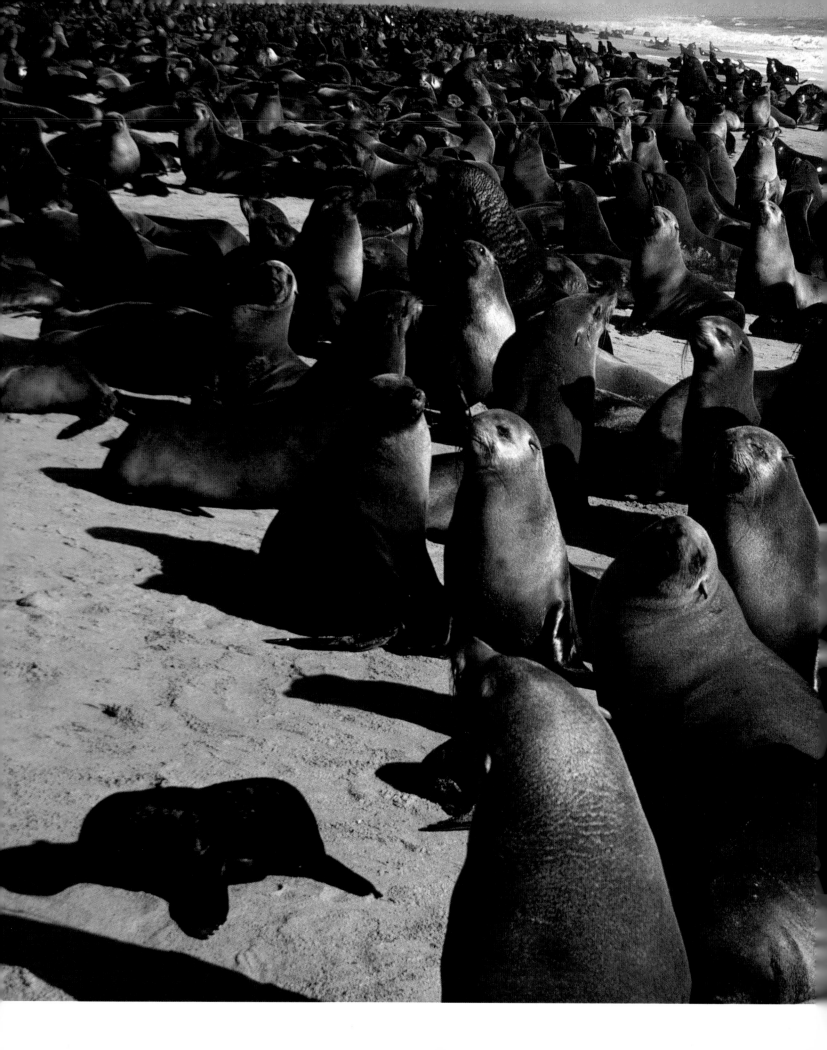

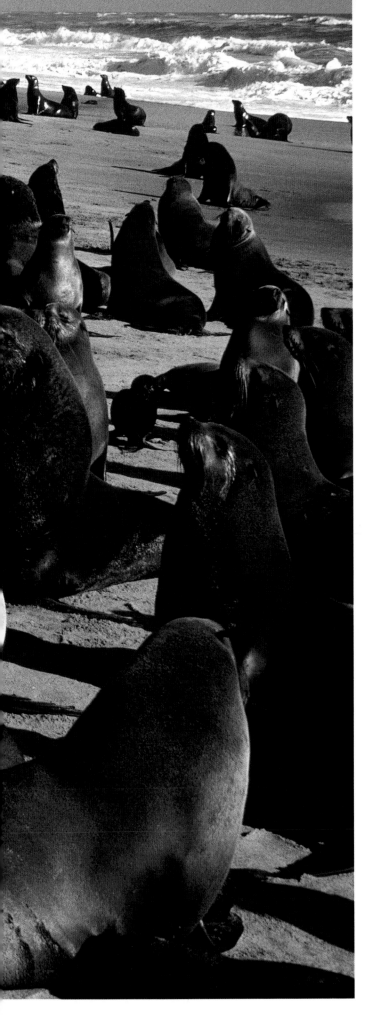

Cape Fur Seal, Namibia, Africa

February 3, 1488 was a black day for fur seals and penguins. Both were discovered by Europeans on that day, and it was a harbinger of worse things to come.

On that fateful day, the Portuguese explorer Bartolomeu Dias, who was sailing down the coast of southern Africa, sailed into a bay he called São Brás, now Mossel Bay. He later wrote, "Within this bay is an islet on which are many very large seals... and birds that cannot fly [and have] the voice of an ass braying." The Cape fur seal (or South African fur seal) and the black-footed penguin had been discovered, and being discovered, history shows us, is nearly always disastrous for the natives, be they humans or animals.

Eleven years after Dias found the seal island, Vasco da Gama, en route to India, stopped there. He counted 3,000 seals, and "for our amusement... [he and his crew] fired among them with bombards."

The Cape fur seal is the largest of all fur seals and the only pinniped of southern Africa. At the time of its discovery and for several centuries afterward, it lived on most of the 47 islands that lie off the coast of southern Africa. These islands are washed by the chilly and fish-rich Benguela Current, and the fur seals could thus remain cool there. On the islands, they were also safe from land predators, the two main ones being lions and Bushmen.

The coasts were then patrolled by Strandloper Bushmen, a now extinct group of Bushmen who lived along the sea. Lions were common in all of southern Africa. The fur seals were safe on their islands, but could not form mainland colonies because of these land predators.

The great colony of Cape fur seals at Cape Cross, Namibia. Cooled by the Benguela Current, the coast here is perfect for the thick-furred seals. The male animals arrive first on the beach, fight for territories, and later jealously guard them and the harems of females that come with the territory.

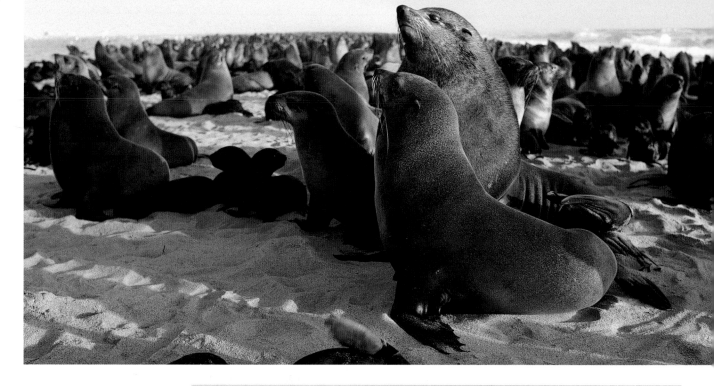

Cape fur seal pups play in the sand at the edge of the rookery at Cape Cross, Namibia. A few days after they are born, the pups leave the crowded colony, where they are in danger of being trampled by massive males. They form pup pods at the edge of the rookery. Here they play a bit and sleep a lot.

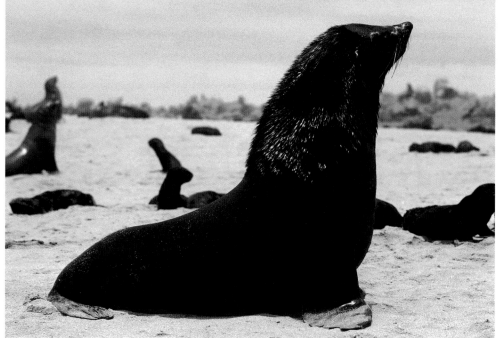

A young male Cape fur seal. (These seals are also called South African fur seals.) They have 24 rookeries in southern Africa, some on offshore islands, but the largest ones are on the mainland. Young males skirt the great colonies, avoiding fights with dominant males but hoping to intercept straying females. Unfortunately for them, this rarely happens.

In the 1820s, thick layers of guano were discovered on the fur seal islands, which were also home to colonies of seabirds. It was "the richest manure in the world," the "white gold" of Africa. Mining guano was messy but lucrative. In England the stuff was worth 10 pounds sterling a ton at a time when a 300-ton ship could be bought for 2,700 pounds sterling.

It was a tough time for the fur seals. They were hunted for their marvelous fur and their breeding islands were being stripped of guano by hordes of miners. Two things saved them: the elimination of

A bit unsteady on its oversized flippers, a recently born fur seal pup leaves the rush and roar of the great rookery. Pups rest at the edge of the colony in chummy pup pods. When a mother returns from feeding at sea, she calls loudly for her pup. It answers immediately and eagerly, for the call means milk. The female then comes to her pup, identifying it by its voice and smell. Moments later the pup is nursing.

Bushmen and lions, and the discovery of diamonds.

In 1908, large deposits of diamonds were discovered in Namibia, then a German colony. To forestall a free-for-all diamond rush, a 21,182-square-mile (54,861-sq-km) coastal zone (a region nearly twice the size of Belgium) was declared off limits to all but a few authorized humans.

Fur seals discovered this restricted diamond area and moved in. They settled in several colonies. They also formed an immense breeding colony at Kleinzee in South Africa's Namaqualand, another diamond region. Rarely disturbed, the fur seals' numbers multiplied rapidly. Surrounded by diamonds, they pupped in peace and continue to do so. In southern Africa, diamonds are a seal's best friend.

Today, of the 1.3 million Cape fur seals nearly one million live on the mainland. They breed at 24 colonies, from the Black Rocks in South Africa's Algoa Bay near Port Elizabeth to Cape Cross in Namibia, a distance of about 1,550 miles (2,500 km).

I spent many months with the fur seals at Cape Cross in the late 1980s. I lived in the small Namibian town of Swakopmund and commuted daily to the fur seal colony. It was a 162-mile (260-km) return trip, which involved going through the Namib Desert.

The 100,000 fur seals at Cape Cross were spread in a broad two-mile- (3-km-) long band along the coast. The seals slowly came to accept my presence. Each morning I approached the same group. The moment they showed signs of fear, I retreated and sat on my camera case, waiting for

them to approach me. The large-flippered jet black pups were the first to come close to me. Full of curiosity, they waddled over to stare and sniff, but were soon whisked away by their worried mothers.

Each male on the beach ruled a territory and the females who went with it. To avoid fights between neighboring males, which could be bloody, there were narrow neutral zones between their territories. I insinuated myself gradually into the colony, using these neutral zones. Eventually females and pups stopped fearing me. The males felt threatened by me at first, but later came to regard me with haughty indifference. I ultimately spent many enchanting weeks sitting among the massed animals, a tolerated alien within this vast society of seals.

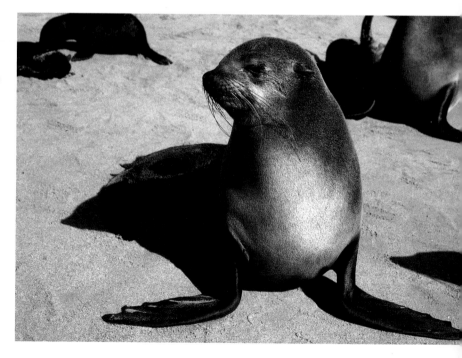

A female Cape fur seal at Cape Cross, Namibia. Once the males have established territories on the beach, the females come ashore, give birth to their pups, and shortly after mate with the resident bull. The beach is cooled by the offshore Benguela Current. Inland the Namib Desert is searing hot. When hot winds from the desert rush over the rookery, all the adult fur seals flee into the sea to escape the danger of becoming overheated. When the heat wave ends, all 100,000 seals return to their places on the beach.

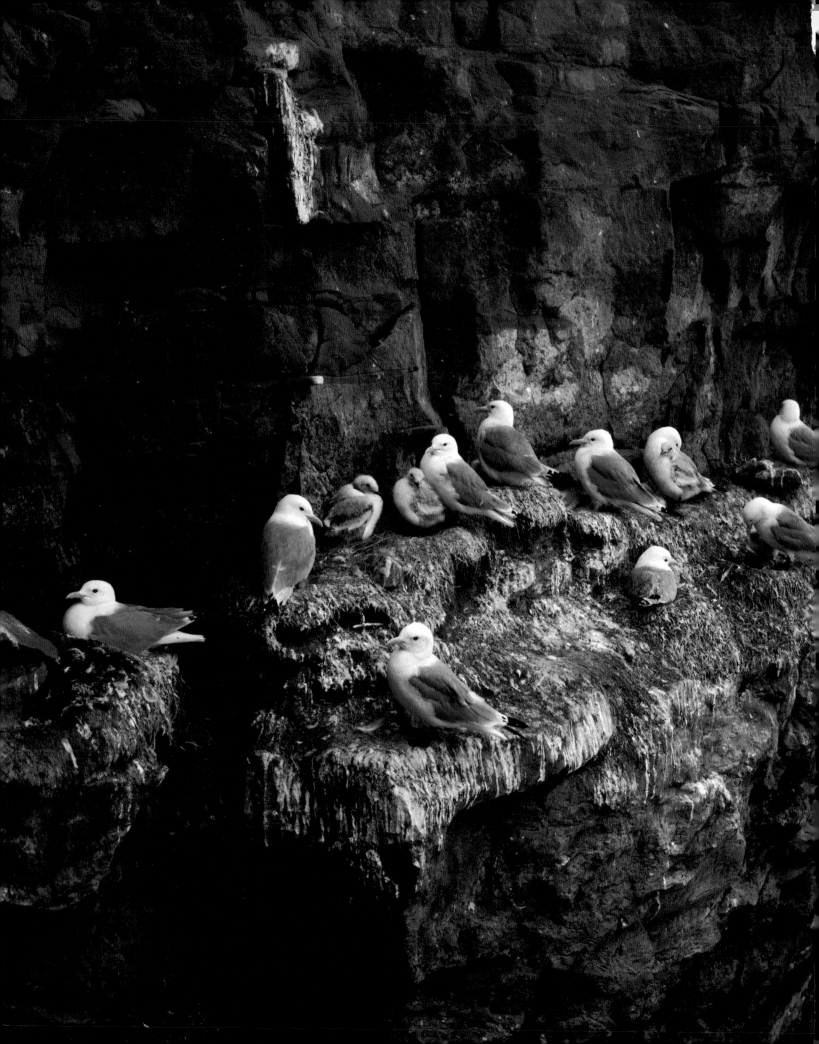

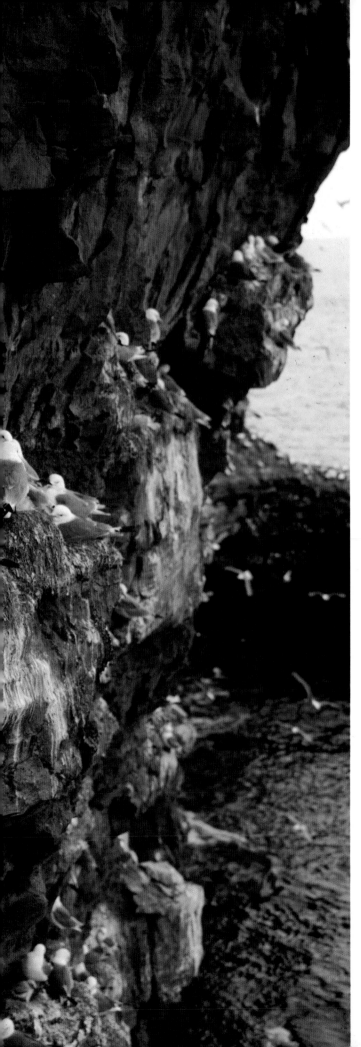

Kittiwake,
Quebec, Canada

Kittiwakes are small, elegant gray-mantled gulls, with wingtips that are so black they look as if they have been dipped in ink. Their bills are yellow with just a touch of green, the eyes a dark maroon brown. Their feet are dark and dainty, their cries loud and strident.

A large kittiwake colony is very noisy and crying is contagious there. A group of birds will begin to mew "kitti-wake, kitti-wake, kitti-wake." As their shrill cry rises, neighbors will join in. Soon a wave of banshee wailing fills the air, lasts a while, and then suddenly it stops.

Kittiwakes have thrived without being pushy. Their range is circumpolar; they nest in immense colonies on northern islands in Alaska, Greenland, and northern Europe. One of their southernmost colonies is on the Rochers aux Oiseaux (Bird Rocks) in the Gulf of St. Lawrence, north of the Magdalen Islands.

When Jacques Cartier passed the Rochers aux Oiseaux on June 26, 1534, there were three islands, all covered with birds. Now one of Cartier's islands has disappeared; the second rises like a jagged tooth above the water, its top covered with gannets; only the third island, Bird Rock, has been able to withstand the gnawing waves and grinding ice of the St. Lawrence. Several species of seabird share the cliffs of this rust red sandstone island, which is 175 feet (53 m) high with a surface that measures 1400 by 400 feet (427 by 122 m). The gannets nest on the widest ledges. The murres lay their eggs on narrow ledges. The razor-billed auks prefer niches. And the kittiwakes attach their nests to every available cornice and to ledges that are so narrow

Kittiwakes nest on the narrow ledges of the sheer-cliffed sandstone island Rochers aux Oiseaux. It lies north of the Magdalen Islands in Canada's Gulf of St. Lawrence. Narrow ledges and small cornices are the kittiwake's preferred nesting sites. Many other seabirds nest here, but they prefer the broader cliff ledges.

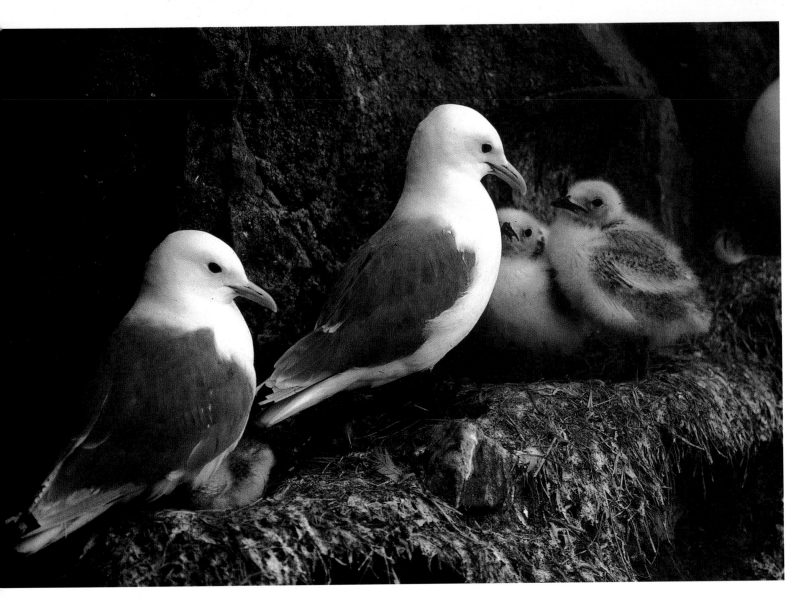

Kittiwake parents and chicks at the Rochers aux Oiseaux. John James Audubon admired the great Bird Rock, as it is called in English, when he sailed past it in 1833. There is a lighthouse on top of the island, and on clear moonlit nights the kittiwakes flit like ghosts through the lighthouse beams.

Kittiwakes atop an iceberg in Inglefield Bay, northwest Greenland. There are numerous kittiwakes in circumpolar regions; the birds have large colonies on many arctic islands, in Greenland and in Alaska. They catch small fish, such as polar cod, which abound in the arctic seas.

no-one else wants to live there. (They make these nests from grass, seaweed, excrement, and mud.)

One of the main reasons kittiwakes have thrived has to do with their choice of a nesting niche. The narrow ledges of soaring cliffs can be risky places to inhabit, but they offer the birds safety from land predators and even from avian predators who find it difficult to land on such a small space.

The kittiwakes' choice of home marks their manners. Their courtship is more stationary and subdued than that of other gulls, since it is difficult to be exuberant on a narrow ledge. The courting birds bow frequently to each other and cry, holding their bills wide open to show their bright, and presumably seductive, orange red tongues.

The pairs' nest is a neat well-cupped structure, held together by excrement; the same handy material is used to cement it firmly to the ledge of the cliff, which may be only three inches (7.6 cm) wide.

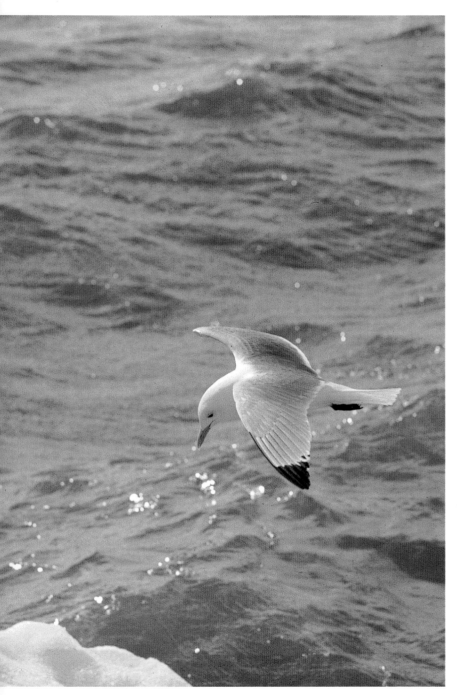

A kittiwake flying above the water of Bering Strait between Alaska and Siberia. In summer, adult birds hunt from the breeding cliffs. They take small fish, crustaceans, mollusks, and plankton from the sea's surface or dip slightly into the water to make their catch. In the winter they wander widely and rest at sea.

The flight of kittiwakes is buoyant and graceful. It is marvelous to watch them when they head back to their home ledges in a storm. They rush toward the rock, then soar high on the cliff-face updraft, and land with elegant ease next to their nesting mates. Both parents incubate the eggs, and the two, or sometimes three, chicks hatch after about 24 days.

One parent guards the small chicks and keeps them warm. The other flies off to look for food. This consists of small fishes, such as polar cod, crustaceans, mollusks, and plankton. In the Far North, masses of polar cod sometimes shoal near the shore. I watched such a school of fish one bright night in northwestern Greenland, the calm sea a deep green, the wavelets flecked with gold. Suddenly a huge flock of kittiwakes descended upon the scene, crying shrilly before they snapped up the massed cod.

Kittiwakes feed their chicks frequently. As a result they grow quickly. Unlike other teenage gull chicks that traipse hither and yon, driven by wanderlust, kittiwake chicks know that one thing you do not do when you grow up on the three-inch (7.6 cm) ledge of a sheer cliff is traipse around. At first the young chicks sit still, sheltered by a parent. Later they stand alone. If a storm develops, they must crouch low and use their sharp-clawed feet to hang onto the nest for dear life.

As chicks belonging to other species of gulls get near fledging time, they flex their wings and practice flying. However, kittiwake chicks rarely budge and certainly don't do wing exercises. So when the time comes to leave the nest, they stand at the edge of the ledge, spread their wings, and hope for the best. Most of them do manage to fly away.

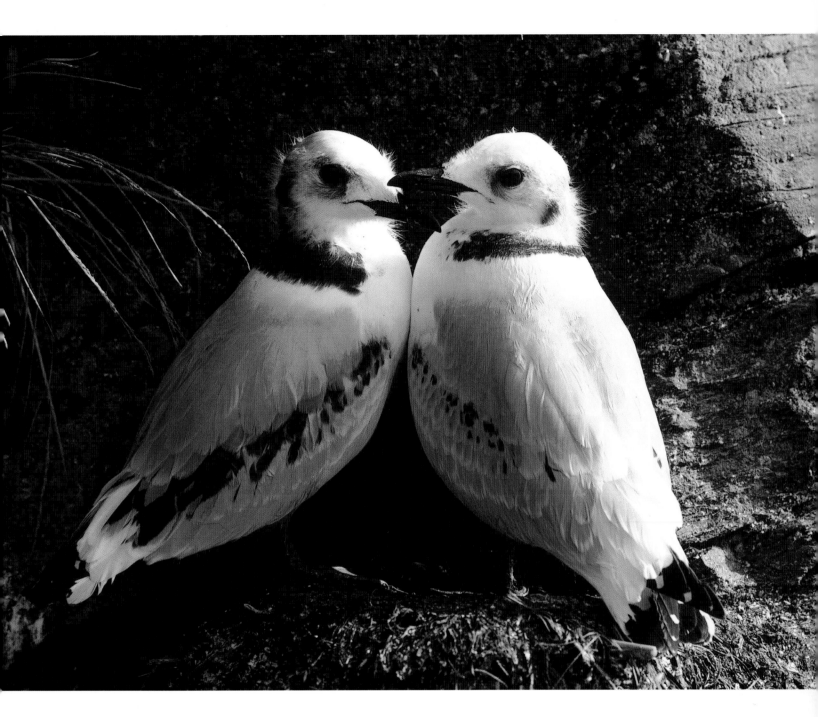

Two young kittiwakes near fledging on a cliff ledge in Alaska. Unlike other gull chicks, which flex their wings and practice flying from their home ledges, kittiwake chicks' movements are restricted by the fact that their ledges are narrow and situated on sheer cliffs. When they finally leave them, they must fly or die. Most of them survive.

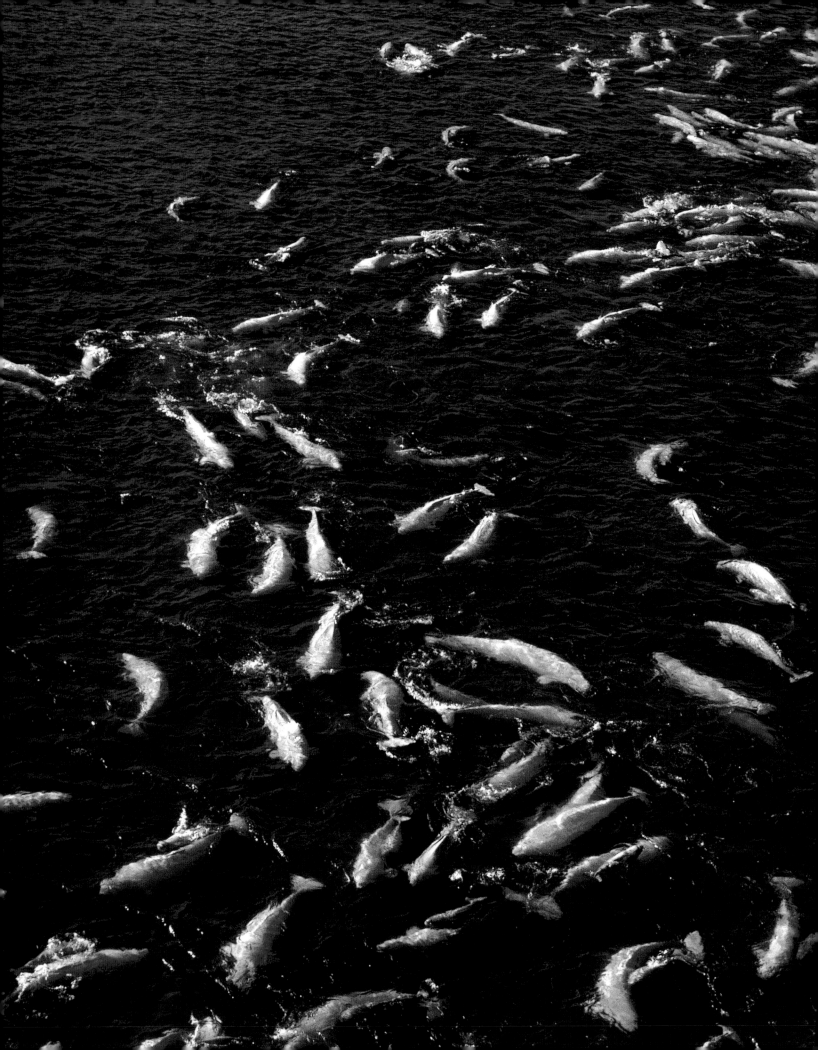

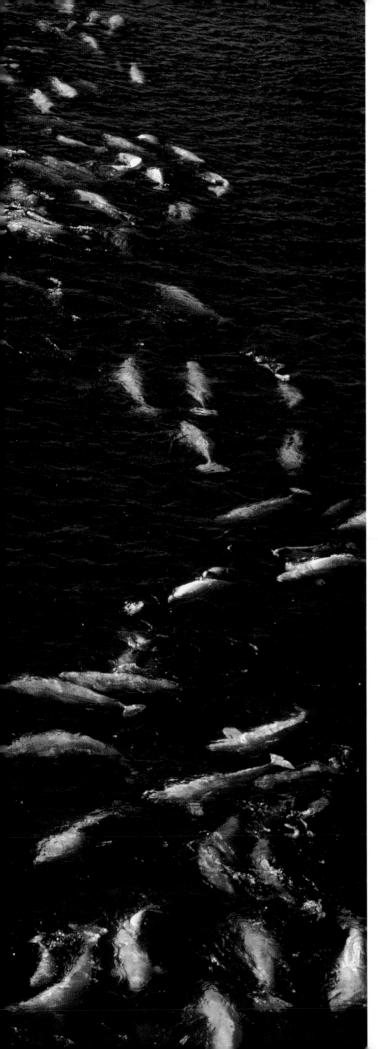

White Whale, or Beluga, Canadian Arctic

In late July of 1819, William Edward Parry of Britain's Royal Navy sailed his two ships, *Hecla* and *Griper*, into the relatively ice-free Lancaster Sound in Canada's High Arctic, the gateway, he hoped, to that Holy Grail of arctic exploration, the Northwest Passage.

He did not traverse the Northwest Passage, but Parry was nonetheless amazed and delighted by what he saw: he found an arctic Eden, the "headquarters of the whales." Giant bowhead whales lolled lazily in the dark sea. On July 30, they saw 89. Narwhal, the ivory-tusked whales of the Far North, were "very numerous," wrote Parry, and white whales "were swimming about the ships in great numbers" with "a shrill, ringing sound, not unlike that of musical glasses badly played." The land that surrounded these teeming waters was grim and gaunt. On August 7, Parry discovered Somerset Island, the most "barren and dreary" place he had ever seen.

I spent three summers on Somerset Island with scientists who were studying white whales. We set up camp in early July near Cunningham Inlet, one of the white whale's favorite summer resorts. (These whales are also called belugas, a word derived from the Russian word for "white"—*belyi*.) I was sitting on a hill overlooking Cunningham Inlet when the whales arrived in mid-July. They surged through the cool green, pellucid water like gleaming ivory white torpedoes, their heart-shaped flukes rising and falling in smooth cadence, glittering bow waves curling against their buff-browed heads. Dark-hued calves swam like small shadows near their massive white mothers.

The tide rose. More than a thousand whales,

At high tide, hundreds of white whales mill about near one of the delta channels of the Cunningham River on Somerset Island in Canada's High Arctic. More than 1,000 white whales mass each summer in Cunningham Inlet to molt and to bear their calves.

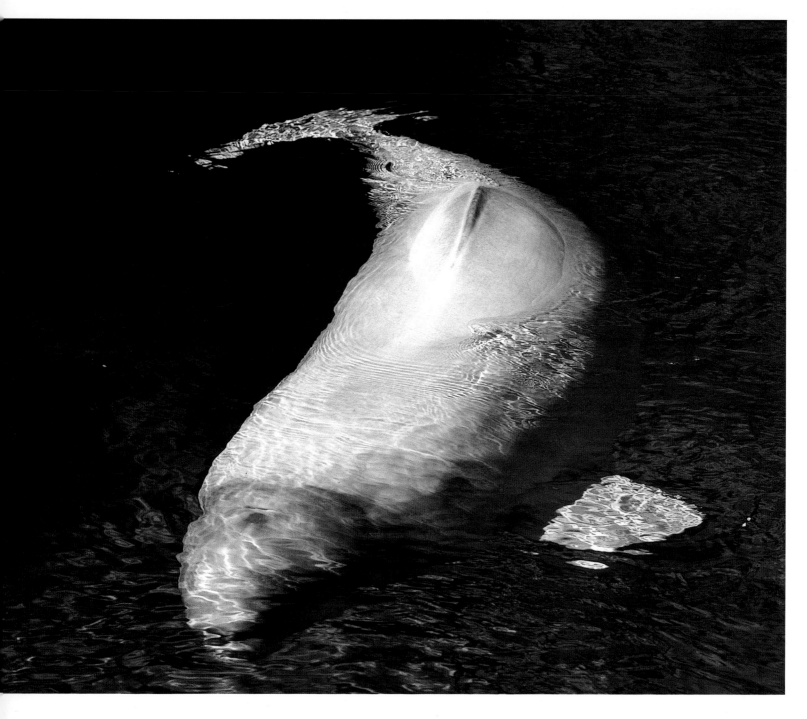

which had previously been scattered near the head of the inlet, began to bunch, each group heading toward one of the deep channels of the Cunningham River's broad-fanned delta, rushing and jostling in the fast-flowing current.

Most white whales live in the arctic waters of circumpolar seas, although one small group (about 500 are left) lives farther south in Canada's St. Lawrence River estuary.

Large males may be more than 16 feet (5 m) long and weigh up to two tons. Most white whales are 9 to 12 feet long (3 to 4 m) and weigh about 2,000 pounds (908 kg). In late fall, winter, and spring the gregarious white whales (scientists estimate their total population to be between 100,000 and 200,000) swim in small pods in ice-free regions of the northern seas. In summer pods merge and head toward their favorite arctic resorts, inlets, and estuaries, where hundreds and sometimes thousands of whales gather for six weeks to two months.

They come to molt and to bear their calves in the slightly warmer waters of such inlets. While adults are sheathed in thick insulative blubber, a newborn calf has only slightly more than one inch (2.5 cm) of protective fat. It must be quite a shock

A newly molted whale, its skin a gleaming white, ascends one of the delta channels of the Cunningham River in the Arctic. Scientists believe the immersion in fresh water may help the molting process. Of all the world's whales, white whales are the only ones to molt so quickly and so close to shore.

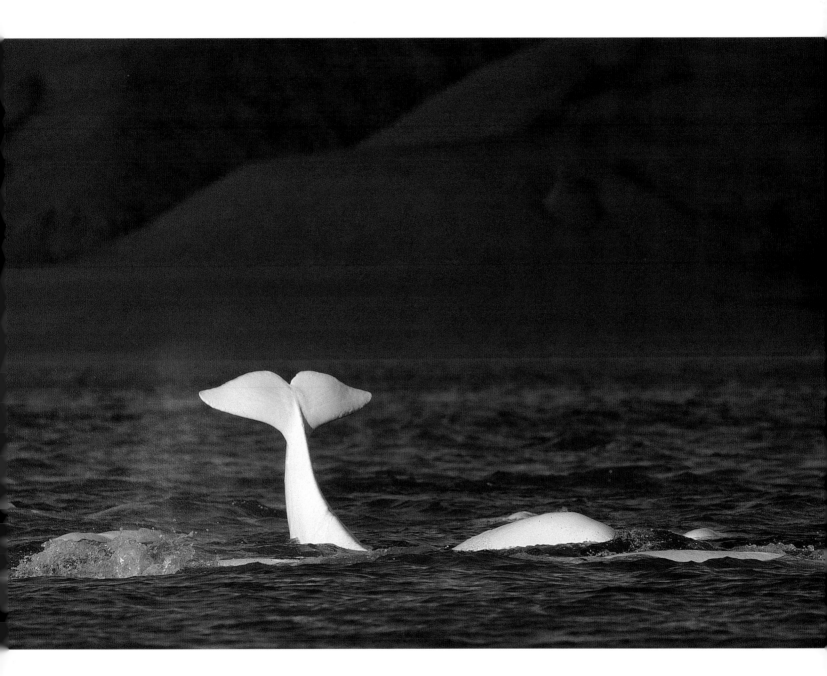

Its tail raised high, a molting white whale rubs and rolls on gravel beds near the shore to slough off its old epidermis— the yellowish outer skin layer. Although it's quite safe to do this on a rising tide, it can be risky on the ebb, and white whales that linger too long occasionally remain stranded.

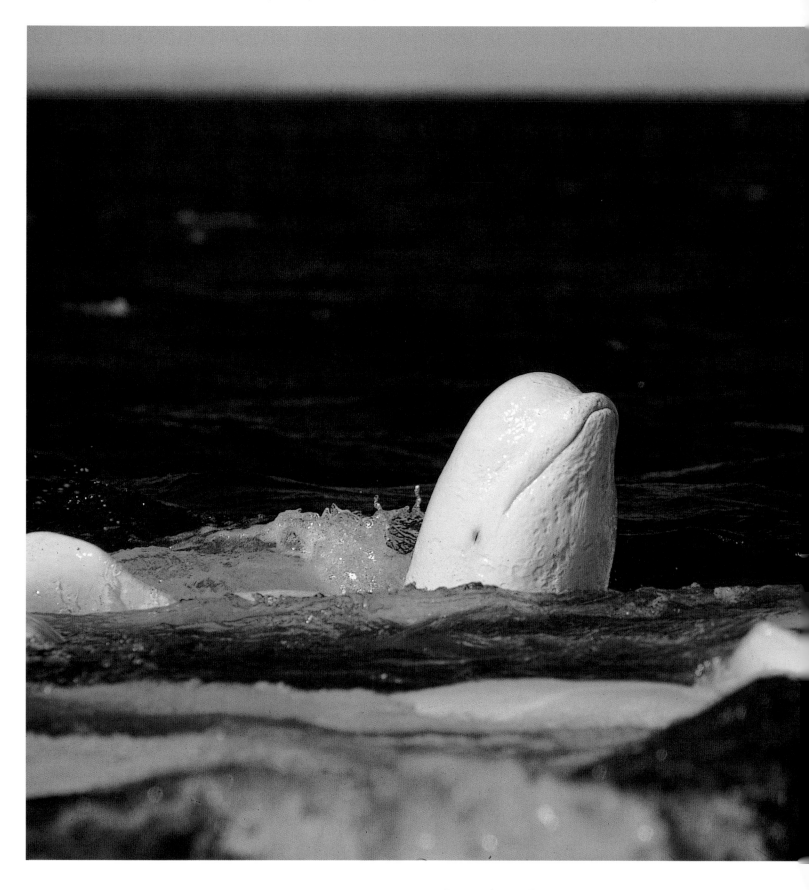

To get a better view, a curious white whale "spy-hops." The whale stands, treading water with its powerful tail. Should something alarm the whale, it makes a distinctive warning call. This results in all the white whales in the vicinity diving instantly to escape the possible danger.

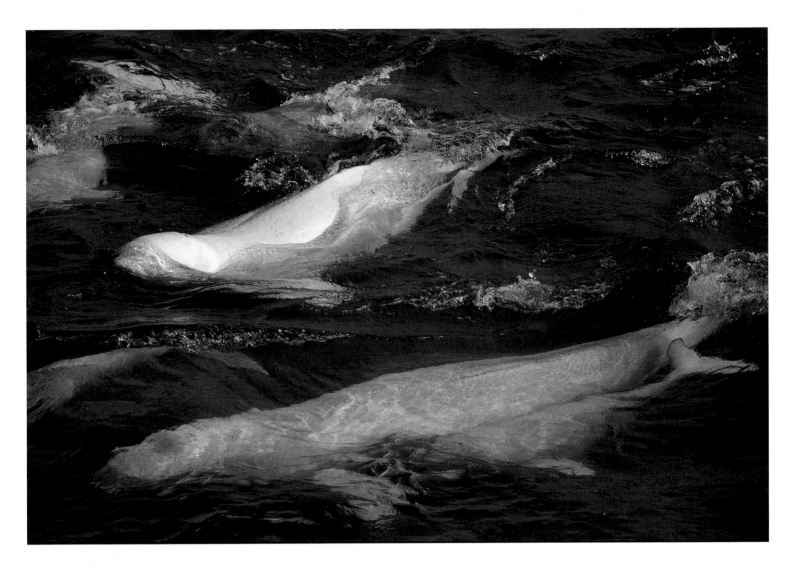

to emerge from the cozy 99°F (37°C) warmth of its mother's womb into an icy sea. A calf drinks its mother's fat-rich (27% fat) milk often and grows fast. The calf sometimes rides upon its mother's back like a small space shuttle atop a bulky 747.

When they arrive at Cunningham Inlet, most whales are the mellow yellow of ancient ivory. Some scratch on the river bottom to slough off their old skin, while others prefer to rub and roll on tide-flooded gravel beaches. Whichever method they choose, when they leave the inlet their new skin is as gleaming white as Carrara marble.

I spent several enchanted summers at Cunningham Inlet, watching the white whales and listening to them "talk." When they see a human on the beach, some whales become very curious. They swim past with raised heads and look at one with sloe-shaped eyes. Or, to get a better view of that curious creature on the coast, they "spy-hop": using their powerful flukes they push themselves halfway

Two adult one-ton (907 kg) white whales rush through the clear water of Cunningham Inlet. The whales arrive as soon as the ice has melted, which is usually in mid-July. They remain there until the end of August. Females give birth to their young in the relatively warm waters of the inlet.

out of the water. And they talk so loudly that you can hear them miles away.

White whales are the most vocal of all whales. Sailors called them "sea canaries," and they can do much more than whistle. They chirp, click, cluck, gurgle, grunt, groan, snort, squeak, moo, trill, yap, and mew. Straining their imaginations to describe the white whale's repertoire of more than 100 distinct sounds, scientists have likened the noises they make to: the sound of a rusty hinge, the shrill scream of a woman, a squeaky snore, a horse's whinny, a baby's cry, and a lecher's whistle. But what the white whales talk about, no one as yet knows.

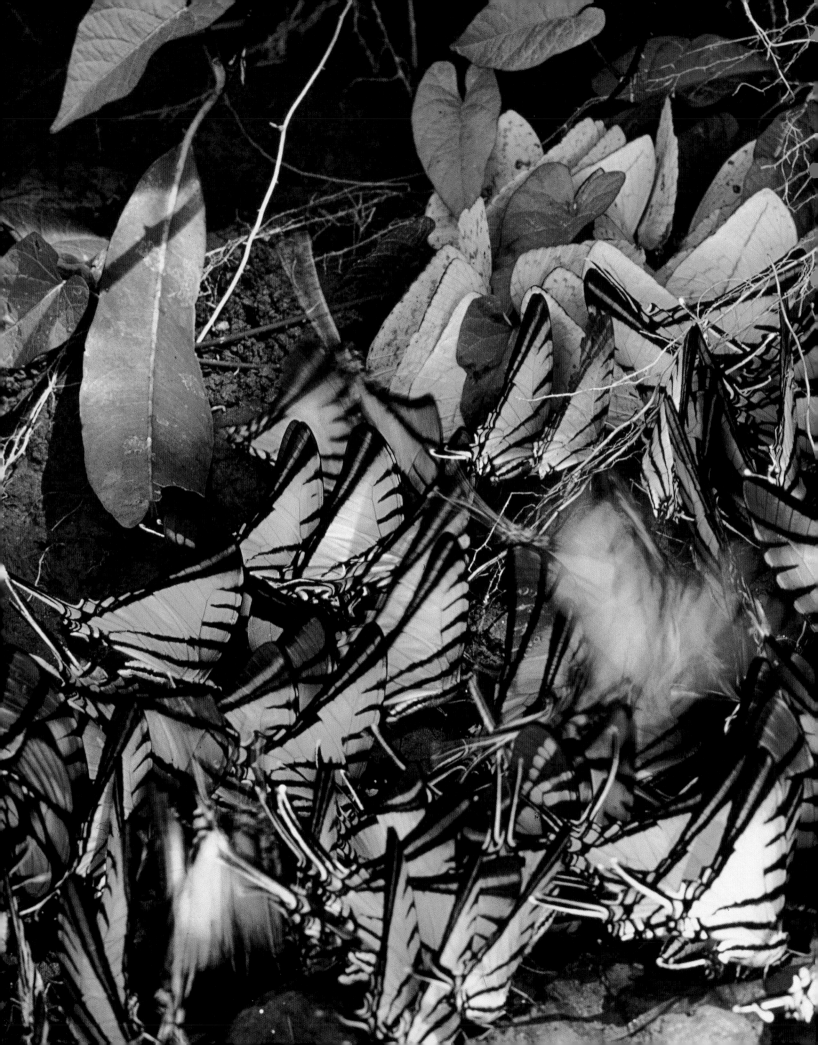

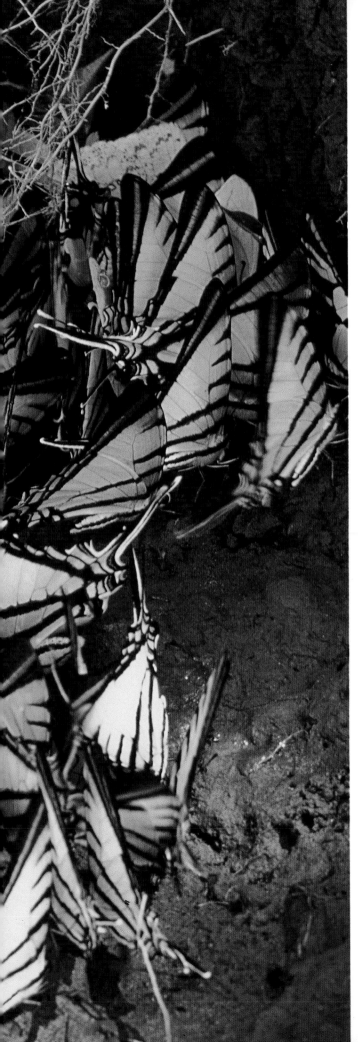

Pierid and Swordtail Butterflies, Upper Amazon Region, Peru

Our Indian boatman cautiously steered us closer to a sloping dead tree in the river. A row of yellow-spotted Amazon river turtles was basking on the tree, brilliant butterflies dancing near their heads. They settled briefly and sipped the turtles' salty tears.

We continued down the river, a tributary of the Rio Madre de Dios in Peru's upper Amazon basin, to a spot where capybaras, pig-sized rodents, often cross the river. Piles of capybara dung lay on shore and hundreds of golden yellow butterflies moistened the excrement with water and then fed on it.

It was hot and humid. We sat motionless in the boat, hoping for capybaras, sweat pouring from our bodies. Suddenly the butterflies landed upon my arms and face, unrolled their hair-thin black proboscises, and sucked in the salty sweat.

In the evening, back at the village, the boatman emptied his bladder. All the returning boatmen urinated on the same spot; it was a sort of tradition. The spot was a whir! of wonderful fluttering colors, for this was the local butterfly bar, where all the males imbibed urine.

Since one associates these lovely butterflies with divine nectar and ambrosia, I at first found their coprophilia slightly shocking. But biologically it makes a lot of sense and, as so often, has a lot to do with sex.

The caterpillars that will one day metamorphose into butterflies live on plant food that lacks salt and is also deficient in nitrogen. Consequently their imago, the adult butterfly, craves salt, nitrogen, and many other minerals. Some of these are needed to produce pheromones, which act as sex attractants.

Adult butterflies do also drink flower nectar. It is rich in sugars; the best nectar contains up to 25

Male swordtails and a few pierid butterflies "puddle," as this behavior is called. During copulation, they pass minerals, nutrients, and sperm on to the female butterflies as a "nuptial gift." The females need these substances to produce eggs.

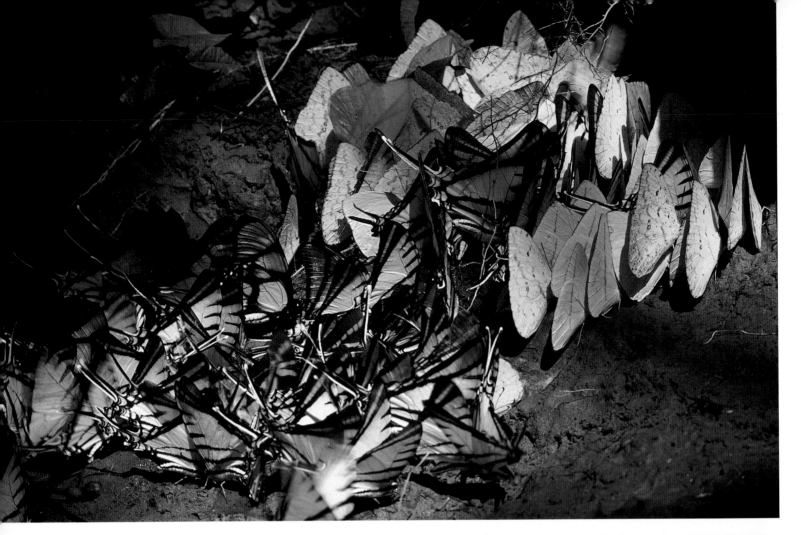

Swordtails (left) and several species of pierid butterflies suck mineral-rich water from a seep near the Madre de Dios River in the upper Amazon region of Peru. These groups of mostly male butterflies are called "puddle clubs," since the butterflies often gather at the edges of water puddles, which contain some of the vital minerals they must pass on to females during copulation.

Pierid butterflies flutter above a yellow-spotted Amazon river turtle; one butterfly sits on its head drinking the turtle's tears. When turtles bask on roots or on tree trunks in rivers, they often weep copiously to keep their sensitive eyes moist. Their tears contain salts that the butterflies crave.

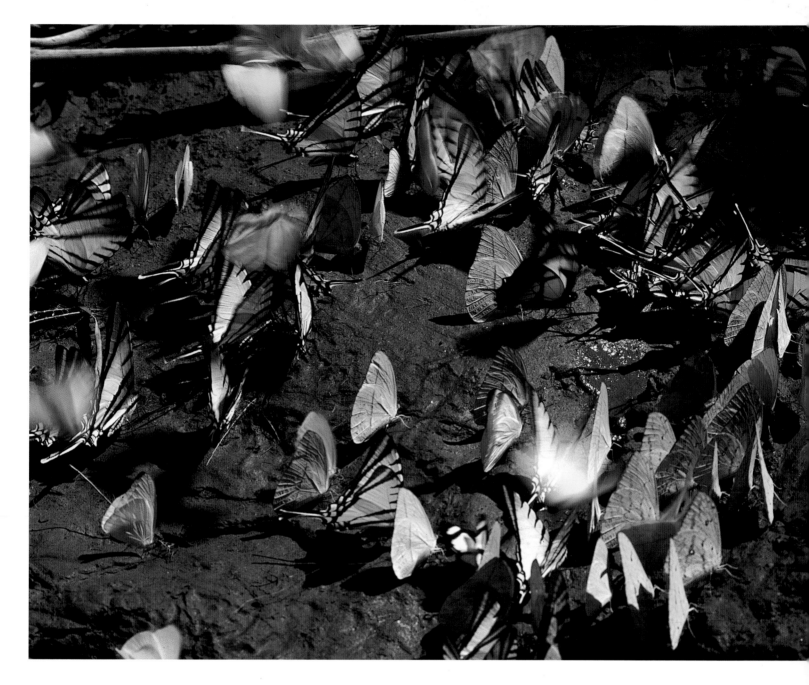

percent sugar and is thus a high-energy food. The females need this to fly, to produce eggs, and to find food-plants suitable for the eggs. But they can't afford the time and energy required to find and absorb the minerals needed for procreation.

These minerals are collected by the male butterflies and passed on during copulation to eager females as spermatophores, known as "nuptial gifts," a package of nutrients, salts, and sperm. Female butterflies can assess the amount of minerals a male carries. If his nuptial gift is ample, she is willing.

The spermatophore, that vital parcel of sperm and mineral-rich food, is no mean gift: it may constitute half the male's weight. To produce it, males must collect minerals. Since they often find

Male pierid butterflies and swordtails at a urine-saturated area near an Indian village in Peru's upper Amazon region. Urine is their favorite drink. It contains many of the substances they require to be accepted as mates by females. The females require the minerals contained in those substances in order to lay their eggs.

some of the essential minerals in puddles, where minerals have been leached out of the soil, groups of butterflies that congregate above mineral-rich areas are called "puddle clubs," and all the males there are said to be "puddling."

If the substance from which they extract minerals is hard, such as dung, rotting fruit, or carrion (preferably in an advanced stage of decomposition),

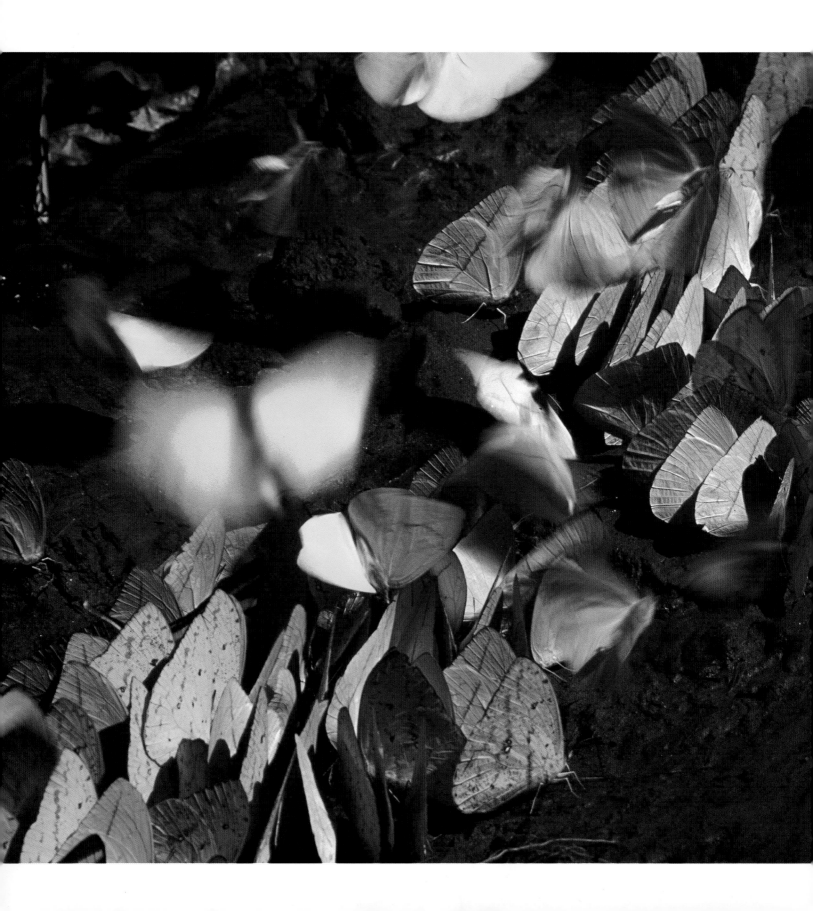

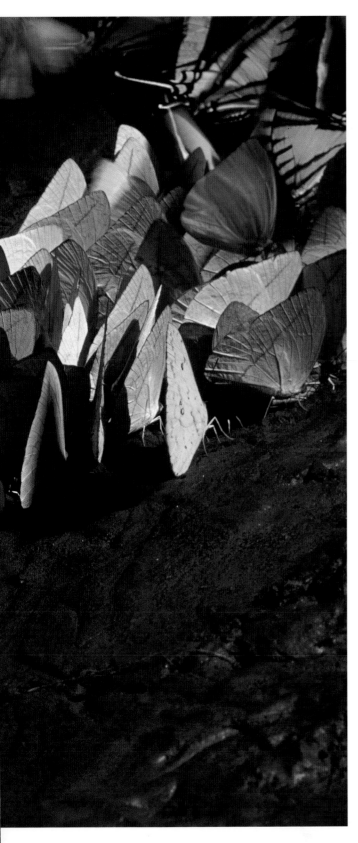

the male butterfly excretes water through its proboscis to soften and ultimately liquefy the substance, and then ingests the mineral-rich mix.

If the mineral source is liquid, like the thousands of seeps along the upper Amazon's riverbanks, the butterflies have the opposite problem: too much liquid. They absorb the mineral-rich water and then excrete the surplus water—either by regurgitating it or by expelling it anally—and retain the precious minerals that they need for mating.

The numbers of butterflies at each mineral-rich source varies greatly: they can range from a few above a weeping turtle to tens of thousands at large mineral sources. Although such large agglomerations might seem like a marvelous target for predators, the mass of swirling color makes it difficult for the hunter to concentrate upon a single victim.

Butterflies in need of minerals extract them from a host of substances, many of them putrid and revolting. As we have seen, one of their favorites is urine. Its strong odor makes it easy to find, and it contains a multitude of substances these creatures need: excess sugars, amino acids, nitrogen, and salts.

For this reason, the spot where the Indian boatmen always relieved themselves, was very popular with many butterflies. Several species of pierids, which looked glorious in their gold, green, and yellow colors, and large groups of elegant swordtails gathered there. The latter are a satiny blue color with black stripes. The sight of these dancing butterflies was wonderful to behold, but it was a bit hard to reconcile it with the fact that they had all come to drink at a urinal.

Several species of pierid butterflies and a few swordtails sip water from a mineral seep near the Madre de Dios River. The butterflies obtain sugar-rich nectar from flowers and this provides them with the energy they need to fly. But to procreate they require certain minerals and consequently mass wherever they can obtain these vital minerals.

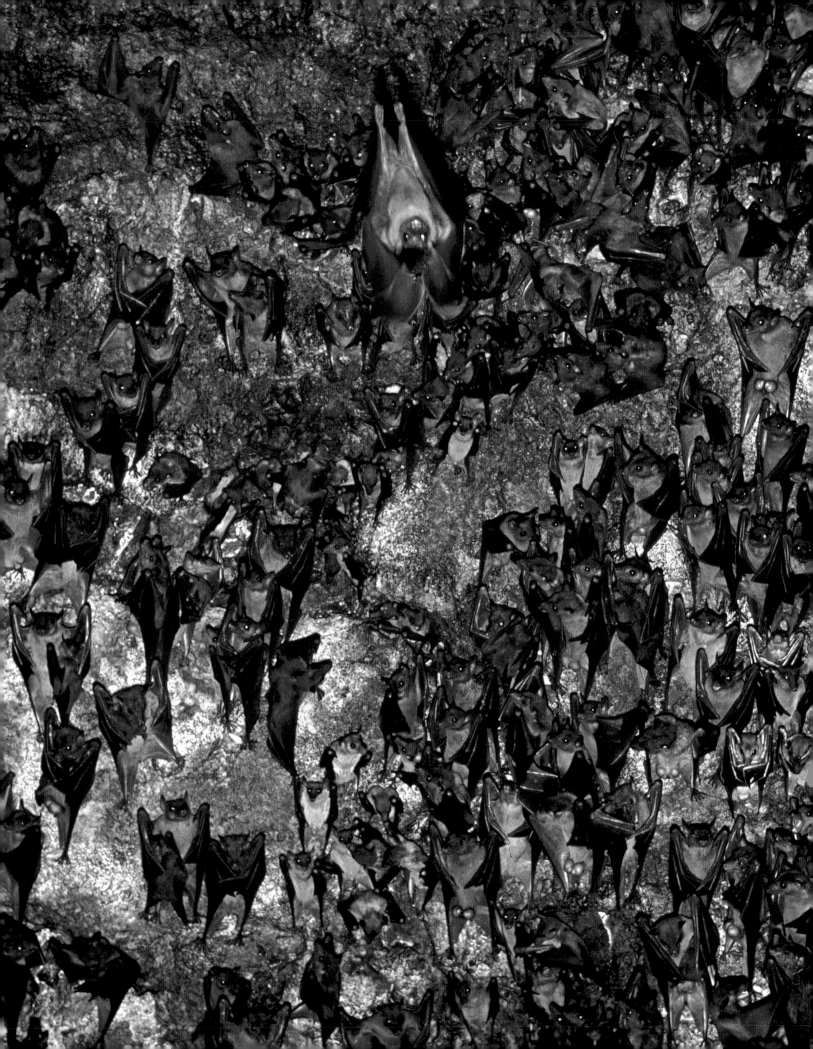

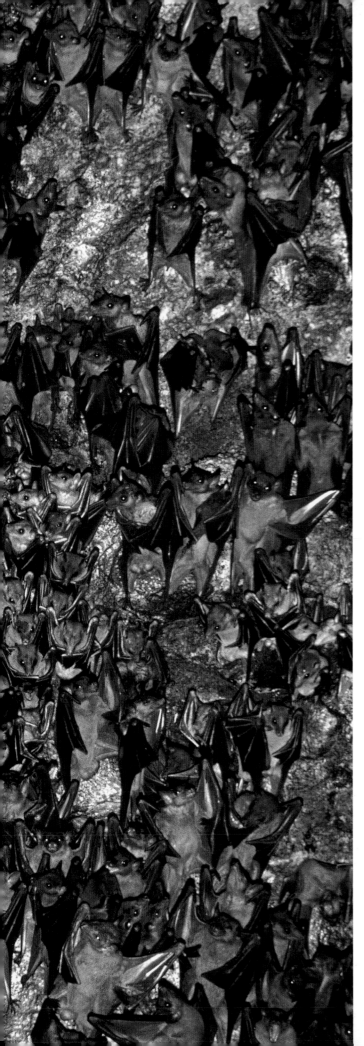

Geoffrey's Roussette, Bali, Indonesia

"No," said the priest, "you may not enter the cave. The cave is sacred. Besides," he added, "the cave is full of giant snakes. It is a very dangerous place."

Legend says the cave Goa Lawah (near the southeast coast of the island of Bali in Indonesia) is also the abode of an enormous, sacred snake called Naga Basuki. According to Hindu legend, this creature is the guardian of the earth's balance.

A great temple complex, which is more than a thousand years old, borders the sacred cave, and small shrines stand at the entrance to the cave. Thousands of worshippers come to pray here. They pray to Shiva the Destroyer and to Naga Basuki, and they place offerings of food and flowers upon the worn steps that lead up to the oval entrance of the ancient cave.

The cave may harbor snakes, but what I really wanted to see during my visit to Bali was the hundreds of thousands of fruit-eating bats to whom the sacred cave is home. However, my request to enter the cave met with a resounding no.

Just as I was rebuffed, an old man, dressed in priestly robes, came toward us. "He is the chief priest of the temple," my guide explained, then added, "he is a very holy man." He was also a very kind man. Informed of my request, the priest smiled and said, "A long time ago, when I was young I once went far into the cave. There are many bats and many snakes, but if you are polite, the snakes will not harm you." He looked at my running shoes and white drill pants and added with an amused chuckle, "And you will get very dirty!" I had his permission. I could enter the sacred cave of bats and snakes.

The caves where insect-eating bats roost in

A bat-covered wall of the sacred Goa Lawah cave on the island of Bali. These creatures are Geoffrey's roussettes, hand-long, fruit-eating bats. Since no one may enter the holy cave, it is a safe sanctuary for the hundreds of thousands of roosting bats.

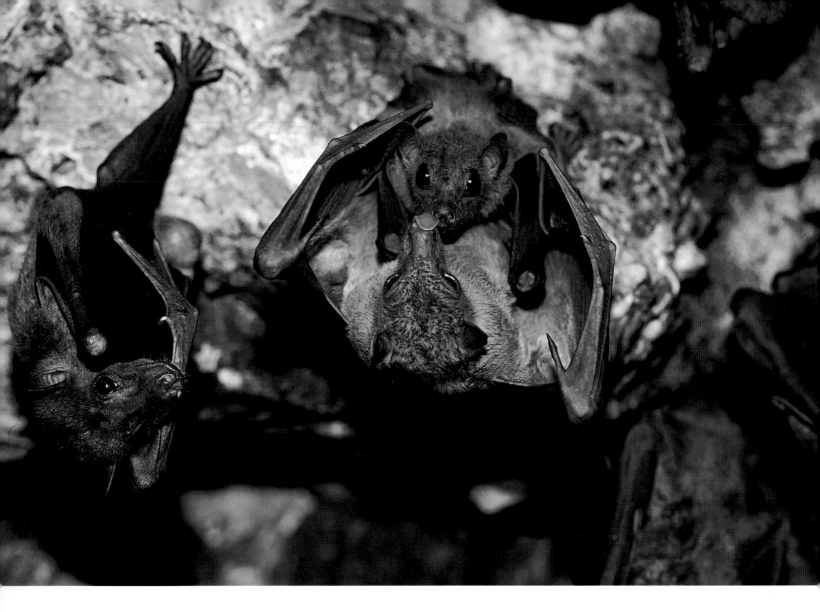

A bat mother licks her pup, as baby bats are called. The newborn clings to its mother's teat and hangs onto her fur with its sharp prehensile toes. Later the mother will cradle the pup in her wings and groom it frequently, for bat mothers are very affectionate. Fruit-bats like the roussette eat fruit, seeds, and nectar and disperse seeds in doing so. This ensures reforestation.

millions, such as the great bat caves in Texas, can be fatal to humans due to the toxic ammonia fumes given off by bat feces and urine.

Goa Lawah is home to hand-long fruit-eating bats, known as Geoffrey's roussettes. Their excrement has a sickly sweet stench. It is potent but not poisonous. I stepped through the oval entrance of the cave into a huge domed chamber, the walls and vaulted roof a tapestry of hanging bats. The ground was slick with slimy guano. Each 11-ounce (300-gram) bat eats about 5 ounces (150 grams) of juicy fruit each night and drinks about an

equal amount of water. The result is a steady rain of feces and urine, which has formed great mounds of guano in the farther reaches of the cave.

The bats are a reddish brown color (the name roussette comes from the French for red, *roux*). They have eager foxy faces and large dark eyes, which looked at me with curiosity but showed no signs of fear. Many of them were females, who cradled their pups, as baby bats are called, in their folded wings.

The first thing that amazed me was the fact that all the bats were hanging upside down. They were suspended from the walls and the great domed ceiling of the cave by five slender, sharp-clawed toes.

This feat is made possible by an ingenious locking mechanism in the bat's foot, called tendon traction, which closes the toes against the rock; the traction is produced by the bat's weight. The instant it grasps the rock, the tendon tightens, its clamping lock snaps shut, and the bat hangs easily, and usually securely, without any exertion.

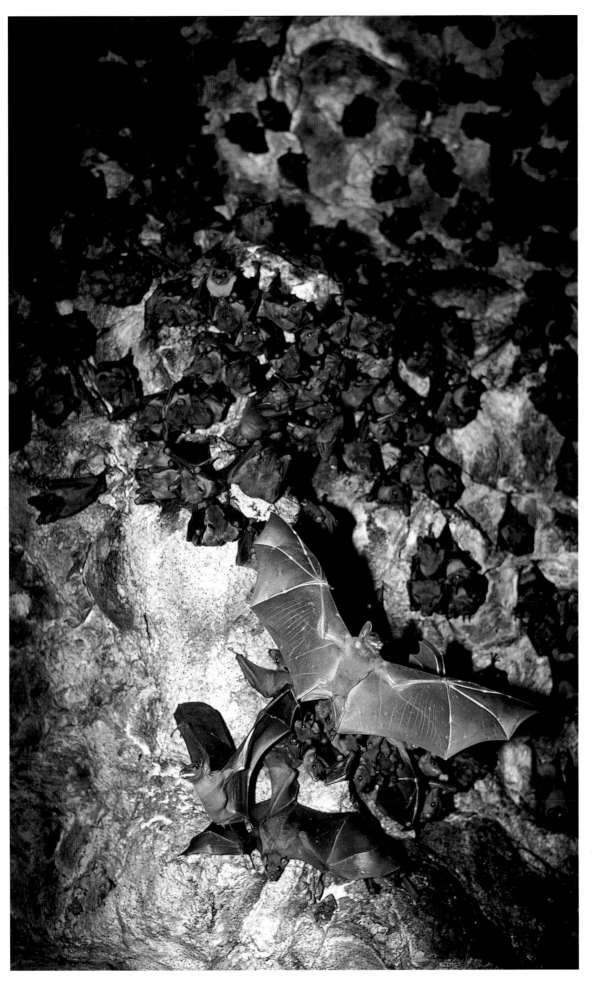

Bats fly through the vast Goa Lawah cave on large, thin-membraned wings. The Balinese temple at the entrance to the cave closes at 5:30 p.m. At about 6 p.m. the sun sets, and half an hour later the bats begin to stream out of the cave. They fly to fruit trees, particularly the giant banyan trees found in the temple gardens and in village squares. They eat the trees' figlike fruit. All the bats return to their cave before dawn.

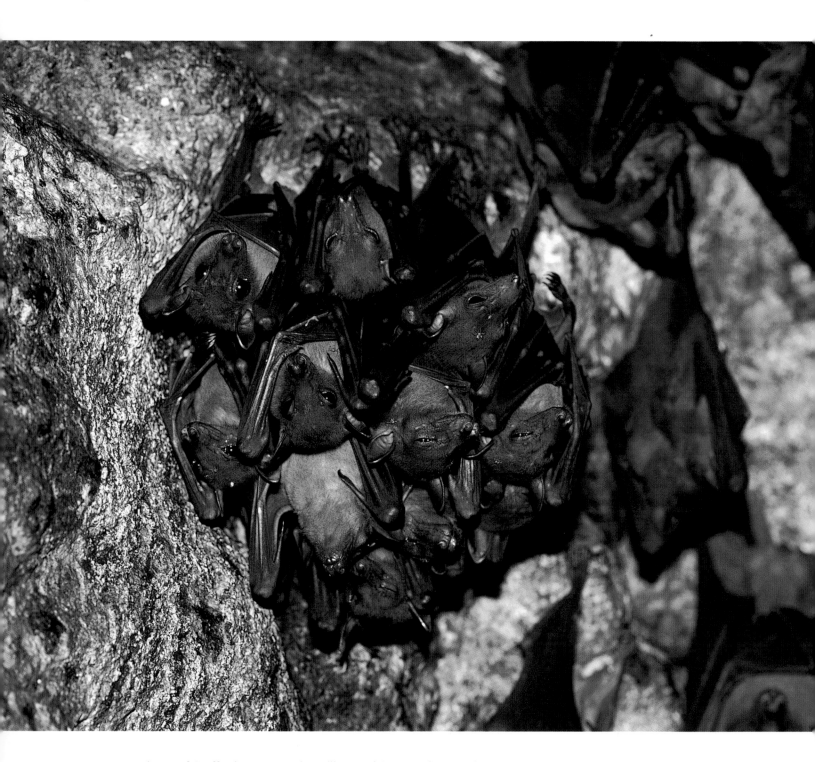

A cluster of Geoffrey's roussettes in Bali's sacred Goa Lawah cave. There are 12 species of these fruit-eating bats in the world. They owe their name roussette, to their reddish brown fur: it is derived from the French word for red, roux. A locking device in the bats' feet enables them to hang upside down with great ease.

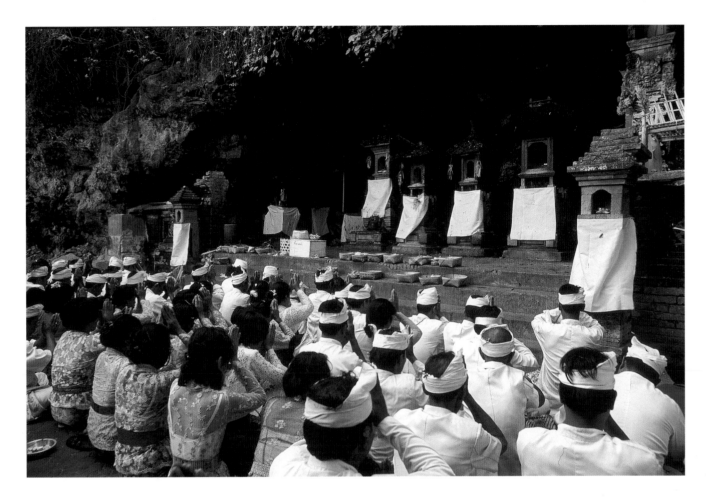

The bats that do fall fly up and reattach themselves to the wall. However, if they fall to the ground, they become instantly mired in the ooze and the snakes eat them. I did not see the snakes until they moved. Like everything else on the cave floor, they were covered by a dark, viscous guano slime.

I was polite and the snakes were fortunately too full and lazy to bother me. They were huge, thick pythons. They stared at me with glassy eyes, then slid through the slime deeper into the cave. I did not follow them. According to legend, a Balinese prince once traversed the entire cave and emerged 22 miles (35 km) farther north at Besakih, the great mother temple of Bali.

If the prince really did go through the entire cave, he must have been quite a sight when he

Balinese worshippers pray near the entrance to the sacred Goa Lawah cave. Small shrines stand at the entrance to the cave, and the pilgrims have brought baskets containing offerings of food and flowers. A temple complex, which is more than a thousand years old, extends to both sides of the cave entrance. Outside, people pray for the dead. Inside the cave there are thousands of fruit-eating bats and some large pythons.

came out, because, after only a few hours in the cave, I looked and smelled as if I had fallen into a cesspool. For the bats, however, this cave is paradise. The snakes, of course, are a nuisance, but their cave is holy and hence a sacred and safe sanctuary for the bats.

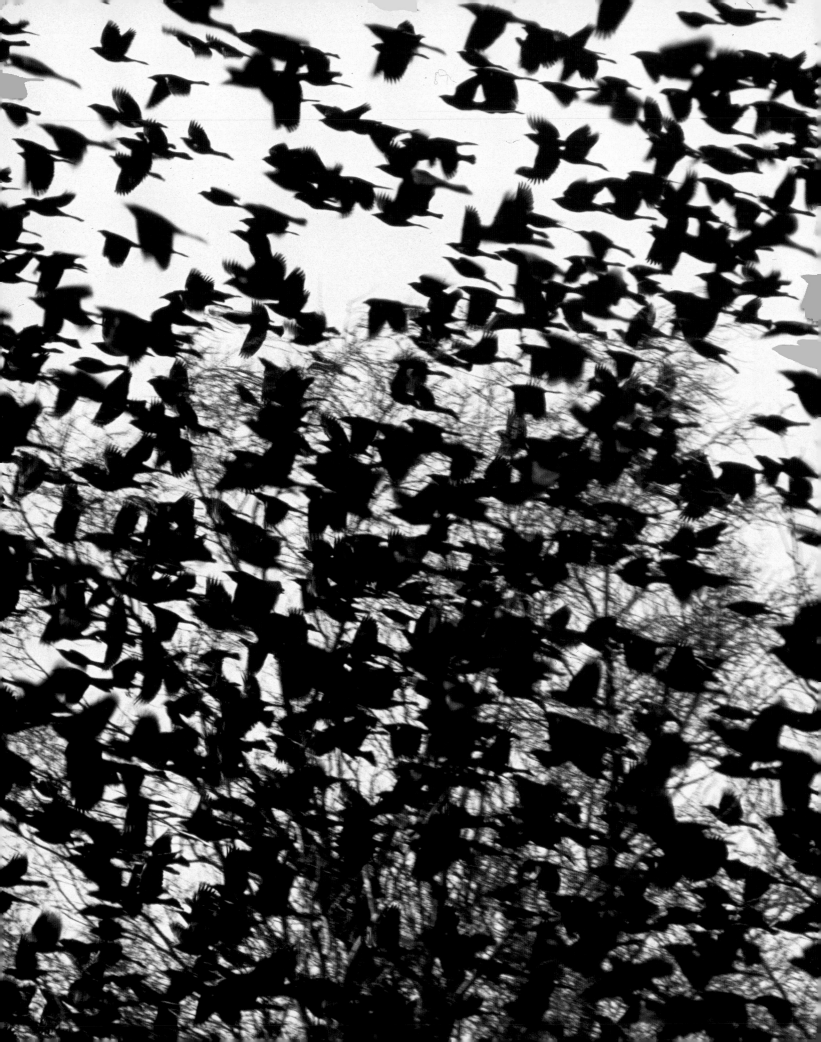

Red-Winged Blackbird, Nebraska, U.S.A.

The red-winged blackbird is probably the most numerous land bird in North America, a distinction once held by the now extinct passenger pigeon. The passenger pigeon was edible and was therefore avidly hunted. Its habitat was destroyed: the great oak forests that provided mast for billions of pigeons were felled by settlers, and the pigeon finally faded into extinction. Humans destroyed the passenger pigeon. However, humans have, to a large extent, underwritten the red-winged blackbird's success story, even if they have not always done so willingly.

The sheer number of red-winged blackbirds is most evident in fall and winter when they mass with grackles and cowbirds in mighty flocks that swarm over the fields in daytime and crowd roosts at night. (The red-winged blackbirds often mass with other blackbirds, too.) One roost in Virginia was the nightly rendezvous of about 15 million blackbirds.

In many ways the red-winged blackbirds owe their large numbers to farmers. The redwings are marsh birds, and in addition to roosting in marshes, they often roost in copses surrounding farmers' homes. In spring and summer, they help farmers by feeding their young insects, many of which are agricultural pests. They usually raise two broods of chicks and feed them entirely on insects. Since there are hundreds of millions of red-winged blackbirds in North America, their consumption of insects is enormous.

Clouds of blackbirds rise from the copse of trees around a farmer's home in Nebraska. These are now probably the most numerous land birds in North America. In spring they disperse to breeding territories, and in fall they mass in flocks that sometimes number millions of birds.

In fall and winter, these birds eat mainly seeds and grains. At this time of year their sheer numbers are evident since they mass in huge, happy, hungry flocks and fly from farmer's field to farmer's field harvesting oats, barley, and corn. As they depart, they leave a swath of angry farmers behind them.

In spring the vast flocks of these birds dissolve. The males head for home marshes and establish territories. They are polygamous, and males with large territories are particularly attractive to females. The male sings and displays his beautiful scarlet red yellow-fringed epaulets. Some males move around a territory, changing their song slightly in each area, to give rival males the impression that many males live in the area. With this ruse, they acquire large territories and many females. Ultimately blackbirds are shrewd birds that thrive in part due to their resourcefulness.

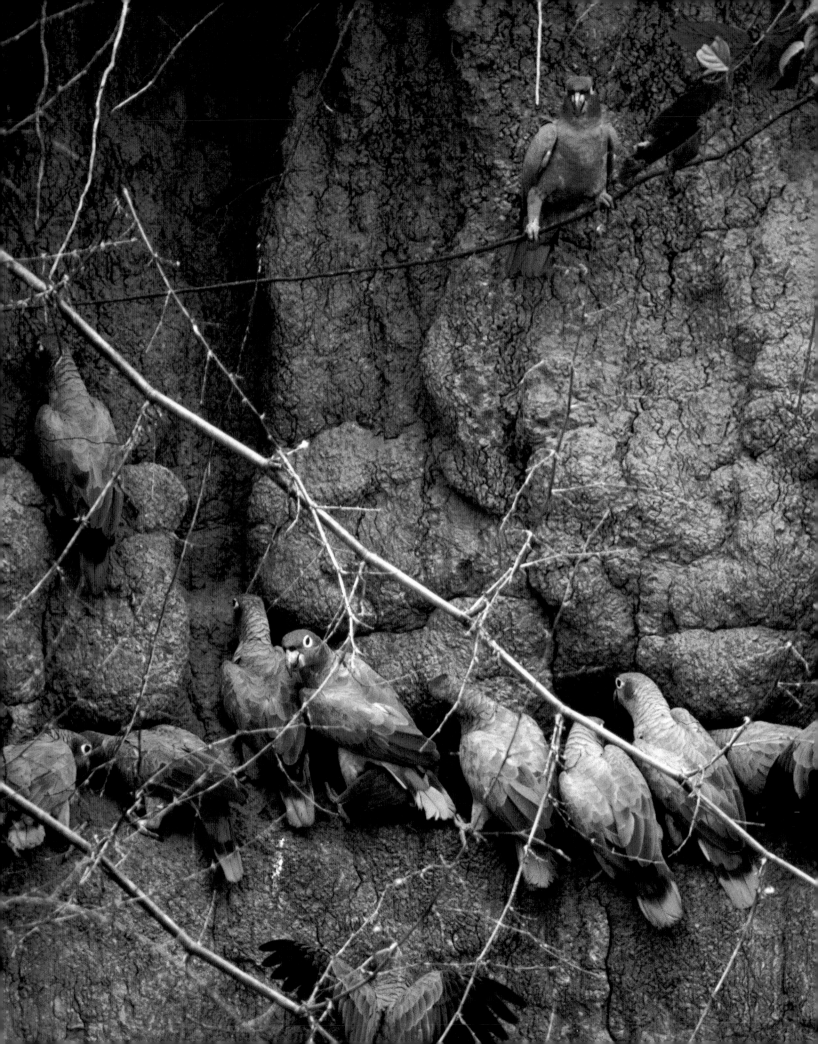

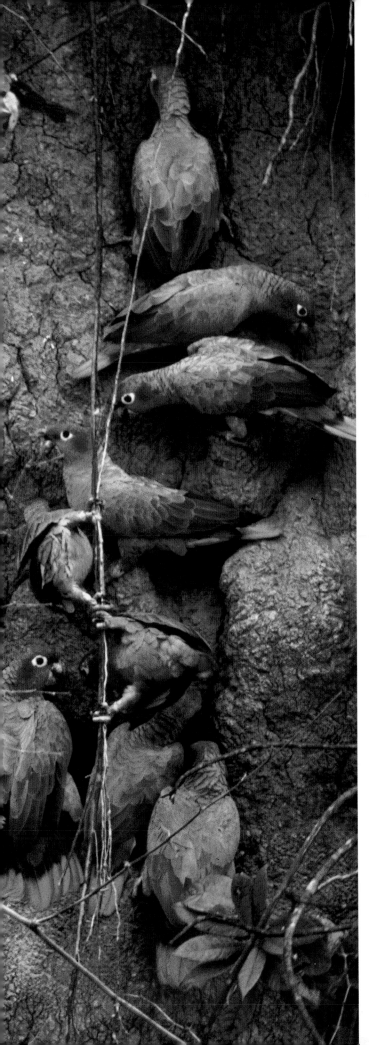

Mealy Parrot,
Upper Amazon Region, Peru

The parrots arrive at dawn. About a hundred mealy parrots sit in the trees above us and talk. Hidden in a blind, we hope they are not talking about us, for the parrots are shrewd, suspicious, and shy. If they guess that the brush pile on the riverbank hides humans, they will not come to the nearby clay lick to eat their daily dose of clay, which soothes their upset stomachs.

The blind was built by experts: Machiguenga Indians who live in small villages along the Manu River in Peru's upper Amazon region. Until recently they hunted parrots and ate them. Now, for a fee, they will help scientists and visitors and spare the parrots. This is an easy choice to make, they tell me, because visitors pay and parrot meat is extremely lean and tough. This is not surprising, since parrots are long-lived birds. Forty years is common in the larger species, and a few have reportedly lived for more than 80 years.

The Indians pick us up at our riverside camp at 4 a.m. in a long flat-bottomed motor-driven boat. One man steers, the other sits in the bow and guides us up the river past snags and fallen trees. The boat purrs through the humid velvet black of the tropical night. Our Indian guide seems to have the night vision of an owl.

We crawl up a clayey bank into the canvas blind; the Indians hand us our gear, carefully adjust the brush that hides our blind, and leave.

With the light of day, the parrots arrive, among the first a troupe of leaf-green mealy parrots, who do their morning exercises in the trees above us. Like all the world's 340 parrot species, the mealy parrots are zygodactylous, which means two of their toes face forward, two backward. This gives the foot a strong, prehensile grip. The birds turn and twist

Mealy parrots at a colpa, *a clay lick, in the upper Amazon region of Peru. Some of the fruit these parrots eat contain poisons that can be neutralized or buffered by a daily dose of clay.*

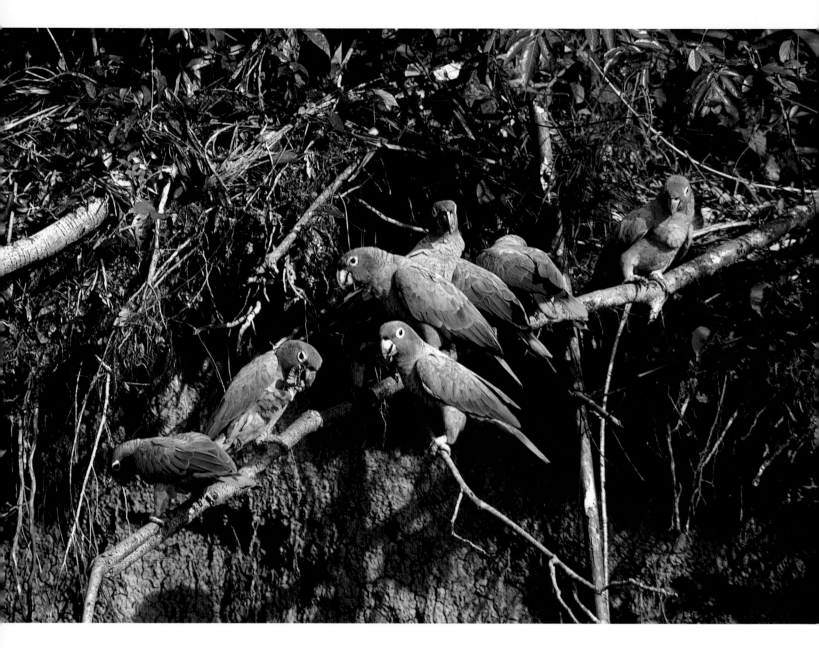

Like most parrots, mealy parrots are skilled climbers. They use both their strong prehensile feet and their beaks to advance themselves. They perch upon a branch near the clay wall, reach over, grab a footful of the clay they crave and eat it from the cupped foot.

in the branches, somersault, and climb up the aerial root of a parasitic plant, using their beak as a third foot. They talk continuously.

Their repertoire is loud and varied, ranging from raucous shrieks to confidential murmurings. The reason for all this talk and nervous climbing is that the parrots are prey to conflicting urges: they crave the clay but fear the steep, exposed riverbank, where they become easy targets for eagles, their top enemies. The main tenor of their talk appears to be, "You first!"

Finally a mealy parrot soars down, lands on the steep riverbank, hangs on with its sharp-clawed feet, and, like a woodpecker, uses its strong, square tail as a prop against the wall. Apprehensive, the parrot looks in all directions. One warning cry from the other parrots and it will flee.

Nothing happens, so the rest of the group drifts down and begins to eat the kaolin-based clay, which the birds need to counteract the toxins in some of their foods.

We are near one of 40 known clay licks, or *colpas*, as they are called in Amazonia. The Indians, of course, have always known of them, but scientists only began to investigate them in the 1970s. And it's only since the early 1980s that they've studied them and the visiting parrots intensively.

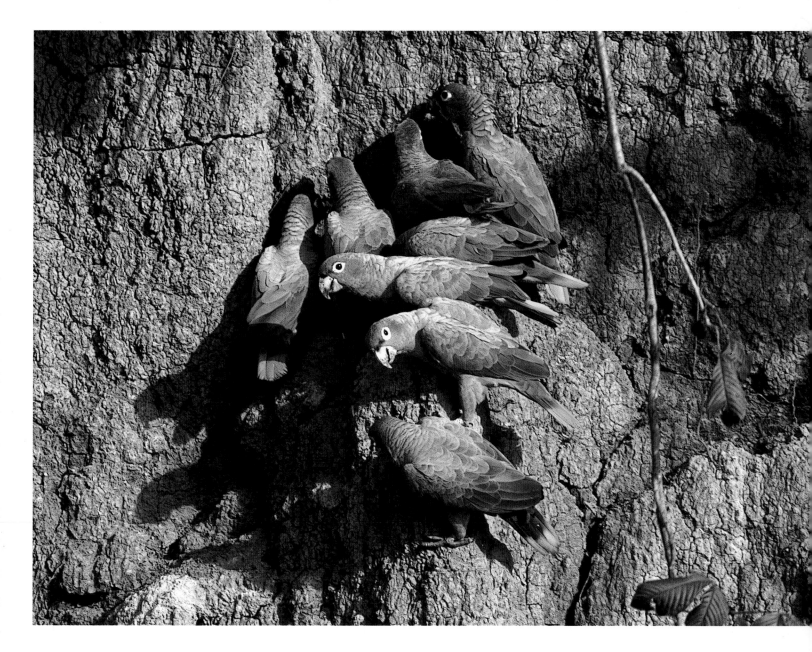

Gregarious mealy parrots cluster at a clay lick. Although the leaf-green parrots are well camouflaged when they feed in the rainforest canopy, on the high and open riverbank they are conspicuous and vulnerable. While some parrots eat the soothing clay, others remain alert for any possible danger, especially eagles, which eat parrots.

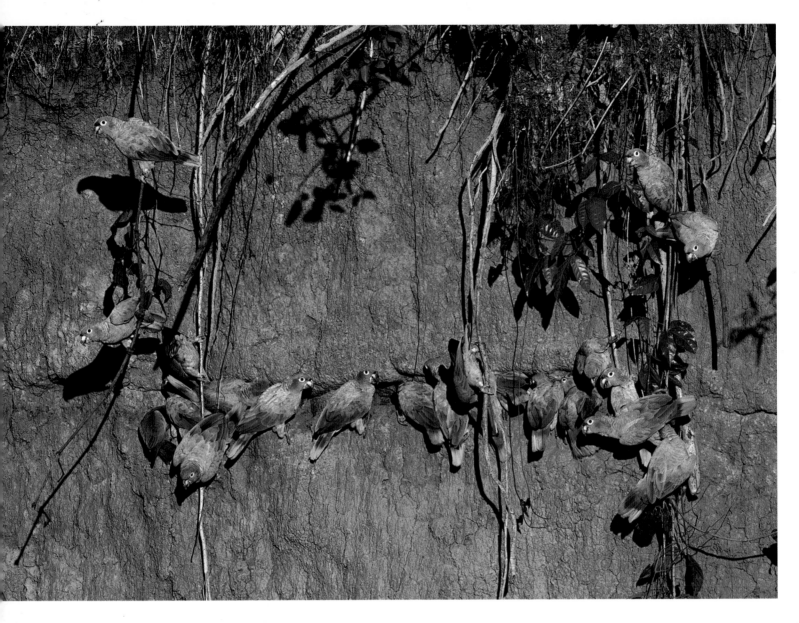

During the day, about a dozen parrot species visit our *colpa* in waves of noise and marvelous color. The birds range in size from huge macaws to masses of small, nervous blue-headed parrots. Until then I had only seen the latter in captivity. Parrots have the unenviable distinction of numbering among humankind's most ancient pets.

The first came to Europe from Asia. Onesikritos, a helmsman in the fleet of Alexander the Great, returned with the first parrots ever seen in Europe. They were rose-ringed parakeets, which had then been known for a long time as "Alexander parrots." Heliogabalus, a particularly unpleasant Roman emperor, served roast parrots to his guests and live parrots and peacocks to his lions until his guards killed him. By 1412, pet parrots were so common in Europe that the Vatican employed a *custos papagalli*, "the keeper of the pope's parrots."

Eighty-one years later Columbus returned from the New World with parrots, which are thought to have included macaws and the more common but less flamboyant mealy parrots.

Returning to my sojourn in the upper Amazon, the mealy parrots near our blind are now stuffing themselves with clay. Some hack it out of the wall with sharp beaks; others dangle from an exposed root with one foot, grab a footful of clay with the other foot, and eat it. Some are left-footed, others right-footed, but they are all marvelously skilful. They eat so fast that they can hardly talk, but some remain constantly alert. A warning cry shrills in response to a nearby eagle, and a green cloud of frightened parrots rushes away from the reddish wall. The clay wall is empty for a while, then the parrots gather again in the trees above us.

Born acrobats, mealy parrots descend from roots that dangle over the clay bank from the rainforest floor above. They hang on with both legs and take mouthfuls of clay with their beaks, or reach for the clay with one sharp-clawed foot, rake in a footful and eat it.

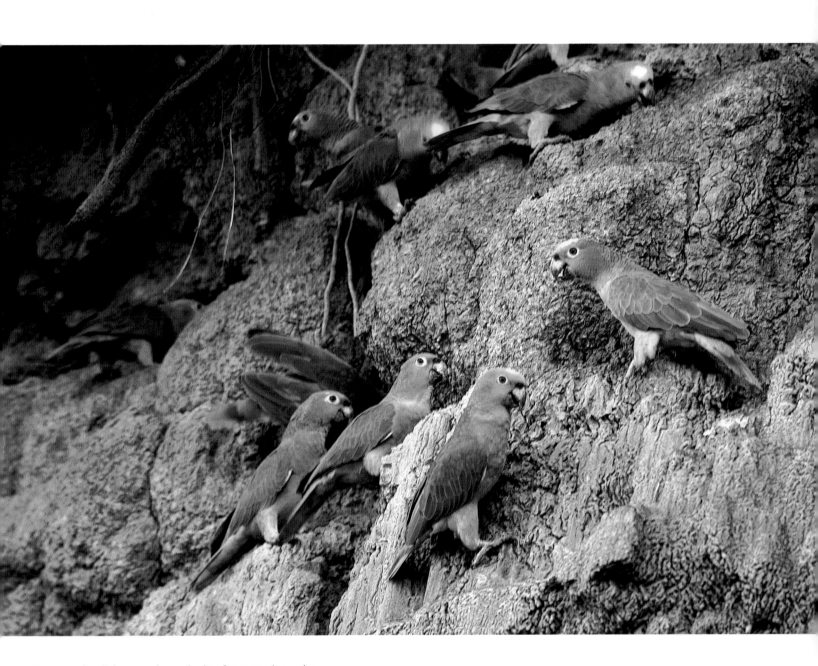

At some clay licks—used, no doubt, for centuries—the parrots have dug ledges into the clay. The mealy parrots cut into the clay wall with their sharp beaks.

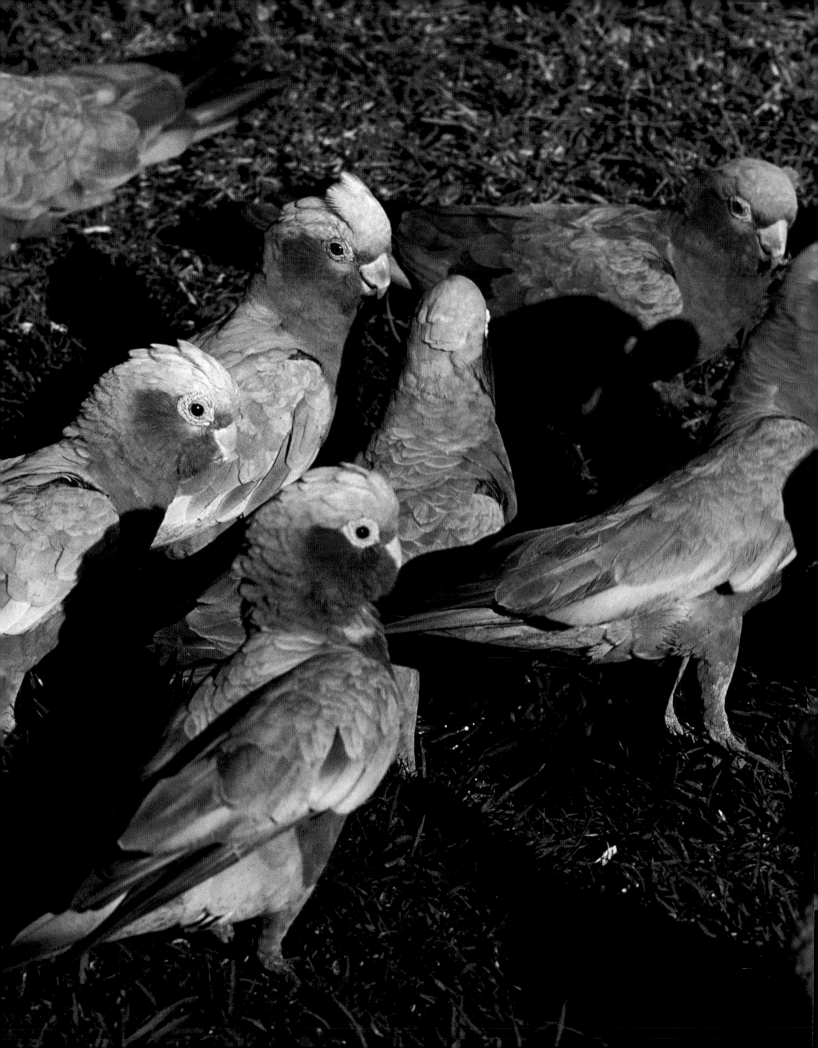

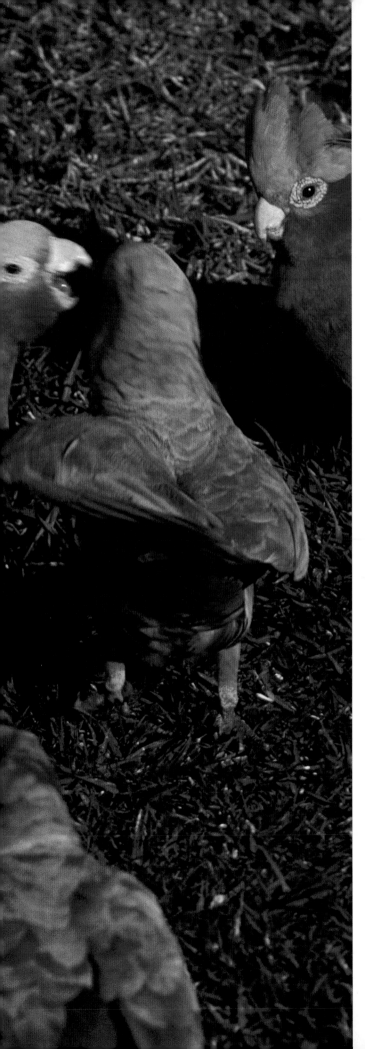

Galah,
Australia

Galahs are the most common and widespread of all Australian parrots. Beautiful and noisy, they often roost in large flocks high up in eucalyptus trees. About half an hour after sunrise, they fly with rhythmic wing beats over the land in search of food. In the early morning sunshine, they look bright pink and pearly gray.

Having eaten dry seeds and grains all day, the galahs become thirsty by late afternoon and head for the local watering place. Since the birds eat a lot of grain, farmers are not overly fond of them. Yet, they have inadvertently helped the galahs. Australian farmers have dug ponds for their thirsty sheep and cattle or built ingenious watering systems for them. When the water in a trough falls below a certain level, a pump kicks in and fills the trough with water from a well. Sheep and cattle know this and come to drink, and the galahs know it too. They are usually very careful: while most of the birds drink at the trough, some of them sit as sentinels on nearby trees and let out a strident yell the moment they spot a car or a human.

However, galahs are not always careful when they alight on country roads to eat gravel, which helps them grind the grain in their gizzards. They can be slow in taking off and are sometimes run over by cars. Perhaps this explains why "galah" is an Aussie term for "idiot."

Galahs may be noisy, quarrelsome, and occasionally fatally slow on the uptake, but on the whole they are astute and wily birds and therefore they thrive. They fear humans and thus keep away from them. During months of driving in Australia, we saw hundreds of flocks of these beautiful birds but always from afar.

Australia's brilliantly colored cockatoos, known as galahs, gather at a water hole in the evening. Since the hole is small, only two or three birds can drink at once. As a result this small group is being pushed and jostled by other birds, who are keen to get to the water.

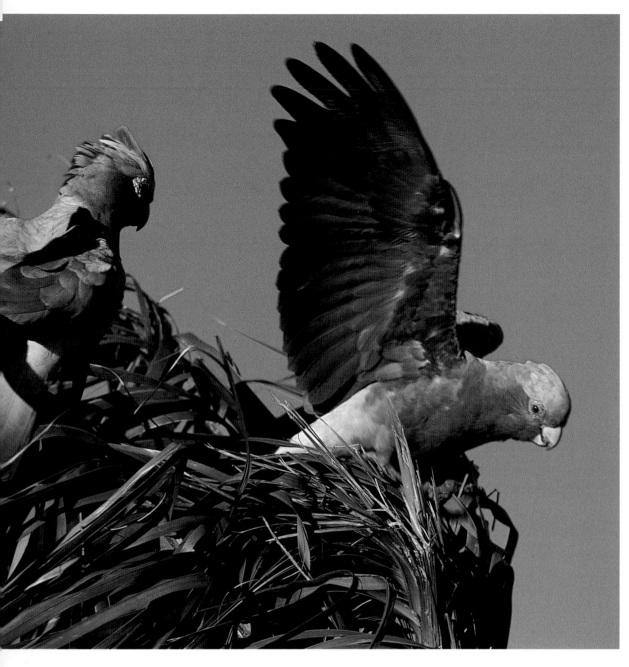

Galahs are Australia's most common and wide-spread parrots. Disliked by farmers since they eat grain, the birds post sentinels while they drink at a farmer's pond or water-trough. When the lookout birds spot danger, they scream and all the galahs fly away.

I complained about the galah's wariness to an Australian ornithologist friend. He laughed and said, "If you knew how some farmers feel about galahs, you'd be cautious, too," then added, "But no worries, mate. Drive to Kalbarrie. They've got a crowd of galahs in their city who aren't so cautious about people."

In Kalbarrie galahs are popular. Flocks of them waddle methodically across the town's extensive lawns and eat the spiky seeds of several weeds. The parrot's nutcracker beak is strong, efficient, and mobile. The upper and lower mandibles are hinged to the skull, the bill's edges are serrated, and there is a filelike ridge in the upper mandible that keeps the lower mandible honed and sharp—a fact well-known to anyone who's been bitten by a pet parrot.

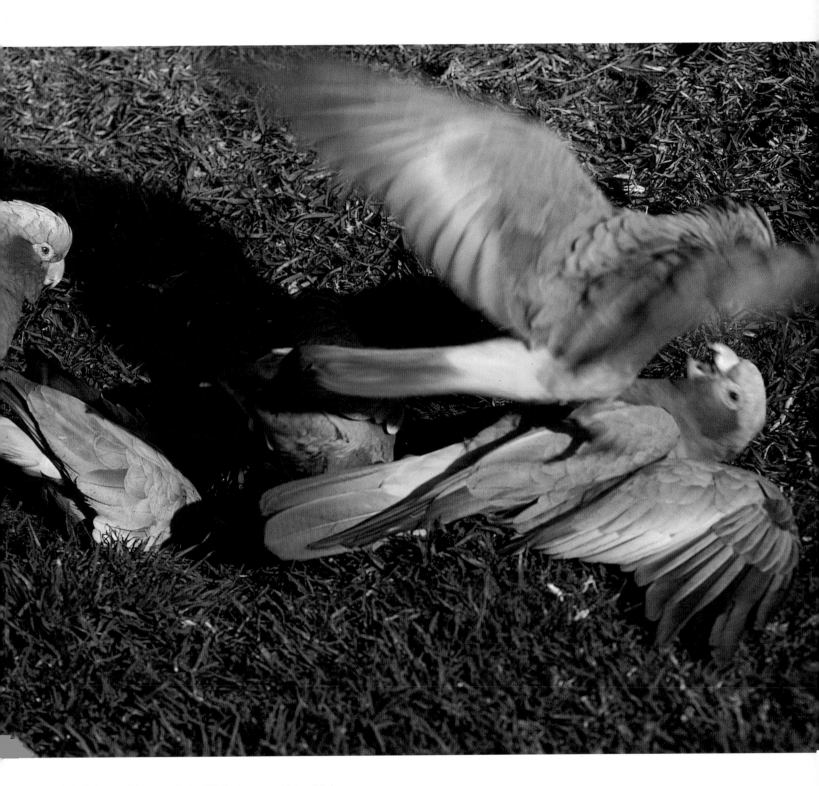

A galah fight at the water hole. While two would-be drinkers
have a knock-down match, a bird behind them drinks at the
well. Each evening, the galahs scream and quarrel, demanding
precedence at the water hole, but fights are rare.

228 The galah's tongue, like that of other parrots, is thick, strong, and sensitive. It moves and rotates seeds and nuts into just the right position for cracking, and there's no nut some parrot cannot crack.

The feeding adult galahs on Kalbarrie's lawns are trailed by lazy, whiny teenage chicks. They are old enough to gather their own food, but they've been spoiled by doting parents and prefer to cry and beg. It works. A male turns, the youngster squats, opens its bill appealingly, and the father regurgitates food into his offspring. Adult males and females look alike, but males have soft brown eyes, while the eyes of females are a fiery red.

Late afternoon is the galahs' drinking time, and the Kalbarrie birds gather on a lawn with a small water hole. At most, two or three birds can drink there at the same time. A galah dips deep, holds the water in its beak, bends backward, tips its head, and lets the water flow down its throat. However, it is difficult to do this smoothly, if another thirsty galah is impatiently tugging at your tail.

At the water hole, I observed the sequence of galah assertion and aggression nightly. First comes a sort of waddling bully strut. The bird raises and lowers its pink crest rapidly, puffs out its chest, and lets out a piercing screech. It's mostly bluff, dare and counter-dare, and very noisy and colorful. Occasionally the galahs fight: wings whack and rosy feathers float across the lawn. As the sun sets, the rose pink birds fight less and drink hurriedly. Then, as twilight falls upon the lawn, they all rise and roost together in chummy flocks in the eucalyptus trees.

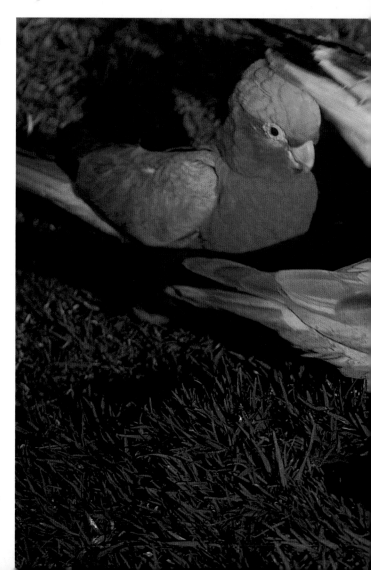

An immature silver gull at the galahs' favorite water hole in Kalbarrie, Australia. The galahs threaten the gull, and as it dips to drink, they try to pull it by the tail. But they are leery of the gull's long, sharp bill.

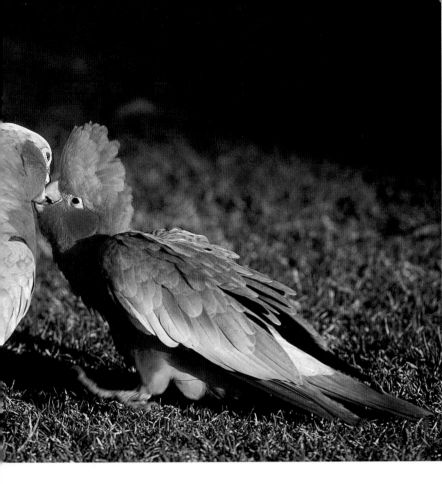

An adult galah (left) feeds a begging chick. The chick is fully fledged and old enough to fend for itself. But galahs, like many other parrots, are doting parents. So they spoil their chicks and feed them with regurgitated seeds when the youngsters cry.

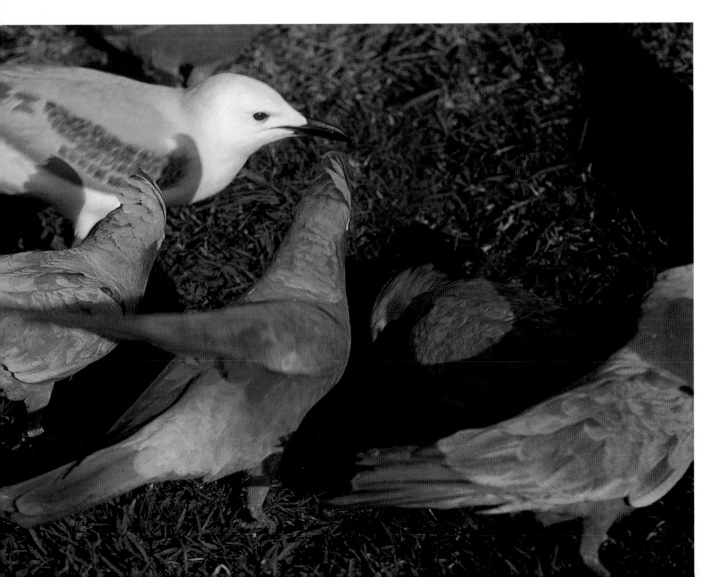

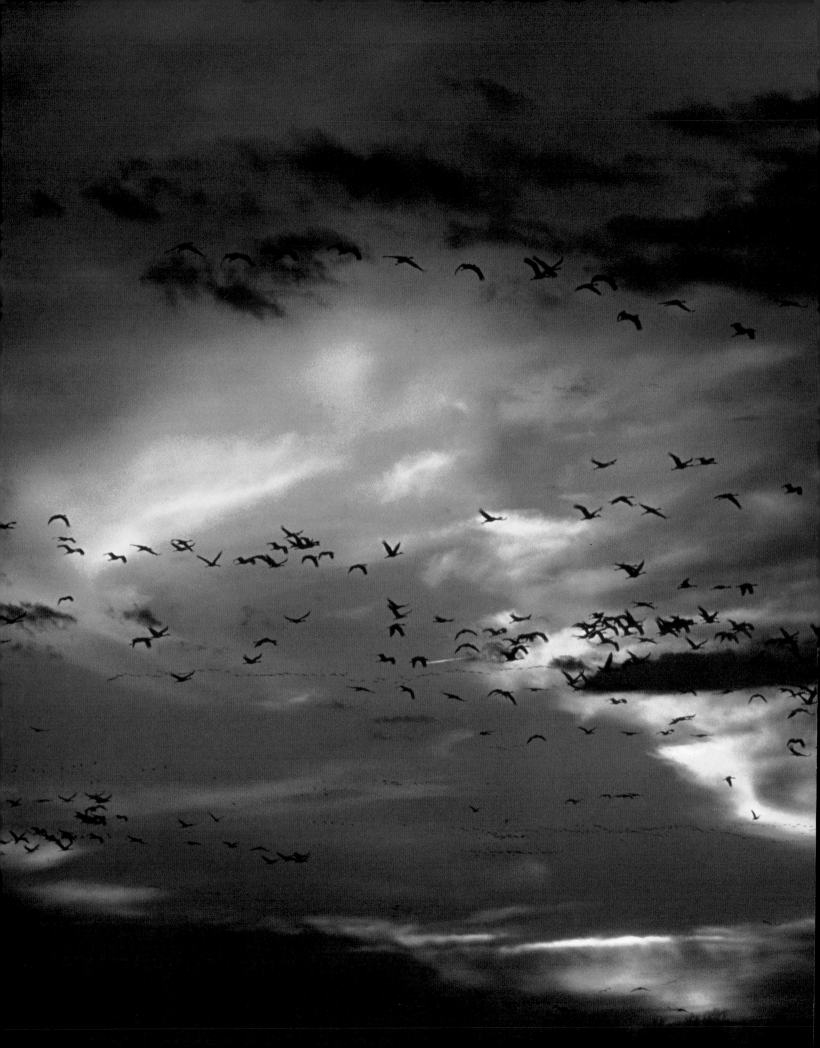

Sandhill Crane, Nebraska, U.S.A.

When French explorers and voyageurs reached Nebraska in the 18th century they said, *"C'est plat!"* ("it's flat"), and that's how the Platte River got its name. It's a broad, braided, lazy river, full of islets and sandbanks. These sandbanks are vital to sandhill cranes. They roost on them at night, safe from predators.

Every spring, half a million sandhill cranes mass along a 76-mile (120-km) stretch of the central Platte known as Big Bend. This is the largest assembly of cranes in the world. The birds gather in the vital staging area between their winter quarters in Texas, New Mexico, and Mexico and their nesting regions on the tundras of the Canadian Arctic and Alaska. About 80,000 cross the Bering Strait and nest in Siberia.

On a March night we sit in a blind near the Platte River. It is dark and damp and cold. Dawn will soon come, and all along the river cranes are calling. It's a marvelous, thrilling call: a gurgling clarion "garoooo." This powerful and primeval sound is the ancient, ultimate call of the wild. Cranes are among the oldest living birds on earth; their call has soared over hills and plains for more than 60 million years.

It is one of the loudest bird calls in the world, made possible by the crane's extraordinary trachea, or windpipe. The windpipe, longer than the four-foot- (1.2-m-) tall bird, is looped within the keel of the breastbone. This amplifies the crane's call and gives it a deep resonance, a throbbing timbre that is both fanfare-loud and oddly eerie.

A single crane call carries about two miles

At sunset, sandhill cranes return to roost on the sandbanks of Nebraska's Platte River, where they are safe from predators. About half a million sandhill cranes—the largest concentration of cranes in the world—gather at this staging area. Most arrive in early March, spend a month feeding on nearby fields and meadows, then leave in early April for their breeding grounds in the Far North.

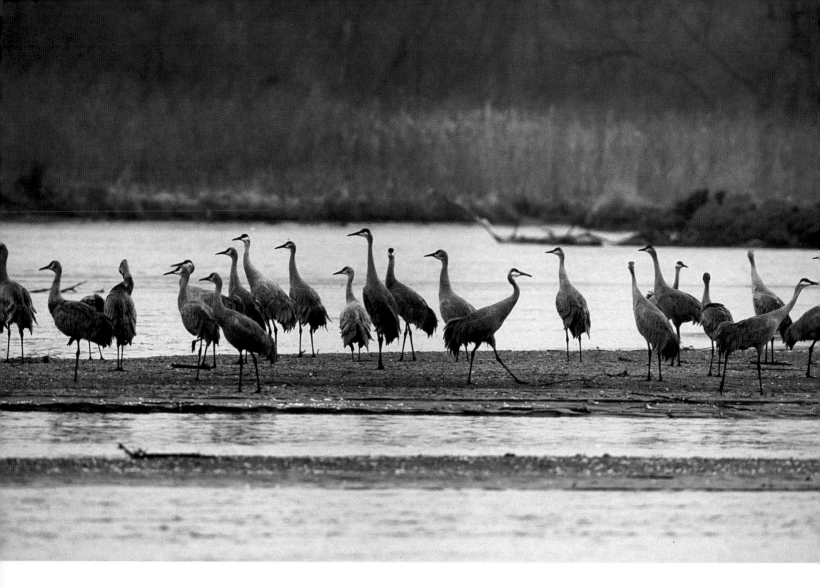

(3 km). There are probably 30,000 cranes within calling distance. Dawn pulses with their wild cries. Gray shapes take form in the gray light of dawn. A few hundred scarlet-capped cranes crowd the sandbank in front of our blind, standing straight as sentinels on their long stiltlike legs.

The cranes are restless. A few fly over, the excitement spreads, the volume of calls grows. As the first rays of sunlight glint through the cottonwoods on the riverbank, the cranes rise, flock after flock, and fly inland to glean fall grain on farmers' fields.

For once, the farmers do not mind. In fact, they're pleased. Ninety percent of the crane's food is waste corn from last year's harvest, which would sprout as unwanted volunteer corn in next year's crop. I drive along the grid of rural roads, and see cranes busily feeding among the cornstalks and stubble.

The birds are extremely shy. In every group, a few wary cranes stand guard. If I stop the car, the sentinels call and all the cranes move farther away from the road. If I get out, they retreat farther or may fly away.

Toward noon, the cranes gather on meadows. The corn they eat is converted into a one- to two-pound (.5- to 1-kg) layer of fat, which provides fuel for the flight to their breeding grounds in the Far North. In addition, they need proteins and minerals. They obtain most of these from the earthworms, snails, insect larvae, and other invertebrates they gather on the meadows. After the midday meal, they preen, then rest. A few dance.

Cranes mate for life. They are long-lived birds and, hence, in many countries, such as Japan, they symbolize marital harmony and happiness. The Romans also believed this. The word "congruence," a synonym for harmony, is derived from *grus*, the Latin name of the crane.

The dancers we see on the meadow are mostly young birds responding to the hormonal glow of young love. The dance—slow and courtly, with

In the gray light of dawn sandhill cranes stand on a sandbank in the Platte River. Most cranes winter in Texas and New Mexico. Then in spring they fly to the Platte River, where they remain for a month before heading to their northern nesting grounds. They feed on waste grain (mostly corn) left from the previous fall's harvest and amass the fat reserves they need to fuel their long flight. Nights are spent on sandbank roosts, safe from predators.

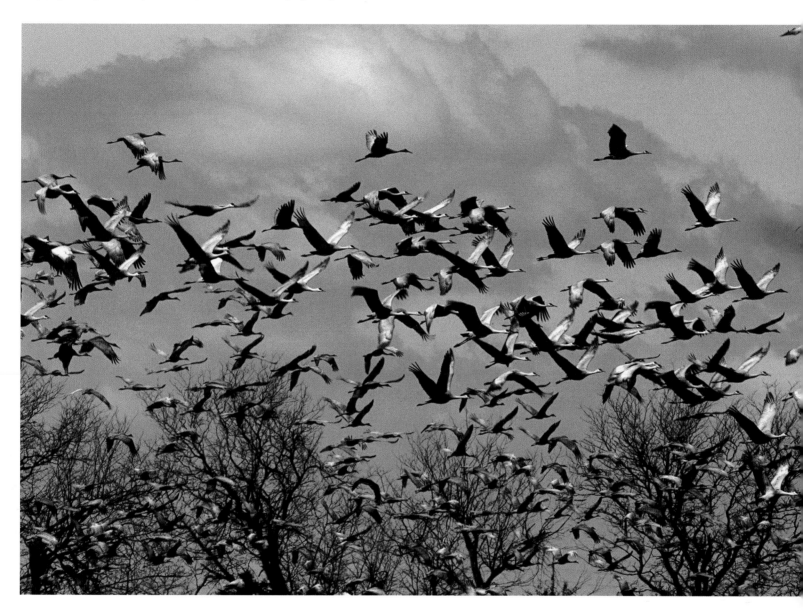

Toward noon, the cranes head for meadows near the Platte River, where they will feed on invertebrates to augment their corn diet with proteins and minerals. They preen and rest, then take off en masse to fly to other fields and eat more corn.

At sunrise cranes fly to farmers' fields to eat corn. They roost at night on sandbanks in the river. During the one month the half-a-million cranes spend at the Platte River, they gorge on corn to accumulate the fat reserves they need for the flight to their nesting grounds in the Far North.

abrupt jolts of passion—somehow suits the tall and stately birds. Both partners bow repeatedly, showing off their scarlet pates, jump ecstatically with half-open wings, then bow again. Older couples also dance, but less frequently and more sedately, to renew their bonds.

In the afternoon the cranes head for the fields again to fatten up on corn. The widely scattered birds usually feed in groups of three, consisting of both parents and their young. The adult female normally lays two large eggs, but, as a rule, the pair raises only one chick. The youngsters are now as tall as their parents and have the same satiny gray, dun-tinged plumage. However, they have not yet acquired their parents' stentorian French-horn calls. The best they can do is a sort of pre-puberty peeping. The voice change will come when they are about one year old.

In the sun's afterglow, cranes fly above the Platte River in loose flocks. They roost on the Platte River's sandbanks, where they are safe from predators.

In the evening, I stand among the cottonwoods on a sandy knoll overlooking the Platte River. As the sun begins to set, dark legions of flying, bugling cranes soar above the river to their nightly sandbank roosts. The sun sets, the sky glows in somber red; the wild cries of tens of thousands of cranes, limned against the burning sky, blend into a mighty, magical chorus.

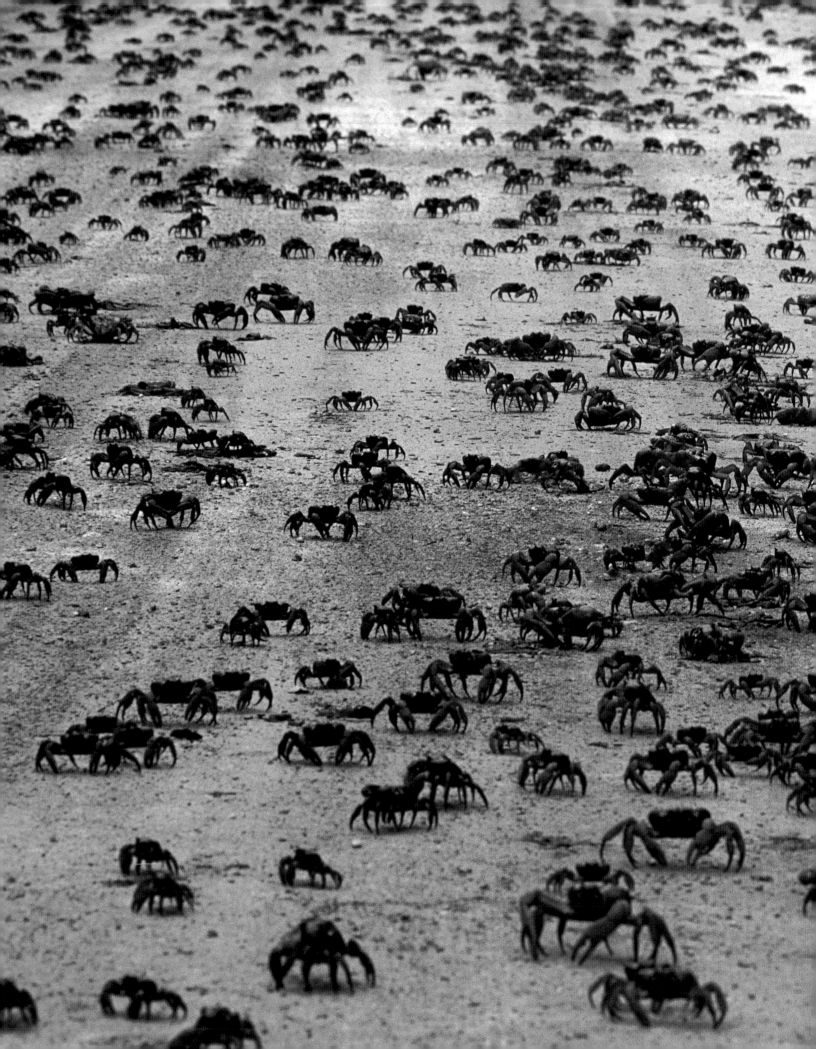

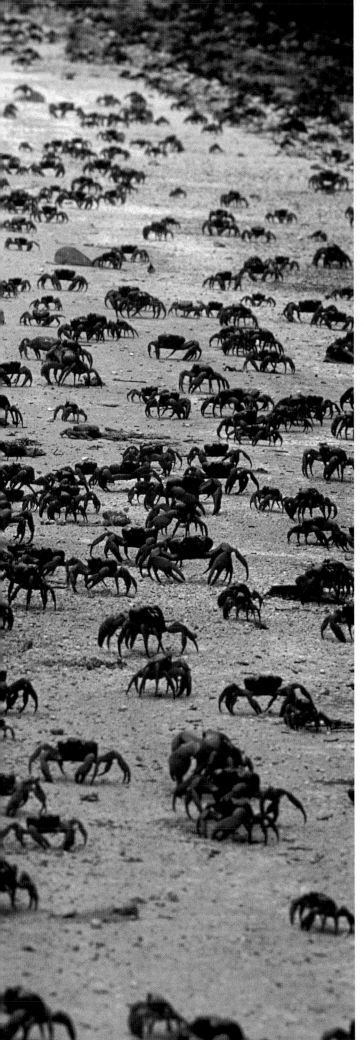

Red Crab, Christmas Island, Indian Ocean

Christmas Island lies in the Indian Ocean 1,600 miles (2,600 km) northwest of Perth, Australia, and 223 miles (360 km) south of Java, Indonesia. The 52-square-mile (135-sq-km) island once belonged to Britain but was ceded to Australia in 1958. Rich phosphate deposits are mined on a portion of it, but most of it consists of a national park, which is protected by law.

Christmas Island is above all the island of crabs: 15 species of these creatures live here, from massive seven-pound (3-kg) robber crabs with claws so powerful they can open coconuts (and snip off fingers with ease) to small freshwater crabs, clad in a carapace of the most exquisite Meissen china blue.

Red crabs are the most numerous crabs on the island. About 120 million adult red crabs inhabit the island. They live in the rainforest, which covers a plateau 650 feet (200 m) above sea level. The soaring rainforest is surprisingly neat. It contains little undergrowth and the forest floor is clean. It is the home of the red crabs, and they keep it tidy. They live in burrows and come out to forage when it's humid. Leaves, seeds, and leaf litter are their principal foods. During the dry season, they plug their burrows with dead leaves and stay within the humid earth, for their gills must remain moist; otherwise they will die.

Once the rainy season begins and the island is soaked, the male crabs emerge and begin their march toward the sea, the largest males in the van. (These veterans are 10 to 12 years old.) This immense army of hand-sized fiery red crabs marches sideways, crab-fashion, in serried ranks

Red crabs live only on Christmas Island in the Indian Ocean. Once a year, at the beginning of the rainy season, about 120 million red crabs leave their rainforest burrows and head toward the sea, crossing the forest floor and island roads on the way there. During the migration, many island roads are closed to car traffic.

Millions of red crabs march through the forest to the sea. The crabs mate in roomy burrows near the coast, which have been dug out by males to allure females. Once they have mated, the males return to their rainforest homes. The females remain in the coastal burrows while their eggs develop in brood pouches. Each female produces about 100,000 eggs.

A red crab crosses an island brook during its migration to the sea. Red crabs originated in the sea millions of years ago, but are now land crabs. However, they have retained their gills and must live in a humid environment in order to survive. In the rainforest they live in moist burrows, and their annual march to the sea begins shortly after the rainy season has started.

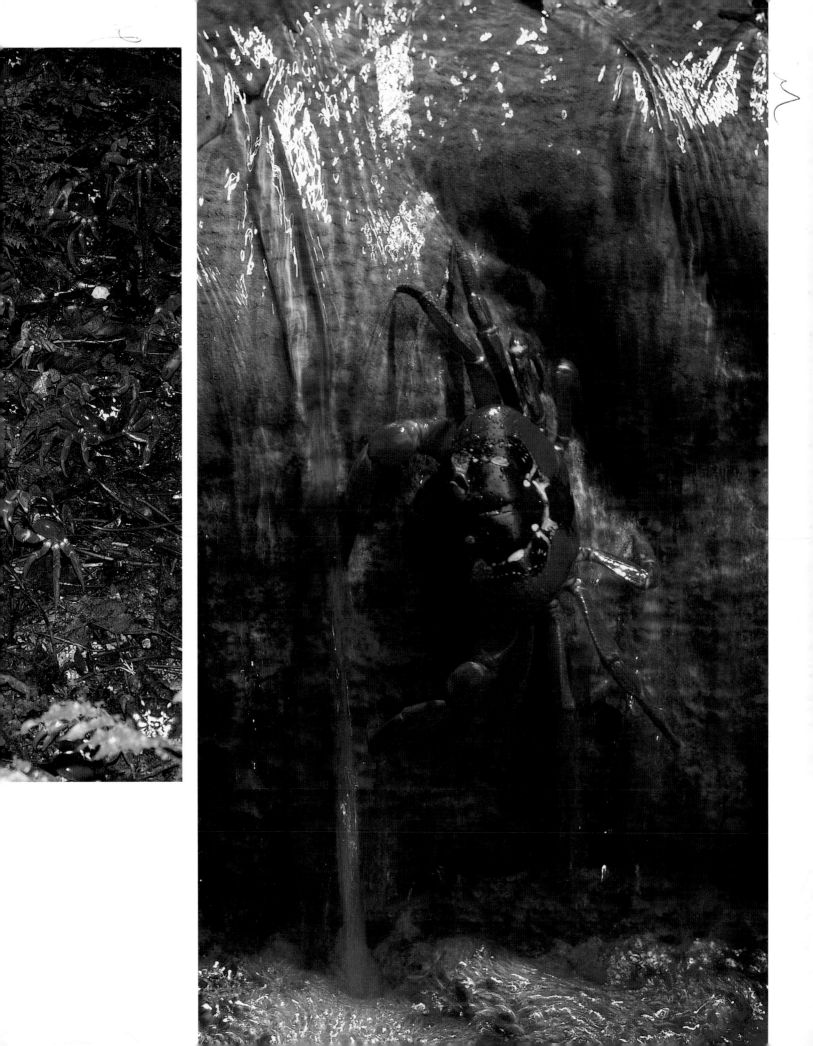

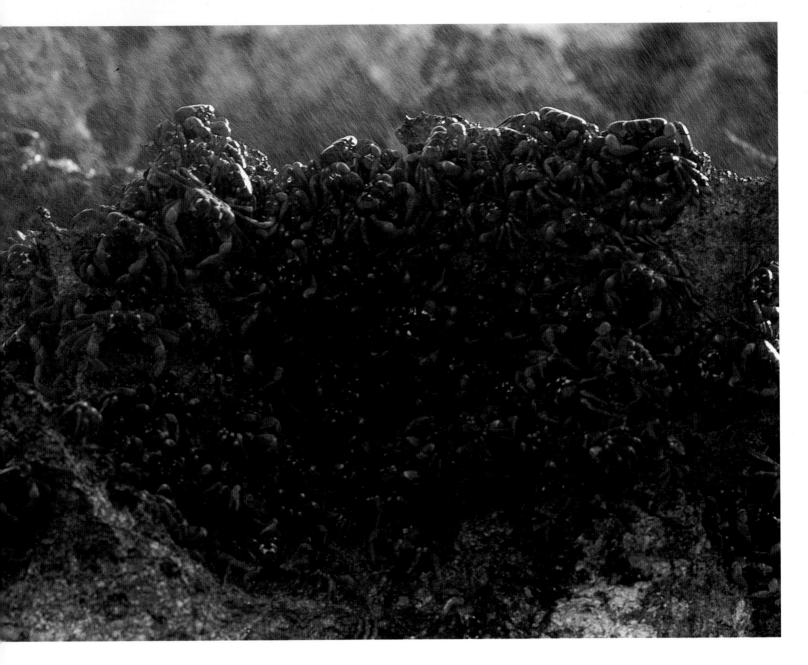

from the rainforest, down steep limestone slopes, across roads, through the backyards of the island's settlement, down to the coast.

There the males honeycomb the terraces near shore with roomy burrows. When the female army arrives a few days later, each male courts a female and tries to coax her into his den. As a rule, little coaxing is required because owners of spacious burrows are attractive to females.

They mate in the burrow, and then the males trudge back uphill to their rainforest homes, their duty done. Each female remains in her nuptial burrow for about 12 days while her 100,000 eggs mature. Finally, during the dark, wet nights in the last phase of the lunar cycle, the pregnant females leave the burrows, their brood pouches bulging with eggs, and head for the sea.

Millions of crabs line the shore. They dart into a rushing wave, raise their bodies, shake vigorously, and a dark cloud of eggs spreads into the sea. Upon contact with saltwater, the 100,000 eggs of each female hatch instantly into larvae and drift out into the ocean.

The return migration then begins, and much of the island is again covered by myriad crabs, so shiny red they look lacquered. One reason these crabs have thrived is that they live on a remote island and have no enemies. Animals don't eat them and the few humans who have tried have all confessed that they taste awful. This fact has also helped to ensure their survival.

Female red crabs cling to the rough limestone rock of the coast, drenched by flying spray. The females empty their egg-filled brood pouches into the sea. As soon as the eggs come into contact with saltwater, they hatch into larvae, which get carried out to sea by currents. The larvae develop at sea and after 30 days they return to Christmas Island as tiny crabs.

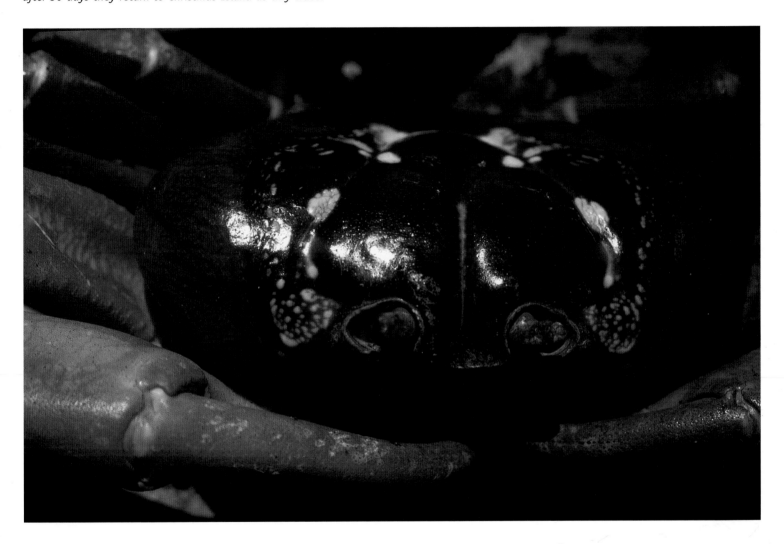

Their larvae are less lucky. They spend about 30 days at sea, where they are the manna of many creatures, among them the plankton-eating whale sharks. These are the largest sharks in the world, and at this time of year they come from far and wide to the waters near Christmas Island to feed on red crab larvae.

However, since there are trillions of red crab larvae, lots of them survive. These survivors metamorphose into nearly ¼-inch- (five-millimeter) long baby crabs, which crawl inland and hide in the rainforest. They grow and molt and then grow some more. They dig burrows and keep the forest floor clean, and in the fullness of time, they join the march of millions of red crabs to the sea.

A large male red crab near the entrance to its rainforest burrow. The largest males, who are about 10 to 12 years old, head the epic march of millions of red crabs to the sea. Near the coast they dig spacious nuptial burrows and await the coming of the females who follow the male migration within a few days.

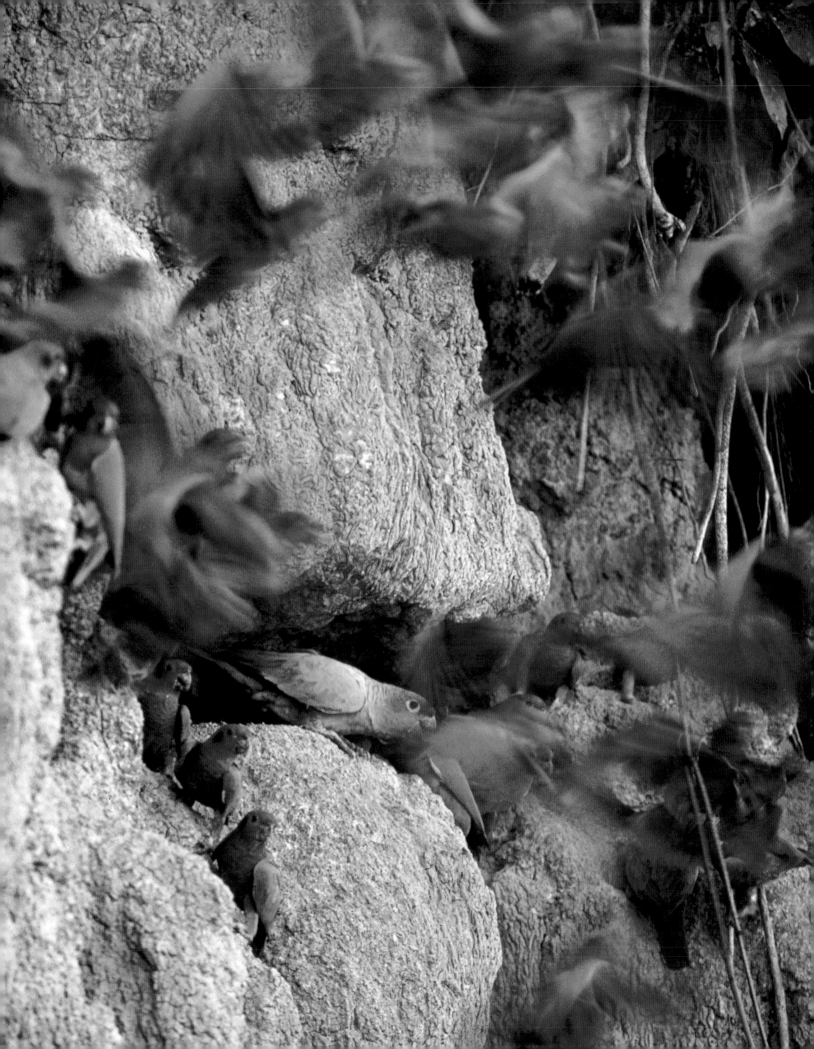

Blue-Headed Parrot,
Upper Amazon Region, Peru

Since plants can't walk but their seeds must travel, many have a mutually beneficial arrangement with animals. Just as flowers reward pollinators with sips of nectar, plants reward animals with food. Animals may eat fruit when they are ripe and are expected to disseminate the seeds. A splendid quid pro quo arrangement.

However, some parrots of the Amazon region do not play by these rules. They eat unripe fruit whose seeds are not yet ready to germinate. Worse, they often also eat the seeds. Biologists call them "seed predators." Some plants try to foil this predation by adding alkaloids and tannins to their fruit to make it toxic. The fruit, now poisonous and dangerous, should be safe from marauders.

Some parrots, however, are one up in this plant–animal game of ploy and counterploy. As we have seen, they have discovered that certain types of kaolin clay act as detoxicants. They can eat poisonous fruit with impunity, provided they also eat clays that neutralize the poison.

The kaolin is both antidote and food supplement. It contains the calcium and some of the sodium, vital to birds' health, which is often lacking in the parrots' fruit and seed diet. To obtain it, parrots flock en masse to certain upper Amazon riverbanks to eat their daily dose of soothing clay. Kaolin is good for humans, too. The widely used anti-diarrheal medicine Kaopectate is a clay-based product and so is Milk of Magnesia.

That some clay substances may be good for you has long been known by many South American Indians. The famous scientist and explorer Alexander von Humboldt reported in the late 18th century that the Otomac Indians of the upper

Frightened by an eagle, blue-headed parrots take flight. At this clay lick in the Upper Amazon region of Peru, the clay-eating parrots have cut fissures, nooks, and galleries into the riverbank. The clay detoxifies the poisons in some of the fruit the parrots eat.

Orinoco River ate clay with their food. A century later, the English explorer Henry Bates, who had traveled on the Amazon, remarked that "most people in the upper parts of the Amazon have this strange habit." Villagers in the High Andes still eat *colpa* to buffer the toxic effects of some varieties of wild potatoes. (*Colpa* is a Quechua Indian word that means "salty earth.")

Colpa is now also the name of the clay licks in Amazonia where the parrots gather during those periods of the year when their diet includes poisonous fruit. As previously mentioned, I traveled to Peru's upper Amazon region to observe parrots at one of the area's 40 clay licks. My fellow bird-watchers and I set out for the *colpa* before dawn. We hid in a blind near the clay lick and were soon able to take in the daily parrot parade, full of color and noise.

The blue-headed parrots were the most numerous parrots. They were small but gorgeous: the body emerald green, the head, neck, and chest a shimmering velvety blue. Unlike the larger parrots that grabbed clay by the beakful or raked a footful of clay from the wall and then ate it, the smaller blue-headed parrots nibbled at the sienna brown clay.

They ate and argued. How they could talk so loud and so much with beakfuls of clay was a riddle to me. And how they worried! Although they were reasonably safe in the shelter of the rainforest canopy where they normally live, they felt exposed and vulnerable clinging to the open clay wall of a 40-foot (12-m) riverbank.

As many as a thousand parrots of 10 to 15 species may gather at a large clay lick like the one I visited. Unfortunately the local eagles and hawks

Alarmed by the presence of a raptor, hundreds of blue-headed parrots fly high above a river in Amazonia. The rush of brightly colored birds makes it difficult for a bird of prey to concentrate upon a single victim, and thus all the birds may escape it.

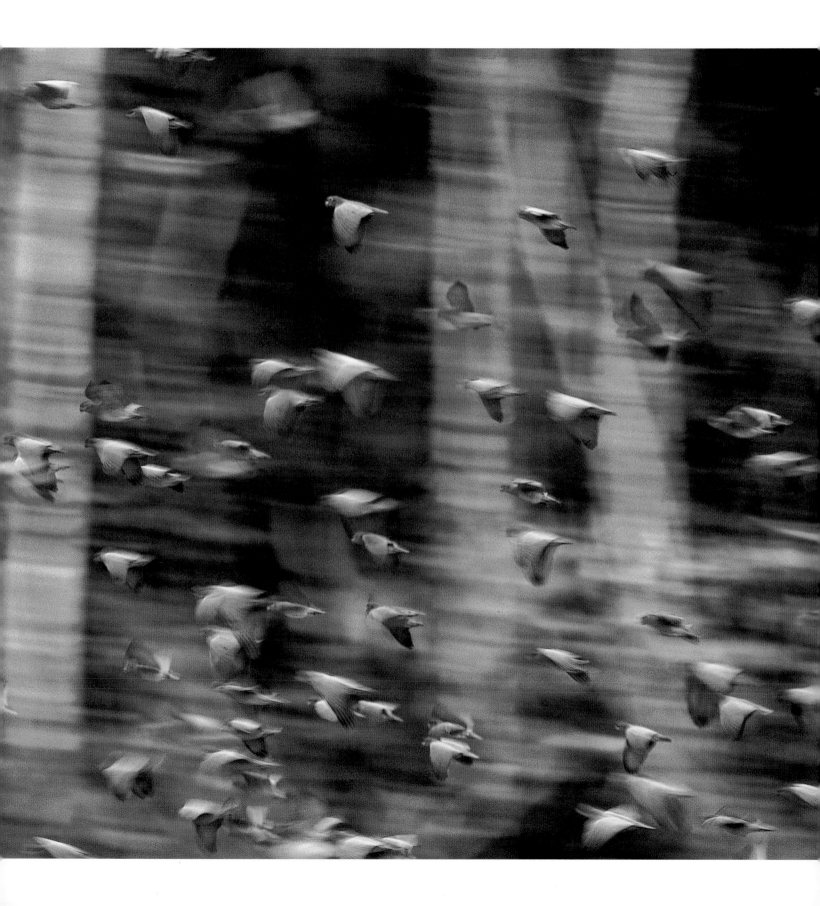

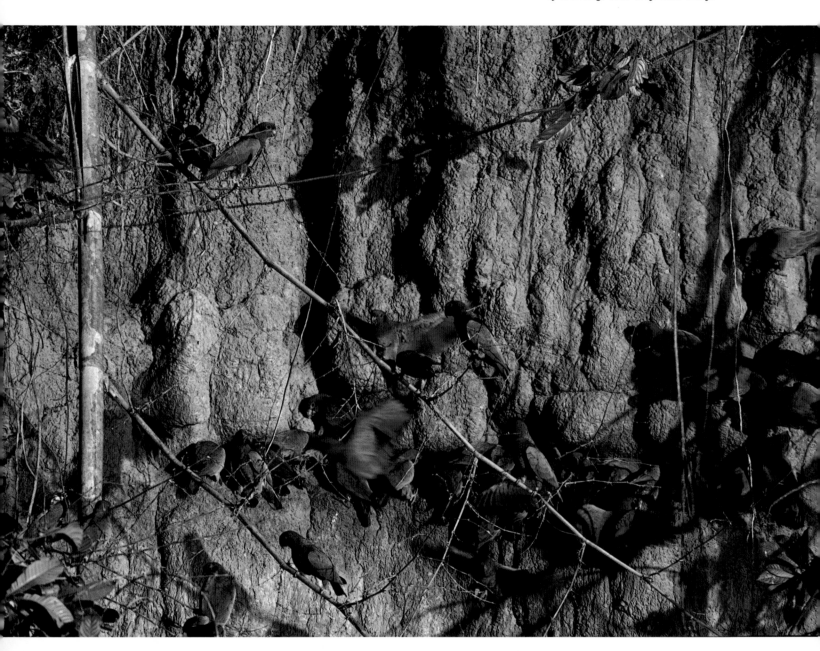

Beautiful and numerous, the blue-headed parrots come in large flocks to the clay licks of Amazonia. By eating certain kaolinlike clays, the parrots neutralize the poison in the fruits they eat.

who like to eat parrots are well aware of this. This accounts for the speed with which the nervous parrots consume the clay.

Parrots in the trees above the *colpa* we visited acted as sentinels. They spotted an eagle and screamed a warning. Within seconds the entire mass of blue-headed parrots took off, creating such a rushing swoosh of parrots that it was impossible for the raptor to zero in on a single bird.

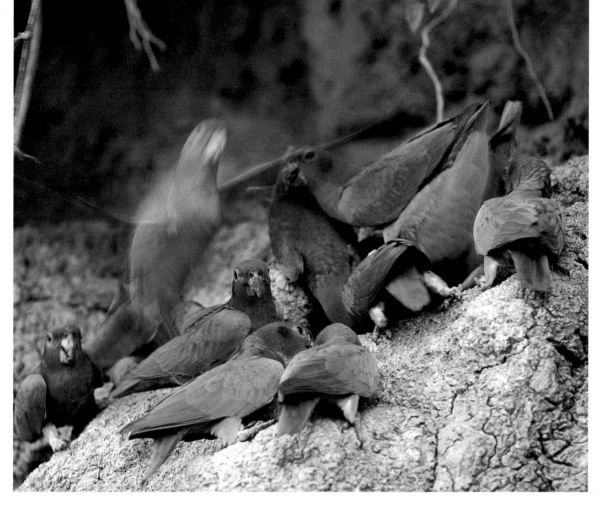

The smaller parrots, such as these blue-headed parrots, arrive at the clay licks just after dawn. They nibble clay to allay the effects of toxins in their food. First described by travelers in the 1960s, about 40 of these colpas, as the clay licks are called, have since been discovered in Amazonia.

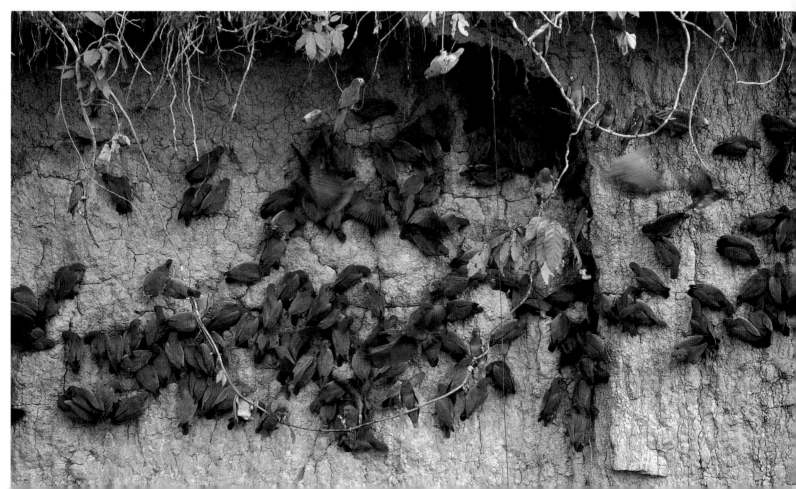

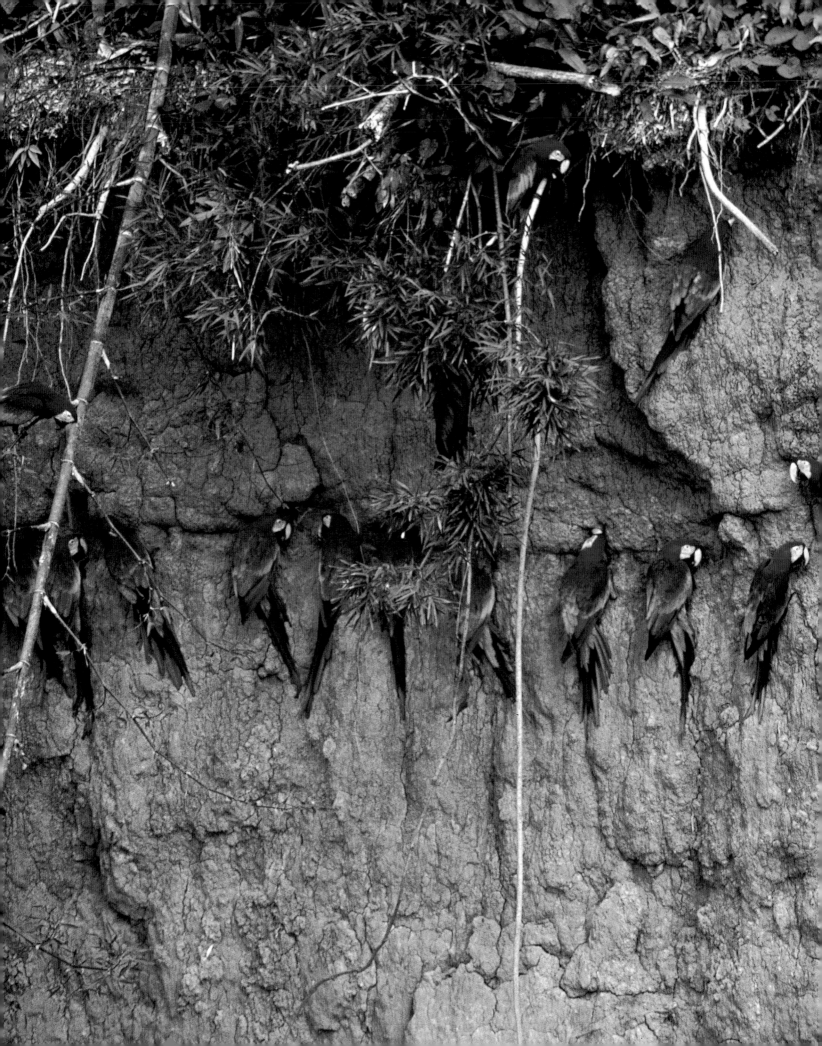

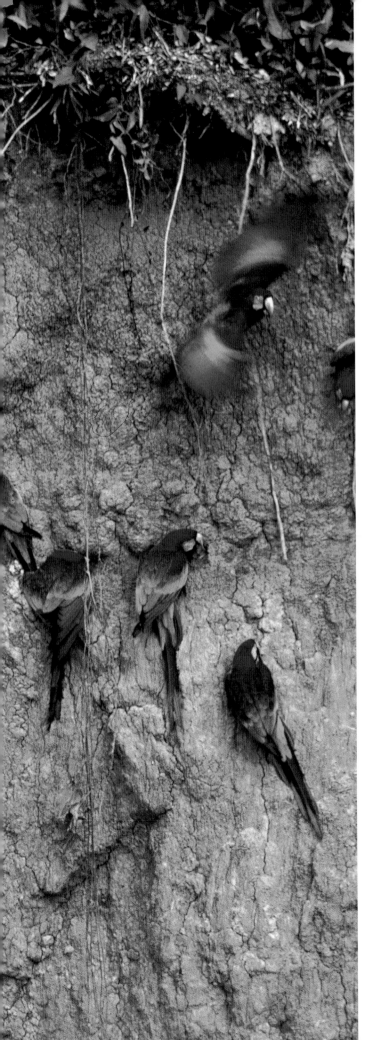

Red-and-Green Macaw, Upper Amazon Region, Peru

The hura tree of Amazonia has explosive seed containers. The seeds are surrounded by a pulpy pod. As the pulp dries and shrinks, pressure begins to build inside the pod. Finally the pod explodes with a shotlike bang that can be heard a mile away and scatters seeds to a distance of more than 40 feet (12 m). Its popular name is the "monkey's dinner bell."

To forestall the pilfering of unripe fruit, the hura tree saturates it with a potent poison. The pod contains a caustic white sap, which is so strong that it will create great red welts on human skin and blind a human if it gets into his or her eyes.

The hura pod seems well protected. Yet macaws eat the forbidding fruit with pleasure and no apparent ill effect. They are able to counteract the fruit's poison by flying to the nearest *colpa*, (an Amazonian clay lick) and eating a type of clay that neutralizes it. These *colpas* are the parrot drugstores of Amazonia.

About 15 species of parrots frequent the *colpas* during the seasons when many of the fruits they consume are toxic in order to eat the detoxifying clay. The largest and the loudest of these birds are the macaws. The author Peter Matthiessen likened their shrill screeching to "the most fiendish of children's noisemakers," and the naturalist Gerald Durrell warned that if you ever buy a macaw it will "deafen you with its screams."

My encounter with macaws in Peru's upper Amazon region, which I've previously alluded to, certainly confirmed these authors' observations. As we hid in a blind near one of the *colpas* on the Manu River before dawn, the first macaws

Red-and-green macaws cling to a steep riverbank in Amazonia, eating the clay they need to neutralize the poison they have ingested with some of their favorite fruit. Large and loud, with three-foot (1-m) wingspans and high-decibel voices, the macaws visit this clay lick every day during the season when they eat fruit that is laced with toxins. It is one of 40 clay licks that are known to exist in the upper Amazon region.

A cautious macaw couple in the trees above the clay lick. Among the branches of the rainforest canopy, macaws are fairly safe from surprise attacks by eagles, their main enemies. But at the clay lick they sit in the open. So while they crave the clay, they always dawdle in nearby trees until other macaws come along; then, finding courage in numbers, they descend to eat the clay.

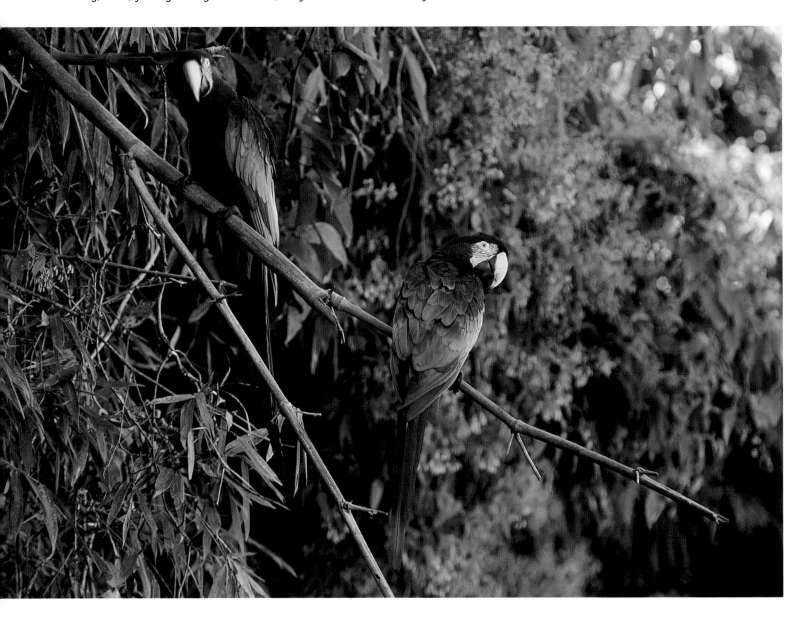

announced their arrival with raucous high-decibel screams and an explosion of color.

The smaller parrots came to the *colpa* just after dawn. The red-and-green macaws arrived about mid-morning. A couple settled in the tree above our blind and screeched. (Macaws are monogamous; if all goes well, a pair can be married for 40 years, for they are long-lived birds.)

These are the largest of the macaws and at our *colpa* they were the most numerous. They are three feet long (1 m) from the top of their scarlet heads to the tip of their bright blue tails, and in flight they are a burst of fiery red, emerald green, and sapphire blue with a three-foot (1-m) wingspan. They are vocal and clever. The red-and-green macaws at our blind were also apprehensive and cautious. This was because they craved the clay they needed to allay the effect of the toxins in the poisonous fruit they had consumed. Yet they were afraid to visit the clay lick on the sheer riverbank as they would feel exposed there and vulnerable to attacks from eagles, their main enemies.

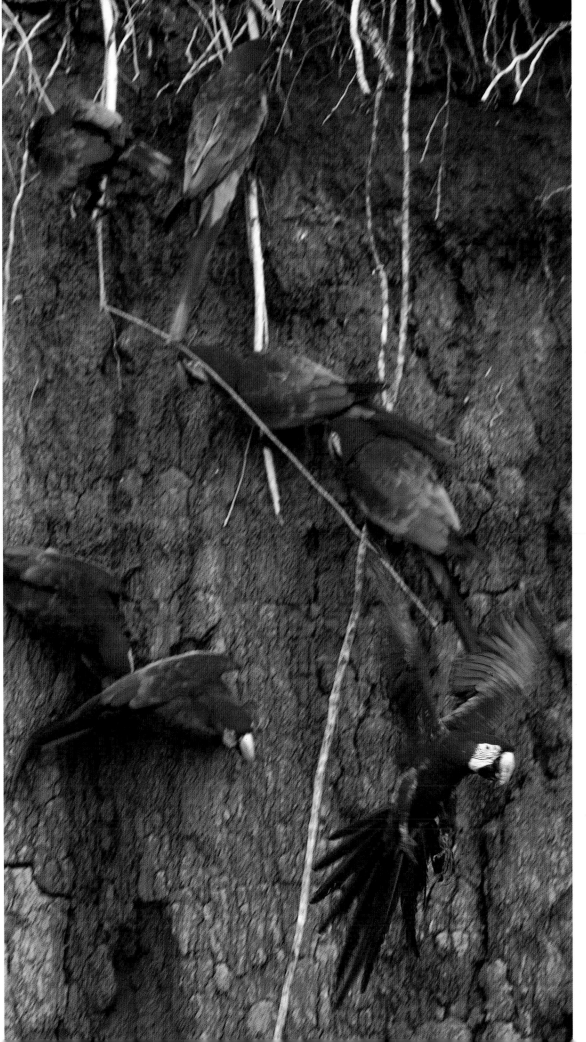

Using their sharp-clawed feet and strong beaks to hang from roots near the clay lick or to cling to the clay, macaws manage to stuff themselves with gobs of the clay they need to detoxify the poisonous fruit they eat. They are the largest and the most colorful parrots that mass at the colpas of Amazonia.

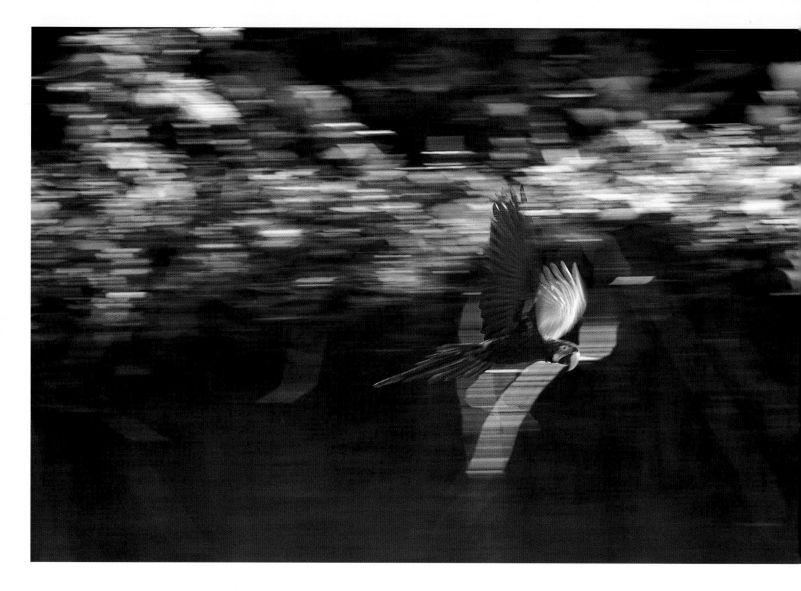

Troubled by indecision—to go or not to go—the macaws above our blind nervously indulged in what ethologists call displacement behavior. They climbed up and down the branches of the tree, using their feet and beaks. They also turned somersaults, pattered back and forth, and squawked loudly and incessantly. Soon other macaws joined the first couple and copied their antics, so that they resembled a brilliant crowd of feathered acrobats.

Their worries turned out to be justified. An eagle appeared in the sky, but it was not alone. Another group of macaws had risen above it and now followed the eagle screaming murder. Since no eagle can hope to hunt successfully with an escort of screaming macaws, the great bird soon soared away to look for less wary prey.

As if encouraged by this rout, the macaws in the tree glided down to the *colpa*, surged upward for a moment, and then hooked their sharp-clawed feet into the clay wall. Most of them had landed at a horizontal crack in the clay bank, a favorite place of all parrots. Eating clay near one another, they spread along the dun-colored clay wall, a brilliantly hued frieze of macaws.

Couples kept close together and some were followed by pesky teenage parrots asking to be fed. These youngsters are old enough to cut their own clay, but prefer to let their parents do it. They hang from roots and vines and act pathetic. They have a distinctive shrill whine that would get on anybody's nerves. After a while, an exasperated parent gives in and clambers over to the begging youngster and regurgitates gobs of clay into its gullet.

After about an hour, the macaws we were observing were stuffed with clay. Couples peeled off the wall, then all the birds cried and yelled and flew away in a blaze of vivid colors. The most brilliant and most noisy spectacle in the animal world was over for another day.

In a burst of brilliant color, a red-and-green macaw leaves the colpa in Amazonia and heads for the rainforest canopy. Macaws eat a wide array of fruit and seeds, some of them poisonous. To neutralize these poisons, they visit special colpas to ingest clays that act as detoxicants.

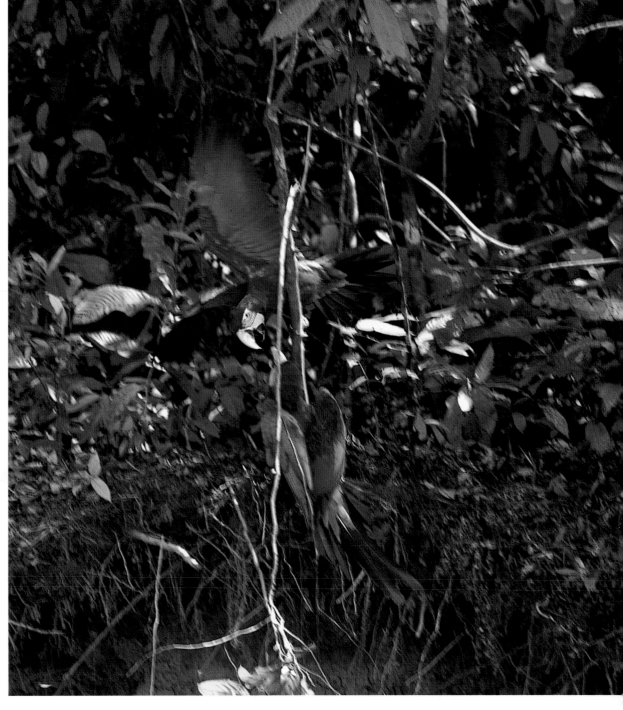

Although it is old enough to get its own clay, a young macaw prefers to pester its indulgent parent to give it some. The adult eats the healing clay, then regurgitates it into the gullet of the begging youngster. The female, as a rule, lays two eggs, but the adults nearly invariably raise only one chick.

Afterword

I died at 10:42 a.m. on June 19, 1984, on an operating table at the Montreal General Hospital. I was suffering from ventricular tachycardia, and my doctors were trying to find the most suitable medication for me to prevent these potentially fatal attacks. During a test my heart, which had already been damaged by an earlier heart attack, went into overdrive, then stopped. At this moment I had a preview of paradise.

Being dead was surprisingly pleasant. I seemed divorced from my body. Cocooned in blissful euphoria, I floated in another world. This world was suffused with a pure white light. The light parted like a curtain, and beyond it I saw something or someone, vaguely at first, then more distinctly.

Then I felt a massive jolt, and the vision vanished. Euphoria was replaced by pain. A powerful electric shock had restarted my heart. I had been clinically dead for two minutes and seven seconds. All that I had felt and seen during that time remained clear, except for one thing. The image of whatever or whoever I had seen beyond the light was obliterated, and my efforts to recover it proved fruitless.

Later I read that other people who have died and then been revived have experienced feelings and a vision like mine during the few minutes that they were clinically dead. In every case, the focal point of their vision also vanished beyond recall.

Following the heart attack that nearly took my life, I was lucky enough to receive a heart transplant, which gave me a new lease on life, and I have tried to use it well. Since I find earthly paradise in nature, the marvel of massed animals has filled me with awe, and this book is the result of that fascination.

I have not tried to improve on nature with the help of digital editing software, as is now the fashion. Computers can do wonders: they can move pyramids, align scattered zebras into regimented ranks of Prussian perfection, or take a hundred animals and create a mighty band of thousands from them. Truly marvelous, yet, to me, somehow not quite true. I prefer to photograph what I see, and the unaltered pictures are in this book.

Most books on animals these days are filled with caveats and sad musings about the demise of certain species, as well as dire predictions about what havoc environmental changes are wreaking on wildlife. Unfortunately, these depressing facts are usually correct. In this book, however, I have dwelt primarily on the beauty, the diversity, the infinite wonder of the natural world. It is my celebration of nature and of life.

Also by Fred Bruemmer